CONSTRUCTING MASCULINITY

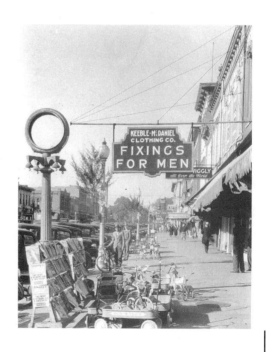

Also in this series:

DISCUSSIONS IN CONTEMPORARY CULTURE
 Edited by Hal Foster

VISION AND VISUALITY
 Edited by Hal Foster

THE WORK OF ANDY WARHOL
 Edited by Gary Garrels

REMAKING HISTORY
 Edited by Barbara Kruger and Philomena Mariani

DEMOCRACY
 A Project by Group Material
 Edited by Brian Wallis

IF YOU LIVED HERE
 The City in Art, Theory, and Social Activism
 A Project by Martha Rosler
 Edited by Brian Wallis

CRITICAL FICTIONS
 The Politics of Imaginative Writing
 Edited by Philomena Mariani

BLACK POPULAR CULTURE
 A Project by Michele Wallace
 Edited by Gina Dent

CULTURE ON THE BRINK
 Ideologies of Technology
 Edited by Gretchen Bender and Timothy Druckrey

VISUAL DISPLAY
 Culture Beyond Appearances
 Edited by Lynne Cooke and Peter Wollen

CONSTRUCTING MASCULINITY

EDITED BY

MAURICE BERGER

BRIAN WALLIS

SIMON WATSON

PICTURE ESSAY BY

CARRIE MAE WEEMS

ROUTLEDGE

NEW YORK

LONDON

Published in 1995 by

Routledge
29 West 35th Street
New York, NY 10001

Library of Congress
Cataloging-in-Publication Data
is available upon request

p. cm.
Includes bibliographical references.
ISBN 0-415-91052-8
ISBN 0-415-91053- 6 (pbk.)

British Library Cataloguing-in-Publication
Data also available

Contents

ONE

WHAT IS MASCULINITY?

MASCULINITY AND REPRESENTATION

HOW SCIENCE DEFINES MEN

MASCULINITY AND THE RULE OF LAW

MALE SUBJECTIVITY AND RESPONSIBILITY

MICHAEL GOVAN,
EXECUTIVE DIRECTOR,
DIA CENTER FOR THE ARTS

NOTE ON THE SERIES

The idea of organizing a conference and publication to question issues of power through a consideration of masculinity was brought to us by Maurice Berger, Brian Wallis, and Simon Watson, who have since dedicated themselves to the success of this project. We commend their efforts to find ways of reconfiguring traditional political, social, and aesthetic definitions of gender by bringing this distinguished and diverse group of scholars together. We also extend our thanks to the contributors, who have given generously of their time to present their papers at the conference and revise them for publication here.

Charles Wright, former Director of Dia; Lynne Cooke, Curator; and Karen Kelly, Director of Publications; were instrumental in conceiving "Constructing Masculinity" within the framework of the Discussions in Contemporary Culture series. Franklin Sirmans, Publications Assistant, worked tirelessly on both the organization of the conference and this publication. We would also like to thank the entire Dia staff, especially those at Dia's 22nd Street location, in New York City for helping to pull off the conference smoothly.

It has been wonderful to work with Carrie Mae Weems on the photographic essay in this book. The clarity of her vision and process has been an inspiration. We thank Leslie Sharpe for her thoughtful design of the interior of the book. Bethany Johns, who has worked on the design of each volume of the Discussions series, has again provided an elegant cover for this book.

Our collaboration with Routledge on this book project was prompted by our shared commitment to providing forums for cultural studies debates. We thank Bill Germano at Routledge for his enthusiasm for this project, and Eric Zinner, Stewart Cauley, and Adam Bohannan for their assistance in many aspects of production.

Public programs at Dia are supported, in part, by a generous grant from the Lila Acheson Wallace Theatre Fund at Community Funds, Inc.

MAURICE BERGER,
BRIAN WALLIS,
AND SIMON WATSON

INTRODUCTION

One of the most compelling images from the Civil Rights Movement is a photograph taken by Ernest Withers in Memphis in 1968, just a week before the assassination of Martin Luther King, Jr. Across a wide city street stands a nervous crowd of at least a hundred African-American men. It is an orderly protest, defiant but nonviolent. Each man holds before himself a sign saying simply "I Am A Man." Thirty years ago, this slogan stressed that all men were—or should be—equal. Yet, as the photograph so subtly emphasizes, both manliness and equality are contingent upon intersecting social conditions, always riven by issues of race, class, gender, and sexuality. This old

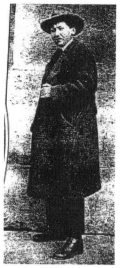
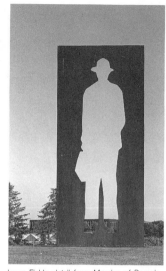

Jonathan Borofsky, *Man with Briefcase*, 1987

Laura Fields, detail from *Mansion of Despair*, 1993.

photograph suggests something of the dilemma one faces today in attempting to speak plainly about masculinity. It is no longer possible simply to declare one's manhood as a form of identity politics. Masculinity, the asymmetrical pendant to the more critically investigated femininity, is a vexed term, variously inflected, multiply defined, not limited to straightforward descriptions of maleness.

Over the past several decades, cultural critics in the fields of feminist, race, gay and lesbian, and subalternist studies have struggled to challenge normative social roles and to contest the logic of patriarchy. This examination has taken many forms, from the creation of gender and ethnic studies departments in universities, to the invention of fictional characters who enact or reject the stereotypes of masculinity and femininity, to the scientific investigation of the genetic determinants of race, gender, and sexuality. When masculinity has been subjected to the critical gaze of these practices, it has inevitably been reinscribed as a complex and discursive category that cannot be seen as independent from that of other productive components of identity.

Within the ideological structure of patriarchal culture, heterosexual masculinity has traditionally been structured as the normative gender. Rather than simply seeking to overthrow this standard or focusing on the social determinants of sexual difference, many feminists have challenged the fixity of all subject positions. This approach has emphasized the multiplicity of identity, the ways in which gender is articulated through a variety of positions, languages, institutions, and apparatuses. This position maintains that gender is constructed; that is, who we

are is shaped by historical circumstances and social discourses, and not primarily by random biology. Gender roles, the subject positions we occupy in society, are constructed from a complex web of influences; some of these effects we control, others we do not.

For Homi Bhabha, this element of choice produces an anxiety that typifies the masculine position. He recalls the wounding question he periodically fielded from his angry, impatient father: "Are you a man or a mouse?"[1] Yet masculinity seems to demand such anxious choices, existing at the threshold between fixity and annihilation, between identity and nonidentity. Refusing to buy into the stereotypes that say masculinity is only about men, that it exists in opposition to femininity, that it is socially fixed and always recognizable, that it is straight and white, Bhabha argues that we must disturb masculinity, and "draw attention to it as a prosthetic reality—a 'prefixing' of the rules of gender and sexuality; an appendix or addition, that willy-nilly, supplements and suspends a 'lack in being.'"

In compiling this book, it was not our intention to fix masculinity, to eliminate its formative anxieties, to define its meaning, or to reinscribe its strengths. Rather, the overarching methodological and theoretical question of this book, as its title suggests, concerns the issue of how and why masculine identities are constructed, socially and personally. What are the imperatives, responsibilities, and problems that determine these constructions? Can the univalent notion of masculinity be replaced by the idea of multiple masculinities in which rigid boundaries of sexual and gender representation are blurred and even redrawn? One conclusion that the essays collected here share is that the category of "masculinity" should be seen as always ambivalent, always complicated, always dependent on the exigencies of personal and institutional power. Masculinity is realized here not as a monolithic entity, but as an interplay of emotional and intellectual factors—an interplay that directly implicates women as well as men, and is mediated by other social factors, including race, sexuality, nationality, and class.

A key conceptual bias inherent to our intellectual project stems from the work of Judith Butler, who argues that gender, rather than merely constructed, is performative, that it inevitably unfolds as a series of "performed" operations that render complex meanings about the normative standards that we cannot escape, the choices we can make, and the means by which we represent both. Of course, the social origins of gender division are not at all amorphous. The formation of gender differences in language—that is, the ways in which categories of the masculine and the feminine are defined by and eventually ingrained in language—most often produces a rigid and fictive construction

Maurice Berger, Brian Wallis, and Simon Watson

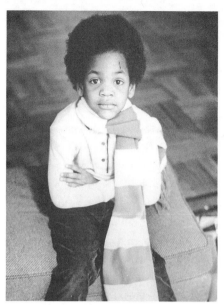

Lyle Ashton Harris, detail from *The Good Life*, 1994.

of reality. Women and men, therefore, are condemned to conform to binary sexual differences that appear to be inevitable, even natural. As such, the "naming" of sex is, according to Butler, "an act of domination and compulsion"—a means of forcing us to accept the idea of the masculine and the feminine as an inevitable binary opposition.[2] Such false stabilizations of gender, of course, inscribe onto the masculine and the feminine a coherent and ultimately coercive sexuality, in which the sexes are understood to mirror the flat, nearly oppositional roles of a compulsory, socially sanctioned heterosexuality.

But social and cultural constructions of the masculine and feminine are never so inevitable and unitary. For one, the gender discontinuities that charge hetero, bi, gay, and lesbian sexualities do not conform to a simple binary opposition between men and women. The formations of gay and lesbian sexuality, for example, are not necessarily drawn around the boundaries of gender at all, an idea exemplified by bull dykes who dress like men or drag queens who masquerade as women. Hence, this regulatory ideal is no more than a "norm and a fiction that disguises itself as a developmental law regulating the sexual field that it purports to describe."[3] In other words, gender identity can act as a coercive ideal that exists principally to protect the norm of heterosexuality. It is in this sense, then, that gender, rather than being static and reactive, is inevitably performative, continually unfolding as a complex enactment of self-representation and self-definition. As Butler observes:

Gender is not a noun, but neither is it a set of free-floating attributes, for we have seen that the substantive effect of gender is performatively produced and compelled by the regulatory practice of gender coherence. . . . In this sense, gender is always a doing, though not a doing by a subject who might be said to preexist the deed. . . . In an application that Nietzsche himself would not have anticipated or condoned, we might state as a corollary: There is no gender identity behind the expressions of gender; that identity is performatively constituted by the very "expressions" that are said to be its results.[4]

The results of this "performance" may work to defy original or primary gender identities, as in the cultural practices of cross-dressing; or it may stylize butch-femme identities in order to exaggerate, play with, or, in a more reactionary sense, conform to socially defined notions of the masculine or the feminine.

Because such options of self-presentation are the product of dramatic and contingent constructions of meaning, they proffer an essentially optimistic understanding of masculinity, since what is performed—what is, in a sense, fluid and temporal rather than socially fixed and static—can be reevaluated and even changed. Hence the acceptance of such a performative reading of gender begs one of the central questions of this project: if the rigid social constructions of the masculine have resulted in political and cultural forces of oppression, repression, and denial, can masculinity be rehearsed in a way that alters its ideological boundaries? In other words, can masculinity be performed so as to render it less repressive, less tyrannical?

Michel Foucault's definition of power is critical to our understanding of the social construction of gender, since the notions of unequal power and oppression are central to most struggles for equality.[5] Foucault challenged the notion of power as monolithic and repressive, and established an understanding of power as productive. Power is not simply limiting, restrictive, and negative—the social equivalent of the Father's "no." Rather, power flows through a network of disciplinary codes and institutions. Norms and standards are replicated and disseminated through schools, medicine, law, prisons, religion, even art; and in their circulation and reinforcement they actively determine social relations and create subject positions. For instance, the defining of madness in the nineteenth century, through a whole regime of texts and representations, created a situation whereby insane people were treated differently in all contacts with society; previously such a position had not existed.

What Foucault calls "disciplinary systems" are the processes and institutions through which power is replicated and enforced; they function by developing competencies or incompetencies within a particular field of practice or

MAURICE BERGER, BRIAN WALLIS, AND SIMON WATSON

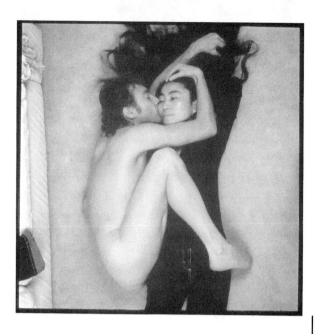

knowledge. Men, for instance, may conventionally be socialized to excel in ath-
letics and manual labor but not in, say, cooking. Paradoxically, these skills
enhance the power of the subject while further subjugating him, locking him
with a stereotypical gender position. According to Foucault's model of gender,
however, identity is not fixed but fragmented and shifting. Thus it is possible to
destabilize conventionalized notions of identity and gender. For Foucault, a
fundamental way to challenge conventional social position is to challenge the
way modern societies organize and control the knowledge claims of the
human sciences.

Because masculinity belongs to no one gender, race, sexuality, or intellec-
tual discipline, it is important to represent multivalent ways of thinking about
the conditions, sensibility, and psychological, economic, legal, and medical
imperatives that enforce it. For this reason, our investigation was structured
around five areas, suggesting Foucault's "disciplinary systems": philosophy
("What is Masculinity?"), culture ("Masculinity and Representation"), science,
("How Science Defines Men"), law ("Masculinity and the Rule of Law"), and
political practice ("Male Subjectivity and Responsibility").

"What is Masculinity?" questions society's normative standards for the
masculine, and contemplates the extent to which men and women can tran-
scend these stereotypes and proscriptions. "Masculinity and Representation"
explores the ways in which representations of men and maleness in the media

and in the arts are negotiated and circulated, and how such images can produce and ultimately reshape notions of the masculine; "How Science Defines Men" and "Masculinity and the Rule of Law" consider masculinity in relationship to two dominant social institutions—science and law— that play a vital role in constructing stereotypes about gender, sexuality, and race, and in establishing power relationships within and between the sexes; and "Male Subjectivity and Responsibility" interrogates the question of how an informed, activist notion of masculinity can contribute to the political debate around identity and power.

Ultimately, these essays expand the notion of "men in feminism"—the subject and title of Alice Jardine and Paul Smith's groundbreaking anthology published in 1987—to include a radical rethinking of masculinity itself. While an increasing number of male academic, political, and cultural figures have felt comfortable enough in recent years to proclaim themselves feminists, absorbing aspects of feminist politics and theory into their thinking, their gestures are most often built on an essentialized and static dichotomy between men and women. But men must do more that admit their complicity in patriarchy; they must begin to rethink the very boundaries that shape and define what it means to be a man.

Conversely, women must play an important part in this reevaluation, an idea suggested by Eve Kosofsky Sedgwick's admonition that "when something is about masculinity, it isn't always 'about men.'"[6] Far from being just about men, the idea of masculinity engages, inflects, and shapes everyone. As the essays included here demonstrate, any examination of these relations of power—and any hope for the social repositioning of the masculine—must include a nuanced examination of the emotional, spiritual, intellectual, economic relationship of men to the rest of society, as well as a radical speculation on just what form these refigured masculinities, cognizant of the reality of social difference, might take.

NOTES

1. Homi K. Bhabha, "Are You a Man or a Mouse?" pp. 57–65, in this volume.

2. Judith Butler, *Gender Trouble: Feminism and the Subversion of Identity* (New York: Routledge, 1990), p. 115.

3. Ibid., p. 6.

4. Ibid., pp. 25–26.

5. See Michel Foucault, "The Subject and Power," in *Art After Modernism: Rethinking Representation*, ed. Brian Wallis (Boston: David Godine, 1984), pp. 417–32; and Foucault, *The History of Sexuality, Vol. 1: An Introduction* (New York: Vintage Books, 1980).

6. Eve Kosofsky Sedgwick, "Gosh, Boy George, You Must Be Awfully Secure in Your Masculinity!" p. 12, in this volume.

WHAT IS
MASCULINITY

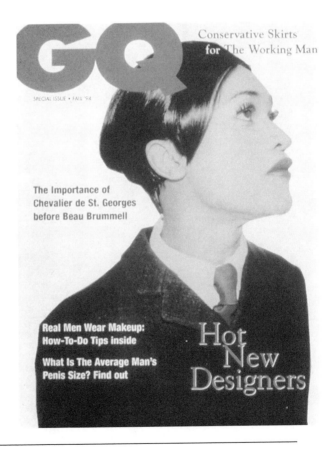

EVE KOSOFSKY SEDGWICK

"GOSH, BOY GEORGE, YOU MUST BE AWFULLY SECURE IN YOUR MASCULINITY!"

The title I have chosen for this text is borrowed from a hapless
Long Island disc jockey who was overcome with admiration while interviewing
a celebrity, only to finally hear himself blurting it out—"Gosh, Boy George . . . !"
My intent is to propose some axioms that may be helpful for stimulating, and
even possibly disrupting, the conversation on the topic of masculinity.

 The first axiom I would like to propose is what I have always imagined as
Boy George's response to the Long Island disc jockey:

Nothing to do, that is, with men. And when something is about masculinity, it is not always "about men." I think it is important to drive a wedge in, early and often and if possible conclusively, between the two topics, masculinity and men, whose relation to one another it is so difficult not to presume. Even in the prospectus prose for a serious book—this book, as a matter of fact—whose aim seems to be to problematize every conceivable aspect of masculinity, it is still notable that the distinctive linkage between masculinity and the male subject, or the subject of men, goes unquestioned. In asking "What Is Masculinity?" for instance, the editors begin: "Men of all ages and cultural backgrounds—straight, gay, and bisexual—are beginning to ask and explore key issues about the nature of masculinity. . . ."

Maybe we could update that to "Men of all ages and cultural backgrounds—straight, gay, bisexual, and female"?

Later in the same document, I am invited to consider how "traditional representations of masculinity have played a crucial role in shaping the economic, cultural, and political status of *men*"; how science views "traits that are typical to *men*"; whether it is "possible to imagine a critical *men's* movement"; and finally, climactically, "How *men* [can] rethink their power in an effort to reconstruct themselves personally and politically."[1]

Of course, the last thing I want to do is to minimize the importance of questions like these. But it does seem necessary to emphasize how crucially the force of such questions is vitiated when they are presented as *the* questions about masculinity *per se*—when, that is, an inquiry begins with the presupposition that everything pertaining to men can be classified as masculinity, and everything that can be said about masculinity pertains in the first place to men. Gosh, Boy George must really be secure in *something* when he has the courage to perform in drag—and he is a boy, at least his name says he is, so what he is secure *in* must be "masculinity," "his" masculinity. It is less obviously absurd, but all the more insidious, when, for example, nominally gay-affirmative psychologists such as Richard Friedman assume that the only form self-respect can take in boys, in boys gay or straight, is and has to be something called "masculine self-regard."[2] The boys I know who were so profoundly nourished, and with such heroic difficulty, by their hard-won feminine and effeminate self-regard—and for that matter, the girls who extracted the same precious survival skills from a sturdily masculine one—ought to present much more of a challenge than they have so far to the self-evidence of such formulations.

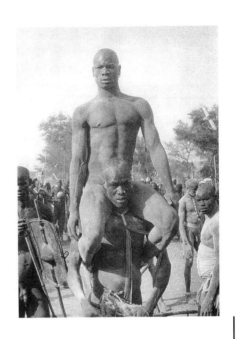

I would ask that we strongly resist, then, the presupposition that what women have to do with masculinity is mainly to be treated less or more oppressively by the men to whom masculinity more directly pertains. My purpose is not to file an *amicus curiae* brief with the "men of all ages and cultural backgrounds" who are "beginning to explore key issues about the nature of masculinity." I am exploring them myself. Nor do I mean to issue a *Consumer Reports* test-kitchen rating on the new masculinities. As a woman, I am a consumer of masculinities, but I am not more so than men are; and, like men, I as a woman am also a producer of masculinities and a performer of them.

It seems to me that the women who might better speak to these issues are some of those who are beginning to write so directly and eloquently about masculinity and/or about butch identity in women, largely but not exclusively in lesbian contexts: Leslie Feinberg, for example, or Judith Halberstam, or the contributors to Joan Nestle's "femme-butch anthology," or Judith Frank, who originated the ineradicably compelling notion of "butch abjection."[3] I myself, embarrassingly, can only speak from the subject position newly classified by Minnie Bruce Pratt as "adult children of mothers who couldn't figure out whether to be butches or femmes."[4] (Actually, my mother finally did figure it out; but it took her until the of age of seventy, so I am trying to be patient with my own confusions on this topic.)

In another sense, though, it may be that there is an even *stronger* case to be made in this regard by a writer who self-identifies, roughly speaking, as a

EVE KOSOFSKY SEDGWICK

confused femme (or do you consider the epithet redundant?). At any rate, that is the experience out of which I am trying to figure out how to articulate this. More specifically, in very briefly framing three further propositions on masculinity, I want to draw on what I occasionally have the composure to describe as the most interesting experiment I have undergone (or, euphemistically, "conducted") in the semiotics of gender, something I have written a little bit about before—namely, the half-year or so I spent in 1991 doing intensive chemotherapy following a diagnosis of node-positive breast cancer. The treatment involved, among other things, a by-no-means-uncommon disruption in the somatic signifiers (and for that matter the signifieds) of gender—and more profoundly and simply, of bodily health. I do not want to dwell now on the encounter with mortality entailed in this experience; rather on, for instance, the many, many encounters in the mirror with my bald and handsome father and my bald and ugly grandfather; or the phantom conversations, more haunting than a phantom breast, in which sometimes I still hear myself challenging some imaginary sexual assailant by—what? It is hard to piece this together—but I think what I am doing in these fantasies is defiantly exposing my mastectomy scar, and cementing my triumph over this attacker by making clear to him that underneath the clothing and the prosthesis, I am *really* a man whom he has had the poor judgment to mistake for a vulnerable woman.

When I first got the breast cancer diagnosis, one of the good friends who called to check in and cheer me up was a gay man I had known and loved for a long time, a psychoanalytic theorist, who reminded me that he, too, had had a pretty bad breast cancer scare several years before. But his lump had turned out to be benign—"And it was a good thing too," he said on the phone, "because you know what the treatment of choice is for *male* breast cancer? Castration!" I congratulated him on his narrow escape from a fate evidently seen as worse than death. And I did not make any connection between that and the moment, months later, when I was finishing chemotherapy and the question of hormone therapy came up, when I suddenly noticed that both my cheerful oncologist and the matter-of-fact medical textbooks I could not seem to stop reading apparently had the same question on their mind: to castrate—me!—or not to castrate. I did not even know what the word could really mean, in this context, but that did not keep me from bursting into the tears that mark the heaping of injury on insult: here I thought I already *was*! All these years my Lacanian friends had me convinced I had nothing to lose.

Maybe the weirdest part of this story is that even now, at the end of it, I actually do not know whether I got castrated or not. It turns out that for

Loren Cameron, *Loren Cameron*, 1993.

women, as indeed for men, there exist the alternatives of surgical ablation or chemical ablation (also I thought "ablation" was something done by Latin nouns) of the gonads, which for women means the ovaries—and since the chemo had already knocked my reproductive system into a cocked hat, the question of further ablation turned out to be, as they say, moot. I believe, but I am not sure, that that is a way of saying that the castration had, indeed, already happened. *Maybe* of saying that *any* postmenopausal woman is by definition, as Germaine Greer would put it, a female eunuch.

But the point of this shaggy-dog medical thriller, right now, is to mark how different, and how rather unpredictably different, the notion of castration is in a female context from a male context. For a man, it seems clear enough what is signified by castration: that is, a threat to masculinity. But it is still fully ambiguous to me whether the tears I was bawling out at the mention of castration were wept in response to a threat against my masculinity, or my femininity.[5] A rather too fancy way of broaching the commonplace—but it is an important commonplace, and one that people always forget—that . . .

2. MASCULINITY AND FEMININITY ARE IN MANY RESPECTS ORTHOGONAL TO EACH OTHER

Orthogonal: that is, instead of being at opposite poles of the same axis, they are actually in different, perpendicular dimensions, and therefore are independently

variable. The classic research on this was, of course, Sandra Bem's work on psychological androgyny; she had people rated on two scales, one measuring stereotypically female-ascribed traits and one measuring stereotypically male-ascribed ones; and found that many lucky people score high on both, many other people score low on both, and most importantly that a high score on either of them does not predict a low score on the other.[6]

If we may be forgiven a leap from two-dimensional into *n*-dimensional space, I think it would be interesting, by the way, to hypothesize that not only masculinity and femininity, but in addition effeminacy, butchness, femmeness, and probably some other superficially related terms, might equally turn out instead to represent independent variables—or at least, unpredictably dependent ones. I would just ask you to call to mind all the men you know who may be both highly masculine and highly effeminate—but at the same time, not a bit feminine. Or women whom you might consider very butch and at the same time feminine, but not femme. Why not throw in some other terms, too, such as top and bottom? And an even more potent extension into *n*-dimensional space could, ideally, make representable a factor such as race, as well. I am thinking, for instance, of a fascinating recent paper by Riché Richardson in which she analyzes the differential meanings, in African-American men's (effeminate) drag performance, of imitations of "white" femininity compared to imitations of "black" femininity.[7]

One implication of work like Sandra Bem's is that not only are some people more masculine or more feminine than others, but some people are just plain more *gender-y* than others—whether the gender they manifest be masculine, feminine, both, or "and then some."

Which brings us to . . .

3. MASCULINITY AND FEMININITY ARE THRESHOLD EFFECTS

This includes masculinity and femininity and, we might add, some of the other gender-salient dimensions that we have also been discussing. By "threshold effects," I mean places where quantitative increments along one dimension can suddenly appear as qualitative differences somewhere else on the map entirely. I will offer only one example of this—which must also serve to introduce Proposition 4, as a matter of fact—and unfortunately it involves only my hunches about an issue on which I am probably the least expert witness available: that is to say, the reception history of my own gendered self-presentation around the time of the chemotherapy "experiment." But, for what it's worth, here is my observation. It so happened that the end of the half-year of chemo,

INVASION
SCENT FROM THE FAR EAST

Little Tokyo Little Saigon Little Shanghai

during which time I was totally bald, and at the end of which I suddenly devel-
oped this fabulous babylike fuzz (which I almost wore away with the sheer joy
of having it to fondle), it so happened that this moment, the first moment when
I felt able—indeed, irrepressibly eager—to venture out into the world without
one of those little penitential ethnic beanies on my head, coincided with the
fifth annual Lesbian and Gay Studies Conference, that year being held at
Rutgers. So, of course, I went and displayed my wares, and my hairs.

Now, I had been fortunate enough to attend all four of the previous confer-
ences in this series (three at Yale, one at Harvard). And, much as I had
treasured the almost overwhelming stimulus and camaraderie that was on tap
at each one of them and the sense that as scenes they were among the most
fun I had ever happened on, I had nonetheless the sense, at each one, of
being, as a body, erotically invisible to most of the other participants, both male
and female. This did not get me down too much, but I did notice it, and at
some level felt a bit forlorn. Strikingly different was the feeling of being in this
particular body at that particular conference, the Rutgers conference, at that
particular moment. Suddenly, it seemed to me—outlandish, near-bald, and
extremely happy—that I had had the great pleasure of *clicking*, with an almost
audible *click*, into visibility in the grid of a certain lesbian optic. I felt, really for
the first time, that I looked exactly as I ought and wished to look, and was vis-
ible as so doing.

Now, here is the part of it that was really instructive—and by instructive I mean that it took me forever to catch on to. It was clear to me that this vibrant sense of having a body, having a visible body, was tied to the butchness of, as a woman, swaggering around in the world, or at least in New Brunswick, with almost no hair. So far so good, I thought; I had always been attracted to very butch women, and now, it seemed to me, by some miracle, I was going to get to turn into one. And wasn't this what I had wanted?

What emerged over time, however, as I learned to read myself and to read other women's (and indeed men's) responses to my bodily habitus in a some-what more subtle and differentiated way, was not the story of this particular miracle. It was something else: that what I had become visible as was, in fact (no big surprises here), quite femme. The surprise was in seeing that it required the crossing over a threshold of, precisely, butchness, to become vis-ible as, precisely, if it is precisely, femme. That is to say, I had to stumble my way onto a map of sexy gender-y-ness in the first place; and the portal to that place, for women, or for lesbians, or for queers, or just for me, I do not know yet, is marked "butch." The rheostat that you might think would adjust the seamless gradations from feminine to femme seemingly has to get interrupt-ed by the on/off switch of butch.

4. IN MASCULINITY/FEMININITY, A DYNAMIC OF SELF-RECOGNITION MEDIATES BETWEEN ESSENTIALISM AND FREE PLAY

Proposition 4 is about transformations like the one I have just sketched: about try-ing to find, not a middle ground, but a ground for describing and respecting the inertia, the slowness, the process that mediates between, on the one hand, the biological absolutes of what we always are (more or less) and, on the other hand, the notional free play that we constructivists are always imagined to be attributing to our own and other people's sex-and-gender self-presentation. I want to mark here a space in which there might be broached some description at a psychological level of how such changes may actually occur: namely through a slow and rather complicated feedback mechanism that I would summarize in the phrase: "Will I be able to recognize myself if I . . . ?"

This proposition interests me especially because I would want to argue that, while to some degree it is probably true of everybody, it seems likeliest to be truest of people who experience their bodies in the first place as not just prob-lematic, but precisely stigmatic. I am sure that not every visibly handicapped person, or transgendered person, or person of color, or fat person, or visibly

Jeff Scales, *Omega Branding: Memphis*, 1988.

sick person, or person with gender-"inappropriate" voice or demeanor in fact experiences his or her body as stigmatic most or necessarily even any of the time. But it is a very plain fact that many of us do. And I would like with this proposition to open something like a door into the mix of paralysis or transfixion, with extraordinary daring and often outrageousness, with strange sites of stylistic conservatism, with an almost uncanny discursive productiveness, that many of us experience as we struggle to continue the adventure of recognizing ourselves and being recognized in these problematic femininities and masculinities that constitute us and that we, in turn, constitute.

NOTES

1. Maurice Berger, Brian Wallis, and Simon Watson, prospectus for *Constructing Masculinity*, n.p.

2. The phrase occurs in Richard C. Friedman, *Male Homosexuality: A Psychoanalytic Perspective* (New Haven: Yale University Press, 1988), p. 245.

3. Leslie Feinberg, *Stone Butch Blues* (Ithaca: Firebrand Books, 1993); Judith Halberstam, "F2M: The Making of Female Masculinity," in Laura Doan, ed., *The Lesbian Postmodern* (New York: Columbia University Press, 1994); Joan Nestle, ed., *The Persistent Desire: A Femme-Butch Reader* (Boston: Alyson, 1992); and Judith Frank, personal communication.

4. Pratt described herself in approximately these terms during an informal talk at Duke University, Feb. 21, 1994.

5. It is interesting to me that when I try to tell people this story, often concluding with "—but now I

EVE KOSOFSKY SEDGWICK

realize I *was* castrated!" they incorrectly assume that I am describing the supposedly traumatic psychological impact of the loss of a breast. It is easy for people to arrive at the crisp homology "breast:femininity::phallus:masculinity," and that neatly metaphorical substitution offers a kind of presumptive pseudosense that altogether effaces the literal fact that women are indeed castratable; effacing, as well, the challenge that this fact offers to conventional gender schematics.

6. Sandra Bem, "The Measurement of Psychological Androgyny," *Journal of Consulting and Clinical Psychology* 42 (April 1974): 155–62; Bem, "The Theory and Measurement of Androgyny: A Reply to the Pedhazur-Tetenbaum and Locksley-Colten Critiques," *Journal of Personality and Social Psychology* 37 (June 1979); and Bem, *The Lenses of Gender: Transforming the Debate on Sexual Inequality* (New Haven: Yale University Press, 1993).

7. Riché Richardson, "Sistuh Girl Terry McMillan: Crossing the Threshold to the Trenches," paper delivered at the College Language Association, Durham, N.C., Apr. 15, 1994.

MELANCHOLY GENDER/REFUSED IDENTIFICATION

In mourning the world becomes poor and empty; in melancholia it is the ego itself.
—Sigmund Freud, "Mourning and Melancholia" (1917)

How is it then that in melancholia the superego can become a gathering-place for the death instincts?
—Freud, *The Ego and the Id* (1923)

It may at first seem strange to think of gender as a kind of melancholy, or as one of melancholy's effects, but let us remember that in *The Ego and the Id* (EI), Freud himself acknowledged that melancholy, the unfinished process of grieving, is central to the formation of those identifications which form the ego itself. Indeed, those identifications which are formed from unfinished grief are the modes in which the lost object is incorporated and phantasmatically preserved in and as the ego. Consider, in conjunction with this insight, Freud's further remark that "the ego is first and foremost a bodily ego" (EI, 26), not merely a surface, but "the projection of a surface." And

further, this bodily ego will assume a gendered morphology, so that we might well claim that the bodily ego is at once a gendered ego. What I hope first to explain is the sense in which a melancholic identification is central to that process whereby the gendered character of the ego is assumed. Second, I want to explore how this analysis of the melancholic formation of gender sheds light on the cultural predicament of living within a culture that can mourn the loss of homosexual attachment only with great difficulty.

Reflecting on his speculations in "Mourning and Melancholia" (1917), Freud writes, in *The Ego and the Id* (1923), that in the earlier essay he supposed that "an object which was lost has been set up again inside the ego—that is, that an object-cathexis had been replaced by an identification. At that time, however," he continued:

> we did not appreciate the full significance of this process and did not know how common and how typical it is. Since then we have come to understand that this kind of substitution has a great share in determining the form taken by the ego and that it makes an essential contribution toward building up what is called its "character." (28)

Slightly later in this same text, Freud expands this view: "when it happens that a person has to give up a sexual object, there quite often ensues an alteration of his ego which can only be described as a setting up of the object inside the ego, as it occurs in melancholia"(29). He concludes this discussion with the speculation that "it may be that this identification is the sole condition under which the id can give up its objects...it makes it possible to suppose that the "character of the ego" is a precipitate of abandoned object-cathexes and that it contains the history of those object-choices"(19). What Freud here calls the character of the ego appears to be the sedimentation of those objects loved and lost, the archaeological remainder, as it were, of unresolved grief.

But what is perhaps most striking about his formulation here is the way in which it reverses his position in "Mourning and Melancholia" on what it means to resolve grief. In that earlier essay, Freud appears to have assumed that grief could be resolved through a de-cathexis, a breaking of attachment, as well as the subsequent making of new attachments. In *The Ego and the Id*, however, he makes room for the notion that melancholic identification may be a *prerequisite* for letting the object go. And yet, by claiming this, he changes what it means to "let an object go." For there is no final breaking of the attachment: there is, rather, the incorporation of the attachment *as* identification, where identification becomes a magical, psychic form of preserving the object. And insofar as identification is the psychic preserve of the object, and such

identifications come to form the ego, then the lost object continues to haunt and inhabit the ego as one of its constitutive identifications and is, in that sense, made coextensive with the ego itself. Indeed, one might conclude that melancholic identification permits the loss of the object in the external world precisely because it provides a way to *preserve* the object as part of the ego itself and, hence, to avert the loss as a complete loss. Here we see that letting the object go means, paradoxically, that there is no full abandonment of the object, only a transferring of the status of the object from external to internal: giving up the object becomes possible only upon the condition of a melancholic internalization, or what might for our purposes turn out to be even more important, a melancholic *incorporation*.

If, in melancholia, a loss is refused, it is not for that reason abolished. Indeed, internalization is the way in which loss is preserved in the psyche. Or, put perhaps more precisely, the internalization of loss is part of the mechanism of its refusal. If the object can no longer exist in the external world, it will then exist internally; and that internalization will also be a way to disavow that loss, to keep it at bay, to stay or postpone the recognition and suffering of loss.

Is there a way in which *gender* identifications or, rather, those identifications that become central to the formation of gender, are produced through melancholic identification? More particularly, it seems clear that the positions of "masculine" and "feminine" which Freud, in *The Three Essays on the Theory of*

JUDITH BUTLER

Sexuality (1905), understood as the effects of laborious and uncertain accomplishment, are established in part through prohibitions that *demand the loss* of certain sexual attachments, and demand as well that those losses *not* be avowed, and *not* be grieved. If the assumption of femininity or the assumption of masculinity proceeds through the accomplishment of an always tenuous heterosexuality, we might understand the force of this accomplishment as the mandating of the abandonment of homosexual attachments or, perhaps more trenchantly, the *preemption* of the possibility of homosexual attachment, a certain foreclosure of possibility that produces a domain of homosexuality understood as unlivable passion and ungrievable loss. This heterosexuality is produced not only by implementing the prohibition on incest but, prior to that, by enforcing the prohibition on homosexuality. The Oedipal conflict presumes that heterosexual desire has already been *accomplished*, that the distinction between heterosexual and homosexual has been enforced (a distinction which, after all, has no necessity); in this sense, the prohibition on incest presupposes the prohibition on homosexuality, for it presumes the hetero-sexualization of desire.

Indeed, to accept this view, we must begin with the presupposition that masculine and feminine are not dispositions, as Freud sometimes argues, but accomplishments, ones that emerge in tandem with the achievement of het-erosexuality. Here Freud articulates a cultural logic whereby gender is achieved and stabilized through the accomplishment of heterosexual posi-tioning, and where the threats to heterosexuality thus become threats to gender itself. The prevalence of this heterosexual matrix in the construction of gender emerges not only in Freud's text, but in those cultural forms of life that have absorbed this matrix and are inhabited by everyday forms of gender anx-iety. Hence, the fear of homosexual desire in a woman may induce a panic that she is losing her femininity, that she is not a woman, that she is no longer a proper woman, that if she is not quite a man, she is like one, and hence mon-strous in some way. Or in a man, the terror over homosexual desire may well lead to a terror over being construed as feminine, femininized, of no longer being properly a man, or of being a "failed" man, or of being in some sense a figure of monstrosity or abjection.

Now, I would argue that phenomenologically there are indeed all sorts of ways of experiencing gender and sexuality that do not reduce to this equation, that do not presume that gender is stabilized through the installation of a firm heterosexuality, but for the moment I want to invoke this stark and hyper-bolic construction of the relation between gender and sexuality in order to try to

think through the question of ungrieved and ungrievable loss in the formation of what we might call the gendered character of the ego.

Consider that gender is acquired at least in part through the repudiation of homosexual attachments; the girl becomes a girl by becoming subject to a prohibition that bars the mother as an object of desire, and installs that barred object as a part of the ego, indeed, as a melancholic identification. Thus the identification contains within it both the prohibition and the desire, and so embodies the ungrieved loss of the homosexual cathexis. If one is a girl to the extent that one does not want a girl, then wanting a girl will bring being a girl into question; within this matrix, homosexual desire thus panics gender.

Heterosexuality is cultivated through prohibitions, where these prohibitions take as one of their objects homosexual attachments, thereby forcing the loss of those attachments.[1] For it seems clear that if the girl is to transfer the love from her father to a substitute object, she must first renounce the love for her mother, and renounce it in such a way that both the aim and the object are foreclosed. Hence, it will not be a matter of transferring that homosexual love onto a substitute feminine figure, but of renouncing the possibility of homosexual attachment itself. Only on this condition does a heterosexual aim become established as what some call a sexual orientation. Only on the condition of this foreclosure of homosexuality can the scene emerge in which it is the father and, hence, the substitutes for him who

become the objects of desire, and the mother who becomes the uneasy site of identification.

Becoming a "man" within this logic requires a repudiation of femininity, but also a repudiation that becomes a precondition for the heterosexualization of sexual desire and hence, perhaps also, its fundamental ambivalence. If a man becomes heterosexual through the repudiation of the feminine, then where does that repudiation live except in an identification that his heterosexual career seeks to deny? Indeed, the desire for the feminine is marked by that repudiation: he wants the woman he would never be; indeed, he would not be caught dead being her: thus, he wants her. She is at once his repudiated identification (a repudiation he sustains as identification and as the object of his desire). One of the most anxious aims of his desire will be to elaborate the difference between him and her, and he will seek to discover and install that proof. This will be a wanting haunted by a dread of being what it wants, a wanting that will also always be a kind of dread; and precisely because what is repudiated and hence lost is preserved as a repudiated identification, this desire will be an attempt to overcome an identification that can never be complete.

Indeed, he will not identify with her, and he will not desire another man, and so that refusal to desire, that sacrifice of desire under the force of prohibition, will incorporate that homosexuality as an identification with masculinity. But this masculinity will be haunted by the love it cannot grieve. Before I suggest how this might be true, I would like to situate the kind of writing that I have been offering as a certain cultural engagement with psychoanalytic theory that belongs neither to the fields of psychology nor to psychoanalysis, but which nevertheless seeks to establish an intellectual relationship to those enterprises.

This has so far been something like an exegesis of a certain psychoanalytic logic, one that appears in some psychoanalytic texts but which is also contested sometimes in those same texts and sometimes in others; this is, of course, not an empirical set of claims, and not even an account of the current scholarship in psychoanalysis on gender, sexuality, or melancholy. Trained in philosophy, but working now in a field of cultural criticism that draws from psychoanalysis but also moves between literary theory and the emergent discourses of feminist and gay cultural practices, I want merely to suggest what I take to be some productive convergences between Freud's thinking on ungrieved and ungrievable loss and the cultural predicament of living within a culture which can mourn the loss of homosexual attachment only with great difficulty. This problematic is made all the more acute when we consider the ravages of AIDS, and the task of finding a public occasion

and language in which to grieve this seemingly endless number of deaths. But more generally, this problem makes itself felt in the uncertainty with which homosexual love and loss are regarded: is this regarded as a "true" love, a "true" loss, a love and loss worthy or capable of being grieved, and in that sense, worthy or capable of ever having been lived? Or is this a love and a loss haunted by the specter of a certain unreality, a certain unthinkability, the double disavowal of "I never loved her, and I never lost her," uttered by a woman; the "I never loved him, I never lost him," uttered by a man. Is this the "never-never" that supports the naturalized surface of heterosexual life as well as its pervasive melancholia? Is this the disavowal of loss by which sexual formation, including gay sexual formation, proceeds?

For if we accept the notion that the prohibition on homosexuality operates throughout a largely heterosexual culture as one of its defining operations, then it appears that the loss of homosexual objects and aims (not simply this person of the same gender, but *any* person of that same gender) will be foreclosed from the start. I use the word "foreclosed" to suggest that this is a preemptive loss, a mourning for unlived possibilities. For if this is a love that is from the start out of the question, then it cannot happen and, if it does, it certainly did not; if it does, it happens only under the official sign of its prohibition and disavowal.[2] When certain kinds of losses are compelled by a set of culturally-prevalent prohibitions, then we may well expect a culturally-prevalent form of melancholia,

JUDITH BUTLER

one that signals the internalization of the ungrieved and ungrievable homosex-ual cathexis. And where there is no public recognition or discourse through which such a loss might be named and mourned, then melancholia takes on cultural dimensions of contemporary consequence. Of course, it comes as no surprise that the more hyperbolic and defensive a masculine identification, the more fierce the ungrieved homosexual cathexis, and in this sense we might understand both "masculinity" and "femininity" as formed and consolidated through identifications that are composed in part of disavowed grief.

If we accept the notion that heterosexuality naturalizes itself by insisting on the radical otherness of homosexuality, then heterosexual identity is purchased through a melancholic incorporation of the love that it disavows: the man who insists upon the coherence of his heterosexuality will claim that he never loved another man, and hence never lost another man. And that love, that attach-ment, becomes subject to a double disavowal: a never-having-loved and a never-having-lost. This "never-never" thus founds the heterosexual subject, as it were; this is an identity based upon the refusal to avow an attachment and, hence, the refusal to grieve.

But there is perhaps a more culturally-instructive way of describing this scenario, for it is not simply a matter of an individual's unwillingness to avow and hence to grieve homosexual attachments. When the prohibition against homosexuality is culturally pervasive, then the "loss" of homosexual love is pre-cipitated through a prohibition which is repeated and ritualized throughout the culture. What ensues is a culture of gender melancholy in which masculinity and femininity emerge as the traces of an ungrieved and ungrievable love, indeed, where masculinity and femininity within the heterosexual matrix are strength-ened through the repudiations they perform. In opposition to a conception of sexuality which is said to "express" a gender, gender itself is here understood to be composed of precisely what remains inarticulate in sexuality.

If we understand gender melancholy in this way, then perhaps we can make sense of the peculiar phenomenon whereby homosexual desire becomes a source of guilt. In "Mourning and Melancholia," Freud argues that melancholy is marked by the experience of self-beratement, and he writes:

> If one listens patiently to a melancholic's many and various self-accusations, one cannot in
> the end avoid the impression that often the most violent of them are hardly at all applicable
> to the patient himself, but that with insignificant modifications they do fit someone else, some
> person whom the patient loves or has loved or ought to love . . . the self-reproaches are
> reproaches against a loved object which have been shifted onto the patient's own ego. (24B)

Freud goes on to conjecture that the conflict with the other which remains unresolved at the time the other is lost reemerges in the psyche as a way of continuing the quarrel. Indeed, the anger at the other is doubtless exacerbated by the death or departure that constitutes the occasion for the loss. But this anger is turned inward and becomes the substance of self-beratement.

In the essay "On Narcissism" (1914), Freud links the experience of guilt with the turning back into the ego of homosexual libido. Putting aside the question of whether libido can be homosexual or heterosexual, we might rephrase Freud and consider guilt as the turning back into the ego of homosexual attachment. If the loss becomes a renewed scene of conflict, and if the aggression that follows from that loss cannot be articulated or externalized, then it rebounds upon the ego itself, in the form of a superego. This will eventually lead Freud to link melancholic identification with the agency of the superego in *The Ego and the Id*, but already, in the essay "On Narcissism," we have some sense of how guilt is wrought from ungrievable homosexuality.

The ego is said to become impoverished in melancholia, but it appears as poor precisely through the workings of self-beratement. The ego ideal, what Freud calls the "measure" against which the ego is judged by the superego, is precisely the ideal of social rectitude defined over and against homosexuality. Freud writes that:

JUDITH BUTLER

> This ideal has a social side: it is also the common ideal of a family, a class or a nation. It binds not only the narcissistic libido, but also a considerable amount of his homosexual libido, which in this way becomes turned back into the ego. The want of satisfaction that arises from the non-fulfillment of this ideal liberates homosexual libido, is transformed into a sense of guilt and this is social anxiety. (101–102)

But the movement of this "transformation" is not altogether clear. After all, Freud will argue in *Civilization and its Discontents* (1930) that these social ideals are transformed into a sense of guilt through a kind of internalization that is not, ultimately, mimetic. It is not that one only treats oneself as harshly as one was treated but, rather, that the aggression toward the ideal and its unfulfillability is turned inward, and this self-aggression becomes the primary structure of conscience: "by means of identification [the child] takes the unattackable authority into himself."(129)

In this sense, in melancholia the superego can become a gathering-place for the death instincts. As such, the superego is figured as a site where the death instincts gather, but is not necessarily the same as those instincts or their effect. In this way, melancholia attracts the death instincts to the superego, where the death instincts are understood as a regressive striving toward organic equilibrium, and the self-beratement of the superego is understood to make use of that regressive striving for its own purposes. Where melancholy is the refusal of grief, it is also always the incorporation of loss, the miming of the death it cannot mourn. In this sense, the incorporation of death draws on the death instincts such that we might well wonder whether the two are separable from one another, analytically or phenomenologically.

The prohibition on homosexuality preempts the process of grief and prompts a melancholic identification which effectively turns homosexual desire back upon itself. This turning back upon itself is precisely the action of self-beratement and guilt. Significantly, homosexuality is *not* abolished, but preserved, and yet the site where homosexuality is preserved will be precisely in the prohibition on homosexuality. In *Civilization and its Discontents*, Freud makes clear that conscience requires the continuous sacrifice or renunciation of instinct to produce that peculiar satisfaction that conscience requires; conscience is never assuaged by renunciation but, paradoxically, strengthened ("renunciation breeds intolerance")(128). For renunciation does not abolish the instinct; it deploys the instinct for its own purposes, such that prohibition, and the lived experience of prohibition as repeated renunciation, is nourished precisely by the instinct that it renounces; in this scenario, renunciation requires the

very homosexuality that it condemns, not as its external object, but as its own most treasured source of sustenance. The act of renouncing homosexuality thus paradoxically strengthens homosexuality, but it strengthens homosexuality precisely *as* the power of renunciation. Renunciation becomes the aim and vehicle of satisfaction. And it is, we might conjecture, precisely the fear of setting loose homosexuality from this circuit of renunciation that so terrifies the guardians of masculinity in the U.S. military. For what would masculinity "be" were it not for this aggressive circuit of renunciation from which it is wrought? Gays in the military threaten to undo masculinity only because this is a masculinity made of repudiated homosexuality.

Although I have been attempting to describe a melancholy that is produced through the compulsory production of heterosexuality and, so, a heterosexual melancholy that one might read in the workings of gender itself, I want now to turn this analysis in a slightly different direction, in order to suggest that rigid forms of gender and sexual identification, whether homosexual or heterosexual, appear to spawn forms of melancholy as their consequence. I would like to reconsider first the theory of gender as performative that I elaborated in *Gender Trouble*, and then to turn to the question of gay melancholia and the political consequences of ungrievable loss.

I argued that gender was performative, and by that I meant that there is no gender that is "expressed" by actions, gestures, speech, but that the performance of gender was precisely that which produced retroactively the illusion that there was an inner gender core. Indeed, the performance of gender might be said retroactively to produce the effect of some true or abiding feminine essence or disposition, such that one could not use an expressive model for thinking about gender. Moreover, I argued that gender is produced as a ritualized repetition of conventions, and that this ritual is socially compelled in part by the force of a compulsory heterosexuality. I used the example of the drag performance to illustrate what I meant, and the subsequent reception of my work unfortunately took that example to be exemplary of what I meant by performativity. In this context, I would like to return to the question of drag to explain in more clear terms how I understand psychoanalysis to be linked with gender performativity, and how I take performativity to be linked with melancholia.

It would not be enough to say that gender is only performed or that the meaning of gender can be derived from its performance, whether or not one rethinks performance as a compulsory social ritual. For there are clearly workings of gender that do not "show" in what is performed as gender, and the reduction of the

psychic workings of gender to the literal performance of gender would be a mistake. Psychoanalysis insists that the opacity of the unconscious sets limits to the exteriorization of the psyche. It also argues, rightly I think, that what is exteriorized or performed can be understood only through reference to what is barred from the performance, what cannot or will not be performed.

The relation between drag performances and gender performativity in *Gender Trouble* went something like this: when it is a man performing drag as a woman, the "imitation" that drag is said to be is taken as an "imitation" of femininity, where the "femininity" that is imitated is not understood as being an imitation at all. And yet, if one considers that gender is acquired, that it is assumed in relation to ideals that are never quite inhabited by anyone, then femininity is an ideal which everyone always and only "imitates." Thus, drag imitates the imitative structure of gender, revealing gender itself as an imitation. However playful and attractive this formulation may have seemed at the time, it did not address the question of how it is that certain forms of disavowal and repudiation come to organize the performance of gender. How is the phenomenon of gender melancholia to be related to the practice of gender performativity?

Moreover, given the iconographic figure of the melancholic drag queen, one might ask whether there is not a dissatisfied longing in the mimetic incorporation of gender that is drag. Here one might ask also after the disavowal that occasions the performance and which performance might be said to enact, where performance engages "acting out" in the psychoanalytic sense.[3] If melancholia in Freud's sense is the effect of an ungrieved loss,[4] it may be that performance, understood as "acting out," is essentially related to the problem of unacknowledged loss. Where there is an ungrieved loss in drag performance, perhaps it is a loss that is refused and incorporated in the performed identification, one that reiterates a gendered idealization and its radical uninhabitability. This is, then, neither a territorialization of the feminine by the masculine nor a sign of the essential plasticity of gender. What it does suggest is that the performance allegorizes a loss it cannot grieve, allegorizes the incorporative fantasy of melancholia whereby an object is phantasmatically taken in or on as a way of refusing to let it go. Gender itself might be understood in part as the "acting out" of unresolved grief.

The above analysis is a risky one because it suggests that for a "man" performing femininity, or for a "woman" performing masculinity (the latter is always, in effect, to perform a little less, given that femininity is already cast as the spectacular gender) there is an attachment to—and a loss and refusal of— the figure of femininity by the man, or the figure of masculinity by the woman.

Bill Traylor, *Untitled (Man with Dog)*, n.d.

Thus it is important to underscore that drag is an effort to negotiate cross-gendered identification, but that cross-gendered identification is not the paradigm for thinking about homosexuality, although it may well be one among others. In this sense, drag allegorizes some set of melancholic incorporative fantasies that stabilize *gender*. Not only are a vast number of drag performers straight, but it would be a mistake to think that homosexuality is best explained through the performativity that is drag. What does seem useful in this analysis, however, is that drag exposes or allegorizes the mundane psychic and performative practices by which heterosexualized genders form themselves through the renunciation of the *possibility* of homosexuality, a foreclosure that produces a field of heterosexual objects at the same time that it produces a domain of those whom it would be impossible to love. Drag thus allegorizes *heterosexual melancholy*, the melancholy by which a masculine gender is formed from the refusal to grieve the masculine as a possibility of love; a feminine gender is formed (taken on, assumed) through the incorporative fantasy by which the feminine is excluded as a possible object of love, an exclusion never grieved, but "preserved" through the heightening of feminine identification itself. In this sense, the "truest" lesbian melancholic is the strictly straight woman, and the "truest" gay male melancholic is the strictly straight man.

What drag does expose, however, is that, in the "normal" constitution of gender presentation, the gender that is performed is constituted by a set of

JUDITH BUTLER

disavowed attachments, identifications that constitute a different domain of the "unperformable." Indeed, it may be—but need not be—that what constitutes the *sexually* unperformable is performed instead as *gender identification*.[5] To the extent that homosexual attachments remain unacknowledged within normative heterosexuality, they are not merely constituted as desires that emerge and subsequently become prohibited; rather, these are desires proscribed from the start. And when they do emerge on the far side of the censor, they may well carry that mark of impossibility with them, performing, as it were, as the impossible within the possible. As such, they will not be attachments that can be openly grieved. This is, then, less the *refusal* to grieve (the *Mitscherlich* formulation that accents the choice involved) than a preemption of grief performed by the absence of cultural conventions for avowing the loss of homosexual love. And it is this absence that produces a culture of heterosexual melancholy, one that can be read in the hyperbolic identifications by which mundane heterosexual masculinity and femininity confirm themselves. The straight man *becomes* (mimes, cites, appropriates, assumes the status of) the man he "never" loved and "never" grieved; the straight woman *becomes* the woman she "never" loved and "never" grieved. In this sense, then, what is most apparently performed as gender is the sign and symptom of a pervasive disavowal.

Moreover, it is precisely to counter this pervasive cultural risk of gay melancholia (what the newspapers generalize as "depression") that there has been an insistent publicization and politicization of grief over those who have died from AIDS; the NAMES Project Quilt is exemplary, ritualizing and repeating the name itself as a way of publicly avowing the limitless loss.[6]

Insofar as the grief remains unspeakable (some part of grief is perhaps always unspeakable), the rage over the loss can redouble by virtue of remaining unavowed. And if that very rage over loss is publicly proscribed, the melancholic effects of such a proscription can achieve suicidal proportions. The emergence of collective institutions for grieving are thus crucial to survival, to the reassembling of community, the rearticulation of kinship, the reweaving of sustaining relations. And insofar as they involve the publicization and dramatization of death—as in the case of "die-ins" by Queer Nation—they call to be read as life-affirming rejoinders to the dire psychic consequences of a grieving process culturally thwarted and proscribed.

Melancholy can work, however, within homosexuality in specific ways that call to be rethought. Within the formation of gay and lesbian identity, there may be an effort to disavow a constitutive relationship to heterosexuality. When this

disavowal is understood as a political necessity in order to *specify* gay and lesbian identity over and against its ostensible opposite, heterosexuality, that cultural practice culminates paradoxically in a weakening of the very constituency it is meant to unite. Not only does such a strategy attribute a false, monolithic status to heterosexuality, but it misses the political opportunity to work the weakness in heterosexual subjectivation, and to refute the logic of mutual exclusion by which heterosexism proceeds. Moreover, a full-scale denial of that interrelationship can constitute a rejection of heterosexuality that is to some degree an identification *with* a rejected heterosexuality. Important to this economy, however, is the refusal to recognize this identification which is, as it were, already made, a refusal that absently designates the domain of a specifically gay melancholia, a loss which cannot be recognized and hence cannot be mourned. For a gay or lesbian identity position to sustain its appearance as coherent, heterosexuality must remain in that rejected and repudiated place. Paradoxically, its heterosexual *remains* must be *sustained* precisely through the insistence on the seamless coherence of a specifically gay identity. Here it should become clear that a radical refusal to identify suggests that on some level an identification has already taken place, an identification that is made and disavowed, a disavowed identification whose symptomatic appearance is the insistence on, the overdetermination of, the identification by which gay and lesbian subjects come to signify in public discourse.

This raises the political question of the cost of articulating a coherent identity-position if that coherence is produced through the production, exclusion, and repudiation of a domain of abjected specters that threaten the arbitrarily closed domain of subject-positions. Indeed, it may be that only by risking the *incoherence* of identity that connection is possible, a political point that correlates with Leo Bersani's insight that only the decentered subject is available to desire.[7] For what cannot be avowed as a constitutive identification of any given subject-position runs the risk not only of becoming externalized in a degraded form, but repeatedly repudiated and subjected to a policy of disavowal.

The logic of repudiation that I have charted here is in some ways a hyperbolic theory, a logic in drag, as it were, that overstates the case, but overstates it for a reason. For there is no necessary reason for identification to oppose desire, or for desire to be fueled through repudiation. And this remains true for heterosexuality and homosexuality alike, and for forms of bisexuality that take themselves to be composite forms of each. Indeed, we are made all the more fragile under the pressure of such rules, and all the more mobile when ambivalence and loss are given a dramatic language in which to do their acting out.

NOTES

This paper was first presented at the Division 39 Meetings of the American Psychological Association in New York City in April of 1993 and appeared previously in *Psychoanalytic Dialogues* 5 no. 2 (1995), pp. 165–180. Parts of this essay are drawn from Judith Butler, *Bodies that Matter: On the Discursive Limits of "Sex"* (New York: Routledge, 1993). All citations from Freud are from the *Standard Edition*.

1. Presumably, sexuality must be trained away from things, animals, parts of all of the above, and narcissistic attachments of various kinds.

2. The notion of foreclosure has become Lacanian terminology for Freud's notion of "*Verwerfung*." Distinguished from repression understood as an action by an already-formed subject, foreclosure is an act of negation that founds and forms the subject itself. See the entry, "Forclusion," in J. Laplanche and J.-B. Pontalis, *Vocabulaire de la psychanalyse*, (Paris: Presses Universitaires de France, 1967), pp. 163–67.

3. I thank Laura Mulvey for asking me to consider the relation between performativity and disavowal, and Wendy Brown for encouraging me to think about the relation between melancholia and drag and for asking whether the denaturalization of gender norms is the same as their subversion. I also thank Mandy Merck for numerous enlightening questions that lead to these speculations, including the suggestion that if disavowal conditions performativity, then perhaps gender itself might be understood on the model of the fetish.

4. See "Freud and the Melancholia of Gender" in my *Gender Trouble: Feminism and the Subversion of Identity* (New York: Routledge, 1990).

5. This is not to suggest that an exclusionary matrix rigorously distinguishes between how one identifies and how one desires; it is quite possible to have overlapping identification and desire in heterosexual or homosexual exchange, or in a bisexual history of sexual practice. Further, "masculinity" and "femininity" do not exhaust the terms for either eroticized identification or desire.

6. See Douglas Crimp, "Mourning and Militancy," *October*, no. 51 (Winter, 1989): 97–107.

7. Leo Bersani, *The Freudian Body: Psychoanalysis and Art* (New York: Columbia University Press, 1986), pp. 64–66, 112–13.

CAROLE S. VANCE

SOCIAL CONSTRUCTION THEORY
AND SEXUALITY

SEXUALITY AND GENDER

The intellectual history of social construction theory is complex, and the moments offered here are for purposes of illustration, not comprehensive review. Social construction theory drew on developments in several disciplines: social interactionism, labeling theory, and deviance in sociology; social history, labor studies, women's history, and Marxist history; and symbolic anthropology, cross-cultural work on sexuality, and gender studies, to name only the most significant streams. In addition, theorists in many disciplines responded to new questions raised by feminist and lesbian/gay scholarship concerning gender and identity.

Feminist scholarship and activism undertook the project of rethinking gender in the 1970s, which had a revolutionary impact on notions of what is natural. Feminist efforts focused on a critical review of theories which used reproduction to link gender with sexuality, thereby explaining the inevitability and naturalness of women's subordination.

This theoretical reexamination led to a general critique of biological determinism, in particular of received knowledge about the biology of sex differences. Historical and cross-cultural evidence undermined the notion that women's roles, which varied so widely, could be caused by a seemingly uniform human reproduction and sexuality. In light of the diversity of gender roles in human society, it seemed unlikely that they were inevitable or caused by sexuality. The ease with which such theories had become accepted suggested that science was conducted within and mediated by powerful beliefs about gender, and in turn provided ideological support for current social relations. Moreover, this increased sensitivity to the ideological aspects of science led to a wideranging inquiry into the historical connection between male dominance, scientific ideology, and the development of Western science and biomedicine.

Feminist practice in grassroots activism also fostered analyses which separated sexuality and gender. Popular struggles to advance women's access to abortion and birth control represented an attempt to separate sexuality from reproduction and women's gendered role as wives and mothers. Discussions in consciousness-raising groups made clear that what seemed to be a naturally gendered body was in fact a highly socially mediated product: femininity and sexual attractiveness were achieved through persistent socialization regarding standards of beauty, makeup, and body language. Finally, discussions between different generations of women made clear how variable their allegedly natural sexuality was, moving within our own century from marital duty to multiple orgasm, vaginal to clitoral eroticism, and Victorian passionlessness to a fittingly feminine enthusiasm. Sexuality and gender went together, it seemed, but in ways that were subject to change.

In 1975, anthropologist Gayle Rubin's influential essay, "The Traffic in Women," made a compelling argument against essentialist explanations that sexuality and reproduction caused gender difference in any simple or inevitable way. Instead, Rubin explored the shape of "a systematic social apparatus which takes up females as raw materials and fashions domesticated women as products." She proposed the term "sex/gender system" to describe "the set of arrangements by which society transforms biological sexuality into products of human activity, and in which these transformed sexual needs are satisfied."[1]

In 1984, Rubin suggested a further deconstruction of the sex/gender system into two separate domains in which sexuality and gender were recognized as distinct systems.[2] Most prior feminist analyses considered sexuality a totally derivative category whose organization was determined by the structure of gender inequality. According to Rubin's formulation, sexuality and gender were analytically distinct phenomena which required separate explanatory frames, even though they were interrelated in specific historical circumstances. Theories of sexuality could not explain gender, and taking the argument to a new level, theories of gender could not explain sexuality.

This perspective suggested a novel framework: sexuality and gender are separate systems which are interwoven at many points. Although members of a culture experience this interweaving as natural, seamless, and organic, the points of connection vary historically and cross-culturally. For researchers in sexuality, the task is not only to study changes in the expression of sexual behavior and attitudes, but to examine the relationship of these changes to more deeply based shifts in how gender and sexuality have been organized and interrelated within larger social relations.

SEXUALITY AND IDENTITY

A second impetus for the development of social construction theory arose from issues that emerged in the examination of male homosexuality in nineteenth-century Europe and America. It is interesting to note that a significant portion of this early research was conducted by independent scholars, nonacademics, and maverick academics usually working without funding or university support, since at this time the history of sexuality (particularly that of marginal groups) was scarcely a legitimate topic. As this research has recently achieved the barest modicum of academic acceptance, it is commonplace for properly employed academics to gloss these developments by a reference to Foucault and *The History of Sexuality* (1978). Without denying his contribution, such a singular genealogy obscures an important origin of social construction theory, and inadvertently credits the university and scholarly disciplines with a development they never supported.

The first attempt to grapple with questions of sexual identity in a way now recognizable as social construction appears in Mary McIntosh's 1968 essay on the homosexual role in England.[3] A landmark article offering suggestive insights about the historical construction of sexuality in England, her observations initially vanished like pebbles in a pond until the mid-1970s, when they were again taken up by writers involved in the questions of feminism and gay liberation. It is at this time that an identifiably constructionist approach first appears.

CAROLE S. VANCE

The earliest scholarship in lesbian and gay history attempted to retrieve and revive documents, narratives, and biographies which had been lost or made invisible due to historical neglect as well as active efforts to suppress the material by archivists, historians, and estates. These documents and the lives represented therein were first conceived of as "lesbian" or "gay," and the enterprise as a search for historical roots. To their credit, researchers who started this enterprise sharing the implicit cultural ideology of fixed sexual categories then began to consider other ways of looking at their material, and to ask more expansive questions.

Jeffrey Weeks, English historian of sexuality, first articulated this theoretical transition.[4] Drawing on McIntosh's concepts of the homosexual role, he distinguished between homosexual behavior, which he considered universal, and homosexual identity, which he viewed as historically and culturally specific and, in Britain, a comparatively recent development. His rich and provocative analysis of changing attitudes and identities also contextualized sexuality, examining its relationship to the reorganization of family, gender, and household in nineteenth-century Britain.

Jonathan Katz's work also demonstrates this process. His first book, *Gay American History*, is in the tradition of a search for gay ancestors.[5] In the course of researching his second book, however, he began to consider that the acts of sodomy reported in American colonial documents from the seventeenth century might not be equivalent to contemporary homosexuality.[6] Colonial society did not seem to conceive of a unique type of person—a homosexual—who engaged in these acts. Nor was there any evidence of a homosexual subculture or individuals whose subjective sense of identity was organized around what we understand as sexual preference or identity. Katz's second book marks a sharp departure from the first, in that records or accounts that document same-sex emotional or sexual relations are not taken as evidence of "gay" or "lesbian" identity, but are treated as jumping-off points for a whole series of questions about the meanings of these acts to the people who engaged in them and to the culture and time in which they lived.

These intellectual developments are also evident in early work on the formation of lesbian identity and in work considering the question of sexual behavior and identity in non-Western cultures (for example, Gilbert Herdt's work in New Guinea). From this expanding body of work came an impressive willingness to imagine: Had the categories "homosexual" and "lesbian" always existed? And if not, what were their points of origin and conditions for development? If identical physical acts had different subjective meanings, how was

Cindy Sherman, *Untitled, #227*, 1990.

sexual meaning constructed? If sexual subcultures come into being, what leads to their formation? And although these questions were initially phrased in terms of homosexual identity and history, it is clear that they are equally applicable to heterosexual identity and history, implications just now being explored.

SEXUALITY AS A CONTESTED DOMAIN

Continuing work on the history of the construction of sexuality in modern, state-level society shows that sexuality is an actively contested political and symbolic terrain in which groups struggle to implement sexual programs and alter sexual arrangements and ideologies. The growth of state interest in regulating sexuality (and the related decline of religious control) made legislative and public policy domains particularly attractive fields for political and intellectual struggles around sexuality in the nineteenth and twentieth centuries. Mass movements mobilized around venereal disease, prostitution, masturbation, social purity, and the double standard, employing grassroots political organizing, legislative lobbying, mass demonstrations, and cultural interventions utilizing complex symbols, rhetoric, and representations. Because state intervention was increasingly formulated in a language of health, physicians and scientists became important participants in the newly developing regulatory discourses. They also actively participated in elaborating these discourses as a way to legitimate their newly-professionalizing specialties.

CAROLE S. VANCE

Although socially powerful groups exercised more discursive power, they were not the only participants in sexual struggles. Minority reformers, progressives, suffragists, and sex radicals also put forward programs for change and introduced new ways of thinking about and organizing sexuality. The sexual subcultures that had grown up in urban areas were an especially fertile field for these experiments. Constructionist work shows how their attempts to carve out partially protected public spaces in which to elaborate and express new sexual forms, behaviors, and sensibilities are also part of a larger political struggle to define sexuality. Subcultures give rise not only to new ways of organizing behavior and identity but to new ways of symbolically resisting and engaging with the dominant order, some of which grow to have a profound impact beyond the small groups in which they are pioneered. In this respect, social construction work has been valuable in exploring human agency and creativity in sexuality, moving away from unidirectional models of social change to describe complex and dynamic relationships among the state, professional experts, and sexual subcultures. This attempt to historicize sexuality has produced an innovative body of work to which historians, anthropologists, sociologists, and others have contributed in an unusual interdisciplinary conversation.

THE DEVELOPMENT OF SOCIAL CONSTRUCTION MODELS, 1975–1990

The increasing popularity of the term "social construction" obscures that fact that constructionist writers have used this term in diverse ways. It is true that all reject transhistorical and transcultural definitions of sexuality, and suggest instead that sexuality is mediated by historical and cultural factors. But a close reading of constructionist texts shows that social constructionists differ in their views of what might be constructed, variously including sexual acts, sexual identities, sexual communities, the direction of erotic interest (object choice), and sexual desire itself. Despite these differences, all share the urge to problematize the terms and field of study.

At minimum, all social construction approaches adopt the view that physically identical sexual acts may have varying social significance and subjective meaning, depending on how they are defined and understood in different cultures and historical periods. Because a sexual act does not carry with it a universal social meaning, it follows that the relationship between sexual acts and sexual meanings is not fixed, and it is projected from the observer's time and place at great peril. Cultures provide widely different categories, schema, and labels for framing sexual and affective experiences. These constructions

Catherine Opie, left: *Chicken*; and right: *Oso Bad*; from the Being and Having series, 1991.

not only influence individual subjectivity and behavior, but they also organize and give meaning to collective sexual experience through, for example, the impact of sexual identities, definitions, ideologies, and regulations. The relationship of sexual acts and identities to organized sexual communities is equally variable and complex. These distinctions, then, between sexual acts, identities, and communities are widely employed by constructionist writers.

A further step in social construction theory posits that even the direction of erotic interest itself, for example, object choice (heterosexuality, homosexuality, bisexuality, as contemporary sexology would conceptualize it) is not intrinsic or inherent in the individual, but is constructed from more polymorphous possibilities. Not all constructionists take this step; and for those who do not, the direction of desire and erotic interest may be thought of as fixed, although the behavioral form this interest takes will be constructed by prevailing cultural frames, as will the subjective experience of individuals, and the social significance attached to it by others.

The most radical form of constructionist theory is willing to entertain the idea that there is no essential, undifferentiated, sexual "impulse," "sex drive," or "lust," which resides in the body due to physiological functioning and sensation.[7] Sexual desire, then, is itself constructed by culture and history from the energies and capacities of the body. In this case, an important constructionist question concerns the origin of these impulses, since they are no longer assumed to be intrinsic or perhaps even necessary. This position, of course, contrasts sharply with more middle-ground constructionist theory, which implicitly accepts an inherent desire which is then constructed in terms of acts, identity, community, and object choice. The contrast between middle-ground

CAROLE S. VANCE

and radical positions makes it evident that constructionists may well have arguments with each other, as well as with those working in essentialist and cultural influence traditions. Nevertheless, social construction literature, making its first appearance in the mid-1970s, demonstrates a gradual development of the ability to imagine that sexuality is constructed.

CULTURAL INFLUENCE MODELS OF SEXUALITY, 1920–1990

By contrast, conventional anthropological and virtually all social science approaches to sexuality from 1920 to 1990 remained remarkably consistent. Just as sexuality itself remained an unexamined construct, the theoretical foundations remained unexamined, unnamed, and implicit, as if they were so inevitable and natural that there could be little dispute or choice about this standard, almost generic, approach. For that reason, I want to suggest the name "cultural influence model" to call attention to its distinctive features and to promote greater recognition of this paradigm. In this model, sexuality is seen as the basic material—a kind of universal Play-Doh—on which culture works, a naturalized category which remains closed to investigation and analysis.

On the one hand, the cultural influence model emphasizes the role of culture and learning in shaping sexual behavior and attitudes. In this respect, it rejects obvious forms of essentialism and universalizing. Variation was a key finding in many studies, in cross-cultural surveys, in ethnographic accounts of single societies whose sexual customs stood in sharp contrast to those of the Euro-American reader, and in theoretical overviews. Culture is viewed as encouraging or discouraging the expression of generic sexual acts, attitudes, and relationships. Oral-genital contact, for example, might be a part of normal heterosexual expression in one group but taboo in another; male homosexuality might be severely punished in one tribe yet tolerated in another. Anthropological work from this period was characterized by a persistent emphasis on variability.

On the other hand, although culture is thought to shape sexual expression and customs, the bedrock of sexuality is assumed—and often quite explicitly stated—to be universal and biologically determined; in the literature, it appears as "sex drive" or "impulse." Although capable of being shaped, the drive is conceived of as powerful, moving toward expression after its awakening in puberty, sometimes exceeding social regulation, and taking a distinctively different form in men and women.

The core of sexuality is reproduction. Although most anthropological accounts by no means restrict themselves to analyzing reproductive behavior alone, reproductive sexuality (glossed as heterosexual intercourse) appears as

the meat and potatoes in the sexual menu, with other forms, both heterosexual and homosexual, arranged as appetizers, vegetables, and desserts. (These metaphors are not unknown in anthropological narratives.) Ethnographic and survey accounts almost always follow a reporting format that deals first with "real sex" and then moves on to the "variations." Some accounts supposedly about sexuality are noticeably short on details about nonreproductive behavior; Margaret Mead's article about the cultural determinants of sexual behaviors (in a wonderfully-titled volume, *Sex and Internal Secretions,* 1961) travels a dizzying trail which includes pregnancy, menstruation, menopause, and lactation, but very little about nonreproductive sexuality or eroticism. Similarly, a more recent book, expansively titled *Varieties of Sexual Experience* (1985), devotes all but a few pages to reproduction, marriage, and family organization.

Within the cultural influence model, the term "sexuality" covers a broad range of topics. Its meaning is often taken for granted, left implicit as a shared understanding between the reader and author. Tracking its use through various articles and books shows that sexuality includes many wildly different things: intercourse, orgasm, foreplay; erotic fantasies, stories, humor; sex differences and the organization of masculinity and femininity; and gender relations (often called sex roles in the earlier literature).

In this model, sexuality is not only related to gender but blends easily, and is often conflated, with it. Sexuality, gender arrangements, masculinity and

CAROLE S. VANCE

femininity are assumed to be connected, even interchangeable. This assumption, however, never illuminates their culturally- and historically-specific connections; it obscures them. The confusion springs from our own folk beliefs that: (1) sex causes gender, that is, male-female reproductive differences and the process of reproduction (framed as and equated with "sexuality") give rise to gender differentiation, and (2) gender causes sex, that is, women as a marked gender group constitute the locus of sexuality, sexual desire, and motivation. Reproduction and its organization become the prime movers in all other male-female differentiation and in the flowering of the gender system. Gender and sexuality are seamlessly knit together.

Finally, the cultural influence model assumes that sexual acts carry stable and universal significance in terms of identity and subjective meaning. The literature routinely regards opposite-gender sexual contact as "heterosexuality" and same-gender contact as "homosexuality," as if the same phenomena were being observed in all societies in which these acts occurred. With hindsight, these assumptions are curiously ethnocentric, since the meanings attached to these sexual behaviors are those of the observers, and of twentieth-century, complex, industrial society. Cross-cultural surveys could fairly chart the distribution of same- or opposite-gender sexual contact or the frequency of sexual contact before marriage. But when investigators report instead on the presence or absence of "homosexuality" or "sexual permissiveness," they engage in a spurious translation from sexual act or behavior to sexual meaning and identity, something later theoretical developments would come to reject.

To summarize, the cultural influence model recognizes variations in the occurrence of sexual behavior and in cultural attitudes which encourage or restrict behavior, but not in the meaning of the behavior itself. In addition, anthropologists working within this framework accept without question the existence of universal categories like heterosexual and homosexual, male and female sexuality, and sex drive.

Despite these many deficiencies, it is important to recognize the strengths of this approach, particularly in its intellectual, historical, and political context. Anthropology's commitment to cross-cultural comparison made it the most relativistic of social science disciplines in regard to the study of sexuality. Its finding of variation called into question prevailing notions about the inevitability or naturalness of sexual norms and behavior common in America and Europe, and questioned also the connection between sexual regulation and social or familial stability. The variability it reported suggested that human sexuality was malleable, and capable of assuming different forms. Work in the cultural influence tradition

undercut more mechanistic theories of sexual behavior, still common in medicine and psychiatry, that suggested sexuality was largely a function of physiological functioning or instinctual drives. The cultural influence model began to develop social and intellectual space in which it was possible to regard sexuality as something other than a simple function of biology.

Although work in the cultural influence model contributed to the development of social construction theory, there is a sharp break between them in many respects. This difference has not been recognized by many still working within the cultural influence tradition. Indeed, many mistakenly seem to regard these new developments as theoretically compatible, even continuous with earlier work. Some have assimilated terms or phrases (like "social construction" or "cultural construction") in their work, yet their analytic frames still contain many unexamined essentialist elements. It is not the case that the cultural influence model, because it recognizes cultural variation, is the same as social construction theory.

A different attempt at assimilation is found in the assertion that the debate between essentialists and social constructionists in regard to sexuality is a replay of the nature/nurture controversy. This is a profound misunderstanding of social construction theory. In nature/nurture debates, researchers are proposing alternative biological or cultural mechanisms to explain phenomena they observe. At present, most observers agree that human behavior is produced by a complex interaction of biological and cultural factors; they differ on the relative weight they assign to each. Although it might be appropriate to find some similarity between essentialists and the nature camp, to equate social construction to the nurture camp is mistaken. Social construction theory is not simply arguing for cultural causation. In addition, and more importantly, it encourages us to deconstruct and examine the behavior or processes which both nature and nurture camps have reified, and which they want to "explain." Social construction suggests that the object of study deserves at least as much analytic attention as the suspected causal mechanism.

A social construction approach to sexuality would examine the range of behavior, ideology, and subjective meaning among and within human groups, and would view the body, its functions, and sensations as potentials (and limits) which are incorporated and mediated by culture. The physiology of orgasm and penile erection no more explain a culture's sexual schema than the auditory range of the human ear explains its music. Biology and physiological functioning are determinative only at the most extreme limits, and there to set the boundary of what is physically possible. The more interesting question for

CAROLE S. VANCE

research on sexuality is to chart what is culturally possible—a far more expansive domain. Ecological adaptation and reproductive demands similarly explain only a small portion of sexual organization, since fertility adequate for replacement and even growth is relatively easy for most groups to achieve. More important, sexuality is not coterminous with or equivalent to reproduction: reproductive sexuality constitutes a small portion of the larger sexual universe.

In addition, a social construction approach to sexuality must also problematize and question Euro-American folk and scientific beliefs about sexuality, rather than project them onto other groups in a manner which would be most unacceptably ethnocentric in any other subject area. Thus, statements about the importance of sexuality in human life, the universally private status of sexual behavior, or its quintessentially reproductive nature need to be presented as hypotheses, not a priori assumptions. Anthropology seems especially well suited to problematize these most naturalized categories, yet sexuality has been the last domain (trailing even gender) to have its natural, biologized status called into question. For many of us, essentialism was our first way of thinking about sexuality, and it still remains hegemonic.

NOTES

1. Gayle Rubin, "The Traffic in Women: Notes on the 'Political Economy' of Sex," in *Toward an Anthropology of Women*, ed. Rayna Reiter (New York: Monthly Review Press, 1975), pp. 157–210, quoted from pp. 158–59.

2. Gayle Rubin, "Thinking Sex: Notes for a Radical Theory of the Politics of Sexuality," in Carole S. Vance, ed., *Pleasure and Danger: Exploring Female Sexuality* (New York: Routledge & Kegan Paul, 1984), pp. 267–319.

3. Mary McIntosh, "The Homosexual Role," *Social Problems* 16 (1968): 182–92.

4. Jeffrey Weeks, *Coming Out: Homosexual Politics in Britain from the 19th Century to the Present* (London: Quartet Books, 1977).

5. Jonathan Katz, *Gay American History* (New York: Crowell, 1976).

6. Jonathan Katz, *Gay Lesbian Almanac* (New York: Harper & Row, 1983).

7. There is no suggestion here that the most radical forms of social construction theory are necessarily the best, although the exercise of totally deconstructing one of the most essential categories, sexuality, often has an electrifying and energizing effect on one's thinking. Whether this degree of deconstruction can be plausibly maintained is another question.

WAYNE KOESTENBAUM

THE ARYAN BOY WHO PISSED ON MY FATHER'S HEAD

STORY

At some overnight nature retreat, long ago, outside Berlin, my father awoke to discover someone pissing on his head. It was the Aryan boy in the upper bunk. While my father told me this story, I was bathing, under his supervision; a plastic cup floated beside me in the soapy water.

I've often thought of this Aryan boy, circa 1936, pissing on my father's head, and of my position, naked in the tub, while he told me the story—one of the few anecdotes he passed on to me about his childhood in Nazi Germany.

Another story: Hitler paraded through the streets, and my father saluted him because everyone else was saluting. It was the thing to do.

Otherwise I heard little about tyranny. Who knows if the boy in the story was really Aryan, or if I'm remembering the story correctly?

CUP

In the bathtub, I pissed in the plastic cup. Pissing in the cup produced a hard-on, but once the penis grew hard, piss-flow paradoxically stopped. I liked to use the cup as a ladle, gathering bathwater to rinse shampoo suds out of my hair.

Enjoyable, to place the cup over one's newly emergent penis in the bathtub.

GALICIA

On my mother's side, there were some shadowy relatives—who knows their names?—in Galicia. My mother remembers conversations in the early 1940s, late at night, at the Brooklyn kitchen table. Letters from Galicia. Nothing could be done to save these shadows. I guess I'm Galician.

The window of Wolf's jewelry shop was smashed. Did that hate-filled atmosphere make Wolf's son—my mother's father—the difficult man he became? At his death, his unfinished project was a book about the Jew in American literature. "When did you stop being an observant Jew?" I asked him, and he said, "What are you talking about? I never stopped."

THE REPRODUCTION STORY

My older brother had a new book, *The Reproduction Story*, about vagina and penis, secrets of mating, special feelings you develop for members of the opposite sex. I was taking a bath. My mother threw the book into the bathroom, saying "Your brother isn't old enough for this book." She was furious at him for some misdeed, sass or subversion. He was, as the saying goes, in the doghouse. "Your brother's not mature enough for this book," she said, meaning, *The bastard's lost his right to learn the reproduction story*. Good. Now the story was my property. Naked in the tub, I read about gonads. I lost track of plot. I pissed into the plastic cup.

MORE ON THE ARYAN BOY WHO PISSED ON MY FATHER'S HEAD

A miracle, that piss stops once you want to come, that "come" and "piss" functions are dialectical, mutually exclusive.

Did my father consider the boy an Aryan? Was that the term? Or did my father simply call him "Gentile"? I should ask my father about that incident, but

our rapport has disintegrated. The times of bathing, of pissing into the cup after he left the bathroom, are over. Just as well. But I should figure out whether his aunt's middle name was really Sarah, or whether that was just the name the Germans put on her visa to signify her race.

MORE ON THE ARYAN BOY PISSING

"How are babies conceived?" I asked my older brother, and he told me, "Daddy pisses in Mommy." Therefore, from the beginning of time, I knew that such relations were degrading.

MORE ON PISSING

Is urine a home remedy? Two scholars—women—were swimming in the ocean. A jelly-fish stung one, so the other pissed on her colleague's sting: a proven antidote.

When you piss in the ocean you are not ejecting fluid; rather, you are accepting fluid's absence. You are deciding that you don't want to hold in those muscles, that your liquids sympathize with the saline surround; you want intimacy with coral, crabs, jellyfish, and wrack. That's probably why the little girl in *The Exorcist* pissed on her parents' fancy rug during their dinner party. She wanted to make a big, Satanic statement. She wanted to show exactly what she thought of their Georgetown regime. My next step in life is to identify with the possessed girl in *The Exorcist*.

KEITH WRITES:

"This is how my lover and I met, at a sleaze bar (now closed), getting our fill in the rest room. . . . We both like to give as well as receive golden showers. Meeting others into this 'sport' is becoming impossible. We display our yellow hankies proudly—and sometimes our wet crotches!—only to receive puzzled looks and outright stares. This is in leather bars! Can you put us in touch with groups, organizations?" (*Honcho*, April 1994.)

ORGASM

I was naked in the tub. My father said: "And I awoke to discover I was all wet." Or he said: "I wondered where the liquid was coming from." Or he said: "And I looked up and there was the Aryan bully, pissing on my head." Meanwhile I was ensconced in Mr. Bubble.

There is a time in life when one's own penis—if one has a penis—is a negligible article of faith.

WAYNE KOESTENBAUM

This is what passed through my mind as my very first hand-manipulated orgasm approached: "There's no way I'm going to mess up this clean bathtub with my spermy stuff." So I stopped. For weeks afterward I thought I'd irreparably damaged my potential to come, because I'd interrupted that originary burst.

SHE DIDN'T SAY A WORD

My grandfather said, of his mother, "She never once raised her voice." This was a compliment. She never raised her voice to her husband, Wolf, who translated the Bible into Yiddish at night: during the day he was a jeweler with a broken shop window. Wayne stands for Wolf; shared W, meager memorial.

MORE ON THE CUP

My fundamentalist friend lay naked on his bathroom throw rug. I said, "I've discovered a neat trick. Look." And I put the bathroom cup over my hard penis. I wanted to teach him secrets of the cup. But he had other plans. He said: "Lie on top of me." My fundamentalist friend wanted me to fuck him. I said, "No way." Then he decided we should stay up past midnight playing World War II strategy games. To this day I regret not fucking my fundamentalist friend on the rug. In my own fashion I, too, am a fundamentalist. I believe in the fundament and I believe in these fundamentals.

PROSTHETIC MATH

I believed the math teacher's penis was prosthetic because I'd seen it hang loose and inanimate like a stale *bûche de Noël* out of his pants at the urinal.

The squirt named Wasserman who sent a thank-you card to the math teacher: was Wasserman Jewish, too, and did that explain his safari shirt and his friendship with the math teacher with prosthetic penis and recipe for Waldorf salad tucked between algorithmic pages? Even then I thought of Wasserman as Water Man.

SHAKE IT OUT

"Shake it out afterward," my father wisely said. Smart man, to say "shake it out afterward." I'm sure he showed me how to shake it out, but there's always more dribble than science can account for. At what exact moment in sexual arousal is the flow of urine stopped? Do you have to wash your hands after pissing? Rumor has it, urine is hygienic. I suppose humiliation has nothing to

do with masculinity, extermination has nothing to do with masculinity, my father and I have nothing to do with masculinity, shaking the penis out after pissing to make sure there are no dribble drops left over has nothing to do with masculinity.

TYRANNY

Kobena Mercer recently said, in *Artforum*, that we have plenty of discussions about desire and pleasure, but not enough about "pain and hatred as everyday structures of feeling." I agree. To "pain and hatred" I would add "tyranny." Tyranny is an everyday structure of feeling. We do not have enough discussions of tyranny's mundanity; everyone who analyzes tyranny pretends not to be friends with it, but what if finally we narrated our tyrannic urges?

MY FATHER SALUTING HITLER

It was a parade; my father didn't know better. My father, little Jewish boy, saluted Hitler. Someone must have found it cute, someone else must have found it not cute. Up went my father's hand in mimic salute. Someone must have found it cute.

ONE PROBLEM WITH THIS DISCOURSE

Is that it sounds like a victim's . . . , or like the discourse of someone who considers himself a victim. I must find a way not to sound the victim note. I must find a way to speak as tyrant, not because I want to be a tyrant or become more tyrannical, but because there is little about my desire or my death that does not fall under the heading "tyranny."

CALL MASCULINITY "TYRANNY" AND SEE WHAT HAPPENS

My mother did the tyrant's work. It was her job to incarnate tyranny—for example, when she threw *The Reproduction Story* like dog food into the bathroom while I lay in the tub.

I always wondered about the difference between breasts in men and breasts in women, and I prayed I would not grow up to become like my father, a man with breasts, though now in retrospect I realize those were just fatty chest muscles, good pectorals gone to seed. I looked down at my chest to make sure that it did not protrude. I longed for absolute flatness, but also at other moments was eagerly stuffing crumpled paper towels in my shirt to simulate *La Dolce Vita*'s Anita Ekberg.

"VISIT THE RABBI WHILE YOU'RE IN VENICE,"

my grandfather said, and I wondered why I should waste time in Venice visiting the rabbi. Why squander an afternoon visiting the ghetto in Venice, I thought, when there are so many more uplifting tourist sites? My grandfather wanted to prove that Robert Browning was a Jew; I wondered why anyone would bother.

I tell my imaginary son, "Visit the sleaze bars while you're in Venice." I'm sure I feel the same wash of sentiment, anger, pride, self-righteousness, and victimization about queerness that my grandfather felt about Jewishness.

ICE CUBE

Ice cube my grandfather sucked as he died: the tyrant sucked an ice cube. Hard to take in moisture while you're dying, I suppose, so he sucked an ice cube—or, rather, my grandmother brought the ice cube to his tyrant lips. My mother has his tyrant features, and I have my mother's tyrant features: slim mean face, hysterical brown button eyes that will not see the other side of the equation. Odd, that tyrant features passed through my mother to me. Someone must bring ice to the tyrant's lips, quenching tyrannic thirst, like the thirst of Prometheus, tied to the rock, liver eaten by vultures. Find the rock we're tied to, find the source of the rivets. The tyrant is a tyrant because he thinks his liver is being eaten by vultures.

WHERE PROMETHEUS PISSED

Right on the rock. Tied to rock eternally, he pissed right where he was tied. That was part of the Promethean picture. I suppose the rock was in the middle of the ocean, so the piss just washed off the sides of the rock and blended with the wandering sea. You piss where you are bound. When Prometheus was thirsty, my grandmother was not there to give him a taste of ice cube wrapped in handkerchief.

NUN JEW

My mother said "nun Jew" to refer to non-Jews. "Nun," as in "The Flying Nun." Nun Jew. We said "popo" for ass, "pee-pee-thing" for penis, "pee-pee-thing" for vagina. Why have two different words? "Pee-pee-thing" covers both bases. "Piss-toy" would have been an alternative locution. Does it matter what words you use? It matters what words you use.

NUN JEW CUM

The first time I swallowed cum I didn't care what I was swallowing. The second time
I swallowed cum I gargled afterward with Listerine. The first two times were
Nun Jew Cum. I don't remember the third time I swallowed cum. That's how it
is with origins.

AGORAPHOBIA

I once knew a therapist who treated agoraphobics in their own houses. She'd visit
them, to help them overcome their fear of agoras. My father voted for Nixon
because of the Israel question. My father usually based his votes on the Israel
question. Long ago, as part of a Sunday-school project, I gave money to plant
a tree in Israel. I didn't know what Israel was. I thought Israel was a country that
needed shade. The space of this discourse—these words, here—is agora-
phobic. I am visiting my own discourse in its house to see if I can help it
overcome its fear of the agora. If you never leave your house can you do dam-
age? You can do damage inside your house, but can you do damage outside
your house if you never leave your house?

I IMAGINE

That the Aryan boy was once my father's friend, but then the boy turned Aryan
in ideology and pissed on my father's head, but the pain of the incident lies
in the Aryan boy's betrayal, his flight from peaceful boyhood into Aryan iden-
tification, his movement from friend-of-my-father into Aryan thug. It is not
possible today to say something absolute about history or hatred, but it
is possible to say I was naked in the tub and that a story infiltrated my con-
stitution; it is possible to speak about the bathwater and my waterlogged
skin; it is possible to say I remember my father laughing as he told me this
story. Have I misconstrued it? Maybe the boy who pissed on his head was
actually a Jew. In 1936 could my father have shared a bunk bed with a
so-called Aryan? In any case, I remember my father chuckling as he told me
the story.

TRANSFERRED TO A JEWISH SCHOOL

His teacher took him aside—do I remember correctly?—and said she could not
give him the "A" he'd earned. Because he was Jewish she must not give him
that grade.

My father liked to eat mashed carrots, sweetened. Mashed carrots, orange, in a bowl.

I imagine the teacher who took him aside and said *because you are a Jew I can't give you the grade you deserve*, I imagine this teacher was a woman, but really she could just as easily have been a man.

So my father transferred to a Jewish school.

Idyllic black-and-white photo of my father at five years old in Berlin, naked, in the yard of his house, unself-consciously urinating on the flowers or the ferns with a small and not yet interesting penis: if I were merely imagining this picture I would tell you, but I am not merely imagining it.

WHY DIDN'T SOMEONE JUST SHOOT HITLER

In *Triumph of the Will*, Hitler moves along a row of soldiers, shaking their hands. Leni Riefenstahl filmed it so that he stares directly into the viewer's eyes, as if to shake the viewer's hand. I stare right into his eyes when he reaches his hand out to clasp mine. That is how Riefenstahl planned it. I have no other place to look.

I find many propagandistic manipulations seductive, including Wagner, but I draw the line at *Triumph of the Will*. I do not find its panoramas seductive. I expected I would find the near-naked Nazi boys attractive, showering in preparation for the rally; I'm relieved to find them scrawny. I'm relieved to know that I might not have found the Aryan boy attractive as he leaned over and let pour onto my head his golden arc.

HOMI K. BHABHA

ARE YOU A MAN
OR A MOUSE?

For my father

To speak of masculinity in general, sui generis, must be avoided at all costs. It is as a discourse of self-generation, reproduced over the generations in patrilineal perpetuity, that masculinity seeks to make a name for itself. "He," that ubiquitous male member, is the masculinist signature writ large—the pronoun of the invisible man; the subject of the surveillant, sexual order; the object of humanity personified. It must be our aim not to deny or disavow masculinity, but to disturb its manifest destiny—to draw attention to it as a prosthetic reality—a "prefixing" of the rules of gender and sexuality; an appendix or addition, that willy-nilly, supplements and suspends a "lack-in-being."

This is the collective project of those who contributed to a dossier on masculinity in a recent issue of *Artforum*.[1] For instance, writer and poet Wayne Koestenbaum says, "I have swallowed the word 'masculine'—even my shadow talks too loudly," and then he acts out/performs the prosthetic nature of masculinity that I have proposed, "Yet I don't know what 'it' is. I dropped it—will you pick it up?"[2] Masculinity, then, is the "taking up" of an enunciative position, the making up of a psychic complex, the assumption of a social gender, the supplementation of a historic sexuality, the apparatus of a cultural difference.

Filmmaker Todd Haynes and historian of literature Herbert Sussman, in the same *Artforum* dossier, take up Koestenbaum's challenge and rush to pick "it" up, only to find that the "it," or "he"—masculine identity—initiates a mobility, a movement of meanings and beings that function powerfully through an uncanny invisibility. "To what else can you attribute that unique sense of naturalness, the standard against which the world of differences is compulsively measured?" Haynes asks.[3] And Sussman's response insists that the compulsive measure of masculinity is a "problematic in which the governing terms are contradiction, conflict, and anxiety."[4]

Each of these attempts at naming masculinity becomes a compulsive probing of the condition itself. Attempts at defining the "subject" of masculinity unfailingly reveal what I have called its prosthetic process. My own masculinity is strangely separating from me, turning into my shadow, the place of my filiation and my fading. My attempt to conceptualize its conditionality becomes a compulsion to question it; my analytic sense that masculinity normalizes and naturalizes difference turns into a kind of neurotic "acting out" of its power and its powerlessness. It is this oscillation that has enabled the feminist and gay revision of masculinity—the turning back, the re-turning, of the male gaze—to confront what historian Peter Middleton describes as the "blocked reflexivity" that marks masculine self-identification, masked by an appeal to universalism and rationality.[5]

It is this oscillation, initiated at the heart of masculinity—its ambivalent identification—that turns its address from an innate invisibility, a normal condition, to a compulsive interrogation. "Are you a man or a mouse?" I can still hear my attorney father repeatedly confronting me in Bombay, his barristerish bravura seeking a kind of exclusive, excluding, bonding. "Do I have to choose?" I remember thinking, in anxious awkwardness, caught impossibly, ambivalently, in between "two different creeds and two different outlooks on life."[6] Gnawed by doubt and indecision, I felt terribly ratty about all of this. Much later, I realized that my question to my father should have been the Lacanian one, "*Qui Vuoi*:

What do you want of me? Why do you keep asking me if I'm the mouse-man when you are rather like Freud's Rat Man?"

And, ironically, it was in that depressing Freudian bestiary, the case of the Rat Man, which dwells on the obsessive nature of one kind of "blocked masculine reflexivity," that I found a response to my own problematic of the oscillatory and ambivalent moods of manhood. "Who do you love most, Daddy or Mummy?" is another version of my father's question, which, Freud writes, "accompanies the child throughout its life," whatever may be the relative intensity of its feelings toward the two sexes, or whatever may be the sexual aim upon which it finally becomes fixed. But, normally, this opposition soon loses the character of a hard-and-fast contradiction, of an inexorable "either-or." Room is found for satisfying the "*unequal demands* of both sides."[7]

Holding onto this anxiety about the domestic scenario of rattish father-love, its compulsion and doubt, I want to displace it onto another kind of anxious love—*amor patriae*—the naturalist, phallic identification with the service of the nation. Now, this link that I am suggesting between nationalism and masculinism is clearly seen in the work of Johann Fichte, often credited with being the father of modern national sentiment. It is rarely remarked of his *Addresses to the German Nation* (1807–1808) that its central metaphor for rational, national identification is the scopic regime.[8] It is the world of perception—the eye of the mind—that fosters a naturalist, national pedagogy which defines the *Menschenfreundlichkeit* of the German nation: "Naturalness [*and manliness*] on the German side," he writes, "arbitrariness and artificiality [*and effeminacy*] on the foreign side, are the fundamental differences."[9]

The arbiter of this nationalist/naturalist ethic is the bearer of a peculiar, visible invisibility (some call it the phallus)—the familial patriarch. The position must be understood as an enunciative site—rather than an identity—whose identificatory axes can be gendered in a range of strategic ways. The instinct for respect—central to the civic responsibility for the *service* of nation-building—comes from the Father's sternness, which is an effect of his "peripheral" position in the family: "This is the natural love of the child for the father, not as the guardian of his sensuous well-being, but as the mirror from which his own self-worth or worthlessness is reflected for him."[10]

But amidst the metaphysics of the "directness of national perception," the Father's image is a form of identificatory indirection or elision—what we may call "phallic" peripherality. For it is the absence of the Father—rather than the mother, who appears "more directly as benefactor"—that constitutes the principle of national self-identification and the *service* of the nation. The national

HOMI K. BHABHA

subject is then founded on the trace of the father's absent presence in the present of the mirror, whereas the mother's immanent "over"-presentness is supplemental—marked by the overbearing shadow of the Father but more clearly held in the line of vision.

This gendering of the nation's familial, domestic metaphor makes its masculinism and its naturalism neurotic. The temporality of the national "affect," represented in the parents' *fort/da* game, turns *amor patriae* into a much more anxious love. Explicitly so when we recall that, in a psychoanalytic sense, anxiety is a "sign" of a danger implicit in/on the threshold of identity, *in between* its claims to coherence and its fears of dissolution, "between identity and non-identity, internal and external."[11] This anxious boundary that is also a displacement—the peripheral—has a specific relevance to national identification when we realize, after Freud, that what distinguishes fear from anxiety is the danger of a loss of perception (a *Wahrnehmungsverlust*) attached to familiar (and familial) images, situations, and representations.[12] The indeterminacy of anxiety produces, as with my reading of the Fichtean mirror, "a traumatic divergence of representation and signification" at the very core of the gendering cathexes that stabilize the "I."[13] As if to emphasize further my articulation of anxiety's "present" and the desire for a national past as a peripherality that borders and bothers the national discourse, Lacan suggests that the structure of anxiety "seems to be that of a twisted border."[14] This structure—a twisted border—has an immediate relevance to our speculations on the national past and its challenge to the naturalism and progressivism of the matrical myth of modern progress. For, as Lacan suggests, that spatial "twisting" is part of a profound temporal disjunction at the heart of anxiety:

> [Anxiety] challenges me, questioning me at the very root of my own desire . . . as cause of this desire and not as object. And it is because this entails *a relation of antecedence*, a temporal relation, that I can do nothing to break this hold rather than enter into it. *It is this temporal relation that is anxiety.*[15]

What happens when the phallic structure of *amor patriae* turns into an anxious ambivalence? What kind of atavism emerges in the political sphere when that "relation of antecedence" which is traditionally associated with patriarchal precedence is challenged at the very root of its desire? Can democracy turn demonic in the service of the nation through observing the imperatives of phallic respect? Surprisingly, in a recent issue of *Time* magazine, Michael Kinsley reflects on such topics in an essay called "Is Democracy Losing Its Romance?"

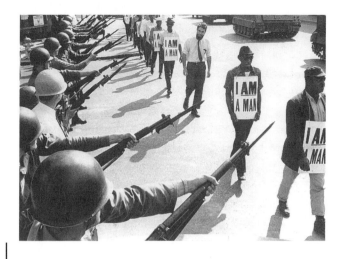

After a *tour d'horizon* of the postcommunist world, during which he concludes
that "democracy, far from suppressing [nationalist hatred], actually gives vent
to [it]," Kinsley turns a homeward glance. In the United States today, he sug-
gests, there has emerged a populism with an antidemocratic flavor, which
"hungers for a strong leader on a white horse. Thus Ross Perot, America's
would-be Fujimori." Then he continues:

> As the current movie *The Remains of the Day* reminds us, there was a time not long ago,
> the 1930s, when openly expressed doubts about the wisdom of democracy as a system
> of government were positively fashionable, even in established democratic societies.
> These days everybody at least pays lip service to the democratic ideal. Will that change?[16]

Is it possible to read Kazuo Ishiguro's *The Remains of the Day*, centered on
the very British bathos of the butler Stevens, a "gentleman's gentleman," as
a parable of the masculinist ritual of "service" to the nation, with the domes-
tic sphere as a substitute for the public sphere? In the British context, "service"
has a double cultural genealogy. It represents an implication in the class struc-
ture where domestic service normalizes class difference by extravagantly
"acting it out" as an affiliative practice, perfectly exemplified in the metonymic
mimicry of the idiomatic naming of the butler as a "gentleman's gentle-
man": "A butler's duty is to provide good service," Stevens meditates, "by

concentrating on what *is* within our realm . . . by devoting our attention to providing the best possible service to those great gentlemen in whose hands the destiny of civilization truly lies."[17]

But, in the very same English context, at the same historical moment, "service" has an imperial and international connotation: the service to the ideal of Empire, conducted through knowledges and practices of cultural discrimination and domination. For instance, in a 1923 essay entitled "The Character of a Fine Gentleman," published in the protofascist journal *The English Review*, H.C. Irwin extols the virtues of "Dutifulness (*pietas*) and reverence for all that deserves veneration," and then proposes three classes of gentleman: the "English gentleman," his "transatlantic cousins," and "*Anglo-Indian worthies*."[18]

The brilliance of Ishiguro's exposition of the ideology of service lies in his linking the national and the international, the indigenous and the colonial, by focusing on the anti-Semitism of the interwar period. He thus mediates race and cultural difference through a form of difference—Jewishness—that confuses the boundaries of class and race and represents the "*insider's outsiderness.*" Jewishness stands for a form of historical and racial *in-betweenness* that again resonates with the Benjaminian view of history as a view from the "outside, on the basis of a specific recognition from within."[19]

If "domestic service" in the figure of the butler is that "unchosen" moment that naturalizes class difference by ritualizing it, then the narrative's attention to Jewishness and anti-Semitism raises the issue of gender and race, and, in my view, places these questions in a colonial frame. It is while Stevens is polishing the silver—the mark of the good servant—that the narrative deviates to recall the dismissal of two Jewish housemaids at the insistence of the fascist Lord Darlington. The gleam of the silver becomes that Fichtean national mirror where the master's paternal authority is both affirmed and, in this case, tarnished by the housekeeper Miss Kenton's pressing of the charge of anti-Semitism against both Darlington and Stevens. This is the ambivalent moment in the narrative, when the "memory" of anti-Semitism and the interwar "English" Nazi connection turns the naturalism and nationalism of the silver service into the "anxiety" of the past—what Lacan has described as the temporal antecedence of the anxious moment.

The preservation of social precedence, embodied in the butler's service, is undone in the temporal antecedence that the presence of the Jew unleashes in the narrative present and the national memory. The English silver—the mark of the gentleman—becomes engraved with the image of Judas Iscariot, the sign of racial alterity and social inadmissibility. But the anti-Semitic historical

Photograph by William Eggleston.

past initiates, as anxiety is wont to do, a double frame of discrimination and domination that produces a temporal montage where Jew and colonized native, anti-Semitism and anticolonial racism, are intimately linked. For the British fascists, such as Ishiguro's Lord Darlington, argued for the Nazi cause on the grounds that Hitler's success was intimately bound up with the preservation of the British Empire. E.W.D. Tennant, who was undoubtedly amongst the most prominent of Lord Darlington's guests, and had certainly basked in the glow of Steven's glinting silver, had this to say in 1933, in an article entitled "Herr Hitler and his Policy," published in *The English Review*:

> The evidence that I saw supports the idea that the burning of the Reichstag and the consequent seizing of the Karl Liebknecht house was an act of providence. The Karl Liebknecht house was set up as a printing works where Communist propaganda was prepared for distribution all over the world. There were thousands of pamphlets in many languages including thousands for distribution among the natives of India and South Africa. *Much information of the highest interest to the British Empire and particularly in regard to India and the Anti-Imperial league is available.*[20]

If "phallic respect" leads periodically to the resurgence of the fascination with fascism—"a strong leader on a white horse"—then I want to end up with an instance of feminist "disrespect" for the hagiography of political father figures, however politically radical they are in intent. My emphasis on the "doubly"

HOMI K. BHABHA

gendered national identification, visible as an oscillation that "loses the character of a hard-and-fast contradiction, of an inexorable either-or," enables an understanding of subaltern agency as the power to reinscribe and relocate the given symbols of authority and victimage.

One way of concretely envisaging such a practice is through the work of artist Adrian Piper. Her series entitled "*Pretend*" deploys the dynamic of the fetishistic gaze to replay the scenario of disavowal across the portraits of black men (including Martin Luther King, Jr.), each of them bearing a piece of the text: "Pretend not to know what you know." The unmarked icon at the end of the series shows three apes in the familiar see-no-evil, hear-no-evil, speak-no-evil triptych. Piper substitutes for the mother figure of the Freudian fetishistic scenario the black father figure of the Civil Rights Movement. The mother's overdetermined "lack" is replaced by the ineradicable *visibility and presence* of the black skin to which Fanon drew our attention; the signifier of sexuality, with its splitting, haunts the male icon of radical victimage that seeks to constitute itself in a continuist political/prophetic tradition of patriarchal activism.

The spectator's identification with the apes incites, even excites, two forms of disavowal and its undoing: it cuts both ways, Janus-faced, across sexual and racial difference and subjection. The viewer cannot but occupy an ambivalent, even incommensurable identification with the visible "black" history of racial victimage and the struggle against it. There is, at the same time, a refusal to "pretend," and a resistance to the disavowal, within black, patriarchal, "race" politics, of the agency of women, gay, and lesbian activists.

Social splittings of form and content are at the core of Piper's work, according to one critic.[21] And in *Pretend*, I think, she is warning us that "what we see is not what we need to get or desire," either in a political or sexual sense. By placing the viewer in a split position—an intermediacy between the ambivalent, phantasmatic scene of sexuality and the more binary, heterosexist tradition of a style of race politics—Piper makes us aware of the complex, perhaps contradictory relation between historical needs, political desires, and the destiny, even density, of our gendered selves.

NOTES

Portions of this essay have been published in a different form in my essay "Anxious Nations, Nervous States," in Joan Copjec, ed., *Supposing the Subject* (London and New York: Verso, 1994).

1. Maurice Berger, comp., "Man Trouble: A Special Project," *Artforum* 32, no. 8 (April 1994): 74–83, 119–22.

2. Wayne Koestenbaum, "'My' Masculinity," in ibid., p. 79.

3. Todd Haynes, "Lines of Flight," in ibid., p. 79.

4. Herbert Sussman, "His Infinite Variety," in ibid., p. 119.

5. Peter Middleton, *The Inward Gaze: Masculinity and Subjectivity in Modern Culture* (New York and London: Routledge, 1992), p. 3.

6. Freud, "Notes Upon a Case of Obsessional Neurosis" (1909), *The Standard Edition of the Complete Psychological Works of Sigmund Freud*, trans. James Strachey (London: Hogarth Press, 1954), vol. 7, p. 128.

7. Ibid., p. 118.

8. Johann G. Fichte, *Addresses to the German Nation* (1807–1808), (Chicago: Open Court Publishing, 1968).

9. Ibid., p. 83.

10. Ibid., p. 173.

11. Samuel Weber, *Return to Freud: Jacques Lacan's Dislocation of Psychoanalysis* (Cambridge: Cambridge University Press, 1991), p. 154.

12. Ibid., p. 155.

13. Ibid.

14. Lacan, quoted in ibid., p. 158.

15. Lacan, quoted in ibid., p. 160 (my emphasis).

16. Michael Kinsley, "Is Democracy Losing Its Romance?" *Time* 143 (Jan. 17, 1994): 68.

17. Kazuo Ishiguro, *The Remains of the Day* (New York: Alfred A. Knopf, 1990), p. 199.

18. H.C. Irwin, "The Character of a Fine Gentleman," *The English Review* 37 (1923): 643.

19. Peter Osborne, "Small-Scale Victories, Large-Scale Defeats: Walter Benjamin's Politics of Time," in Andrew Benjamin and Peter Osborne, eds., *Walter Benjamin's Philosophy: Destruction and Experience* (London and New York: Routledge, 1994), p. 93.

20. E.W.D. Tennant, "Herr Hitler and his Policy," *The English Review* 56 (1933): 373 (my emphasis).

21. Arlene Raven, "Adrian Piper: You and Me," *Pretend*, exhibition catalogue (London: Ikon Gallery, 1991), p. 18.

MASCULINITY AND REPRESENTATION

WHAT IS
MEANS BEING MALE
DEFINES SUBJECTIVITY
AND THE RULE
AND RESPONSIBILITY
OF LAW

two

Camel advertisement.

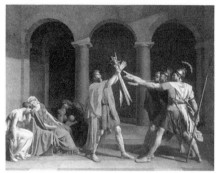

Jacques-Louis David, *The Oath of the Horatii* (1785), Paris, Louvre.

Jacques-Louis David, *Leonidas at Thermopolyae* 1800–1813, Paris, Louvre.

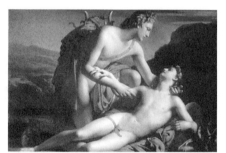

Pierre-Narcisse Guérin, *Iris and Morpheus*; St. Petersburg, The Hermitage.

Zino perfume advertisement.

Anne-Louis Girodet-Triosin, *The Sleep of Endymion*, 1793, Paris, Louvre.

ABIGAIL SOLOMON-GODEAU

MALE TROUBLE

I do not remember the exact year—possibly it was in the late 1980s—that the R.J. Reynolds Tobacco Company, manufacturer of Camel cigarettes, adopted "Joe Camel" as their emblem. But within a short period of time, the penis/testicle-headed camel had become an inescapable presence on billboards, kiosks, building walls, matchbooks, and the printed page. Habituated as viewers were to the testosterone-saturated imagery of the Marlboro Man, the Camel penis-head provoked controversy only when it was discovered that large numbers of young boys were avid devotees of the emblem, and, therefore, presumed to be at risk of actually smoking Camels.

Without getting into any sustained analysis of the semiotic structure of the Camel advertisements, it may be useful to recall that the debut of Joe was more or less contemporaneous with several other phenomena. I refer, for example, to the advent of the so-called men's movement, which, like the Marlboro and Camel campaigns, may be understood as a defensive backlash against uncongenial social and economic realities. Perhaps even more suggestive, however, was the appearance—again, in the same general period—of a far less familiar representation of ideal masculinity: namely, the passive, beautiful, and seductive young man displayed in ways previously reserved for desirable young women, and given poses and facial expressions previously reserved for the iconography of femininity.

Although it is certainly possible to account for these kinds of mass-cultural images empirically, with reference to commercial determinations (the development of new markets, new products, newly targeted groups of consumers, and so forth) and internal adjustments by the advertising agencies themselves (Marlboro, for example, was originally conceived as a woman's cigarette, but it bombed on the market), it seems equally clear that these new, "feminized" iconographies of masculinity in the mass media may presage or reflect tidal shifts in the articulation and, by implication, the lived subjectivity of contemporary men. *What* is presaged or reflected is another matter; it is certainly premature to read such phenomena as cause for feminist celebration. In any case, the recent visibility of masculinity itself as, variously, a disciplinary object of knowledge, a subject of artistic or literary investigation, and a political, ethical, and sexual problematic—a diagnostic primarily derived from and in fact inseparable from feminism and the women's movement—attests, if nothing else, to a destabilization of the notion of masculinity such that it forfeits its previous transparency, its taken-for-grantedness, its normalcy. It is doubtless this loss of transparency that underpins the now-frequent invocations of a "crisis" in masculinity, or, at the very least, a perceived problem in its representations.

Now, the coexistence of radically different and equally widespread expressions of idealized masculinity—for shorthand, the poles represented by the languorous Versace boy and the penis-headed Joe Camel—begs the question as to which variant of masculinity is to be understood as a manifestation crisis. But even more to the point, I am uncomfortable with formulations that imply some utopic or normative masculinity outside crisis. In this respect, I would argue that masculinity, however defined, is, like capitalism, *always* in crisis. And the real question is how both manage to restructure, refurbish, and resurrect themselves for the next historical turn.

In the context of this paper, I am employing the term "masculinity" as a more or less symmetrical pendant to the concept of femininity developed within feminist theory. In other words, masculinity is, like femininity, a concept that bears only an adventitious relation to biological sex and whose various manifestations collectively constitute the cultural, social, and psychosexual expression of gender. Insofar as culture provides us with numerous examples of feminized masculinities and masculinized femininities, and Freud provides us with a model of gender that stresses both its abstraction and precariousness, we do well to acknowledge its historical, provisional, and indeed performative nature. Furthermore, given that almost all anthropologists and ethnographers agree that masculinity appears transculturally as something to be acquired, achieved, initiated into—a process often involving painful or even mutilating rituals—there is ample evidence to suggest that there never is, never was, an unproblematic, a natural, or a crisis-free variant.

For this reason, I respectfully take issue with arguments such as those proposed by Kaja Silverman in her important study, *Male Subjectivity at the Margins*.[1] In her introduction, Silverman proposes a specific historical juncture—the nineteenth-century fin de siècle—during which the nonequivalence of phallus and penis became evident, a crisis in masculinity par excellence. My own work in late-eighteenth- and nineteenth-century French art convinces me, on the contrary, that this "crisis" is—at least in elite visual culture—a veritable and venerable *topos*. How else to explain the appearance in such art of large swords and scabbards so frequently coupled with diminutive genitals? Indeed, one might well make the case that the manifest nonequivalence of physical organ and symbolic phallus is a central problematic in the imagery of heroic masculinity.

In taking as her subject a series of "perverse," "deviant," and variously nonphallic masculinities, Silverman counterpoises them against a putative masculine norm she terms "classical" (that is, phallic, virile, martial, intensely Oedipalized). But again, from the admittedly limited perspective of late-eighteenth- and nineteenth-century French painting, sculpture, and print culture, this norm is far from evident. Thus, what may once have appeared retrospectively as a kind of classical masculine paradigm—represented by, say, David's *Oath of the Horatii* of 1785, a work which heuristically contrasts the separate spheres of masculine and feminine—looks from another optic virtually pathological in relation to, say, Boucher's more egalitarian vision of heterosexual relations. The *pur et dur* masculinities of Jacobin ideology turned out, in fact, to be the most ephemeral of all; David's own students were,

moreover, quite capable of reversing them, as in Girodet-Trioson's *Sleep of Endymion* (1793). David himself produced strikingly different models of masculinity throughout his career, and both pre- and postrevolutionary art are rife with representations of ideal masculinities that are startlingly androgynous, feminized, and passive, and which, like Silverman's nonphallic subjectivities, "not only acknowledge but embrace castration, alterity, and specularity."[2]

By way of example, we can consider Pierre-Narcisse Guèrin's paired paintings *Aurora and Cephalus* (1810) and *Iris and Morpheus* (1811), perhaps the two most extreme examples of both the iconography of role reversal and the morphological effeminacy of an idealized male figure. That contemporary art critics failed to find these remarkably androgynous figures shocking or disturbing can be taken either as a sign of critical self-censorship or as an index of the acceptability, indeed the appeal, of such representations. Guèrin's Cephalus is particularly effeminate; while as dependent as Guèrin's Morpheus on the prior example of Girodet's Endymion, he is given a plumper, more undulant body that floats weightlessly on its billowing cushion of clouds. While Cephalus floats horizontally, unconscious and inactive, Aurora springs up, pushing back the veil of night, while gazing languidly down at the supine body beneath her. With her hubcap breasts, metallic curls, and enameled face, Aurora is a somewhat alarming presence. But it is worth noting that, while the painting's narrative content concerns a sexual role reversal and while the body of Cephalus is radically feminized, Guèrin has also phallicized the figure of Aurora, whose taut and upright body can be read as a displacement of the potency that Cephalus lacks.

In *Iris and Morpheus* both figures are nude, the Iris figure having been given the doll-like features and chic coiffure of Gerard's immensely popular *Psyche* of 1798, the Morpheus figure positioned (like Girodet's Endymion) toward the spectator rather than toward the goddess. As with the iconography of Cupid and Psyche, highly stylized versions of masculine and feminine desirability are here put on display in a manner consistent with a libidinal economy that, while privileging the erotics of masculinity, is equally able to purvey its feminine analogue. Once again, contemporary critical commentary deployed a highly conventionalized language that offered no hint that such imagery constituted a dramatic departure either from earlier prototypes or from more typical representations of gender. Indeed, when one encounters such criticism, written in a spirit of strong partisanship and with enthusiasm (criticism that can fairly be called Winckelmannian), it is clear that the voluptuousness and sensuality of Guèrin's male figures—and many others of the period—could be openly celebrated.

What I am suggesting is that a consideration of these kinds of paintings provides visual evidence of a cultural fantasy in which the feminine can be conjured away altogether—as in the idealized homosexual/homosocial order of David's *Leonidas at Thermopylae* or the arbitrary evacuation of the goddess in Girodet's *Endymion* (where she is replaced by a surrogate moonbeam), only to be reinscribed and recuperated within a masculine representation. Alternatively, through a narrative role reversal, the masculine may be repositioned so as to occupy the conventional place of the feminine. In either case, the motifs and thematics of postrevolutionary history painting—whether stylistically categorized as neoclassical or pre-Romantic—frequently reverse, even refuse, the terms of the intensely virilized masculinity hypostatized in revolutionary discourse and iconography. More suggestively, these narratives and the morphologies of idealized masculinity suggest a colonization of femininity, so that what has been rendered peripheral and marginal in the social and cultural realm, or actively devalued, is effectively incorporated within the compass of masculinity.

This incorporation of femininity has several implications. First, it permits the psychosexual "monism" that Alex Potts has so persuasively demonstrated in David's *Leonidas*.[3] His interpretation supports the argument that the feminized masculinities of postrevolutionary culture represent the ultimate flight from sexual difference and are, if anything, the logical extension of the "real" historical event of women's expulsion from the public sphere. Second, one could argue that, insofar as it was artists, writers, and poets who gave form to these socially symbolic articulations of masculinity, their artistic expressions reflect their own changing status in the emerging free market of cultural production. Last, one could claim that the resurgence of a poetics (and erotics) of feminized masculinity represented a repudiation of a previous model of masculinity that was not only experienced as oppressive, but more important, no longer appropriate to the needs of a new or changing collective imaginary and symbolic order.

In fact, the prevalence of revolutionary and postrevolutionary images of masculinity that thematize—often at the level of narrative—those features of castration, alterity, and specularity specified by Silverman suggests something of the elasticity of categories of ideal masculinity. The imagery of ephebic and beset manhood—male trouble on the level of narrative representation—as well as a widespread cultural acknowledgment (albeit one conceived in aesthetic language) of the role of desire in the delectation of these beautiful male bodies should caution us against assuming that the expression of nonphallic masculinities constitutes any particular quarrel with patriarchal law and order. Nor, for that matter, does it particularly subvert it.

ABIGAIL SOLOMON-GODEAU

The evident popularity of the annihilated ephebe and the frank admiration of seductive male bodies—at least in the period I am discussing—was, as it happened, contemporaneous with a heightened misogyny, a rollback in whatever rights women had briefly acquired during the revolution itself, and an emerging bourgeois civil sphere constituted in large part through the exclusion and discursive silencing of women. Similarly, the equal popularity of explicitly homoerotic themes—often the loves of Apollo—cannot be indexed to any greater tolerance of actual homosexual activity. True, sodomy was banished from the list of capital crimes in France in 1791 due to the abrogation of ecclesiastical laws under which sodomy and pederasty had been classified, but aesthetic and literary discourse was as homophobic in 1800 as it was during the revolutionary period.

How then should the production of images and texts featuring nonphallic masculinities be considered? Do the feminized masculinities of the prerevolutionary culture of *sensibilité*, the Werthers and St.-Preux's, the passive ephebes of the 1790s, the later Romantic sufferers like Chateaubriand's René or Stendhal's Armance, have anything to tell us about our own crop of languid ephebes or armored heroic bodies deployed not for war and conquest but as loci of visual pleasure and spurs to consumption? And how, moreover, does one reconcile the historic fact of intense homophobia (coupled in many instances with intense misogyny) with a profound aesthetic and more or less libidinized investment in the idealized, nude, male body?

In this respect, it would seem to be the case that an eroticized and androgynous representation of masculinity does not necessarily transgress—and, indeed, may affirm—the patriarchal privileges of masculinity, however inflected. Images of beautiful and idealized masculinity obviously operate as much on the psychic level of narcissistic identification as they do on the level of homosocial desire. And, like the contradictions manifested in the coexistence of images of Ramboesque and ephebic masculinity in our own time, the ideology of "dominant" masculinity is at any given moment internally divided. Thus, the feminized masculine and the masculinized masculine are both available possibilities within the organization of what Eve Kosofsky Sedgwick has elaborated as homosocial desire.[4] Furthermore, there is some justification in suggesting that the repression of (female) femininity in the symbolic order, as well as in the civil order (certainly the case in the period of Jacobin hegemony), may promote its reinscription under the aegis of an idealized masculinity. What needs to be explained, therefore, are the circumstances and determinations that at different historical moments promote one fantasy of masculinity over another.

Rather than privileging a certain articulation of male masochism, as Silverman appears to do, it seems equally possible to consider these images of nonphallic masculinity as still operating within the framework of narcissistic identification and homosocial desire. Obviously, both formulations take place within a psychic and cultural arena of intense contradiction. This is another way of saying that the production and consumption of images of desirable masculinity in patriarchal culture take place within a changing social and cultural context that can never afford to acknowledge its own erotic economy, whether on the register of the individual artist or on that of the culture as a whole. Nevertheless, a libidinal investment in the ideal male body was historically furnished with an alibi based on a set of equivalences: spiritual and moral beauty = physical beauty = idealized masculinity. The erotics of the look, and indeed the erotics of the image, have in a sense always been sublimated into the edifying terms of idealist aesthetics, even as they may be simultaneously operative in other registers.

As I have been suggesting throughout, ideologies of gender are historical complexes, and may therefore manifest their own forms of uneven development. For example, the exhibitionistic and narcissistic masculinities of the seventeenth or eighteenth centuries could be later revived (as in the phenomenon of the Thermidorian *jeunesse dorée* or in dandyism) or mocked and ridiculed (as in the bourgeois culture of the July Monarchy). New models of sexed subjectivity, spawned in the revolution are, like their antecedents and successors, perpetually in process, manifesting in some aspects the emerging order of bourgeois hegemony, in others, the residual traces of the old order. If, on the one hand, the stoic masculinities of the Horatii were briefly proposed as ego ideals, they may well have proved too oppressive to masculine subjectivity to be long endured. The erotic and androgynous ephebe, therefore, comes to serve several overlapping functions: as masculine representative of the *beau idéal,* he could evoke narcissistic identification (along the track of what the subject would like to be); as feminized (or infantilized) images of masculinity, he could mobilize fantasies of possession and mastery, standing in, so to speak, for the absent feminine; as an "unstable" image of ambiguous gender, he could generate a phantasmatic free play, an escape from the uncompromising fixities of revolutionary gender ideology. In all cases, however, it was not the symbolic order of patriarchy that was called into question. Rather, it would seem, from the reception of these works, that the masculinity of the spectator was effectively shored up and reaffirmed.

I do not intend to overemphasize whatever similarities may obtain between our own cultural fantasies displayed in contemporary imagery of masculinity

and those produced at the threshold of modernity. Rather, my argument is meant as a cautionary reminder that the articulation of "soft" masculinities, like the related appearance of a men's movement concerned to excavate male fears, anxieties, and desires, or a discourse on gay male sexuality that celebrates the relinquishment of mastery and control, or the theoretical revision of male masochism,[5] need not necessarily have much to do with the relinquishment of the privileges of patriarchy, and certainly need not have anything to do with female emancipation, empowerment, or liberation.

For these reasons, a volume such as this, in which "masculinity" (gay, straight, or bi, and in its many avatars) is interrogated, analyzed, destabilized, and discursively fussed over, but the word "patriarchy," seldom uttered, can, despite enlightened intentions, seem disturbingly disconnected from the worldly effects of privilege and power that are, after all, what the word "patriarchy" denotes. It is all very well and good for male scholars and theorists to problematize their penises, or their relations to them, but is this so very different from a postmodern mal de siècle (a male malady, as Margaret Waller reminds us[6]) in which, once again, it is male subjectivity that becomes the privileged term?

While I suppose I am willing to grant that the current interrogation of masculinity is a useful project, perhaps even an index of positive social change, feminists and men who support feminism should be careful to distinguish a shared emancipatory project from intellectual masturbation. More disturbingly, the very appeal of approaching masculinity as a newly discovered discursive object may have less to do with the "ruination" of certain masculinities in their oppressive and subordinating instrumentalities than with a new accommodation of their terms—an expanded field for their deployment—in which the fundamentals do not change.

NOTES

1. Kaja Silverman, *Male Subjectivity at the Margins* (New York: Routledge, 1992).

2. Ibid., p. 3.

3. Alex Potts, *Flesh and the Ideal: Winckelmann and the Origins of Art History* (New Haven: Yale University Press, 1994).

4. Eve Kosofsky Sedgwick, *Between Men: English Literature and Male Homosocial Desire* (New York: Columbia University Press, 1985).

5. See, for example, Leo Bersani, "Is the Rectum a Grave?" in *AIDS: Cultural Analysis, Cultural Activism,* ed. Douglas Crimp (Cambridge, Mass.: MIT Press, 1987), pp. 197–222.

6. Margaret Waller, *The Male Malady: Fictions of Impotence in the French Romantic Novel* (New Brunswick, N.J.: Rutgers University Press, 1993).

EASTWOOD BOUND

There is a quite well-known photo portrait of Clint Eastwood, made by Annie Leibovitz, which figures the star in what have become his trademark street clothes—green T-shirt, brown corded trousers, and running shoes. He is standing erect against the backdrop of what looks like the film set of a Western. The rebellious, maverick, sometimes Promethean hero that Eastwood is so frequently and fully taken to represent is here heavily tied by ropes around his body and legs. His hands, also heavily bound, are held out in front of the body at about waist height. His expression is perhaps not his most familiar one, but it certainly can be glimpsed occasionally in his movies: it is a

look of vague bewilderment, with a slight crooking of the mouth into a mixture of amusement and annoyance as he looks back at the camera. His eyes are narrowed at the same time as his brows are arched slightly upwards. His straightened body seems to emerge from a billow of dust behind him.

This image was recently used as the cover to a Pluto Press collection of essays called *The Sexuality of Men*. I do not know how it came to be selected for that cover, but it does seem an interesting and apt choice in certain ways. The several male, British authors in the book are concerned with how, as the editors put it, "popular versions of what it is to be a 'real man' have become so outlandish as to prompt the idea that all is not as it should be for the male sex." Consequently, these writers undertake the task of breaking the silence that seems to surround this "hidden subject, resistant to . . . first investigations," male sexuality.[1] On the face of it, Eastwood's public and cinematic personae, among the most visible icons of masculinity in North American culture, can be readily taken not only as the epitome of the silence and the barriers to investigation that the authors are trying to break, but also as an obvious and symptomatic marker of the notion that "all is not as it should be" in regard to masculinity. The silence that many of his film performances appropriate as the sign par excellence of empowered masculinity, the erectness of his body, and the ubiquity of what the book's editors call his "oversized gun," the careless ordinariness of his J.C. Penney clothing, the limited but stark range of his facial and bodily gestures; all these contribute to Eastwood's presence within this culture as one of the more legitimated bearers of its masculinity, "real" or otherwise. At the same time, and many of the movies in which he stars and/or which he directs are somewhat troubled presentations or investigations of the kind of (or, of the image of) masculinity that they popularly stand for.

The trouble is perhaps hinted at in Leibovitz's picture, where this iconic male body emerges from the waves of dust around it to stand tall as the very type of a unique masculine beauty, but where it is simultaneously marked and immobilized by these ropes—signs of a certain helplessness or, at least, of difficulty. And yet the ropes in the photo (especially the five layers that encircle Eastwood's biceps, chest, and back and that are the focal point of the image) might also be indicative of a certain pleasure. That is, a pleasure in powerlessness—a pleasure that could certainly be grasped as an indication that "all is not as it should be" with this man, and that we might expect to be normally hidden from view in this culture and called "perverse"—is adumbrated across the ambivalent gestures of his face, and is, I would also claim, sketched across

his films. Further on, I shall want to regard this pleasure in relation to the idea of masochism, and for now it can certainly be taken to provide an emblematic starting point for discussing male sexuality, in that it presents an ambivalent moment whereby this male body, objectified and aestheticized by Leibovitz's portrait, comes to represent something a little "outlandish."

It has been possible for a long time now for discourses addressing North American notions of masculinity to actually rhapsodize on exactly the outlandish character of that special kind of man—the hero, often the Westerner, who acts as the serviceman for the culture. There is little point in trying to demonstrate here, once again, the long history of that man, from James Fenimore Cooper's pioneering heroes, through "classic" Western protagonists such as Shane, to a plethora of action heroes in the 1980s, such as Eastwood in *Heartbreak Ridge* (1986) or Mel Gibson in *Lethal Weapon* (1987). But it is interesting to see how this brand of male protagonist in all such cultural productions is always in some way marked (and is made enjoyable or at any rate consumable for audiences) by precisely his inability to act as the ultimate solution to the narrative and social contradictions in which he is involved. Natty Bumppo's self-righteousness as he goes around killing and destroying as much or more of "the natural" as he claims to be conserving,[2] the desperate but ecstatic hypostasis of the cowboy faced with an ineluctable tide of westward expansion and modernization at the end of *Shane* (1953), the ineptitude of Mel Gibson's character in *Lethal Weapon* in dealing with the family life that renders his own heroism possible; each of these in some way fails to transcend *fully* the contradictions of the narratives in which they figure.

Now, an orthodox critique of the male heroes in these kinds of popular cultural narratives would be to say that they actually present easy and transcendent solutions to contradictions; my claim is that, to the contrary, the resolutions and solutions are never fully realized. Still less are they embodied in this long line of male heroes of which Eastwood is, of course, an especially important member. Eastwood's interest, it seems to me, resides largely in the tendency of his work to remain, much longer than most other popular cultural narratives, in the rather special or peculiar state of gratification that comes of recognizing the factitious nature of the ultimate solution, and in doing so to exhibit the symptoms of what lies behind that gratification.

This, at first, might seem a peculiar opinion to be holding, and admittedly it is one that flies in the face of the overt narrative frames of popular movies such as Eastwood makes and stars in. However, I have something very particular in mind, in that I want to propose that action and Western movies like Eastwood's

might actually exceed the familiar processes of narrative contradiction and closure and leave what I will call "hysterical residues." Such hysterical residues I take to be the point of interference between the processes of narrative and the construction of diegetical worlds in film. My point is that action movies in particular (although I would like to say all Hollywood movies) throw up this kind of contradictory space, these elements that cannot be ultimately resolved and that remain as a kind of special emblem of the film's relation to the cultural world to which it attends.

In this regard, Eastwood's movies quite routinely open out onto difficult and multivalent questions about the popular cultural representation of masculinity, beyond their always rather formulaic narrative frames; indeed, the narrative disposition of particular tropes of masculinity does not ultimately control or delimit them, and leaves unmanaged and resistant representations of a male hysteria. Of course, I am far from discounting here the significance of narrative closure as a kind of punctual return to noncontradictory positions that satisfy both cultural and generic codes of verisimilitude. But I want to take the stress temporarily away from formulaic endings, and ask to what extent they are but a lure beneath which particular kinds of representational and sexual-political questions can be left unresolved.

In Leibovitz's photo, Eastwood appears to emerge, almost risibly classical, from his own peculiar waves to become an objectified spectacle. At the same time, this spectacle is marked and bound. It is with the tension between (or rather, the pairing of) these two elements—the objectification and eroticization of the male body, and the registration on this body of a masochistic mark—that I want to begin. I am interested in looking at the ways in which contemporary popular movies might effectively stand against some of the notions that writers in film studies deploy when talking about the interfaces of gender considerations and representation, but also I want to sketch out an argument for looking to see what happens when the purportedly "outlandish" nature of representations of masculinity in popular culture are apprehended, not as immediately and irredeemably contemptible, but as something by and through which some of the realities of male-sexed subjectivity are registered.

Paul Willemen, in a very short article about Anthony Mann's Westerns, talks about the way in which the male heroes there are diegetically cast in two distinct ways, the one consequent on the other. First, they are offered simply as spectacle: "The viewer's experience is predicated," Willemen says, "on the pleasure of seeing the male 'exist' (that is walk, move, ride, fight) in or through cityscapes, landscapes, or more abstractly history."[3] This pleasure can readily

be turned to an eroticization of the male presence and the masculine body, and it is always followed up—in Mann's movies just as in most such Hollywood genre movies—by the destruction of that body. That is, the heroic man is always physically beaten, injured, and brought to breaking point. One needs to add to Willemen's formulation the obvious third stage, in which the hero is permitted to emerge triumphant within the movie's narrative line; this stage conventionally cannot occur before the first two. This third stage obviously provides the security and comfort of closure, and is a crucial element in the production of spectatorial pleasure, but Willemen proposes that both of the first stages of representation are also in their way pleasurable for the spectator. The first "pleasure"—that of voyeuristic admiration of the hero's body and presence—is followed diegetically and graphically by the "unquiet pleasure of seeing the male mutilated . . . and restored through violent brutality."[4]

This intertwining in most action scenarios of what we might call on the one hand the solidity of masculine presence, and the demonstration of masculine destructibility and recuperability on the other, is readily apparent in most Eastwood movies, whether they be the Westerns or the cop movies, or even the comedies in which his costar is an ape (*Every Which Way but Loose*, 1978, and *Any Which Way You Can*, 1981). A first impulse would be to consider this as little more than the exigency of Hollywood habits and formulae, but of course it has its ideological ramifications, too. I would claim that this passage—from eroticization, through destruction, to reemergence and regeneration—is such a staple of action movies and Westerns in general that it can readily be called the orthodox structuring code for those movies. There are, I think, several interesting characteristics to it that will bear commentary, insofar as what is at stake here is a certain erotics of the male body that demands or entails peculiar diegetical and graphical representational strategies and processes of viewer identification.

Willemen implicitly proposes that the pleasure of the first two stages needs to be understood in terms of sadistic and masochistic frameworks, where objectification is pleasure yielded to the sadistic gaze, and where the destructibility of the male body is to be grasped as a masochistic trope. Since much film theory regularly deploys the frameworks of sadism and masochism as essential heuristic notions (the notion of sadism—especially in its relation to the gaze—almost chronically, and that of masochism more recently), it might be as well to briefly consider them here.

The cinematic erotics of the male body depend first of all upon that body's objectification. It is common, of course, to regard such objectification as the

PAUL SMITH

standard treatment for *female* bodies in the cinema; equally familiar are the many critiques, deriving so often from Laura Mulvey's seminal article "Visual Pleasure and Narrative Cinema" (1975), that tie this objectification to the sadistic male gaze, to the structure of filmic diegesis, and to the supposedly irredeemably phallocentric nature of the cinematic apparatus itself. Male bodies, too, are subjected to cinematic objectification, but an objectification that is effected by specific cinematic means geared to the male body and perhaps to the female spectator's assumed gaze. The specific nature of male objectification has not been very fully dealt with by critics and theorists, but does receive some treatment from Steve Neale in his article, "Masculinity as Spectacle" (1983). Taking his cue from Mulvey's analysis of the way women's bodies are objectified and made the object of the gaze, Neale also tends to take for granted the sadistic/masochistic doublet. His thesis is that, because of the power of the ritualized structures and relays of the (a priori) sadistic gaze in cinema, a male body must effectively be "feminized" by the apparatus and spectator if it is to become objectified. Dealing with the masochistic stage, he suggests that what occurs there is a "testing" of the male hero, analogous to the investigation of female protagonists in standard dominant Hollywood cinema: "Where women are investigated, men are tested" (16).

Neale's contention, that in order for the male body to be thus objectified it has to be "feminized," is open to question, not least because it relies upon a sweeping generalization (increasingly often doubted in Film Studies) about the conventions and the apparatus of cinema—namely, upon the argument that they are oriented primarily and perhaps exclusively to the male spectator and his processes of identification. Neale's argument is in a sense self-fulfilling, or at least circular. If it is first assumed that the apparatus is male, geared to a male heterosexual gaze, then any instance of objectification will have to involve the "feminization" of the object. However, instances of the erotic display of the male body are rife in contemporary film and media production, and can be shown to be geared to either male or female spectators (or both) in different contexts, in ways that do not conform to the conventional treatment of the female body. There exists a whole cultural production around the exhibition of the male body in the media—not just in film, but in television, sports, advertising, and so on—and this objectification has even been present throughout the history of Hollywood itself, while evidently having been intensified in recent years. Scarcely any of this plethora of images depend upon the feminization of the male; rather, the media and film deploy rather specific representational strategies to eroticize the male body.

In film, Eastwood's primary directorial mentor, Don Siegel, is perhaps one of the first Hollywood directors to have systematically foregrounded the display and the eroticization of the male body and to have turned that display into part of the meaning of his films. Siegel's films in this regard have developed a strong repertoire for dealing with the male body without deploying the particular formal strategies by which female bodies are offered to the male gaze in most Hollywood productions. That is, his work is often concerned with the activity and dynamics of all-male groups, and this concern has allowed the development of something like a cinematic obsession with the male body. Siegel's repertoire of shots and conventions, often duplicated in films that Eastwood directs, can be mined to produce a little semiotics of the heroized male body. Among his most frequently used devices are the following: what I call "under-the-chin shots," where the heroized male figure, shot most often from the waist up, seems to loom above the spectator's eyeline; heavily back-lit shots, in which either the details of hero's whole body or his face are more or less obscured while the general shape is given in silhouette; a preponderance of facial close-ups, in which the actor's gaze is directed from right to left at a roughly forty-five-degree angle, used especially often to deliver Eastwood's characteristic snarls and slight facial movements; and traveling shots and pans that follow the male body's movement in a relatively unsmooth motion, and usually avoid centering the body in the frame.

This is obviously a quite rough and schematic cataloging of the kinds of objectifying shots favored by Siegel, Eastwood, and later by other action-movie directors. But the point here is that these kinds of representational strategies (developed, I think, into something like an industry standard in the last two or three decades) differ from those chronically used to objectify the female body. There is, in other words, a specific and even ritualized form of male objectification and eroticization in Hollywood cinema.

Another of Neale's assumptions—that looking at the male body is something of a taboo in our cultures—is also contradicted by the kinds of strategies that action/Western movies typically make available to themselves. It might still be true, however, that eroticizing the male body ultimately produces a mixed pleasure. According to Willemen, "The look at the male produces [in the male spectator] just as much anxiety as the look at the female" (16). Certainly it is the case that such movies appear to take precautions against the possibility of such anxiety in particular ways. First and most important, the two-stage exhibitionist/masochistic process *must* always be followed by a narrative revindication of the phallic law and by the hero's accession to the paternal and

patronizing function of the third stage of the orthodox action-movie codes. Second (that is, less obligatory than the diegetic resolution), many of these movies accompany the pleasure/"unquiet pleasure" that they establish with a quite marked antihomosexual sentiment—which is to suggest that the masochistic moment is often crucially antihomosexual in its significance.

An example of this latter strategy can be found in the second Dirty Harry movie, *Magnum Force* (1973), in which the antagonists are a band of extremely right-wing young policemen, part of whose "evil" in the movie's terms is their implied homosexuality, their rather butch and leathery appearances, and their close homo-bonding. In movies where homosexuality is not actually imputed to the antagonists (that is, to those characters who are to inflict physical damage on the hero's eroticized body), their sexuality is usually offered as perverse in some other fashion: this is the case, for example, with Scorpio, the main antagonist in the original *Dirty Harry* (1971), who is marked as effeminate and perverse in different ways. In *Sudden Impact* (1983), there is an interesting melding of the two strategies: the leaders of the gang of rapists are, first, Mick, who in the motel scene is shown to be unable to conduct "normal" heterosexual relations, and second, Ray, the movie's "dyke," who procures Jennifer and her sister for the gang to rape and who also seems to have some heterosexual desires (for Mick), which the movie clearly presents as perverse.

Thus, even while these kinds of specifically masculinized representational strategies at the corporeal level are not a feminization of the male body, at the same time they do always carry with them a defense against possible disturbance in the field of sexuality. If it is actually allowed to show itself, this disturbance will always be ultimately annealed, covered over, sometimes literally blown away in and by the narrative frame. In what is perhaps the least well made of the Dirty Harry movies, *The Enforcer* (1976), the first mention of homosexuality comes signally in the final scene as Callahan blows away Bobby Maxwell with the Law's rocket and then mutters, "You fuckin' fruit." Clearly the function of such defenses is not confined to establishing the perversity and evil of the antagonist, but also designed to defend the picture from its having eroticized the male body in such consistent ways.

One particularly interesting text for the way it exhibits some of the strategies I am describing is the Siegel-Eastwood collaboration *Escape from Alcatraz* (1979). The first sequence of this movie, where Eastwood's character is brought as a prisoner into Alcatraz, is especially indicative of Siegel's concerns and his ways of working with the male body. In preparation for his incarceration at Alcatraz, Eastwood's character, Frank Morris, is first stripped and searched in the prison's reception area. The camera then follows his naked body through a kind of gauntlet of objectifying looks from the prison guards as he goes toward his cell. Those looks are intercut by Siegel's typical low-angle, under-the-chin shots of Morris's striding body. These shots are remarkable in that they do not correspond at all to the direction of any of the guards' looks; and similarly, the guards' looks are not used to construct the geography of the prison's space (this is done instead by means of a series of medium-length shots with Morris's body moving across the screen, but never exactly centered in it). Thus there is a disjuncture set up between the direction and function of the camera's look, and the direction and function of the guards' looks. In a more classical Hollywood mode, and in the objectifying passages where it is a question of a woman's body, these looks would normally reinforce each other. Here, the purpose of the lack of coincidence is to deny or defuse the homoerotic charge of this sequence while still producing a voyeuristic look at Morris/Eastwood: to both look and not look at this male body, then, is to engage in a quintessential fetishistic process.

This sequence is mostly classic Siegel—framing the male body as an eroticized but simultaneously disavowed object in a sequence where the central concern is the movement through a space, but a space that does not need to be extremely logically defined. The sequence finishes with a slightly more

unusual shot, as Morris is deposited naked into his dark, barred cell. There, shooting from the guards' side of the cell, the camera picks out Morris's sidelit torso and lingers on it. A storm in the background lights up Morris's stern face for a millisecond, but otherwise all we see is the chest and its musculature. Morris is depicted thus as a kind of threatening Gothic beast, as his shining body glistens in the darkness of its cage. The camera lingers over this final shot, both erotically regarding Morris's body and also clearly pointing out that body's larger-than-life potentialities, all the while prefiguring its inevitable "testing" later in the film.

This objectifying passage is quickly followed by the standard routine of destruction. Morris is variously assaulted by both inmates and authorities in the closed space of the prison. The moment of his worst torment comes at the hands of isolation block guards, and this acts as the catalyst to the acceleration of the movie's narrative line toward Morris's subsequent escape—and his escape will be from the masochistic moment as much as from the prison itself. The movie's final sequence has the prison governor wondering whether Morris and his fellow escapees could have survived the icy waters of San Francisco, while one of his officers muses that the men had vanished into air—the ultimate hypostasis of the heroic body.

As well as following the orthodox codes of the action narrative—objectification and eroticization, followed by near destruction and final hypostasization

of the male body—*Escape from Alcatraz* defends against the apparent per-versity and unquiet pleasure of the early stages by accompanying them with the standard antihomosexual component. After the opening sequence has suggestively turned the guards' policing looks into the dithering carriers of homoerotic objectification, the movie soon introduces a rather unpleasant homosexual inmate whose advances Morris rebuffs, setting himself up for a series of attacks and fights with this man who, predictably, ends up with a knife in his body before Morris escapes.

Further confirmation of the strength of these rather simple conventions is perhaps best given by way of the counterexample of Siegel's earlier picture, *The Beguiled* (1971), in which Eastwood/McBurney is recuperating from seri-ous battle wounds in a Southern girls' school. The Eastwood character's lechery toward some of the school's inmates leads to their punishing him by rather hastily (and probably unnecessarily) cutting off his wounded leg—an amputation that is explicitly referred to as a castration. This corporeal removal is the culmination of Siegel's transgression of the standard rules for this kind of movie: the path of objectification, destruction, then transcendence is not followed here. At least, things are not in their proper order. The damage to McBurney's body has already been sustained before the start of the movie, thus depriving the camera of any opportunity to run the usual objectification routines. Furthermore, there is no triumphant transcendence in the end: after the rushed amputation, McBurney's anger and accusations provoke the women and girls to murder him with poison.

Audiences for *The Beguiled* have never been large, and it remains one of the least successful movies with which Eastwood has been associated, despite his and Siegel's satisfaction with it. Siegel explains the failure by sug-gesting, "Maybe a lot of people just don't want to see Clint Eastwood's leg cut off."[5] Whether that is the case or not, the lack of success of *The Beguiled* underlines in a negative way the fact that Hollywood dramas have induced certain expectations about the masculine corporeal, and cannot readily break them: the exhibitionist/masochistic stages must serve the end of the hero's triumph, and they are inextricably part of the diegetic necessity. Another way of saying this might be to suggest that the masochistic stage of such narra-tives cannot be presented as a complete castration, and that the possibility of transcendence must always be kept available. The masochistic trope in this sense must be no more than a *temporary* test of the male body.

One familiar effect, of course, of the hero's more usual triumph over the deliquescence of his once-objectified body is the promotion of various

PAUL SMITH

metonymically associated notions of regeneration, growth, rebirth, sacrifice, reward, and so on. In that sense one could talk of these various tropes as mythical; we have a tradition of such narrative ideologies to which to appeal, including the traditional story of Christ's ascent after the crucifixion. Indeed, in much occidental cultural production the Christ-figure could be said to have operated chronically as a privileged figure of the pleasurable tension between the objectification and what I call the masochizing of the male body, and it is certainly no accident that so many of the films of the Western or action hero take advantage of references to that figure. Eastwood's movies—and especially his collaborations with Siegel—are rife with such references. Eastwood has starred in or directed several movies that make it an easily identifiable point of reference: *Pale Rider* (1985), for instance, in which he plays a priest; *Thunderbolt and Lightfoot* (1974), in which he is a pretended priest, and several shots allude to the crucifixion; or even *The Beguiled* itself, in which his role is explicitly linked to that of a long-suffering Christ, but in which there is no triumphant transcendence, only the death of his character.

Recent film scholarship has begun to investigate how the concept of masochism and its concomitant "unquiet pleasure" can be deployed in looking at the question of subjectivity (and especially male subjectivity) in filmic relations. One thinks immediately of the work of Kaja Silverman (notably *Male Subjectivity at the Margins*), Gaylyn Studlar (*In the Realm of Pleasure*), and Leo Bersani (*The Freudian Body*, which, while not concerned specifically with film, does address the cultural production of "art" in general).[6] Part of the point in each case is to attempt to complicate, and even undo to some degree, the rather monolithic view of male subjectivity that film scholarship tends to propose.

In their different ways, and with certain disagreements, each of these three writers proposes the masochistic trope, the masochistic moment, as in some sense subversive of conventional or "normal" formations of subjectivity. Bersani, for instance, sees masochism as a formation that disturbs the fixities of literary and visual language to produce a designifying moment, or a denarrativizing moment; more specifically, he reckons that it produces what he calls an "interstitial sensuality," responding to a reader's pleasurable "interpretive suspension between narrative and nonnarrative readings."[7] In a similar fashion, Silverman proposes masochism as a formation of suspension, though her preferred notion is that of "deferral"—masochism as a deferral of male submission beneath the Law of the Father and of the normative pressure of male sexuality. For her, this is indeed a large part of the definition of perverse sexuality, that it be set against the aim-directed "normality" of the male subject. The fully

consummated pleasure of the normal subject is associated with guilt, but the suspended, showy pleasure of the masochistic fantasy is disavowal of the paternal function, a sort of escape from it, and a way of punishing its imposition: "What is beaten in masochism is not so much the male subject as the father, or the father in the male subject."[8] Thus, in Silverman's account, the masochist "remakes the symbolic order, and 'ruins' his own paternal legacy."[9]

In these treatments of masochism as what I am calling a trope, there are considerable difficulties to be negotiated concerning the relation of theoretical schemas to textual matter, and equally to relations of reception. The assumption in what I have to say is that the filmic representations of masculinity act as a kind of demonstration of how masculinity is supposed to work (or, to put it another way, they profer particular meanings around the subject of masculinity and to the male subject). I want to stress here the process of narrativization in which a masochistic moment is but a part, a single element caught up in the machinery of the profering of significance. I want to avoid the temptation of implying that this demonstration forms male subjectivity in and of itself, or that it produces some unavoidable male spectatorial position. Film does have its interpellative effect, of course, but that does not mean to say that it inevitably or indefeasibly determines forms of subjectivity. Cinema is not, that is, simply the symptom of the spectator elaborated, as it were, elsewhere. In other words, I see some kind of disjuncture between representation and subject positions that many film theorists still do not. While allowing for direct spectatorial identification, and thus for the cinema's proffering of subject positions, I dare say that investigation of the representational strategies of film is finally capable of discovering more about the availability of cultural ideologies than about forms of subjectivity.[10]

With such provisions in mind, it becomes difficult to accept entirely the claims of Bersani and Silverman. Each of them exploits the notion of masochism as a perversion in order to suggest that it subverts, undermines, defers, or invalidates the phallic law and the fixities in both subjectivities and meanings that depend upon phallic law. Silverman perhaps summarizes this position best in her claim that the male masochist:

> acts out in an insistent and exaggerated way the basic conditions of cultural subjectivity. . . . [H]e loudly proclaims that his meaning comes to him from the Other, prostrates himself before the gaze even as he solicits it, exhibits his castration for all to see, and revels in the sacrificial basis of the social contract. The male masochist magnifies the losses and divisions upon which cultural identity is based, refusing to be sutured or recompensed. In short, he radiates a negativity inimical to the social order.[11]

PAUL SMITH

Silverman theorizes, then, that male masochism is in itself an oppositional formation. But if, to paraphrase Judith Mayne, we submit the theory to the test of narrative,[12] or investigate the function of the masochistic moment in representational practice, it might be seen that the "inimical" nature of masochism and the pleasurableness of its self-proclamation can be sustained only provisionally: that, in other words, popular cultural narratives in effect enclose and contain male masochism.

This proposition is not, I think, contradicted by Freud's discussion of masochism. In his paper "The Economic Problem in Masochism" (1924), in which he ostensibly deals with the economic system of masochism, Freud is led to quite firmly narrativize the phenomenon.[13] Its etiology is in what he calls erotogenic masochism, "found at bottom in the other forms": *feminine* masochism and *moral* masochism. Erotogenic masochism, the lust for pain, is for Freud the homeostatic result of a negotiation between the libido and the death drive, which he describes at length in *The Ego and the Id* (1923).[14] The relative stability of the outcome of this negotiation provokes exactly the narrative dramas of the feminine and moral forms of masochism. Strict distinctions between these two latter forms are not especially important for my purposes here. But what is common to Freud's explanation of both is the claim that they are exhibitionist and in a sense histrionic, the exhibitionism and the drama being designed to provoke punishment. The punishment most readily comes (particularly in moral masochism) in the shape of "sadistic conscience" or in an intensification of superego activity. Masochism for Freud, then, is characterized by the need of the subject to "do something inexpedient" in order to bring down upon itself the gratifying punishment of the superego. The point I mean to stress here is that masochism's "negativity" is largely a functional catalyst in a formulaic narrative of erotic gratification.

This narrativized context for masochism might need to be considered alongside Silverman's claim for the negativity of male masochism, and for the subversive potential of "bringing the male subject face to face with his desire for the father" through the masochistic moment.[15] One would certainly not want to reject Silverman's particular project as a viable way of articulating radical moments of male subjectivity; but alongside it, one might also have to take account of how, in popular cultural texts, the place of the exhibitionist/masochistic is already accounted for, and already pulled by narrativization into a plot precisely designed to eventually explode the negativity of masochism.

Indeed, it might even be worthwhile to make the rather more wide claim that in fact (that is, in a narrativized frame) the male masochist importantly obeys

and serves the phallic law. Masochism (to paraphrase Lacan) is primarily a neurosis of self-punishment, partly because of the way it has of entailing or invoking the superego's revenge, the return of "sadistic conscience." The masochistic moment certainly promotes deferral and suspense, but a suspense that can work only if it is in the end undone. Male masochism is at first a way of not having to submit to the law, but, equally important, it turns out to be a way of not breaking (with) the law, either. Masochism might well bespeak a desire to be both sexes at once, but it depends upon the definitional parameters of masculinity and femininity that undergird our current cultural contexts.

Male masochism might, finally, be seen as another way for the male subject to temporarily challenge his desire for the father and to subvert the phallic law, and as ultimately another step in the way (might one even say the puerile way?) of guaranteeing the male subject to be the origin of the production of meanings.[16] Indeed, it might be said that male masochism is a kind of laboratory for experimenting with those meanings to which ultimately we accede. The rules of masochism are, then, primarily metaphorical, and the game is a game played out unquestioningly in the thrall of the symbolic; crucially, the lessons of masochism do not last, they come and are gone, forgotten as part of the subject's history of struggle in learning how to triumphantly reach symbolic empowerment. Masochism, grasped in this way, would be a closed space where masculinity sets the terms and expounds the conditions of a kind of struggle with itself—not a struggle necessarily for closure, but a struggle to maintain in a pleasurable tension the stages of a symbolic relation to the father—a struggle in which, ironically, the body becomes forgotten.

The pleasure profered in action movies can be regarded, then, not so much as the perverse pleasure of transgressing given norms, but as at bottom the pleasure of reinforcing them.[17] This is where the narratives of such movies can be justifiably dubbed conservative: they marshal a certain identificatory pleasure into the service of a triumphalist masculinity by employing a process girded around and endlessly reproduced by the narrative conventions of Hollywood and its country's cultural heritage. But even in the most conservative and rigid kind of cultural production, there is an underside, a double edge or a residue. In this instance, something is continually being fended off in this procession. What is common to many of the action movies and Westerns of the sort Eastwood makes is the way in which the exhibition-masochism trope and its pleasure/unquiet pleasure, along with their resolution into a triumphalist view of male activity, reside alongside a residual, barely avowed male hysteria.

That hysteria is often expressed narratively as the sensation of the dangers inherent in identification with women or with homosexuals (of both genders), or else it is a hysterical formation that can be glimpsed in moments of incoherence or powerlessness in the male body and the male presence. Sometimes it is only barely visible in the joins of the text as it produces its apparently seamless cloth. The hysterical moment I am stressing marks the return of the male body out from under the narrative process that has produced what appears to be its transcendence, but that in fact is its elision and its forgetting. In other words, although there is in these movies a conservatively pleasurable narrative path which finishes by suppressing the masculine body and its imaginary, the body nonetheless returns from beneath the weight of the symbolic. What I mean to point to as this hysterical residue, then, is an unresolved or uncontained representation of the body of the male as it exceeds the narrative processes.

The meanings generally profered by these movies concern the male body as that which has to be repressed. This of course sounds paradoxical to say, given the way these movies produce also an apotheosis of masculinity in the serviceman hero. But a simple instance of what I mean can be glimpsed at the climactic moments of any of these action movies, where the male protagonist's control of the narrative situation is never matched by control of his own body. The body here is always represented as de-eroticized, turned into a mass of mere reflexes. The male access to control is clearly marked as a symbolic or metaphorical matter, a process of forgetting the body, forgetting the previous stages of eroticizing and masochizing the body. And yet the body is still there, still in the field of representation, but no longer subject to the somatic meditation that the narrative has thus far constituted.

In warding off this hysterical residue, suffocating its somatic presence with the safe and deferrable pleasure of the symbolic, the male heroic text itself becomes hysterical. In the case of *Sudden Impact*, *Tightrope* (1984), or *The Gauntlet* (1977), there is an explicit alliance on the part of the male protagonist with what is presented as the strength of femininity and women's voices and presence. Such alliances are always finally negated in the narrative, in the sense that the women involved finally have to be pulled beneath the law (even when the law is the male hero's own version of justice) and have their independence replaced by a traditional, disempowered status in relation-(ship) with the male protagonist. And yet they leave their marks on the experience of the movie.

Some of these marks can readily be seen in one of Eastwood's later movies, *Pink Cadillac* (1988), directed by Buddy Van Horn. The female protagonist,

Lou Ann (played by Bernadette Peters), is the target not only of the Eastwood character, Tommy, a bail bondsman, but also of the neofascist "Birthright" gang, whose money she has inadvertently stolen. Before meeting her, Tommy has been a somewhat happy-go-lucky character, known for his histrionic modes of trapping his quarry. For instance, the film opens with him trapping one man by calling on the telephone and pretending to be a deejay for a country station giving away a date with Dolly Parton. Later he arrives in a limousine and livery to complete the act and capture the man. Or else, as the surprise ending to a rodeo scene, Tommy turns up as the rodeo clown to handcuff the winning rider. In terms of the narrative line, these early manifestations of Tommy's motile and protean body act as the scattered instances of his personal and somatic irresponsibility.

It is precisely his changeable body that will be pulled into a different consistency by the end of the movie: he will have made his alliance with Lou Ann, rescued her baby, held hostage by the Birthright, and driven off with her to make plans for a business alliance that will consolidate their personal one. Along the way, his protean abilities are displayed in at least a couple of other set pieces: one where he dresses up in a gold-lamé jacket, puts on a mustache, and effects a Wayne Newton voice, getting into a chase scene where his aging body is made to look ridiculous; and another where he acts as a potential redneck conscript for the Birthright, gaining the confidence of the gang members by putting on a rictus grin and chewing and spitting tobacco, ending the scene with a comic forced swallowing of a rather-too-large wad of tobacco.

These hysterical manifestations of the Eastwood body here are, of course, the comic counterpart to the violent testing of the body that occurs in the action movies. Importantly, however, they are placed similarly into a direct relation with the man's alliance with the transgressive woman. At a crucial moment in the formation of this alliance, the Tommy role provides Eastwood with the opportunity to give one of his most egregious performances: for a number of lines he effects a woman's voice and flutters his eyelids in mimicry of some notion of femininity. Immediately after this, their alliance is sealed at the point where Lou Ann says that she's going to take "no more shit from men," and he responds—in the context, gratuitously and even mysteriously—"That's one thing we have in common. I'm not gonna take no more shit from men."

The alliance leads to his straightening up, as it were, on the way toward becoming the serviceman, the future father for her child, and future partner. Lou Ann's effect, then, in the movie is to provide the place where the body that is out of control can finally find repose. In the meantime, the memory of the

Eastwood body remains untouched: the old panting body that runs around in a gold jacket with its mustache hanging off, the contorted face of the redneck as he almost chokes on his tobacco, the wildly fluttering eyelids of the man impersonating a woman.

It is perhaps to overread to suggest that all these moments are symptoms of the loss of control of the male body. They are, after all, at one level clearly just scripted opportunities for Eastwood to show off the supposed range of his acting abilities. At the same time, they are significant for the way in which the male body appears there as excessive—or, another way of reading it, as defective in relation to the image to which it aspires at the narrative's end. Equally, they are significant for their relation to the woman whose transgressive character is finally reined in along with the male body.

As I have suggested, these symptomatic moments are a comic analogue to the action movie's masochistic moment, but they themselves remain masochistic in their histrionic and exhibitionistic qualities, which foreground the contortion, indignity, and even the aging of the Eastwood body. If the masochistic trope colludes with and finally reverts to narrative closure, such hysterical registrations remain as part of the history of the male body, and are left floating, uncontained, and untranscended by the narrative. What the hysterical, in this sense, bespeaks or figures is something that in my article "Vas" I have called (paradoxically enough) "the unsymbolizable of male sexed experience."[18] That article is an attempt to point out and begin to explore the male imaginary and its registration of both the body and the lived experience of male sexuality. It is generally understood in psychoanalytical theory that repression in the male subject seems to prohibit the speaking of the male body, to block its symbolization. The hypothesis entertained in "Vas" is that, in reality, repression is never complete, and that some part of male somatic experience remains to be registered: this is the strictly unsymbolizable body, a body reduced to figuration outside the schemas of the phallic organization of the symbolic. This body is then left to be figured in ways that I call hysterical.

My most general claim here, then, is that, in the cultural production of this phallocentric society, masculinity is represented first of all as a particular nexus of pleasure. That pleasure is produced in these films through a specific mode of objectifying and eroticizing the male body, and is fortified by a series of operations on that male body that, while they have the trappings of a resistance to the phallic law, are in fact designed to lead the male subject through a proving ground toward the empowered position that is represented in the Name of the Father. Masochism is, in a sense, a metonym for another frequently deployed

masculinist trope—the fun of the chase, where the hunter momentarily puts aside his innate advantages in order to intensify and elongate the pleasure of the exercise.

Within such a representational framework, something escapes or is left unmanaged. The hysterical is what always exceeds the phallic stakes, what jumps off. The hysterical is marked by its lack of containment, by its bespeaking either the travails or the pratfalls of a body, and by its task of carrying what is strictly the unsayable of male experience. That is, what escapes the terrible simplicity of male heterosexual experience and the crude simplicity of homocentric narratives is always something that cannot or should not be represented or spoken. In that sense it is rather apt that Eastwood has become popularly known primarily for the silence of his acting performances and for the sheer presence of his body. And it is remarkable, too, that many of his films explicitly produce and locate that image of himself in a close alliance with femininity.

Eastwood's films tend to arrest themselves, as I suggested before, in the specific gratifications of that place for longer than most other movies would dare. The generous reading of this would be to say that, while they are in that sense predictably unsubtle popular responses (albeit rather belated ones) to the impact of feminism in this culture, they do concern themselves with the difficult task of representing masculinity at the hysterical moment of its potential depriviging, and even at the moment of the deliquescence of masculinity's body (Eastwood was nearly sixty years old when he made *Pink Cadillac*). These movies certainly do not represent an escape from the kind of masculinity that infuses the older ones, like the first Dirty Harry movies, but they can at least be said to attempt to play out that masculinity in relation to femininity. These are not, ultimately, movies that will encourage any radically new male subjectivities, but written across them, in the shape of Eastwood's hysterical body, are the silent signs of what might best be described as a coming out.

Those signs have the function, too, of pointing up the lure of the orthodox codes, where the pleasure of masculine representations is given as essentially and intrinsically bound up with the three-stage shift from objectification to masochism to empowerment. The central masochistic moment is thus a kind of necessity in the conservation of norms of male sexuality within the discourses of popular culture; it represents a way of structuring into the full subjectivity of the egoistic hero a resistance, a way of beating the father to within an inch of his life before replacing him or allowing him to be resurrected, and finally doing things just as well as he can. In this sense the masochistic moment, girded by its moments of pleasurably perverse display and exhibition, serves

a quite orthodox version of the masculine confrontation with the father. But this also means that the masochistic moment is *temporary*, a kind of trial, a rite of passage that we men know we have to go through but that will not take all our energy. What is crucial about it (to me, at any rate) is the way it so often seems here to be less a question of how we might negotiate our sexuality in lived experience, and more a question of how symbolic dramas are channeled and recuperated. Much more on the edge, more outlandish, than this masochistic nexus is the hysteria of being unable to be in control, the sheer excess of the body itself, and the hysterical symptoms we have written on our bodies—symptoms that no ironically masochistic regard for ourselves can completely erase.

NOTES

1. Andy Metcalf and Martin Humphries, eds., *The Sexuality of Men* (London: Pluto Press, 1985), p. 1.

2. See Ann Douglas's remarks on Natty Bumppo in her book *The Feminization of American Culture* (New York: Anchor, 1988), p. 346.

3. Paul Willemen, "Looking at the Male," *Framework*, no. 15–17 (1981): 16.

4. Ibid.

5. Don Siegel, quoted in Stuart Kaminsky, *Don Siegel* (New York: Curtis, 1974), p. 251.

6. Kaja Silverman, *Male Subjectivity at the Margins* (New York: Routledge, 1992); Gaylyn Studlar, *In the Realm of Pleasure: Von Sternberg, Dietrich, and the Masochistic Aesthetic* (Urbana: University of Illinois Press, 1988); and Leo Bersani, *The Freudian Body: Psychoanalysis and Art* (New York: Columbia University Press, 1986).

7. Bersani, *The Freudian Body*, p. 78.

8. Silverman, *Male Subjectivity at the Margins*, p. 211.

9. Ibid., p. 212. Studlar, in *In the Realm of Pleasure*, also investigates "the masochist's disavowal of phallic power" in her readings of some of the Von Sternberg/Dietrich collaborations, such as *Blonde Venus*. Unlike Silverman, however, she is concerned to use masochism as a way of intellectually displacing the phallic schemas which so much film theory assumes. Although one has considerable sympathy with such an effort, Studlar's is insufficient insofar as she is led to posit masochism as a kind of ur-sexuality in which sexual difference is ultimately elided. The masochistic turn, in her version, does more than push toward denarrativization, as in Bersani, but actually *desexualizes* insofar as the privileged figuration of masochism becomes the androgyne. This leaves Studlar with the unfulfilled task of explaining how and why sexual difference emerges. Indeed, her way of taking masochism back to the pre-Oedipal does seem to assume the Oedipal: thus masochism serves the function of countering something which by rights it should make impossible, that is, the phallic schemas of sexual difference. Kaja Silverman's brief argument against Studlar seems right: she writes that Studlar's "is a determinedly apolitical reading of masochism, which comes close to grounding that perversion in biology." Silverman, *Male Subjectivity at the Margins*, p. 417n.

10. This is obviously a schematic rendering of a longer and probably contentious set of arguments about the relation between text and subject position. Some more formal version of these positions can be

found in my Discerning the Subject (Minneapolis: University of Minnesota Press, 1988). The word *profer* is a conflation of—or perhaps a pun on—the English words *offer* and *prefer* and the French word *proférer* (to utter). The conflation suggests, then, that the text offers the reader preferred meanings.

11. Silverman, *Male Subjectivity at the Margins*, p. 206.

12. To be precise, Judith Mayne ends her article, "Walking the 'Tightrope' of Feminism and Male Desire," in *Men in Feminism*, ed. Alice Jardine and Paul Smith (New York: Methuen, 1988), with the following claim, from which I have extrapolated here: "But there is a fit between theory and narrative, and the intersection of feminism and male desire needs to be thought, and rethought, by submitting theory to the test of narrative" (p. 70).

13. Freud, "The Economic Problem in Masochism" (1924), *The Standard Edition of the Complete Psychological Works of Sigmund Freud*, trans. James Strachey (London: Hogarth Press, 1954), vol. 19, pp. 157–72.

14. Freud, "The Ego and the Id" (1923), *Standard Edition*, vol. 19, pp. 3–66.

15. Silverman, *Male Subjectivity at the Margins*, p. 204.

16. My point here is somewhat akin to that of Parveen Adams in her brilliant essay "Of Female Bondage," in T. Brennan, ed., *Between Feminism and Psychoanalysis* (New York: Routledge, 1990): "Think of the masochist in particular; though he may appear as victim he is in fact in charge. He is the stage manager in charge of the scenery, the costumes and the roles" (p. 253).

17. A similar kind of critique of the use of the trope of masochism comes in Tania Modleski, *Feminism Without Women: Culture and Criticism in a "Postfeminist" Age* (New York: Routledge, 1991), especially the chapter entitled "A Father Is Being Beaten." Modleski seems to me correct in her sense that the fashionable deployment of male masochism encourages the secret reimportation of the father, rather more than it produces a feminist masculinity. She suggests that the masochistic project will be "doomed to failure, from a feminist point of view, unless the father is frankly confronted and the entire project of abjection and the law worked through; otherwise . . . the father will always remain in force as the major, if hidden, point of reference—and he may in fact be expected at any time to emerge from hiding with a vengeance" (p. 70).

18. Paul Smith, "Vas," *Camera Obscura*, no. 17 (1988): 31–66.

BELL HOOKS

DOING IT FOR DADDY

When feminist thinker Phyllis Chesler published *About Men***, she**
included a short narrative that has always lingered in my imagination. It con-
cerns Charles Manson and the women who were sexual with him. The story is
that one of the women was interviewed and asked to share what it was like to
fuck him. She replied: "He said, 'Imagine I'm your father.' I did. I did. And it was
very good." This is a story that I have told many times since first reading it. I
have never returned to the book to find if my memory is accurate. This story
delighted me because it reveals quite innocently the extent to which patriarchy
invites us all to learn how to "do it for daddy," and to find ultimate pleasure, sat-
isfaction, and fulfillment in that act of performance and submission.

I thought of this story again recently when I was reading *USA Today*. In the section that brings us the top stories from around the nation was this report from Birmingham, Alabama: "The Jefferson County Commission voted not to remove a courthouse mural of a white female plantation owner, looming over black men picking cotton." No doubt the white woman in this mural is also "doing it for daddy," performing an act of domination that she hopes will win his approval and love.

In white-supremacist capitalist patriarchy, black males and white females are uniquely positioned to compete with one another for the favors white "daddies" in power can extend to them. If the individuals from these groups should fail to understand either their connection to one another or their position in relation to white patriarchy, they are bombarded by mass-media images within the pedagogy of popular culture that consistently remind them that their chances of receiving rewards from the patriarchal mainstream and their hopes for salvation within the existing social structure are greatly enhanced when they learn how to "do it for daddy."

Thinking about the place of black men in the existing social hierarchy, I became fascinated by images of black males in popular culture that represent them as not only eager to "do it for daddy" but, even more, as individuals tortured by what I call "unrequited longing for white male love." For the most part, black males do not represent themselves in this manner. They are represented in this manner by white cultural productions, particularly in television, film, and advertising. The colonizing culture's manipulation of representation is essential for the maintenance of white-supremacist capitalist patriarchy. Representations that socialize black males to see themselves as always lacking, as always subordinated to more powerful white males whose approval they need to survive, matter in white patriarchy. Since competition between males is sanctioned within male-dominated society, from the standpoint of white patriarchy, black masculinity must be kept "in check." Black males must be made subordinate in as many cultural arenas as possible. Representations that socialize black males to embrace subordination as "natural" tend to construct a worldview where white men are depicted as all-powerful. To become powerful, then, to occupy that omnipotent location, black males (and white females) must spend their lives striving to emulate white men. This striving is the breeding ground among black males for a politics of envy that reinforces the underlying sense that they lack worth unless they receive the affirmation of white males.

Two recent films that depict this structure of competition, envy, and black male desire for white male approval are *The Pelican Brief* (1993), directed by

Jo Anne Callis, *Still Life with Ice*, 1981.

Alan J. Pakula, and *Philadelphia* (1993), directed by Jonathan Demme. In *The Pelican Brief*, Julia Roberts, one of Hollywood's leading white, female sex symbols, shares top billing with Denzel Washington, "the" black, male sex symbol. She plays a law student who, as one ad tells us, "writes a legal brief theorizing her ideas of who murdered two Supreme Court Justices"; he plays a *Washington Post* reporter. Initially, the movie focuses on the relationship between Roberts's character and the white male she loves, her former law professor. Significantly, he is positioned as her superior. She admires him, and longs to save him from the alcoholism that is destroying his life. When, as the ad announces, "her brief hits the top levels of government, she must run for her life." Attempting to murder her, the powerful, patriarchal, white government officials kill her lover. Her mission then becomes twofold: she must expose those who murdered the Supreme Court Justices and she must avenge the death of the "good" white patriarch.

Initially, the ads for this film showed a huge image of Julia Roberts's face with Denzel Washington's image in the background. Washington's public-relations agents threatened to withdraw him from the film if the publicity images were not reshot to portray the two stars on equal footing. Since this issue had not been raised by the backers, producers, or directors of *The Pelican Brief*, the need to distinguish the status of the two characters was, presumably, a concern of advertising. Ads are a primary vehicle for the dissemination and

perpetuation of white-supremacist and patriarchal values. Think about how many ads you see in magazines or on television that depict a white, hetero-sexual couple engaged in some "fun" activity while a lone, black, male friend looks on with longing and envy. The message that the ad for *The Pelican Brief* intended to send was that the leading, white, woman star in this film would not be following the usual Hollywood romantic setup, and doing it with the leading man. To put it vulgarly: the pure white madonna would not be fucking the angry black beast. Even the reshot ad was constructed to make it clear that the two stars would not be a couple. And throughout the film, their bodies are care-fully positioned to avoid any contact that could be seen as mutually erotic. Audiences can only wonder what went on behind the scenes during the shooting of this film. Did the director constantly remind the actors that their characters were just working together, that Denzel Washington's character should express a covert romantic interest but that the white female lead must always appear completely devoted to the patriarchal ghost of her white male lover? Both characters are depicted as completely allied with the existing social structure of white-supremacist capitalist patriarchy. They are in it togeth-er, to uphold law and order, to reinforce the values corrupted by evil, greedy, white patriarchs—they are on the side of the "good" white men, whom the system destroys. They vindicate daddy, without in any way questioning his right to remain superior, even in death.

While Roberts's character is initially surrounded by white friends and lovers, Washington's character is the lone, black, male body in a world that is all-white. He longs to succeed in that world, to be the best at this job, to excel. Portrayed as always pandering to the needs of his white male boss, pleading with him to trust him, Washington's character is a perfect image of the black male working overtime to assimilate into mainstream, white, male patriarchy. Of course, part of what makes his character "acceptable" is that he is not threatening to change the system; he is working hard to uphold the values of the existing social structure. There is an underlying insistence throughout the film that no other system could be as good. The film never makes explicit the reasons Washington's character is willing to risk his life to save both the white woman and the white, male-dominated system. The underlying assumption is that he commits to this because he worships, admires, and loves white patri-archal power. He longs both to occupy the power position and to possess the white goddess who is the prize. Significantly, Washington's character is the "good" black man. He not only accepts his subordinate status, he testifies on behalf of and exults in white male superiority. Since he is never portrayed as

belonging to a "black" community, with family, friends, or lovers, his very exis-
tence depends on white affirmation. This imagery reproduces the narrative
of colonialism. The servant/slave has eyes only for the "master." No doubt
this is why Washington's character shows no romantic interest in the white
female hero. He is merely protecting. To make it clear that these two are not
together, the film ends with a caring farewell. After her value is affirmed by
Washington's character, we see the white goddess resting triumphantly on her
symbolic throne—a beach chair. Denzel's character, mind you, is still on the
job, working hard to uphold the patriarchal status quo. But she is rewarded by
leisure, by dominion over a little kingdom somewhere (could it possibly be in
the Third World?), where she can reside in comfort, her needs taken care of
by invisible others. Washington's character advances in his career. And Big
Daddy, his boss, is pleased. Affirmed by the white patriarchal world, he is ready
to work overtime once more to win daddy's love.

Sadly, this representation of black masculinity surfaces even when
Hollywood shifts its usual white patriarchal focus and portrays a gay white male
grappling with the issue of AIDS in the workplace. Until he becomes ill, the cor-
porate lawyer that Tom Hanks plays in *Philadelphia* is in every way one of the
white-supremacist capitalist patriarchal boys—seeking to rise in the hierarchy.
Homosexuality, this film suggests, is not a stumbling block that will impede his
success; AIDS is the barrier the Big Daddys of this film will not cross. Powerful,

white, patriarchal men are not presented as horribly homophobic in this film. The individual who most expresses antigay sentiment is the black lawyer, played by Denzel Washington. Yet somehow, when the sick, unemployed, white male comes to his office demanding support, Washington is won over. His homophobia disappears. Just as *The Pelican Brief* depicted the benevolent, white, male patriarch as "tragic," *Philadelphia* depicts the corporate, white, gay male as vulnerable, as tortured by the system. He is made to appear more noble, more generous than other white men. A social liberal, he has a Hispanic lover, who is portrayed as living only to be the little mammy, taking care of the great white man. Both of these films represent black males and other men of color as acceptable, even lovable, only when they are willing to drop everything in their lives and care for the well-being of "superior" white men. There is nothing in the script of *Philadelphia* that even hints at what would lead Denzel Washington's character to divest himself of his homophobia, and take time away from his wife and newborn baby girl to work overtime defending the Tom Hanks character. The implication is that "good" white males are inherently worthy, deserving of care, and, of course, always superior to black men in their values and actions, even when they are sick and dying.

Images representing black masculinity as based on an unrequited longing for white male love were the stock-in-trade of the television show *Tarzan*. As a child growing up in the segregated South, I would often overhear grown black men expressing their disgust with the *Tarzan* narratives, with the loving devotion the "primitive" black male gave the white male hero. This television show reminded its viewers that even in black nations, on alien soil, the white male colonizer had superior skills and knowledge that were immediately recognized and appreciated by the natives, who were eager to subordinate themselves to the white man. The "bad" black natives who refused to worship white masculinity were often in the roles of kings and queens. Of course, their leadership was corrupted by greed and lust for power, which they exercised with great cruelty and terrorism. Tarzan, the great white father, used his omnipotent power to displace these "evil" rulers and to protect the "good" docile natives.

Representations colonize the mind and imagination. In his essay "White Utopias and Nightmare Realities," Henry Giroux discusses the distinction between the old racism, which relied on biology and science to reinforce white-supremacist thinking, and the new racism, which suggests that racial difference should be overcome even as it reaffirms white power and domination. "Dominant groups are now driving very carefully over a cultural terrain in which whiteness can no longer remain invisible as a racial, political, and historical

construction," he argues. "The privilege and practices of domination that under-
lie being white in America can no longer remain invisible through either an
appeal to a universal norm or a refusal to explore how whiteness works to pro-
duce forms of 'friendly' colonialism." Representations of black males that
portray them as successful yet happily subordinated to more powerful white
males break with the old stereotypes of the lazy darky. The neocolonial black
male is reenvisioned to produce a different stereotype: he works hard to be
rewarded by the great white father within the existing system.

Another fine example of this politics of representation can be see in the
movie *Rising Sun* (1993), which stars Wesley Snipes and Sean Connery.
Snipes's character is a pupil to the powerful, patriarchal, white father, yet "out-
cast" from his own black peer group. In his secondary role, the subordinated
black man not only happily does as the master orders him, always eager to
please, he even falls in love with the Asian woman daddy has cast aside.
Socializing, via images, by a pedagogy of white supremacy, young whites who
see such "innocent" images of black males eagerly affirming white male supe-
riority come to expect this behavior in real life. Black males who do not
conform to the roles suggested in these films are deemed dangerous, bad,
out of control—and, most importantly, white-hating. The message that black
males receive is that, to succeed, one must be self-effacing and consumed by
a politics of envy and longing for white male power. Usually black males are

represented in ads and films in solitary roles, as though they lack connection and identification with other black people. These images convey that this estrangement is necessary for white acceptance. Even though some films, like *Lethal Weapon* (1987) and *Grand Canyon* (1991), portray the secondary black male hero with a family and a community, all the black folks follow his patriarchal lead, and worship at the throne of whiteness.

When these images of homosocial bonding between white and black males converge with images of black male and white female competition for daddy's favor, a structure of representation remains in place that reinforces white-supremacist patriarchal values. Two different images in recent issues of *Vogue* and *Us* share the convention of a staged competition between a white female and a black male. In an *Us* magazine cover story about Drew Barrymore (May 1994), one full-page photograph shows her naked to the waist, wearing only a dark bikini and a boxing belt, and with boxing gloves covering her breasts. Behind her stands a dark-skinned, black, male boxer, whom she has presumably displaced, taking his role and position in the arena. He stares off into space with a look that *Us* says conveys "attitude, displeasure, hardness." Both figures are looking off into the distance, their gaze focused on someone else. Traditionally, boxing was a sport wherein notions of racial superiority were played out in the physical realm, to see if white men were physically superior. Though established to reinforce white prowess, boxing became an arena in which black males triumphed over white patriarchy, using the standards to measure superiority that that system had put in place.

Coincidentally, the June 1994 issue of *Vogue* magazine featured an advertisement that showed a tall, blonde, white model punching a young, black, male boxer. The text alongside the ad offered this story line: "Going for the knockout punch in powerfully sexy gym wear." Like the image of Drew Barrymore, this ad suggests that black males must compete with white females for white patriarchal power and pleasure. And they both suggest the white female has an edge on the black male because she can be sexually alluring; she can win, through "pussy power," in the heterosexual patriarchal arena. These images, and others like them, suggest that white females and black males should not be disturbed by racist sexist hierarchies that pit them against one another, but rather that they should enjoy playing the game, reaping the rewards. Both remain "objects" in relation to white male subjectivity. They share the politics of envy and longing for white male power. Represented as upholding the existing white-supremacist capitalist patriarchy, they appear content and satisfied.

In most movies, the black male protagonist is clearly depicted as hetero-sexual. However, many ads that portray black males (particularly those that show them as the lone black male amid a group of white males engaged in homosocial bonding) leave ambivalent the issue of sexual practice and prefer-ence. Black, gay, male cultural producers, both in film and photography, have been the group most willing to speak about the politics of envy and longing that characterizes some black male responses to white masculinity within the cul-tural context of white-supremacist capitalist patriarchy. Filmmaker Marlon Riggs explored this issue in his documentary, *Tongues Untied* (1989), and Isaac Julien did the same in his short piece, *This Is Not An AIDS Advertisement, This Is About Desire* (1992). Following their lead, Thomas Harris's video, *Heaven, Earth, and Hell* (1993), is an honest interrogation of that interracial sexual border crossing that is informed by feelings of both black, male, racial inferiority and longing for white male affirmation and love. In his series *Confessions of a Snow Queen*, photographer Lyle Ashton Harris offers yet another critical look at that longing for white male affirmation and approval that emerges as an expression of the politics of white supremacy, and how those politics are played out in black life.

While these black gay males seek to interrogate, counter, and subvert con-ventionalized representations in mainstream mass media, black masculinity continues to be represented as unrequited longing for white male love. Since there is little public discussion about the way in which existing popular repre-sentations of black masculinity serve to reinforce and sustain the existing structions of domination, these images are reproduced again and again. Countered primarily by mainstream constructions of the conventional racist/sexist stereotype of the black male as bestial primitive destroyer, these images work together to censor and suppress any complex representation of black masculinity. Until we start naming what we see, even if it is not a pretty picture, and following that articulation with strategies and practices for chal-lenging and changing the image, we will all be trapped in a scenario where we do it for daddy.

MICHAEL TAUSSIG

SCHOPENHAUER'S BEARD

Dedicated to Leslie Camhi, who said the night before last that she
knows more about masculinity than I ever will.

. . . at which point I have to wonder what sort of "knowing" this or
that might be and go on to wonder at what it takes to derail ritual collusion and
see the familiar strangely, let alone change it. I have to ask myself, what sort of
"knowing" is this? Can we destroy only as creators?

"Only as creators." Not so easy. Would that we could, in naming, change.
And so it has been, a rampage in estrangements, confessions, hard cases vil-
ified, ironies ironized, targets targeted, and the ripple of mirth unseating these
poor masculines, these terrible masculines that storm and rage, in an infinitude
of guises, at one moment, and one whopping singleness at the next. Which

Photograph from the French expedition Tierra del Fuego, 1882.

perforce brings me to masks, and the greatest show on earth, by way of Shopenhauer's beard, a great mediation, if not meditation, the great mediation, as we shall see, between essentialism and construction.

Schopenhauer asked: "Why do men have beards?" And the answer he supplied was that the beard served as a mask, necessary for defense against women, who, by nature, are skilled in the arts of deception, which is to say, acting, dissimulation, lying, secrecy, and mimicry, to mention but the first associations that effortlessly spring to mind.[1]

Now, this matter of the beard hits the nail on the head, for in its brief compass lies a worldwide mythology of great complexity with, perhaps, some hints as to how one might create new masculines, presumably in shows other than the greatest show on earth.

And speaking of the head, let us look into this face a little longer, bearded or not, and wonder how it serves for so many people as both window to the soul and mask—and how, as such, in its unthinkable doubleness, the perfected instrument of force and fraud is no less than the public or open secret—that which is known but cannot, for one reason or another, be articulated, and is thus the very stuff of social life.

Further, just to warm up, consider the symmetrical opposition of the face as sign and instrument par excellence of the public secret, in contrast to the genitalia as that which is publicly known but generally concealed—as contrasted

with the face as that which is the most blatantly exposed part of the modern body so as all the better to function as a mask. Yet, like the face, the genitalia can be thought of as a window to the soul, too, it being the blush, in light-skinned people at least, that uncontrollable ascent of blood to the face wrought by the shame of exposure, that brings the otherwise symmetrically opposed face and genitalia together. And of course, for many of us, it is the blush that, in seeing, we pretend not to see. Yes! What sort of "knowing" is this?

Which brings me, perhaps blushing, to some landmarks in the story of this beard, beginning with a professor of biology from the University of Melbourne and with the Alice Springs postman, a man of Irish extraction, traveling through Central Australia at the end of the last century. They will soon be writing one of the most famous ethnographies ever, one that will form the basis for another professor's great book of theory published in far-off Paris in 1912, *Les formes elementaires de la vie religieuse: le systeme totemique en Australie*. "Churinga," they write, "is the name given by the Arunta natives to certain sacred objects which, on penalty of death or very severe punishment, such as blinding by means of a fire-stick, are never allowed to be seen by women or uninitiated men."[2] For men only. To see. The secret magnifies reality, said Georg Simmel. It allows for the possibility of a second world alongside the manifest world—and the latter is decisively influenced by the former. To touch gently, caress, allow to sink into the body. A full-bodied contact, often with dance imitations of kanga-roos, birds, slugs, and other animals. A full-bodied contact occurring most especially with men making men, and therewith society itself, namely the ritual initiation of men—that basic axis around which the social and religious life of so many communities worldwide was based; here, cutting into the penis, what Pierre Clastres—thinking of other places and other times, Bolshevik time, Anarchist time, Ethnographic time, and always of subordination, pain, and inscription—called the "triple alliance" of writing, the body, and the law, a con-nection too weird yet too familiar, indeed, *the* connection between making men, the sacred, and the secret, a mighty connection redolent with epistemological tricks and turns all dependent—and this is the point of this text—all dependent on keeping the secret intact from women (and the uninitiated boys who would seem, perforce, to be "women," too).[3]

"Supposing truth is a woman—what then," writes that Nietzsche man, in the first words of *Beyond Good and Evil*, years after his youthful *Birth of Tragedy*—and was it not influenced by Schopenhauer, if not his beard?—wherein he writes, ". . . *for all of life is based on semblance, art, deception, points of view, and the necessity of perspectives and error*." Did you really think he was talking about art

MICHAEL TAUSSIG

Photographs from the French expedition Tierra del Fuego, 1882.

as in the art gallery? Did you really think it was possible to go from art (which now we may call deception) to the embrace of points (plural) of view? Yes! What sort of "knowing" is that? Revelation of the secret is to be met with death. Note the title: *Elementary Forms of Religious Life*. Everything gets so extreme so quickly, so basic and full of elementality. Blinding with fire-sticks. Keeping the secret secret seems more important than the secret itself. We recall the face, both mask *and* window to the soul. The role of the women, in the long chapters on the initiation of men, there in the central desert, is hazy, because it does not seem that women are totally excluded. They flit in and out, these women who must not see nor hear. There is the extraordinary theater where animals and humans fold into each other and in and out of myth-time, and then there is this other theater of concealment and strategic revelation, little bleeps of revelation danced in and out of that other dancing. The women must never see, never know. They dance on the other side of the break where the young man sits. The ethnographers see. They know. We know. The women come when signaled, to dance on the circumcision ground. They leave. As the man cuts with a flint knife, the women hear the bullroarers sounding all around, the voice, they are told, of a great spirit come to enter the body of the boy and take him away and into manhood. These women flit in and out, on and off the circumcision stage where men make men.

"For a month I sat every evening," writes a tall Englishman living for a year or so in a forest in Central Africa, in the mid-twentieth century.

I sat every evening at the *kumamolimo*; listening, watching, feeling—above all, feeling. If I still had little idea of what was going on, at least I felt that air of importance and expectancy. Every evening, when the women shut themselves up, pretending that they were afraid to see "the animal of the forest"; every evening, when the men gathered around the fire, pretending they thought that the women thought the drainpipes were animals; every evening, when the trumpet drainpipes imitated leopards, elephants and buffalos—every evening, when all this make-believe was going on, I felt that something very real and very great was going on beneath it.[4]

When times are bad, then the forest sings. The women are shut up in their huts. "The women were supposed to believe it really was an animal," our tall Englishman tells us, "and that to see it would bring death."

"There is an old legend," he writes in a comforting, storytelling way, "that once it was the women who owned the *molimo* [the trumpet], but the men stole it from them and ever since the women have been forbidden to see it."

A few years earlier, another Englishman writes of the secret societies in Sierra Leone. "The spirit world," he says:

is characterized and enacted by means of masked figures and various mechanical devices and designs. The mysterious effect is conserved by the oath of secrecy which every member, on entering, must take, and the infringement of which means sickness and even death; and by the prohibition of the sacred bush of the society to all non-members, including especially the women and children.[5]

In Central Amazonia, the same thing. A great secret hidden in the men's house. The sacred flutes/spirits that only men can touch and play, women threatened with gang rape (by the men acting collectively as the flute-in-spirit) if they so much as see them. "Only a few of the oldest Mehinaku men have actually seen a woman raped for seeing Kauka's flutes," writes an anthropologist in 1985. "The last occurrence was around 1940."[6]

Mighty mimics, thought the young Charles Darwin on the beach, bartering and playing with Tierra del Fuegian men in the mid-nineteenth century, speculating, as one does in one's diary, about essential connections occasioned by first contacts—in this case, with the Fuegians as to whether there was a causal connection between being close to nature and being blessed with mimetic prowess.[7]

But we who come later, we who have hunted and scavenged through the sparse documentation of indigenous life in that "land of fire" on the edge of the known universe whose inhabitants were hunted down to make way first

for gold miners and then for sheep at the turn of the century, we have learned about quite other forms of "being close to nature," to "mimetic nature" if you will, as expressed in the men's play in the great hut, the Hain, situated as theatrical space outside the village, and on pain of death forbidden to women and children, a fantastic theatrical space where, with body paint and lichens from the rocks in the surf, and grey down from the chests of seabirds, and mask, and fire, and sound, the gods rise from the earth or descend from the sky to become presenced by the credulous gaze of women.[8]

When an old sheep farmer, son of missionaries from England, who had been born and raised right there, late in the nineteenth century, and had himself been invited into the theater of Fuegian men, wrote his memoirs, he recorded asking the men who acted the gods if the women might be only pretending to believe they were gods, not men acting as gods, so convinced was he that the women knew full well the secret. But the men's reaction left him in no doubt as to "their firm conviction of the women's blind credulity."[9]

The Austrian anthropologist Martin Gusinde, who was himself initiated by the Yamana there in Tierra del Fuego, Land of Fire, in the early 1920s, said this theater was so important that it was equivalent to the state. It founded law. It maintained the law—right there, where the real was the really made up, where holiness and violence came together across the fourth wall of the gender divide, with men acting gods and women acting belief and men acting belief in the women's belief.

The violence threatened against the women outside was to some degree matched by the violence carried out on the male initiate inside the great theater, and when the novice, in an amazingly theatricalized fight to the death with the gods, was finally forced to take off the mask of his opponent by the flames of the fire so as to bear witness to the fact that it was no god but a mere man, his rage could be overwhelming. Moreover, demasking served to strengthen the belief in the reality of the god, not erase it, as the Enlightenment would insist, and demasking occurred again and again. Our old friend Walter Benjamin, who wrote knowingly on art in the age of mechanical reproduction, might have had this in mind when he noted, in his critique of violence, that probably no legislation on earth originally sanctioned lying. It was only late in the Western day that the law, lacking confidence in its own violence, no longer felt itself a match for all others, and began to place penalties on fraud.

But it was not always so. At the beginning of time, in fact, it was the other way around. The woman had the theater and the magical power. The men hunted animals for them, and looked after the children, while the women spent all their time dressing up and personifying the spirit world. When, by a most unfortunate set of circumstances, the men discovered the women were imitating the gods, they stormed the theater and brutally killed the women, leaving only the young girls, whom they later married. But because women were seen as always having a theatrical disposition, a talent for mimicry and hence for disguise and deception, a power linked to sorcery and magic, the men had to forcibly assume for themselves and themselves only the pursuit of these same arts. The phantom of the matriarchy haunts the patriarchies, writes Anne Chapman.[10]

Beyond Good and Evil. Supposing truth is a woman—what then? What is this theater of men making men spanning at least three continents that is not only a representation of dazzling myths and first times but their actualization, and not so much their actualization but, first and foremost, a magnificent excuse for another theater, the theater of concealment and revelation playing with the fourth wall, the only wall that counts, the gender line fatefully implicating holiness and violence?

Unlike the modern theater of illusion, the cinema, where the gaze, so we have been resolutely instructed these past so many years, has been resolutely male, this other theater of men making men and therewith the society as a whole, this theater of holiness, violence, and the public secret, is, if anything, the other way around. Here, the real and the really made up fuse, so long as the men are looked at by women not as men acting but as what it is they represent. The greatest show on earth is what it is. Yes! What sort of "knowing" is this?

With Klaus Theweleit's musings on the muse we might be encouraged, in an examination of masculinity and representation, to shift from psychoanalysis to mythic warfare, from Oedipus to Orpheus in a quite different and far bloodier founding story of male artistry, the man dependent on the female-as-lover whom, through necessity, he eventually kills, this man blessed with the powers of a god, whose song moves even inanimate nature.[11] Some of us may dwell on the different contents of these mythologies, but the pointed point of my stories is to raise the question as to how such myths and, more especially, performative practices, drawn not from the center but from the edges of the Western world, can, in their roundabout but fearsome way, rewrite the "birth of tragedy." Yes! What sort of "knowing" would that be?

MICHAEL TAUSSIG

NOTES

1. I take this observation from a footnote to the "Introduction to the Second Edition" of Julian Pitt-Rivers's very fine book, *The People of the Sierra* (Chicago: University of Chicago Press, 1971).

2. Baldwin Spencer and F.J. Gillen, *The Native Tribes of Central Australia* (1899; reprint, New York: Dover, 1968).

3. Pierre Clastres, *Society Against the State* (New York: Urizen Books, 1977).

4. Colin Turnbull, *The Forest People* (New York: Simon and Schuster, 1962).

5. K.L. Little, "The Poto Society as an Arbiter of Culture," *African Studies* 17, no.1 (1948), pp. 1–15. Citation on p. 4.

6. Thomas Gregor, "Men's House," *Anxious Pleasures: The Sexual Lives of an Amazonian People* (Chicago: University of Chicago Press, 1985).

7. Charles Darwin, *Charles Darwin's Diary of the Voyage of H.M.S. Beagle*, ed. Nora Barow (Cambridge: Cambridge University Press, 1934). The illustrations to this edition come from the several works on the history and lives of the peoples of Tierra del Fuego published in the 1920s in German by the Austrian ethnographer Martin Gusinde.

8. "Hain" was the term used by the Selk'nam or Ona-speaking people of Tierra del Fuego.

9. E. Lucas Bridges, *Uttermost Part of the Earth* (London: Hodder and Stoughton, 1951).

10. Anne Chapman, *Drama and Power in a Hunting Society: The Selk'nam of Tierra del Fuego* (Cambridge: Cambridge University Press, 1982).

11. Klaus Theweleit, *buch der könige* (Basel: Stroenfeld, 1988).

LEO BERSANI

LOVING MEN

For a gay man—and more particularly, for a relatively prosperous,
white, gay man—the subject of this book is fraught with opportunities for bad
faith. The description of the issues to be raised sent out by the editors more
or less precluded the idea of any serious divisions among us. Recent feminist,
Marxist, subalternist, gay and lesbian, and race studies, we were reminded,
"have helped expose the bigotry and intransigence of current gender divi-
sions," and the section on Masculinity and Representation—this one—would,
it was predicted, explore "the extent to which overt and sublimated images of
male domination and power are complicitous in the formation of sexist, racist,

classist, and homophobic attitudes." Our task as authors would be to suggest how "these complacent representations of masculinity [can] be subverted in order to refigure the balance of power in dominant culture."

As a victim, by definition, of homophobia, a gay man can hardly be uninterested in the possibility of such subversions, and yet there is a certain complacency in the assumption that it is unnecessary to examine how *we* might be complicitous in the complacent representations of an oppressive masculinity. I cannot speak for the victims of sexism, racism, and classism (although there are of course many gay people who can), but it seems to me not entirely irrelevant also to explore what might be called the erotic complicity of gay men in the very representations of masculinity that exclude us.

In "Is the Rectum a Grave?" I argued against a tendency among gay activists to deduce the political implications of homosexuality "from the status of homosexuals as an oppressed minority rather than from what I think are . . . the more crucially operative continuities between political sympathies on the one hand and, on the other, fantasies connected with sexual pleasure." There can, I suggested, be a continuity between a sexual preference for rough and uniformed trade, a sentimentalizing of the armed forces, and right-wing politics.[1] In short, while it is indisputably true that sexuality is always being politicized, the ways in which *having sex* politicizes are highly problematic. In his desires, however diverse they may be, and however many other determinants

help to constitute them, the gay man always runs the risk of identifying with culturally dominant images of misogynous maleness. For the sexual drives of exclusively or predominantly gay men do, after all, extend beyond the rather narrow circle of other politically correct gay men. A more or less secret sympathy with heterosexual male misogyny carries with it the narcissistically gratifying reward of confirming our membership in (and not simply our erotic appetite for) the privileged male society. Same-sex desire includes the potential for a loving identification with the gay man's enemies.

I certainly do not mean to propose that political alignments can be wholly accounted for by fantasy identifications. To forestall any such understanding of my argument, I suppose I should explicitly say that you can be turned on by sailors and *not* be a right-wing militarist. Our phantasmatic investments are frequently countered by more consciously and more rationally elaborated modes of reaching out to others, such as liking or admiring people we do not necessarily desire. In that tension lies an important moral dimension of our political engagements. But to be aware of the tension means being aware of both sets of determining factors, and perhaps especially of those identifications and erotic interests it is not always gratifying to acknowledge. The cultural constraints under which we operate include not only visible political structures but also the phantasmatic processes by which we eroticize the real. Even if we are born straight or gay, we still have to learn to desire particular men and women, and not to desire others; the *economy* of our sexual drives is a cultural achievement. Perhaps nowhere are we manipulated more effectively and more insidiously than in our most "personal" choices or tastes in the objects of our desires. Those choices have cultural origins and political consequences. To seek to understand what might be called the line of constraint running from one to the other is itself a political imperative. For a gay man, there may have been no time at which the object of his desire did not include a socially determined and socially pervasive definition of what it means to be a man. An authentic, gay, male, political identity therefore implies a struggle not only against definitions of maleness and of homosexuality as they are reiterated and imposed in a heterosexist social discourse, but also against those very same definitions so seductively and so faithfully reflected by those male bodies that we carry within us as permanently renewable sources of excitement.

Gay men's investment in hegemonic representation of masculinity is not only erotic. In what we like to think of, for example, as a common struggle of gay men and lesbians against a homophobic, male-dominated culture, there is also a social chasm separating the two partners in this alliance. The most

David Hammons, *A Fan*, 1990.

solid foundation for our alliance is a common oppression: discrimination as a result of same-gender sexual preference. And yet, lesbians are an oppressed group sexually invested in an oppressed group. Gay men are an oppressed group not only sexually drawn to the power-holding sex, but also belonging to it themselves. No wonder lesbians (perhaps especially during the early years of gay liberation) have been so suspicious of the gay men with whom they are presumably unified in a common cause. We are, in fact, the pariahs among minorities and oppressed groups. Feminists speak with distaste of our promiscuous male sexuality; African-Americans accuse us of neglecting the crucial issues of class and race for such luxuries as our "gay identity." As white, middle-class, gay men, we are too much like our oppressors, which means that, fundamentally, we can never be sufficiently oppressed. And so, never renouncing privileges inherent in our very being, we nonetheless never cease apologizing for those privileges. We are mortified if we are white and prosperous; and insofar as the "male 'I' has enjoyed something of a psychic and cultural monopoly on subjectivity that needs to be dissolved," we will seek to be born again, this time "engendered," as a recent volume puts it, by feminism, in the anxious hope of "deconstructing" our repellently renascent male selves.[2]

Without questioning the good faith or the intelligence of those who make such announcements of self-erasure, we should view them with suspicion.

Male homosexuality has always manifested itself socially as a highly specific blend of conformism and transgression. For an impoverished African-American, to conform is to embrace the racial and economic injustices from which he or she suffers; for a woman, to conform is to accept a heterosexist definition of female identity; for most gay men, to conform is to pick up the privileges waiting for them as men. Nothing a woman agrees to do for the dominant culture will ever give her all the privileges intrinsic in our society to maleness; nothing Clarence Thomas agrees to do will ever make him completely white. The pressures of the double lives gay people have been forced to lead can of course be enormous, but even those pressures are something of a luxury. If we can live with them, and if we do not get caught (and those "ifs" should not be minimized), the advantages are very great indeed: potentially unlimited vistas of social opportunity, and all the sex we want, if necessary, on the sly.

If a gay specificity is too troubling to consider (both for ourselves and for straight America, although for quite different reasons), then it is tempting to meld in—either with those other groups whose oppressed state we yearn to be worthy to share, or with mainstream America. And intellectually it is gratifying to think of homosexuality as something much more significant, epistemologically and politically, than a sexual preference. *Angels in America*, for instance, has been telling its thrilled audiences that to be gay in the 1980s was to be a metaphor not only for Reagan's America but perhaps for the entire history of America, a country in which there are "no gods, . . . no ghosts and spirits . . . no angels, . . . no spiritual past, no racial past, there's only the political."[3] The enormous success of Tony Kushner's muddled and pretentious play is a sign, if we needed still another one, of how ready and anxious America is to see and hear about gays—provided we reassure America how familiar, how morally sincere, and how innocuously full of significance we can be.

By both applauding such reductions and assimilations, and claiming at the same time that we are different without being willing to define that difference, we merely position ourselves for reproaches and reprisals from all those groups bound to discover eventually what separates us from them. "Men in feminism," for example, is bound to lead to angry complaints about "feminism without women." The latter is the title of a book by Tania Modleski, who compares the relation between feminism and some of its contemporary male theorists to that of the mother and the male child in Gilles Deleuze's notion of masochism, in which "the male child allies himself with the mother against the law of the father, which it is the function of the mother to beat out of the son." For these theorists, Modleski argues, "feminism itself has come to occupy the

position of the mother who is identified with the law." But this alliance, as Modleski puts it,

> is doomed to failure, from a feminist point of view, unless the father is frankly confronted and the entire dialectic of abjection and the law worked through; otherwise, as Deleuze's analysis confirms, the father will always remain in force as the major, if hidden, point of reference—and he may in fact be expected at any time to emerge from hiding with a vengeance.[4]

Male feminism thus risks remaining an affair—yet another one—strictly "between men," attesting once again to the extraordinary difficulty men have, not in speaking *for* women or *through* women to each other, but in *addressing women*. Furthermore, the possibility of a constitutive inability in maleness (both heterosexual and homosexual) to make such an address is elided by the more comforting project of grouping politically against a presumably common enemy (who, in fact, still firmly in power, hardly bothers to answer the charge). Phantasmatic complicities are denied through a deceptively self-immolating participation in the struggle against the evil Law of an evil patriarchy, thus making it even more difficult to struggle against those complicities, that is, against men's massive and complex investment in the law.

This de-gaying, and this de-sexualizing of gayness—both of which obfuscate male homosexuality's excited and troubled relation to hegemonic images

of masculinity—have recently been both qualified and reaffirmed as "queer theory." Now "gay" becomes what Michael Warner, in his introduction to an important collection of essays in queer theory, calls a "thoroughgoing" resistance to regimes of the normal.[5] This generous definition puts all resisters in the same queer bag—a universalizing move I appreciate, but which fails to specify the sexual distinctiveness of the resistance. This is particularly unfortunate since queer theorists protest, albeit ambiguously, against the exclusion of the sexual from the political. Warner, protesting against leftist social theory in which sexuality plays no role, raises the prospect of making "sexuality a primary category for social analysis"; Andrew Parker calls for "a sex-inflected analysis of class formations."[6] But unless we define how the *sexual specificity* of being queer (a specificity perhaps common to the myriad ways of being queer and the myriad conditions in which one is queer) gives to queers a special aptitude for making that challenge, we are likely to come up with a remarkably familiar, and merely liberal, version of it.

In a brilliant essay on Thoreau, Warner does document the political productivity of a particular sexuality. He impressively traces the link between anality in Thoreau and the "paradigmatically liberal problems of self-possession and mutuality," thus giving a wholly persuasive illustration of how "political systems are always inhabited by the body."[7] But in *Fear of a Queer Planet*, his formulation of a queer political challenge is itself paradigmatically liberal: "Being queer . . . means being able, more or less articulately, to challenge the common understanding of what gender difference means, or what the state is for, or what 'health' entails, or what would define fairness, or what a good relation to the planet's environment would be."[8] It seems peculiarly dismissive of the majority of human beings to suggest that you have to be queer to understand what "fairness" is, or "what 'health' entails"—unless of course queer is stripped of its (inescapably minoritary) sexual specificity, and is simply a *consequence* of an understanding of fairness and of health. If queerness means more than simply taking sexuality into account in our political analyses, if it means that modalities of desire are not only the objects and effects of social operations but are constitutive of our very imagination of the social and the political, then something has to be said about how erotic desire for the same might revolutionize our very understanding of how the human subject is, or might be, socially implicated.

In the same volume, Lauren Berlant and Elizabeth Freeman make an important distinction between the essential geniality of Queer Nation and a "negation of their own audience," a split that they also find characteristic of certain parts of 'zine culture: "The application for citizenship in the Bitch Nation, for

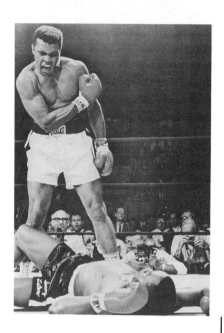

example, repudiates the promise of community in common readership, the privileges of a common language, and the safety of counteridentity."[9] And, drawing on Hannah Arendt's description of the "relatively new phenomenon" of "the social realm," a realm based on "conformism" and in which "those who did not keep the rules could be considered to be asocial and abnormal," Warner concludes, very interestingly, with the suggestion that queers are objecting to "the cultural phenomenon of societalization." However, the value of this suggestion is somewhat lessened by the reduction of the protest to a response to "the normalizing methodologies of modern social knowledge."[10] There is a more radical possibility: *homo-ness itself necessitates a massive redefining of relationality*. More fundamental than a resistance to normalizing methodologies is a potentially revolutionary inaptitude—perhaps inherent in gay desire—for heteroized sociality.

In our societies, the power of representations of masculinity is such that it can perhaps be resisted only by a provisional withdrawal from relationality itself, and a redefinition of sociality. What that might mean has, in fact, been traced for us by homosexual writers as different from one another as Gide and Genet. Desire for the same subverts an oppressive psychology of desire as lack (a psychology that grounds sociality in castration). A new reflection on homo-ness might lead us to a salutary devalorizing of difference (which, as Monique Wittig has argued, always implies hierarchy); or, more exactly, to a

notion of difference not as a trauma to be overcome (*this* view nourishes a heterosexist male relation to women), but rather as a nonthreatening supplement to sameness.

NOTES

1. Bersani, "Is the Rectum a Grave?" in Douglas Crimp, ed., *AIDS/Cultural Analysis/Cultural Activism* (Cambridge, Mass.: MIT Press, 1988), p. 206.

2. See especially the Introduction to Joseph A. Boone and Michael Cadden, eds., *Engendering Men: The Question of Male Feminist Criticism* (New York and London: Routledge, 1990).

3. Tony Kushner, *Angels in America: A Gay Fantasia on National Themes, Part One: Millenium Approaches* (New York: Theatre Communications Group, 1992), p. 72.

4. Tania Modleski, *Feminism Without Women: Culture and Criticism in a "Postfeminist" Age* (New York and London: Routledge, 1991), pp. 69–70. See also Alice Jardine and Paul Smith, eds., *Men in Feminism* (New York and London: Methuen, 1987).

5. Michael Warner, "Introduction," in Warner, ed., *Fear of a Queer Planet: Queer Politics and Social Theory* (Minneapolis: University of Minnesota Press, 1993), p. xxvi.

6. Ibid., p. xv; Andrew Parker, "Unthinking Sex: Marx, Engels, and the Scene of Writing," in ibid., p. 22.

7. Michael Warner, "Thoreau's Bottom," *Raritan* 11 (Winter 1992): 78.

8. Warner, "Introduction," p. xiii.

9. Lauren Berlant and Elizabeth Freeman, "Queer Nationality," in Warner, ed., *Fear of a Queer Planet*, p. 221.

10. Warner, "Introduction," pp. xxv, xxvii.

HOW SCIENCE DEFINES MEN

three

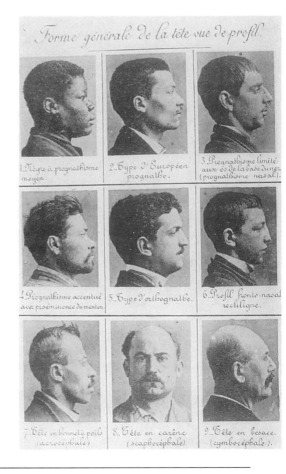

Forme générale de la tête vue de profil.

1. Nègre à prognathisme moyen.

2. Type d'Européen prognathe.

3. Prognathisme limité aux os de la base du nez (prognathisme nasal).

4. Prognathisme accentué avec proéminence du menton.

5. Type d'orthognathe.

6. Profil fronto-nasal rectiligne.

7. Tête en bonnet à poils (acrocéphale).

8. Tête en carène (scaphocéphale).

9. Tête en besace (cymbocéphale).

ANNE FAUSTO-STERLING

HOW TO BUILD A MAN

How does one become a man? Although poets, novelists, and playwrights long past answered with discussions of morality and honor, these days scholars deliberate the same question using a metaphor—that of social construction. In the current intellectual fashion, men are made, not born. We construct masculinity through social discourse, that array of happenings that covers everything from music videos, poetry, and rap lyrics to sports, beer commercials, and psychotherapy. But underlying all of this clever carpentry is the sneaking suspicion that one must start with a blueprint—or, to stretch the metaphor yet a bit more, that buildings must have foundations. Within the

soul of even the most die-hard constructionist lurks a doubt. It is called the body.

In contrast, biological and medical scientists feel quite certain about their world. For them, the body tells the truth. (Never mind that postmodern scholarship has questioned the very meaning of the word "truth.") My task in this essay is to consider the truths that biologists extract from bodies, human and otherwise, to examine scientific accounts—some might even say constructions—of masculinity. To do this, I will treat the scientific/medical literature as yet another set of texts open to scholarly analysis and interpretation.

What are little boys made of? While the nursery rhyme suggests "snips and snails, and puppy-dogs tails," during the past seventy years, medical scientists have built a rather more concrete and certainly less fanciful account. Perhaps the single most influential voice during this period has been that of psychologist John Money. Since at least the 1920s, embryologists have understood that during fetal development a single embryonic primordium—the indifferent fetal gonad—can give rise to either an ovary or a testis. In a similar fashion, both male and female external genitalia arise from a single set of structures. Only the internal sex organs—uteri, fallopian tubes, prostates, sperm transport ducts—arise during embryonic development from separate sets of structures. In the 1950s, Money extended these embryological understandings into the realm of psychological development. As he saw it, all humans start on the same road, but the path rapidly begins to fork. Potential males take a series of turns in one direction, potential females in another. In real time, the road begins at fertilization and ends during late adolescence. If all goes as it should, then there are two, and only two, possible destinations—male and female.

But, of course, all does not always go as it should. Money identified the various forks in the road by studying individuals who took one or more wrong turns. From them, he derived a map of the normal. This is, in fact, one of the very interesting things about biological investigators. They use the infrequent to illuminate the common. The former they call abnormal, the latter normal. Often, as is the case for Money and others in the medical world, the abnormal requires management. In the examples I will discuss, management means conversion to the normal. Thus, we have a profound irony. Biologists and physicians use natural biological variation to define normality. Armed with this description, they set out to eliminate the natural variation that gave them their definitions in the first place.

How does all this apply to the construction of masculinity? Money lists ten road signs directing a person along the path to male or female. In most cases these indicators are clear, but, as in any large city these days, sometimes graf-

fiti makes them hard to read and the traveler ends up taking a wrong turn. The first sign is *chromosomal sex*, the presence of an X or a Y chromosome. The second is *gonadal sex*: when there is no graffiti, the Y or the X instructs the fetal gonad to develop into a testis or an ovary. *Fetal hormonal sex* marks the third fork: the embryonic testis must make hormones which influence events to come—particularly the fourth (*internal morphologic sex*), fifth (*external morphologic sex*), and sixth (*brain sex*) branches in the road. All of these, but especially the external morphologic sex at birth, illuminate the road sign for step number seven, *sex of assignment and rearing*. Finally, to become either a true male or a true female in John Money's world, one must produce the right hormones at puberty (*pubertal hormonal sex*), acquire and express a consistent *gender identity and role*, and, to complete the picture, be able to reproduce in the appropriate fashion (*procreative sex*).[1]

Many medical texts reproduce this neat little scheme, and suggest that it is a literal account of the scientific truth, but they neglect to point out how, at each step, scientists have woven into the fabric their own deeply social understandings of what it means to be male or female. Let me illustrate this for several of the branches in the road. Why is it that usually XX babies grow up to be female while XYs become male? Geneticists say that it is because of a specific Y chromosome gene, often abbreviated SDY (for "Sex-Determining Gene" on the Y). Biologists also refer to the SDY as the Master Sex-Determining Gene and say that in its *presence* a male is formed. Females, on the other hand, are said to be the default sex. In the *absence* of the master gene, they just naturally happen. The story of the SDY begins an account of maleness that continues throughout development. A male embryo must activate its master gene and seize its developmental pathway from the underlying female ground plan.

When the SDY gene starts working, it turns the indifferent gonad into a functional testis. One of the first things the testis does is to induce hormone synthesis. It is these molecules that take control of subsequent developmental steps. The first hormone to hit the decks (MIS, or Mullerian Inhibiting Substance) suppresses the development of the internal female organs, which lie in wait ready to unveil their feminine presence. The next, fetal testosterone, manfully pushes other embryonic primordia to develop both the internal and external trappings of physical masculinity. Again, medical texts offer the presence/absence hypothesis. Maleness requires the presence of special hormones; in their absence, femaleness just happens.[2]

Up to this point, two themes emerge. First, masculinity is an active presence which forces itself onto a feminine foundation. Money sometimes calls

ANNE FAUSTO-STERLING

this "The Adam Principle—adding something to make a male." Second, the male is in constant danger. At any point male development can be derailed: a failure to activate SDY, and the gonad becomes an ovary; a failure to make MIS, and the fetus can end up with fallopian tubes and a uterus superimposed on an otherwise male body; a failure to make fetal testosterone, and, despite the presence of a testis, the embryo develops the external trappings of a baby girl. One fascinating contradiction in the scientific literature illustrates my point. Most texts write that femaleness results from the absence of male hormones, yet at the same time scientists worry about how male fetuses protect themselves from being femininized by the sea of maternal (female) hormones in which they grow.[3] This fear suggests, of course, that female hormones play an active role, after all; but most scientists do not pick up on that bit of logic. Instead, they hunt for special proteins the male embryo makes in order to protect itself from maternally induced feminization. (It seems that mother is to blame even before birth.)

Consider now the birth of a boy-child. He is perfect: Y chromosomes, testes descended into their sweet little scrotal sacs, a beautifully formed penis. He is perfect—except that the penis is very tiny. What happens next? Some medical texts refer to a situation such as this as a social emergency, others see it as a surgical one. The parents want to tell everyone about the birth of their baby boy; the physicians fear he cannot continue developing along the road to masculinity. They decide that creating a female is best. Females are imperfect by nature, and if this child cannot be a perfect or near-perfect male, then being an imperfect female is the best choice. What do the criteria physicians use to make such choices tell us about the construction of masculinity?

Medical managers use the following rule of thumb:

> Genetic females should always be raised as females, preserving reproductive potential, regardless of how severely the patients are virilized. In the genetic male, however, the gender of assignment is based on the infant's anatomy, predominantly the size of the phallus.[4]

Only a few reports on penile size at birth exist in the scientific literature, and it seems that birth size in and of itself is not a particularly good indicator of size and function at puberty. The average phallus at birth measures 3.5 cm (1 to 1.5 inches) long. A baby boy born with a penis measuring only 0.9 inches raises some eyebrows, but medical practitioners do not permit one born with a penis less than 0.6 inches long to remain as a male.[5] Despite the fact that the intact organ promises to provide orgasmic pleasure to the future adult it is

surgically removed (along with the testes) and replaced by a much smaller clitoris which may or may not retain orgasmic function. When surgeons turn "Sammy" into "Samantha," they also build her a vagina. Her primary sexual activity is to be the recipient of a penis during heterosexual intercourse. As one surgeon recently commented, "It's easier to poke a hole than build a pole."

All this surgical activity goes on to ensure a congruous and certain sex of assignment and sex of rearing. During childhood, the medical literature insists, boys must have a phallus large enough to permit them to pee standing up, thus allowing them to "feel normal" when they play in little boys' peeing contests. In adulthood, the penis must become large enough for vaginal penetration during sexual intercourse. By and large, physicians use the standard of reproductive potential for making females and phallus size for making males, although Suzanne J. Kessler reports one case of a physician choosing to reassign as male a potentially reproductive genetic female infant rather than remove a well-formed penis.[6]

At birth, then, masculinity becomes a social phenomenon. For proper masculine socialization to occur, the little boy must have a sufficiently large penis. There must be no doubt in the boy's mind, in the minds of his parents and other adult relatives, or in the minds of his male peers about the legitimacy of his male identification. In childhood, all that is required is that he be able to pee in a standing position. In adulthood, he must engage in vaginal heterosexual intercourse. The discourse of sexual pleasure, even for males, is totally absent from this medical literature. In fact, male infants who receive extensive penile surgery often end up with badly scarred and thus physically insensitive members. While no surgeon finds this outcome desirable, in assigning sex to an intersexual infant, sexual pleasure clearly takes a backseat to ensuring heterosexual conventions. Penetration in the absence of pleasure takes precedence over pleasure in the absence of penetration.

In the world of John Money and other managers of intersexuality, men are made not born. Proper socialization becomes more important than genetics. Hence, Money and his followers have a simple solution to accidents as terrible as penile amputation following infant circumcision: raise the boy as a girl. If both the parents and the child remain confident of his newfound female identity, all will be well. But what counts as good mental health for boys and girls? Here, Money and his coworkers focus primarily on female development, which becomes the mirror from which we can reflect the truth about males. Money has published extensively on XX infants born with masculinized genitalia. Usually such children are raised as girls, receiving surgery and hormonal

treatments to femininize their genitalia and to ensure a feminine puberty. He notes that frequently such children have a harder time than usual achieving clarity about their femininity. Some signs of trouble are these: in the toddler years, engaging in rough-and-tumble play, and hitting more than other little girls do; in the adolescent years, thinking more about having a career and fantasizing less about marriage than other little girls do; and, as an adolescent and young adult, having lesbian relationships.

The homologue to these developmental variations can be found in Richard Green's description of the "Sissy Boy Syndrome." Green studied little boys who develop "feminine" interests—playing with dolls, wanting to dress in girls' clothing, not engaging in enough rough-and-tumble play. These boys, he argued, are at high risk for becoming homosexuals. Money's and Green's ideas work together to present a picture of normality. And, surprise, surprise, there is no room in the scheme for a normal homosexual. Money makes a remarkable claim. Genetics and even hormones count less in making a man or a woman than does socialization. In sustaining that claim, his strongest evidence, his trump card, is that the child born a male but raised a female becomes a heterosexual female. In their accounts of the power of socialization, Money and his coworkers define heterosexual in terms of the sex of rearing. Thus, a child raised as a female (even if biologically male) who prefers male lovers is psychologically heterosexual, although genetically she is not.

Again, we can parse out the construction of masculinity. To begin with, normally developing little boys must be active and willing to push one another around; maleness and aggression go together. Eventually, little boys become socialized into appropriate adult behavior, which includes heterosexual fantasy and activity. Adolescent boys do not dream of marriage, but of careers and a professional future. A healthy adolescent girl, in contrast, must fantasize about falling in love, marrying, and raising children. Only a masculinized girl dreams of a professional future. Of course, we know already that for men the true mark of heterosexuality involves vaginal penetration with the penis. Other activities, even if they are with a woman, do not really count.

This might be the end of the story, except for one thing. Accounts of normal development drawn from the study of intersexuals contain internal inconsistencies. How *does* Money explain the higher percentage than normal of lesbianism, or the more frequent aggressive behavior among masculinized children raised as girls? One could imagine elaborating on the socialization theme: parents aware of the uncertain sex of their children subconsciously socialize them in some intermediary fashion. Shockingly for a psychologist,

however, Money denies the possibility of subconsciously driven behavior. Instead, he and the many others who interpret the development of inter-sexual children resort to hormonal explanations. If an XX girl, born with a penis, surgically "corrected" shortly after birth, and raised as a girl, subsequently becomes a lesbian, Money and others do not look to faulty socialization. Instead, they explain this failure to become heterosexual by appealing to hormones present in the fetal environment. Excess fetal testosterone caused the masculinization of the genitalia; similarly, fetal testosterone must have altered the developing brain, readying it to view females as appropriate sexual objects. Here, then, we have the last bit of the picture painted by biologists. By implication, normal males become sexually attracted to females because testosterone affects their brain during embryonic development. Socialization reinforces this inclination.

Biologists, then, write texts about human development. These documents, which take the form of research papers, textbooks, review articles, and popular books, grow from interpretations of scientific data. Often written in neutral, abstract language, the texts have the ring of authority. Because they represent scientific findings, one might imagine that they contain no preconceptions, no culturally instigated belief systems. But this turns out not to be the case. Although based in evidence, scientific writing can be seen as a particular kind of cultural interpretation—the enculturated scientist interprets nature. In the process, he or she also uses that interpretation to reinforce old or build new sets of social beliefs. Thus, scientific work contributes to the construction of masculinity, and masculine constructs are among the building blocks for particular kinds of scientific knowledge. One of the jobs of the science critic is to illuminate this interaction. Once this is done, it becomes possible to discuss change.

NOTES

1. For a popular account of this picture, see John Money and Patricia Tucker, *Sexual Signatures: On Being a Man or a Woman* (Boston: Little, Brown and Co., 1975).

2. The data do not actually match the presence/absence model, but this does not seem to bother most people. For a discussion of this point, see Anne Fausto-Sterling, "Life in the XY Corral," *Women's Studies International Forum* 12 (1989): 319–31; Anne Fausto-Sterling, "Society Writes Biology/Biology Constructs Gender," *Daedalus* 116 (1987): 61–76; and Anne Fausto-Sterling, *Myths of Gender: Biological Theories about Women and Men* (New York: Basic Books, 1992).

3. I use the phrase "male hormone" and "female hormone" as shorthand. There are, in fact, no such categories. Males and females have the same hormones, albeit in different quantities and sometimes with different tissue distributions.

ANNE FAUSTO-STERLING

4. Patricia Donahue, David M. Powell, and Mary M. Lee, "Clinical Management of Intersex Abnormalities," *Current Problems in Surgery* 8 (1991): 527.

5. Robert H. Danish, Peter A. Lee, Thomas Mazur, James A. Amrhein, and Claude J. Migeon, "Micropenis II: Hypogonadotropic Hypogonadism," *Johns Hopkins Medical Journal* 146 (1980): 177–84.

6. Suzanne J. Kessler, "The Medical Construction of Gender: Case Management of Intersexed Infants," *Signs* 16 (1990).

PHILOMENA MARIANI

LAW-AND-ORDER SCIENCE

Is there a cure for boyhood? So asks the *New York Times* in an editorial ostensibly critical of the tendency to read "boyish" behavior— "aggression, rowdiness, restlessness, loud-mouthedness, rebelliousness" —as a sign of latent criminality or personality disturbance. Boys are taking the rap in record numbers for such childhood behavioral syndromes as attention deficit/hyperactivity disorder, oppositional defiant disorder, and conduct disorder, outnumbering girls diagnosed as "problem children" by at least four to one. One explanation offered for the higher rate of disturbance among boys: their inflexible brains. Hardwired in utero by exposure to

testosterone, the embryonic male brain is less pliant than its female counterpart, thus more susceptible to injury "during the arduous trek down the birth canal." Although not serious enough to constitute full-fledged brain damage, these injuries can cause subtle neurological impairments that presumably place a boy at risk for later acting-out, even criminal, behavior.[1] Those who survive the fetal ordeal with unscrambled brains are well equipped to meet the demands of family, school, and workplace. The rest are born losers.

The logic tracing a direct line from testosterone to congenital insult to loudmouthedness may seem obscure. But speculations such as this (with and without testosterone) are currently driving a substantial share of research on the origins of "antisocial" behavior.[2] The fact that *antisociality* itself is a culturally-constructed concept has been buried under an avalanche of research purporting to locate its cause in "individual vulnerabilities" that give rise to personality syndromes like attention deficit/hyperactivity disorder (ADHD), conduct disorder (CD), oppositional defiant disorder (ODD), and antisocial personality disorder (APD). And as researchers assemble data linking this cluster of syndromes in a developmental path leading straight to criminality (ADHD → ODD and/or CD → APD)[3] the lead weight of the behavioral sciences has landed with a punitive thud on the heads of children. Not surprisingly, the more children's behavior is probed for markers of deviance, the more restricted become definitions of nondeviance or "prosociality."

Researchers justify the convergence on children by citing the dramatic rise in juvenile crime and violence since the mid-seventies. But this does not explain the ideological orientation of the research, dominated by a biomedical model and favoring organic explanations. For that, we must explore its thematic preoccupations and discursive strategies, through which are revealed cultural anxieties far removed from the actual behavior of children. One notes in particular the slippage from identifying and preventing "deviance" to defining and circumscribing permissible forms of behavior. Establishing the biological bases of *conformity* is central to research on antisocial behavior. The alliance of psychiatry, the social sciences, and the "hard" sciences in constructing children as potential perps (or nonconformists) is grounded in an image of the child—particularly the male child—as a belligerent, willful creature, naturally avaricious and aggressive, in need of constant punishment if he is to learn the "avoidance of transgression." Who is served by this puritanical formulation, the social tensions it addresses and alleviates, will be explored in the pages that follow.

The constellation of childhood behavioral syndromes collectively referred to as the disruptive disorders evokes an immediate question: Disruptive to whom? Clinical diagnoses of ADHD, CD, or ODD depend largely on parent/teacher ratings obtained through instruments like the Aberrant Behavior Checklist. Parents and teachers are hardly disinterested bystanders, but their interests are rarely questioned. They may be cruel, domineering, indifferent, tedious, stupid. They may simply not like the fact that a child cracks wise. But in the diagnostic process, power is in the hands of the perceiver. It is unlikely that children will be given the same opportunity to fill out problem behavior checklists for their caretakers. In this context, children's rational responses to the world around them can easily be pathologized, and willfulness can be transformed into a disorder, boredom treated with Ritalin, management problems warehoused in child guidance clinics. The exhaustive array of behaviors considered symptomatic of the disruptive disorders, as catalogued in psychiatry's canonical text, the *Diagnostic and Statistical Manual of Mental Disorders* (DSM), range from inattention, disobedience, running away, callousness, impatience, arguing with adults, bossiness, impulsivity, and lying, to fire-setting and the use of physical violence—allowing plenty of leeway for misuse. Perhaps this is why prevalence rates for CD and ODD have reached estimates as high as 16 percent of the school-age population.[4]

Psychiatry pathologizes—that is, after all, its job. Meanwhile, a growing cadre of behavioral scientists is constructing the frame through which childhood disorders are biologized. The broader purpose of this biobehavioral research, as stated by its advocates, is preventive: to intervene before a childhood disorder develops into the apparently intractable adult antisocial personality disorder. Frederick Goodwin, a neuropsychiatrist, and until recently director of the National Institute of Mental Health (NIMH), formulated the goals of this preventive project—dubbed the Violence Initiative—as the early detection of behavioral patterns with "predictor value." In a presentation before the American Psychiatric Association, Goodwin elaborated on NIMH's goal to "design and evaluate psychosocial, psychological, and medical interventions for at-risk children before they become labeled delinquent or criminal."[5] A seemingly benign objective, but Goodwin is also the perpetrator of the notorious "monkey remarks," and it is worth reproducing those comments here to properly contextualize his approach to prevention:

> If you look, for example, at male monkeys, especially in the wild, roughly half of them survive to adulthood. The other half die by violence. That is the natural way of it for males, to

knock each other off and, in fact, there are some interesting evolutionary implications of that because the same hyperaggressive monkeys who kill each other are also hypersexual, so they copulate more and therefore they reproduce more to offset the fact that half of them are dying.

Now, one could say that if some of the loss of social structure in this society, and particularly within the high impact inner-city areas, has removed some of the civilizing evolutionary things that we have built up . . . maybe it isn't just [a] careless use of the word when people call certain areas of certain cities *jungles*, that we may have gone back to what might be more natural, without all of the social controls that we have imposed upon ourselves as a civilization over thousands of years in our own evolution.[6]

The message is clear: when the lid is off, monkeys and (black) urban males kill and copulate to excess. In fact, the lid was off at NIMH, and out popped an ugly display of bourgeois *realpolitik*. Here's James Breiling, another NIMH researcher, with a take-no-prisoners assessment of treatment options:

If we wanted to do the simple thing, it would be to prevent the birth of males. But that's not going to happen. . . . Are we going to put lithium in the drinking water of Watts? No. That's absurd. . . . Should we give the appropriate medications? Absolutely. . . . There's no question that there's a genetic contribution [to violent behavior]. . . . You can't say, "Gee you have bad genes, don't reproduce"; you'd eliminate the bulk of the population.[7]

Meanwhile, NIMH released reports estimating that one of every twenty urban males suffered from APD—or psychopathy, in popular parlance.

Louis Sullivan, director of Health and Human Services at the time, dismissed Goodwin and Company's public utterances as "momentary lapses." Others were less sanguine. In the ensuing controversy, critics—including the Congressional Black Caucus, the American Psychological Association, and the National Association of Social Workers—demanded Goodwin's removal from government service. (He was promoted instead.) Many voiced stronger criticisms, charging that NIMH's so-called violence prevention project was in reality an attempt to subject young black men to biologically invasive social control techniques, and its ultimate goal to isolate a crime gene. The charge was serious enough to provoke a disclaimer from Sullivan: "There is no truth to the allegation that anyone at the National Institute of Health [NIMH's parent agency] is supporting research for a violence gene. . . . There is no plan to put black young men on drugs to control a violence gene."[8]

Over the next several months, two panels, under both the Bush and Clinton administrations, were formed to review the National Institute's portfolio on

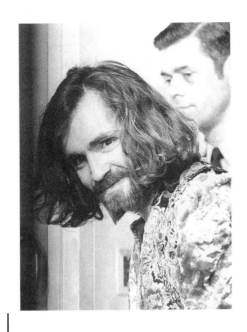

violence research.[9] Here I will concentrate on the NIMH projects reviewed by the panels, which comprise the majority. Of 189 projects, fully one-quarter (forty-six) are devoted to childhood disruptive behavior disorders (DBDs). Of these, fifteen target boys exclusively, but because of boys' near-exclusive patent on DBD diagnoses, we can assume that, in the majority of research projects, the subjects are male. As for racial composition, whites comprise at least 80 percent of the research subjects in twenty-five projects, children of color 80 percent or more in five; the remaining sixteen contain equal distributions (or a slightly greater number of whites). Although behavioral perspectives dominate in all forty-six DBD studies, almost half (twenty-one) show a *bio*behavioral or strictly biological orientation. Of these, fifteen focus on whites, one on children of color, and the rest have an equal distribution (again, with whites slightly overrepresented).

Goodwin's vision of an urban (black) male populace reverting to the natural order of things, unbound by civilizing imperatives and other modes of social control (not unlike the nineteenth-century bourgeois nightmare of King Mob), makes sense in a cultural terrain dominated by right-wing ruminations on social decline. But the concern with *blackness* reflected in public statements by proponents of the Violence Initiative masked much of the government research portfolio's content. Although black children are represented in substantial numbers throughout the portfolio, a review of the biobehavioral projects reveals anxieties of another order: here *whiteness*,

PHILOMENA MARIANI

more specifically, white masculinity, has been earmarked for the laboratories. Naturally, class plays a role as well, but in unexpected ways. In locating subject samples, researchers rely heavily on clinic populations, that is, children already referred to psychiatrists, psychologists, or other child-development experts. Middle-class children are more frequently identified as psychiatrically disordered and referred to mental health services, while low-income children are labeled delinquent and channeled into the criminal justice system (reform school, summer boot camp, and so on). This skewed referral process is the result of both class bias in perceptions of problem behavior and the resources available to a given community. Consequently, the profile of a typical research subject does not easily merge with the slack-jawed cretin of Kallikak fame, that is, "poor white trash." This is especially true of research on ADHD.[10]

That white, middle-class boys are crucial objects of biobehavioral research is implicitly confirmed by Sarnoff Mednick, a biocriminologist responsible for the widely-cited genetic studies on criminality using adoption cohorts:

> It seems quite clear that socioeconomic factors provide the reasons for crime for *most criminals*. . . . To the extent that some criminals have deviant psychological or biological characteristics that help predispose them to antisocial behavior, then societal manipulation *alone* will not be sufficient to prevent crime. . . . [B]iological factors predict best in those areas, situations, or among those groups in which social factors . . . do not "explain" antisocial behavior. . . . These include, for example, middle- and upper-class background, recidivistic criminality, female criminality, or crime in rural areas.[11]

In other words, sociology and the criminal justice system will do quite nicely for the "underclass." Neuropsychiatry and medication will solve the mystery of middle-class deviance (or at least contain it). Bioresearch is laced with assumptions about the perfection of suburbia and the bourgeois home. Willful blindness to instability in the middle-class family underwrites research on the disruptive disorders, compels faith in clinical diagnostic instruments dependent on parent testimony, and more. We will return to this later.

What of the charge of genetic essentialism advanced by critics of the Violence Initiative? This is also modified by a review of the portfolio. While not explicitly genetic in orientation (at least, not in any simpleminded way, as suggested by the notion of a "crime gene"), research imperatives *are* framed by a disease model. Violence is studied as a function of individual behavior (rather than social structure), its causes situated in biological "deficits" or psychogenic disturbance. (Even this distinction is deceptive, since psychiatric disorder is increasingly conceptualized as organically based.) Genetics do enter the picture,

Glenn Ligon, *Skin Tight: Ice Cube's Eyes*, 1995.

however, by the backdoor, to use Troy Duster's characterization.[12] Goodwin's comments provided a public glimpse into the more sinister directions of aggression research as a whole. The NIMH portfolio represents a mere sliver of the violence research pie. A broader view of this multidisciplinary field reveals that cultural and sociological explanations have been virtually eclipsed by individualizing frameworks. Among the latter, behavioral genetics and a retooled biocriminology advance the cause of hereditarianism through twin and adoption studies of criminality and mental illness. Experimental psychology and neuropsychiatry focus on identifying the neurological or physiological substrates of "personality traits" presumably conducive to criminality, for instance, aggressiveness, impulsivity, fearlessness, guiltlessness, the inability to defer gratification (all culture-bound notions, but treated as timeless essences in the literature). Common to this broader enterprise is the dream that "violence-prone" individuals will eventually be detected through biological markers.

To follow the logic of biobehavioralism, (defective) biology constructs (a defective) society. One may well ask how it is that biobehavioral scientists so easily dispose of social structure in research on anti*social* behavior. The answer is that they do not. Social structure does have a place in the biological paradigm— as an intervening variable. As such, it is effectively emptied of any significance in the construction of social behavior. But again, this disappearing act is accomplished through slightly more complex means than resorting to apocalyptic

invocations of the Darwinian swamp. The obscene invective of evolutionist entre-preneurs like Charles Murray, Richard Herrnstein, Robert Wright, and their cadre in the sociobiology camp has sparked widespread criticism and extensive cov-erage in mainstream media. The vast majority of biological research, however, neither makes much use of evolutionary constructs nor engages in social the-orizing. Instead, behavioral scientists are absorbed in the conventional pursuits of their discipline—data collection and interpretation. On the surface, at least, their work appears uncontroversial. It is precisely this nameless, faceless research, conducted under the imprimatur of Big Science, on which loose can-nons like Frederick Goodwin rely while otherwise conjuring species suicide. Although structurally related to earlier forms, the new biological determinism is shrewder than vulgar craniometry, and is abetted by ideologically "pure" tech-nical advancements like brain imaging. Because of this, and because it responds to anxieties specific to our cultural moment, biobehavioral research has received the generous endorsement of the scientific establishment and uncritical accep-tance by the media. Its appeal is enhanced by the promise of enormous economic return in the form of new technologies and pharmaceuticals.

Goodwin's speech before the American Psychiatric Association illustrates the seductiveness of the new biological determinism, for what is interesting about his excursion through the minefield of violence research is what did *not* offend public sensibilities. In a rhetorical dodge typical of biobehavioralists, Goodwin stakes a "reasonable" position between the extreme poles of envi-ronmental and biological determinism: "Biology versus psychosocial is anachronistic. The question is how do psychosocial forces and biological fac-tors interact with each other." But all of this is so much hot air. Environmental etiological factors are duly noted—substandard housing, decaying infrastruc-ture and the collapse of community networks, drugs, alcohol, guns, family "disharmony" and divorce, parental rejection and abuse. However, these are relevant chiefly for their impact on susceptible individuals: "the environment does not cause one to be violent or to develop a criminal record if there isn't a vulnerability already there, but if there is a vulnerability already there certainly a bad environment can amplify it." Artlessly formulated, but he makes his point. Delinquents are distinguished from nondelinquents by biological vulnerabilities activated by "environmental poisons." For instance, children may respond to one such poison, abuse, by exhibiting "negative behaviors" such as aggression and poor impulse control. But, according to biobehavioralists, their *capacity* to be aggressive or impulsive resides in low serotonin levels, high androgen levels, neurological deficits, or psychiatric disorder (assumed to be innate).

Moreover, "a hypothesis that needs to be considered [is] that the abusing parent is manifesting an impulsivity, a violence trait which is transmitted to the abused child genetically [and] increases the child's risk of later violence." And so on, until abuse loses all meaning as a social act inflicted on one social actor by another more powerful social actor. Instead, "particular biological evidence suggests that [conduct-disordered children] have more problems with their behavioral inhibition system. Now how did they get that way?"

How indeed? This is, of course, the central question: who and what is to blame for children's "disorder"? Framing children as malignant carriers has both emotional and ideological appeal. Abusive parents would no doubt be ardent enthusiasts of the idea. The abused child, along with the poor (black) child, is an iconic figure in bioresearch (in fact, any child ready to point an accusing finger at the system). That the abused child and the poor child are not necessarily the same entity perhaps explains why biocriminologists, among others, devote so much energy to neutralizing the effects of maltreatment. Winging through the literature on neurotransmitters, brain injury, twin studies, ad nauseam, Goodwin neglects to mention that almost every study cited—his *evidence*—is conjectural and subject to methodological criticism. But the provisional nature of bioresearch (replications are always just around the corner) rarely induces reflection. In a better world, the negative behaviors of *bio-behavioralists*—impulsively generalizing from small population samples, aggressively promoting spurious data, callously reducing children's pain to neural static—would earn them a diagnosis of antisocial personality disorder.

Lurking in the background of all discussions of childhood behavior disorders is the dread APD, popularly referred to as psychopathy. As a diagnostic category, APD has a long and contentious history.[13] As a cultural construct, it represents psychiatry's attempt to pathologize norm violation. APD is the psychiatric term for chronic disturbance in an individual's relation to society. It is also the psychiatric dumping ground for incorrigibles, a diagnostic category applied to rogue males, measured against the yardstick of bourgeois masculinity.[14] But the terms of its application are fluid, shifting with the social context. The psychopathic construct makes its first appearance in France and the United States in the aftermath of the bourgeois revolutions. A second wave of interest, from the 1860s through eighties, coincides with a period of fierce class conflict and mass immigration. The juvenile delinquent panic of the 1940s and fifties provides the context for a third resurgence of interest in psychopathy. Finally, in the 1980s, the psychopath is seen prowling in ever-increasing numbers through the suburban junkyards and inner-city wreckage of postindustrial America.

APD's history begins in 1801, as a special class of insanity, with the French alienist Pinel. Confronted with the case of a young nobleman given to violent outbursts, yet otherwise in full possession of his reasoning faculties (that is, free of delusions), Pinel concocted a new psychiatric classification, *manie sans délire*. Following Pinel's account, sightings of similarly enigmatic temperaments begin to appear regularly in the psychiatric records. In 1812, Benjamin Rush, an American physician and signer of the Declaration of Independence, applied the phrase "moral derangement" to "persons of sound understandings, and some of uncommon talents who are affected with [a] lying disease in the will. . . . Persons thus diseased cannot speak the truth upon any subject. . . . The moral faculty, conscience, and the sense of deity are sometimes totally deranged." The disease, according to Rush, was congenital, an "innate, preternatural moral depravity."[15] Two decades later, the English physician J.C. Prichard described personalities in whom "the power of self-government is lost or greatly impaired and the individual is found to be incapable, not of talking or reasoning upon any subject proposed to him, but of conducting himself with decency and propriety in the business of life."[16] For these reprobates, Prichard fashioned the term "moral insanity."

Over the next hundred years, clinicians elaborated the symptomatology of this disorder, variously labeled moral imbecility, moral idiocy, constitutional ethical aberration, constitutional immorality, defective delinquency, psychopathy, and sociopathy. In particular, they noted in their morally insane patients a malicious delight in violating social norms, recklessness, excessive passion, a refined talent for deception, licentiousness, boastfulness, extravagance, eccentricity, arrogance, criminal propensities (running the gamut from colossal fraud to sadistic murder), impulsivity, a childish desire for immediate gratification, and indifference to punishment, none of which could be "explained" by a shortage of intelligence or rationality. Central to this clinical confusion is the figure of a diabolical man—*the psychopath*, as he would eventually be called—shamelessly flaunting his irresponsible habits, dangerously impervious to social criticism, utterly lacking in regard for others. Worse, he liked himself—a fact both insulting and incomprehensible to his virtuous custodians.

Moral defect, of course, is at the heart of nineteenth-century explanations for "deviance," that is, poverty, insanity, rule-breaking, and so forth. In the latter part of the century, clinicians refined the picture of moral insanity as a congenital disease, reflected in nomenclature like "moral imbecile" or "constitutional defective" and compatible with prevailing Spencerian perspectives. This move coincides with increasing disenchantment with the use of moral

Sitting Bull

insanity in the courts. Some worried that diagnosticians were confusing their work with what was more properly police business. From Prichard's original sketch, moral insanity had grown to encompass a special group of individuals who, though rational, perpetrated appalling crimes. Previously considered "merely vicious," they were now treated as mentally disturbed men who had "lost their ability to accept society's judgments about what constituted moral behavior."[17] This "loss" constituted their illness. Critics protested that mere "depravity" was being confused with mental disease, and the successful use of moral insanity as a defense in criminal trials prompted a crusade to undermine its legitimacy. In 1881, the conviction of President Garfield's assassin, Guiteau—judged both morally insane *and* criminally responsible—deflated the psychiatric profession's ambition that its purview would extend to the policing of social malfeasance in the absence of classic symptoms of lunacy.

From then on, clinicians feverishly attacked the problem of clarifying a discrete diagnostic entity. In the process, moral insanity was gradually transformed from mental illness to innate or "instinctive" character defect (ultimately, personality disorder), afflicting a special class of individuals and manifested in *chronic, unmotivated* misconduct or antisocial behavior. Moral turpitude, then, remained an object of clinical scrutiny, but only if persistent. For instance, in 1883, the Scottish physician T.S. Clouston differentiated two entities, both properly regarded as morally insane: first, the gentleman who has briefly "lost

his moral sense" (and, presumably, can retrieve it), and second, moral idiots, children "so constituted that they cannot be educated in morality on account of an innate brain deficiency." It was this "want of development" that predisposed the moral idiot to antisocial/criminal acts, among other distasteful conduct.[18]

Clouston's distinction leaves room for benign legal treatment of the respectable gentleman who, struck with a temporary bout of moral insensibility, defrauds the insurance company or murders his wife. The congenitally afflicted street urchin, on the other hand, lies beyond domestication and must be placed permanently in stir, for the protection of society. Naturally, given the historical moment, hereditarian precepts and psychiatric concepts toiled together in mutually vivifying ways. The moral idiot or imbecile—unrestrained by "right thinking" or "sober habits"—closely resembled Cesare Lombroso's "born criminal," in whom guilt, responsibility, self-control, and modesty were singularly lacking. "Moral Daltonism" referred to special cases of moral insanity in which the afflicted evinced no awareness of wrongdoing. In such cases, the prognosis was negative:

> Let us accept this moral imbecility as the incurable infirmity of an irresponsible victim, to whom, as the piteous crossbearer of the sins of society, we owe kindly nursing, and protection against himself by a grateful and total withdrawal from the community, which, in its turn, has a right to demand that he shall not scathe our common stock with permanent taint in blood and morale.[19]

After the turn of the century, and until the delinquency panic of the 1940s and fifties, speculation on psychopathy fell into a period of relative quiescence, with occasional forays into the diagnostic morass. Most significantly, G.E. Partridge introduced the concept of sociopathy in 1930, with "criminality, vagabondage, [and] habitual idleness" the cardinal presenting symptoms.[20] Then, amidst the flurry of research prompted by the delinquency "epidemic," the American Psychiatric Association officially adopted first sociopathy (in 1952), then antisocial personality disorder (in 1968) to describe the psychopathic entity. However, psychopathy remained the preferred term for those predisposed to organic explanations.

For most clinicians, acts of an "outrageous character," in particular criminal acts, remained the hallmark of the disorder, propelled by an obtuse rejection of the social contract. (The image of psychopathy as a gratuitous renunciation of all things civilized was enshrined in Robert Lindner's psychoanalytic study of 1944, *Rebel Without a Cause*.[21]) By the decade of the delinquent, the

psychopath had become a social menace of enormous proportions. Along the trajectory from *manie sans délire* to APD, as clinicians labored to establish a set of enduring traits characteristic of the disorder, a vast array of personality deficits had accumulated in the body of the psychopath. Several defining features remained stable, namely, the triumvirate of guiltlessness, moral degeneracy, and impulsivity. But in the face of such an amorphous creature, the list of sins expanded rather than contracted. We find lovelessness and a stunning lack of affect in the McCords' study, *Psychopathy and Delinquency*. For Lindner, the indicia of this "peculiar variety of behavior" included "nomadism" and senseless rebellion: "the psychopath, like Johnstone's rogue-elephant, is a rebel, a religious dis-obeyer of prevailing codes and standards." For Benjamin Karpman, "psychopaths do not and seemingly cannot develop those binding emotions and tender attachments which lie at the very basis of human evolution and our whole social structure," presumably because of their "utter and complete selfishness . . . of a primitive, even savage, kind. . . ." According to Hervey Cleckley, the psychopath's most perverse feature was his ability to pass for the boy next door: "There is nothing at all odd or queer about him. . . . He looks like the real thing." It was this "mask of sanity" that made the psychopath so difficult to detect, hence so threatening to the social order.[22]

The *Diagnostic and Statistical Manual* simplified matters: the psychopath was fundamentally *un*socialized.[23] But what caused the disorder? Needless to say, few situated the psychopath in a social reality. Some clinicians spoke with confidence of a biological mechanism, but the specific workings of this mechanism were ill-defined. Bafflement is the more common clinical reaction to the psychopath, obsessively referred to as inexplicable. This obnoxious (some would say, sham) perplexity licensed the mulish attachment to underlying syndromes. Thus, tramps ride the rails, not because a cataclysmic economic depression has thrown them out of work, but to satisfy a perverse pleasure in vagabondage arising from "defective inhibition." The "delinquent" runaway is impelled by a congenital contempt for authority, not the nightmare of savage beatings. Psychopathy may be a social menace, but its causes precede the social order. Diagnostic categories do not, however. Clearly, the psychopathic construct has tremendous value as an instrument of social control, consigning the grievances of the "vicious classes" or unruly adolescents to the psychiatric dustbin.

But its versatility extends beyond the policing of ill-bred incorrigibles. Early American conceptions of mental disorder were profoundly linked to antimodernist sentiment. Ideologically handicapped by a commitment to a Christian-Jeffersonian model of village stability, clinicians assumed mental disorder was

indirectly induced by the pressures of civilization—that is, urbanization, industrialization, capitalism itself—and all its attendant "temptations." Edward Jarvis, a nineteenth-century physician, expressed the mix of antidemocratic, patriarchal sentiment and nostalgia for an agrarian ideal common among his colleagues:

> In this country, where no son is necessarily confined to the work or employment of his father, but all the fields of labor, of profit, or of honor are open to whomsoever will put on the harness . . . the ambition of some leads them to aim at that which they cannot reach, to strive for more than they can grasp. . . . In an uneducated community, or where people are overborne by despotic government, or customs, where men are born in castes and die without ever overstepping their native condition, where the child is content with the pursuit and the fortune of his father . . . there these undue mental excitements and struggles do not happen.[24]

This vision of insanity, a mental mirror of the chaos clinicians saw around them in a "permissive" social climate, suggests other fears haunting the purveyors of moral management. As character disorder, first moral insanity, then psychopathy represent the negative pole of bourgeois masculinity, cultivated and unleashed by the excesses of capitalism. This is evident in early descriptions of the morally deranged: the gentleman of formerly "sober and domestic habits, frugal and steady in his conduct" who erupts into violence or commits a spectacular fraud, the wayward offspring of "genteel citizens," who prefer a life of adventure to steady employment. In short, psychopathy is anarchy—against respectable fathers, against the work ethic, against self-denial, against bourgeois identity itself—emanating from the dark interior of Bourgeois Man. Cleckley's view of the psychopath's most bewildering trademark—*he looks like one of us*—reminds us that psychopathy, as a diagnostic category, functions to contain class-gender traitors and expel counterfeits.

With all this in mind, let us return to present-day formulations of antisocial personality disorder, in particular, the work of two influential biocriminologists, Robert Hare and Sarnoff Mednick.[25] Among other activities, Hare participated in the field trials on antisocial personality disorder conducted by the American Psychiatric Association in preparation for the 1994 revisions to the *DSM*. Mednick is a dogged promoter of biogenetic research on criminality. Like Goodwin, each indulges in the kind of soothsaying-cum-cultural theorizing that explodes the myth of objective science. In each, the implicit biologism of the psychopathic construct is furbished with an eighties gloss, resurrecting the moral idiot for popular consumption.

Hare began his work on psychopathy—"a dark mystery with staggering implications for society"—by developing a clinical instrument, the Psychopathy Checklist, to identify "true psychopaths" in prison populations. For Hare, the psychopath represents a far greater threat to the social order than the garden-variety jailbird who "merely breaks the rules." The danger arises from the psychopath's stunning (congenital) deficits, in particular, an incapacity for empathy and a lack of "conscience" (the current biobehavioral euphemism for "morality"). The checklist, designed to expose these "psychopathic traits" in an individual, would enable researchers to ferret out the genuine recalcitrant, or so Hare claims.[26]

Gunning for the true criminal psychopath is one mission among many. The "youthful psychopath" is Hare's principle quarry. As an experimental psychologist, Hare outlines the parameters of research on antisocial behavior in the superficially neutral tone of the social scientist. As a cultural critic, he deploys the scare tactics and cynical manipulations typical of biocriminologists. In *Without Conscience*, a kind of self-defense manual against the predations of psychopaths, Hare cites preposterous numbers (no source given) on the enemy presence: "there are at least 2 million psychopaths in North America; the citizens of New York City have as many as 100,000 psychopaths among them," ensnaring "innocents" in their larcenous and/or murderous exploits. Framing the problem as one of a society held hostage to the iniquities of moral

deficients, Hare calls for drastic preventive measures. It is here that the Spartan order so dear to biobehavioralists is clearly revealed. To avert the psychopathic menace, detection efforts must begin in the earliest years, in "predelinquency." Although Hare treads rather delicately on this topic, his goal is clear: to incorporate screening procedures for psychopathy into the everyday practices of diagnosticians of childhood disorders. He presents two case studies of children, "Jason" and "Adorable, Terrifying Tess," who, as toddlers, are assaulting siblings, parents, and family pets with intent to kill. By the end of this chilling narrative of three-year-olds run amok, the reader will agree to anything, including the most invasive forms of "prevention" such as psychosurgery.

Occasionally, Hare seems to recognize that the traits he identifies as typical of the psychopath are perfectly consistent with a patriarchal-capitalist social structure—at which point he hurriedly emphasizes the hopelessness of looking to that social structure for explanations. Sociocultural factors receive the standard dismissive gloss. To wit, a society in crisis (ours, unquestionably) provides "lucrative feeding grounds" for the psychopathic predator, much as the early American republic unloosed an epidemic of moral derangement. The family is blameless. Quoting liberally from the fifties' best-seller, The Bad Seed ("This novel is remarkably true to life"), Hare places parents at the receiving end of their mutinous child's wrath: "The parents of a psychopath can do little but stand by helplessly and watch their children tread a crooked path of self-absorbed gratification accompanied by a sense of omnipotence and entitlement." Social factors and parenting practices influence psychopaths only in the way the disorder develops and is expressed in behavior. So, a stable family will produce a con artist or a white-collar criminal, while a "deprived and disturbed background" produces a murderous thug or rapist. Finally, Hare makes children responsible for their own abuse: "While some assert that psychopathy is the result of attachment difficulties, I turn the argument around: In some children the very failure to bond is a symptom of psychopathy."[27]

Convinced that the psychopath's "social insensitivities and core attributes are more the result of constitutional (perhaps genetic) factors," Hare proposes that the central problem is a physiological incapacity to be properly socialized.[28] And what are the components of this socialization process?

> Socialization . . . contributes to the formation of what most people call their conscience, the pesky inner voice that helps us to resist temptation and to feel guilty when we don't. Together, this inner voice and the internalized norms and rules of society act as an "inner policeman," regulating our behavior in the absence of the many external controls, such as

laws, our perceptions of what others expect of us, and real-life policemen. . . . However, for psychopaths. . . . the social experiences that normally build a conscience never take hold.[29]

For biobehavioralists like Hare, these conscience-producing experiences consist of the learning of fear and anxiety. Based on a conditioning model, Hare's brand of research on psychopathy relies on inferences drawn from experiments with aversive or painful stimulation.[30] For instance, a laboratory subject is informed that in sixty seconds he will receive an electric shock. Researchers then assess the subject's capacity for "anticipatory fear" by measuring pulse rate or skin conductance (that is, perspiration). A sluggish reaction time presumably indicates fearlessness. Numerous experiments like this have been performed on "psychopaths" with the aim of demonstrating the physiological basis for their lack of "conscience." Hare himself has acknowledged the contradictory and inconclusive results of such studies. Nevertheless, he continues to support the basic assumptions behind the fear-anxiety paradigm:

> We don't know why the conscience of the psychopath—if it exists at all—is so weak. However, we can make some reasonable guesses:
>
> Psychopaths have little aptitude for experiencing the emotional responses—fear and anxiety—that are the mainsprings of conscience. In most people, early childhood punishment produces lifelong links between social taboos and feelings of anxiety. The anxiety

associated with potential punishment for an act helps to suppress the act. . . . [But] in psychopaths, the links between prohibited acts and anxiety are weak, and the threat of punishment fails to deter them.[31]

The unself-conscious authoritarianism of biocriminology's research on psychopathy extends to its approach to antisocial behavior in general. The bleak world envisioned by Hare, in which punishment is the primary tool of socialization, is a world of self-denial, guilt, and shame. This is biocriminology's ideal world.

Take the work of Sarnoff Mednick, who would return us to the conceptual swill of nineteenth-century elaborations of moral insanity, in which monogamy and mortgage payments become the equivalent of "law-abiding behavior." For Mednick, the moral—divinely ordained—*is* the social. Citing the Ten Commandments as the cornerstone of "civilized behavior," Mednick astutely observes that the "major thrust of the message is negative—'thou shalt *not*.' . . . " Because people have a tendency to "exhibit aggressive, adulterous, and avaricious behavior," children must be taught to "*inhibit* impulses leading to transgression of those codes." The family is the principle "censuring agent" in this training regimen, administered in one of three ways: through modeling, positive reinforcement, or negative reinforcement. The first two are thrown out on cost-benefit grounds:

> If our civilization had to depend solely on modeling . . . it is conceivable that things might be even more chaotic than they are today. It is also possible to use positive reinforcement to teach inhibition of forbidden behavior; but again, reinforcing a child 24 hours a day while he is *not* stealing seems a rather inefficient method and not very specific.

Given that love is impractical and children—native delinquents that they are—cannot be trusted to automatically adopt the "standards" of their parents, the "childhood learning of the avoidance of transgression (i.e., the practice of law-abiding behavior) demanded by the moral commandments" is most effectively accomplished by "producing a bit of anticipatory fear in the child." If the "fear response is large enough, the extended fingers will relax and the stealing impulse will be *successfully inhibited*."[32]

Notably, researchers of delinquency unshackled by the biological paradigm have consistently noted the presence of a physically brutal, emotionally cruel, and competitive father who demands total compliance from his son, intimidating him with the constant threat of punishment— the very form of "discipline" so crucial to the social order envisioned by biocriminologists. I am not suggesting that childhood abuse "causes" antisocial behavior (although it is certainly one

of the critical "environmental poisons," the rational response to which has been pathologized as disorder). What I am suggesting is that in the upside-down world of biocriminology, in which fear and anxiety integrate citizens into the social order, and discipline equals love, it is unlikely that abuse would even be recognized as such. Instead, in the patriarchal family, biocriminologists see the optimum ingredients for the construction of a well-functioning inner cop.

The bedlam of scientific research on antisocial behavior reveals a few coherent narratives. Here, I have focused on strands in biocriminology pertaining to children, in particular boys. Earlier I suggested that the scope of this research was more complex than recognized in initial criticisms generated by Goodwin's comments, specifically that biobehavioralism has a meaningful interest in policing the behavior of white boys. Does the inclusion of white boys—and many middle-class boys at that—as subjects make biobehavioral research any less problematic? No, but it does indicate that this research is underwritten by multiple social tensions, not well understood unless we are attentive to the current (perceived) crisis of bourgeois masculinity and parental authority. There is no question that the spector of "underclass" violence looms large in the minds of researchers, evidenced by the ritualistic invocation of urban crime. Neither is there any doubt that biocriminology serves the postindustrial order by disavowing its devastating impact on inner-city neighborhoods and working-class suburbs. On the other hand, if it can be said that the underbelly of racism is apprehension about preserving one's own culture—in this case, white, bourgeois, heterosexual, masculinist culture, perceived to be in decline—the individualizing tactics of biobehavioralism become a strategy for assuring future dominance by enforcing conformity. After all, if white boys are *out of control*, how can they be expected to *maintain control* as white men? An earlier generation of wardens was bedeviled by the spector of "permissiveness" afflicting their very own. Pathologizing the problem both contained it and shored up a tenuous bourgeois identity-in-formation. As cultural constructs, the new disorders of conduct reflect similar anxieties and offer similar solutions. Putting kids on Ritalin seems a small price to pay when the future of "civilized behavior" is at stake.

In the present climate of rabid family preservationism, an emergent parental rights movement, and the vision of authoritarian family government perpetrated by Christian nationalists, it should not be surprising that biobehavioralism explicitly defends the patriarchal family. Echoing the ruthless convictions of Christian fundamentalists who recommend "breaking the child's will" by

PHILOMENA MARIANI

whatever means necessary, or the blighted orthodoxy that social catastrophe follows from "indulgent parenting," biocriminologists conceive of children as natural enemies of the social, by which they mean *authority*.[33] Moreover, feminist activists and a spectacularly successful child protection movement have forced into public awareness both the prevalence and the deleterious effects of abuse, among them, mental illness and the learning of violent behavior. In the process, they have politicized the family, exposing its unequal power relations, questioned customary notions of discipline, and challenged parental privilege in dispensing punishment. Biocriminologists, by undermining the validity of research connecting violence against children to other social problems, by denying the existence of abuse *in toto*, and by evacuating the political context of "parenting practices," rescue parents from unpleasant reflections on their own culpability. This is surely one reason why the new biological determinism is so persuasive.

Biocriminologists are right about one thing: patriarchs are perfectly suited to the task of frightening children into submission. Science is doing its part to insure that children will learn to settle for less, indeed, to strip them of any sense of entitlement. Biobehavioral conceptions of "adjustment, "socialization," "law-abiding behavior," "antisocial," "misconduct"—mirrored in diagnostic categories and clinical evaluative instruments—reflect, more than anything else, attempts to constrain children's ability to narrate their own stories, reducing them to mere ciphers of adult expectation and desire.

NOTES

1. *New York Times*, Aug. 24, 1994.

2. For a review of this research (the bulk of it conducted since 1980), see National Research Council, *Understanding and Preventing Violence*, esp. vol. 2, *Biobehavioral Influences* (Washington, D.C.: National Academy Press, 1994).

3. See, for example, Russell A. Barkley, "Attention Deficit Hyperactivity Disorder," *Psychiatric Annals* 21 (December 1991): 725–33; Rachel G. Klein and Salvatore Mannuzza, "Long-Term Outcome of Hyperactive Children: A Review," *Journal of the American Academy of Child and Adolescent Psychiatry* 30 (May 1991): 383–87; and *Newsweek*'s cover story on ADHD, July 18, 1994.

4. For the constellation of symptoms, see American Psychiatric Association, *Diagnostic and Statistical Manual of Mental Disorders: DSM-IV* (Washington, D.C.: APA, 1994), pp. 78–94.

5. Frederick Goodwin, "Conduct Disorder as a Precursor to Adult Violence and Substance Abuse: Can the Progression Be Halted?" Unpublished transcript, APA Annual Convention, May, 1992, p. 6.

6. Transcript of comments delivered at a meeting of the National Mental Health Advisory Council, Feb. 11, 1992; see *New York Times*, Feb. 22/28, 1992.

7. *Los Angeles Times*, Apr. 24, 1992.

8. *New York Newsday*, Sept. 28, 1992.

9. For conclusions and recommendations of the panels, see U.S. Department of Health and Human Services, *Report of the Secretary's Blue Ribbon Panel on Violence Prevention* (Washington, D.C., January 1993), and National Institutes of Health, *Report of the Panel on NIH Research on Antisocial, Aggressive, and Violence-Related Behaviors and Their Consequences* (Bethesda, Md., April 1994). Descriptions of each project in the portfolio were compiled for the review process and made available to interested members of the public by the Division of Science Policy, National Institutes of Health.

10. Given the increasing tendency to view childhood attention deficit and hyperactivity as chronic conditions predisposing to adult antisocial behavior, federally sponsored violence research must be scrutinized in relation to the government portfolio on ADHD, containing some forty-odd projects. Again, most of this research targets white male children, and features several drug trials and significant interest in identifying a neurobiological basis for attentional problems, frustration tolerance, and impulse control (23 of the 40 projects are biobehavioral). The latter two concepts are central to theoretical and diagnostic formulations of antisocial personality disorder.

11. Sarnoff Mednick, "Human Nature, Crime, and Society," *Annals of the New York Academy of Sciences* 347 (1980): 336, 338, 345.

12. Troy Duster, *Backdoor to Eugenics* (New York: Routledge, 1990).

13. For historical surveys and debates, see the following: Michael Craft, *Ten Studies into Psychopathic Personality* (Bristol: John Wright & Sons, 1965); Sydney Maughs, "A Concept of Psychopathy and Psychopathic Personality," *Journal of Criminal Psychopathology* 2 (1941): 329–56, 465–99; Norman Dain and Eric T. Carlson, "Moral Insanity in the United States, 1835–1866," *American Journal of Psychiatry* 118 (1962): 795–801; William and Joan McCord, *Psychopathy and Delinquency* (New York: Grune & Stratton, 1956), pp. 20–34; and G. E. Partridge, "Current Conceptions of Psychopathic Personality," *American Journal of Psychiatry* 10 (1930): 53–99. I am focusing here primarily on the Anglo-American discourse of psychopathy. The clinical entity of psychopathy, first called "moral insanity," now antisocial personality disorder, should not be confused with "sexual psychopathy," a related but distinct diagnostic category. For an excellent discussion, see Estelle B. Freedman, "'Uncontrolled Desires': The Response to the Sexual Psychopath, 1920–1960," *Journal of American History* 74 (June 1987): 83–106.

14. Women are rarely diagnosed as psychopathic; when they are, the diagnosis is usually based on transgressions against reproductive sexuality: i.e., lesbianism, rejection of marriage, sexual promiscuity, prostitution. See Hervey Cleckley, *The Mask of Sanity* (St. Louis: C.V. Mosby, 1941), for examples.

15. Craft, *Ten Studies into Psychopathic Personality*, p. 8.

16. McCord and McCord, *Psychopathy and Delinquency*, p. 21.

17. Dain and Carlson, "Moral Insanity," p. 795.

18. Craft, *Ten Studies into Psychopathic Personality*, pp. 9–10.

19. Maughs, "A Concept of Psychopathy," pp. 347, 351.

20. Partridge, "Current Conceptions," p. 55.

21. Robert M. Lindner, *Rebel Without a Cause: The Hypnoanalysis of a Criminal Psychopath* (New York: Grove Press, 1944).

22. Ibid., p. 2; Maughs, "A Concept of Psychopathy," pp. 347, 351.

23. American Psychiatric Association, *Diagnostic and Statistical Manual of Mental Disorders: DSM-II* (Washington, D.C.: APA, 1968), p. 43.

24. Quoted in David J. Rothman, *The Discovery of the Asylum* (Boston: Little, Brown, 1971), p. 115.

25. Cf. Robert D. Hare, "Psychopathy and Physiological Activity during Anticipation of an Aversive Stimulus in a Distraction Paradigm," *Psychophysiology* 19 (1982): 266–71; Robert D. Hare, "Twenty Years of Experience with the Cleckley Psychopath," in *Unmasking the Psychopath*, ed. William H. Reid et al. (New York: Norton, 1986); Sarnoff Mednick et al., eds., *The Causes of Crime: New Biological Approaches* (Cambridge: Cambridge University Press, 1987); Sarnoff Mednick and Jan Volavka, "Biology and Crime," *Crime and Justice* 2 (1980): 85–158. Mednick's genetic studies on criminality are included in *The Causes of Crime*, pp. 74–93.

26. Robert D. Hare, *Without Conscience: The Disturbing World of the Psychopaths Among Us* (New York: Simon & Schuster, 1993), pp. 1–2.

27. Ibid., pp. 156, 172–73.

28. Hare, "Twenty Years of Experience," p. 12.

29. Hare, *Without Conscience*, p. 75.

30. For examples of stimulus-aversion research, see Robert D. Hare and Daisy Schalling, eds., *Psychopathic Behavior: Approaches to Research* (Chichester: Wiley & Sons, 1978). For the canonical text on fearlessness, see David T. Lykken, "A Study of Anxiety in the Sociopathic Personality," *Journal of Abnormal Psychology* 55 (1957): 6–10, and Lykken's popularization, "Fearlessness: Its Carefree Charm and Deadly Risks," *Psychology Today* (September 1982): 20–28.

31. Hare, *Without Conscience*, p. 76.

32. Mednick, "Human Nature, Crime, and Society," pp. 343–44.

33. For a review of current fundamentalist conceptions of child discipline, see Philip Greven, *Spare the Child: The Religious Roots of Punishment and the Psychological Impact of Physical Abuse* (New York: Alfred A. Knopf, 1991), pp. 60–81.

SIMON WATNEY

GENE WARS

INTRODUCTION

One of the most immediate challenges that faces the academy in
relation to the AIDS crisis is the remarkable authority given to behavioral social
psychology in the area of HIV/AIDS education. In recent years, social psycho-
logical research has thoroughly dominated public HIV/AIDS education policy. This
is surprising, because social psychology, which is geared primarily toward seek-
ing invariant determinants for human sexual behavior, lacks any concept of
desire, and is unable to recognize such fundamental emotions as ambivalence,
conflict, projection, or defensiveness. Instead, sexual behavior is understood to
be "modifiable," and obstacles to modification must be identified and removed.

This bulldozer approach to actual human sexuality has caused untold harm throughout the length and breadth of AIDS research and policy-making.[1]

In this essay, I want to explore some aspects of a similar challenge facing us from sociobiology, an academic domain that advances hand-in-hand with contemporary genetic determinism, a field known primarily through the Human Genome Project. The purpose of the Genome Project is to identify the supposed genetic determinants of every human variable, from career choice to cross-dressing. The Genome Project offers reassurance that science can still, at the last minute, save the world. As R.C. Lewontin has dryly observed:

> The rage for genes reminds us of Tulipomania and the South Sea Bubble in McKay's *Great Popular Delusions and the Madness of Crowds*. . . . What we had previously imagined to be messy moral, political, and economic issues turn out, after all, to be simply a matter of an occasional nucleotide substitution. While the notion that the war on drugs will be won by genetic engineering belongs to Cloud Cuckoo Land, it is a manifestation of a serious ideology that is continuous with the eugenics of an earlier time.[2]

In the dominant HIV/AIDS social-science discourse, any sexual behavior that carries any risk of HIV transmission for gay men is still routinely theorized as "relapse" and evidence of "denial." These two monolithic terms sum up the way behavioralism imagines the choices facing gay men in our everyday sex lives at the height of an epidemic which has already left 50 percent of gay men infected in some U.S. cities. It is useful to consider how contemporary genetics regards sexuality, since the views of geneticists about what "causes" human sexual variance feed powerfully into public discourse.

Scientific and social-scientific debates about the nature and causes of sexuality play a crucial role in legitimating public policies and in sustaining the ongoing, catastrophic neglect of those at greatest risk from HIV.[3] Even more, this debate has recently centered on the supposed "hardwiring" of homosexual object-choice to identifiable genetic determinants, raising the possibility of genetically "guaranteeing" heterosexuality through the abortion of genetically identified "homosexual" fetuses. Because this debate has such a high public profile, it has profound implications for the way Anglo-American society is encouraged to think about sexuality and gender.

QUEER GENES

In August 1993, the Washington-based Human Rights Campaign Fund (HRCF), a leading U.S. lesbian and gay rights organization, issued a press packet to some eight thousand leading "opinion formers" on Capitol Hill. This packet included a

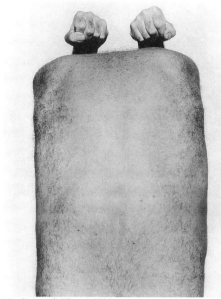

John Coplans, *Self-Portrait*, 1984.

lengthy article from *Atlantic Monthly* called "Homosexuality and Biology," by one Chandler Burr.[4] HRCF Communications Director Gregory King exhorted editors and journalists to "carefully read this article, which rebuts the erroneous assertions that homosexuality is 'chosen' and that being lesbian or gay is a 'preference' rather than a deeply rooted and unchangeable orientation."[5] Claiming that homosexuality has "always been volatile" and "sure to continue to inflame political passions," Burr wrote from within a universalizing discourse that speaks confidently of "homosexuals," their beliefs, and their behavior. His article sets out many of the beliefs that inform the recent, curious adoption of genetic determinism by significant sections of the American lesbian and gay political movement.

In Burr's account, biology is regarded as having delivered the long-awaited "explanation" of homosexuality, after a full century of psychiatric research had failed. It does not seem to have occurred to him that there might be other fields of intellectual practice with valuable things to say on the subject. Burr apparently believes that genetics and a pathologizing model of psychiatry can tell us all we need to know about sexuality. Of course, none of this is exactly new, since behaviorism has long enjoyed a far greater influence within American popular culture than in other Anglophone countries, such as Britain or Australia. The promise of a "gay gene," however, has somewhat changed the situation, by focusing vast amounts of mass-media attention on the subject, often in the crudest and most reductive ways.

SIMON WATNEY

This recent flurry of international mass-media interest in so-called "gay genes" was triggered in the early 1990s by widespread reports on the work of the ceaselessly self-promoting British neurobiologist Dr. Simon Levay. Claiming to have discovered measurable anatomical differences between the brains of gay men and those of straight men, Levay immediately sought to use this research to advance his own political message. He believed that once politicians (and others) realized that homosexuality is genetically determined, and thus not a matter of "choice," they would abandon their prejudices, and grant equal rights to lesbians and gay men—at least in Levay's adopted home, the United States.

This is the message enthusiastically and uncritically being promoted by the Human Rights Campaign Fund. Predictably enough, the media's response to Levay's own work, and that of his colleagues, gives short shrift to any delusion that science can deliver neutral judgments which might exercise an immediate and lasting influence in the fields of politics, ethics, and debates about morality. For example, the *Daily Mail* summarized U.K. media attitudes with this shockingly transparent headline: "Abortion hope after 'gay genes' findings."[6]

The scientific methodology informing Levay's research has been extensively criticized elsewhere.[7] In this essay, I want to focus on the reception of this body of research in the British press, in order to demonstrate that seemingly neutral scientific research concerning sexual orientation is culturally inseparable from a widely held but rarely frankly stated wish on the part of many heterosexuals: to be able to choose the sexuality of their offspring. Levay's work is rooted in a simple, dualistic theory of human sexuality, according to which sexual object-choice is a fixed and immutable biological given. Nor does his work register any trace of awareness that identity does not necessarily or automatically follow sexual desire or even behavior.

Levay is a painfully orthodox sociobiologist. He believes that the "gay gene" is passed on in families because "people who have gay genes might somehow be helping the reproductive success of their relatives."[8] He also believes that gay men naturally:

> gravitate to professions that demand more creative, caring traits. That's probably biological. [Hairdressing] requires a sort of creativity just like flower arranging does. Part of that might be environmental, but I think it's also in part the way their brains develop.[9]

Levay's acquaintance with psychoanalysis is best summarized in his view of Freud as: "A scourge. Absolutely. He started the idea that homosexuality was a state of arrested development caused by defective parenting."[10]

Behind this barrage of fatuous biological determinism lies the naive hope

Barbara Kruger, *Untitled (Your Manias Become Science)*, 1981.

that, by recourse to the supposedly neutral and disinterested voice of science, we might resolve once and for all the complex, ever-changing historical debates about *sexuality as a whole*. Of course, Levay's own extreme partisanship would appear to belie this view. For example, he has stated, only too clearly, "Obviously I wanted to get the results I got. Other results would have been meaningless, because they would have been just another negative finding of no interest to anyone."[11] So much for pretensions to scientific method!

But even if it were true, the "benefits" to lesbians and gay men (or anybody else for that matter) of accepting the belief that sexual object-choice is entirely genetically determined are far from obvious. On the contrary, this genetic determinism is more likely to further displace and retard currently productive discussion and policy-making concerned with antigay prejudice. For no single-cause theory can ever adequately explain the remarkable cultural diversity and mobility of attitudes toward sexuality. Nor can single-cause theories begin to explain the complexity of ways in which homosexual desire has been lived and acted upon (or not) in different historical periods. Rather, single-cause genetic theories of sexual object-choice almost invariably lead to discussions about how much "difference" "we" (meaning heterosexuals) are going to "tolerate," and whether or not it is "unreasonable" to call for the abortion of so-called gay fetuses.

For behind the fantasy of scientific tests to identify homosexuality, there always lies a deeper ambition to confirm the heterosexuality of newborns. This is

SIMON WATNEY

precisely why it is so important to counter the types of lazy thinking exemplified by, for example, Camille Paglia, in her casual assertion of a supposedly universal attribute of the gay male lifestyle: "a sense of beauty that I believe is innate and surely connected with the artistic gene."[12] And, from a rather different perspective, Barbara Ehrenreich's equally casual acceptance of studies that "confirm that homosexuality is as genetically based as being blue-eyed or left-handed."[13]

Yet, to the sociobiologist, rape, cooking, dance skills, and mass murder are equally ascribable to genetic determination. These are "explanations" that "explain" everything and nothing. Hence, the importance of understanding how scientists frame debates about sex and sexuality in the mass media, smuggling in with their "research" a lot of ideological baggage. In the area of sociobiology, these explanations often proceed from the assumption that complex social phenomena such as drug use, domestic violence, unemployment patterns, and so on, all equally reflect distinct genetic determinants, operating prior to and independent of any social circumstances. Thus would biology devour politics.

DIAGNOSING SEXUALITY

On Friday, July 16, 1993, the *Washington Post* and other newspapers around the world reported variations of the received news that "Scientists at the National Institutes of Health have discovered that some gay men have inherited one or more genes that predisposed them to be homosexual."[14] In the next few days, a complex debate took place on both sides of the Atlantic. Writing in the *New York Times* on July 18, Natalie Angier summarized in great detail the political debates between different lobbies of gay men, contrasting those who regarded "genetic proof" as an immediate instrument for legal reform with those who pointed out that bigotry in any case does not respond well to "facts" or "explanations." The article concluded with Lillian Faderman's declaration, "As an historian, I know that whenever the cause of homosexuality has been questioned, a cure is looked for."[15]

Her words were immediately borne out by British press coverage of the story. By the second paragraph of his front-page story, Steve Connor of the *Independent* had noted that "finding a gene that predisposes a person to homosexuality could soon lead to pre-natal diagnostic tests which might in theory be offered to pregnant women to determine whether to abort a fetus carrying the gene."[16] Yet, only two paragraphs further on, Connor reported on scientist Dr. Dean Hamer, who carefully pointed out that his findings "cannot explain all male homosexuality . . . [and] it is likely homosexuality arises from a variety of causes, both genetic and environmental."[17]

On the same day, the *Independent* published a lead article on the subject. This curiously insisted that "Gay genes do not exclude choice."[18] The anonymous writer claimed that, until recent "evidence," "it was generally assumed that homosexuality was a matter of free choice conditioned by upbringing."[19] One danger, the article claimed, was "that a hereditary predisposition to homosexuality might be considered in the same light as a hereditary disease: at best curable, at worst, grounds for an abortion."[20] However:

> Leaving aside the Hitlerian eugenic attitudes implied, only a glance is required in the list of homosexual geniuses down the ages—from Michelangelo to Britten, Bacon and Nureyev—to show the catastrophic loss that would inflict on mankind, and not just by eliminating geniuses. The contribution of homosexuals to making society more civilized and less brutal can hardly be overestimated.[21]

It is fascinating that in British public discourse, a species of argument (based on appeals to genius aesthetes) familiar to Oscar Wilde and his contemporaries a hundred years ago is still being invoked. What was apparently *not* deemed necessary was any strong statement of moral repugnance at the very concept of "gay abortion." This moral lapse should concern us because abortion was indeed the first issue journalists raised, and it dominated British debates. Radio phone-in programs invited listeners to comment on whether or not they would abort a "gay fetus." The issue was made to appear reasonable, just as they discuss whether or or not "AIDS victims" "deserve it."

By the next day, Connor was able to report that "scientists, medical ethicists and gay activists . . . were unanimous in their disgust at ever being able to 'diagnose' for a homosexual predisposition in order to offer pregnant women the possibility of selective abortions."[22] As he had the day before, Connor seemed unable to imagine that some fathers might have a thing or two to say on the subject as well. The editor of the *Bulletin of Medical Ethics* was wheeled out to state that he did not "regard homosexuality as an abnormality that needs to be changed back to heterosexuality."[23]

Yet, "back" from what? From this perspective, homosexuality is a sort of variant of heterosexuality, from which it is assumed to have "changed," somehow. In this manner, the authority of heterosexuality is protected, and the categories of sexuality and sexual identities are never for a moment threatened. A similar debate also took place among Christians, with one leading antigay fundamentalist rejecting abortion, but concluding nonetheless: "To explain the origin of a tendency is not to justify the behavior."[24] In the meantime, in a letter to the editor, a reader of the *Independent* pointed out that it was unlikely that:

"queer-bashers will henceforth be merciful to anyone who can produce evidence of the appropriate genetic marker on their Xq28 chromosome."[25] Another correspondent concluded, "All credit to my mother if it were her gift to me."[26]

On the same day, the *Guardian* provided an excellent analysis of the claims and limits of ongoing genetic research, which quoted in full Dr. Hamer's words from a BBC Radio Four talk show, (in which I had myself taken part):

> We have not found the gene, which we don't think exists, for sexual orientation. We know there are some gay men that don't carry this, and there may be heterosexual men that do carry it. So we have found something that influences sexual orientation without necessarily determining it.[27]

Writing in the arch-Conservative *Daily Telegraph*, eminent evolutionary biologist Richard Dawkins briskly dismissed speculative sociobiological fantasies, concluding nicely that, "if a homosexuality gene lowers its own probability of being reproduced today, and yet still abounds, that is a problem for commonsense as much as for evolution."[28]

A few months previously, an editorial in the *Daily Mail* concerned with the political campaign to reduce the age of consent for gay men from twenty-one to sixteen provided an unusually succinct précis of populist press attitudes toward sexuality and gender. Thus, supposedly:

> It is a biological fact of life that girls develop earlier than boys. Many youths in the mid-teens are still uncertain about the promptings of the feminine side of their nature. If the age of consent is lowered to 16, we know only too well that it would not stop there. . . . What was permitted to youths would be practiced upon boys.[29]

This familiar discourse of the homosexual-as-invert evidently regards homosexuality from the perspective of a seduction theory, whereby "the feminine side" of boys' natures might make them "vulnerable" to the advances of the predatory.

It is far from clear how this familiar cultural allegory of the homosexual-as-corruptor-of-youths relates to claims regarding the supposed causes of homosexuality. Moreover, the more one reads of the media debates about the "gay gene," the more apparent it becomes that this is in fact a debate *à clef*, as it were, with the real subject being heterosexuality, not homosexuality at all. After all, homosexuality remains the central term by which heterosexuality may become aware of itself as a variant, as something other than entirely taken for granted. Thus, the *Daily Mail*'s television critic, in his review of a film about two runaway gay teenagers, primly informs us that "a little more condemnation of the dangers of experimentation and a little more emphasis on the loneliness and torment of many homosexuals would have been welcome."[30]

It must never, ever occur to a *Daily Mail* reader that the boys in question might have had a very good reason to run away, or that the "torments" over which the critic slavers are fantasies which speak far more about his own wishes than about the lives of real gay men. This is the context in which populist "gay gene" and "AIDS cure" stories abound, and they are intimately related, in tone, emphasis, and perspective—always inflexibly from a heterosexual viewpoint, dissociated from us.

CONCLUSION

The narrative of the "gay genes" story reveals no paradox more strange than that of the ostensibly liberal gay men, often scientists, who seek to ground political demands for sexual equality in claims about innate and unchangeable genetic and/or other anatomical differences between homosexuals and heterosexuals. Almost never do these people talk about "gay men," for that would immediately expose them to a diversity of sexual identities that they cannot explain. There are also certain evident parallels here with ongoing feminist debates between women who claim female superiority over men on the grounds of supposedly innate female characteristics, and other feminists who challenge the whole idea of trying to explain the complex world of gender relations in terms of immutable physical differences between women and men.[31]

Moreover the "gay gene" story also reveals a parallel to concurrent news features about the use of the genetic code to "crack" murder cases and so on, about calls for the official regulation of genetic research testing that might predict inherited disorders and then render individuals ineligible for insurance purposes, and so on.[32] Our best response to this confused swamp of genetic "gossip," manufactured by the news industry, is to reject any approach to the understanding of sexuality that does not recognize desire as well as behavior, and history as much as biology. Well meaning but naïve followers of Levay's neoliberal position should recognize that what is at stake in public discourse is not so much a quest for a "gay gene," but a confirmatory test for heterosexual fetuses. Fortunately, biology has steadfastly failed to confirm their projective eugenic fantasies.

NOTES

1. Simon Watney, "AIDS and Social Science: Taking the Scenic Route Through an Emergency," in *Practices of Freedom: Selected Writings on HIV/AIDS* (Durham, N.C.: Duke University Press, 1994), pp. 221–27. See also Eve Kosofsky Sedgwick, "How to Bring Your Kids Up Gay," in *Tendencies* (Durham, N.C.: Duke University Press, 1993), pp. 154–64.
2. R.C. Lewontin, "The Dream of the Human Genome," *New York Review of Books* 39 (May 28, 1992): 37.

3. See Edward King, *Safety in Numbers: Safer Sex and Gay Men* (London: Cassell, 1993; New York: Routledge, 1994).

4. Chandler Burr, "Homosexuality and Biology," *Atlantic Monthly* 271 (March 1993): 47–52.

5. Human Rights Campaign Fund, "Memorandum to Editors and Writers," Aug. 3, 1993, n.p.

6. *Daily Mail* (London), July 16, 1993.

7. For example, William Byne, "The Biological Evidence Challenged," *Scientific American* 270 (May 1994): 50–55.

8. Joe Dolce, "And How Big Is Yours?" *Advocate*, no. 630 (June 1, 1993): 41.

9. Ibid.

10. Ibid., p. 42.

11. Ibid., p. 44.

12. Camille Paglia, "Vox Populi," *Advocate*, no. 612 (Sept. 22, 1992): 96.

13. Barbara Ehrenreich, "The Gap Between Gay and Straight," *Time* 141 (May 10, 1993): 76.

14. Boyce Rensburger, "Study Links Genes To Homosexuality," *Washington Post*, July 16, 1993, p. 1.

15. Natalie Angier, "Study of Sex Orientation Doesn't Neatly Fit Mold," *New York Times*, July 18, 1993, p. 24.

16. Steve Connor, "Homosexuality Linked to Genes," *Independent* (London), July 16, 1993, p. 1.

17. Ibid.

18. *Independent* (London), July 16, 1993, p. 19.

19. Ibid.

20. Ibid.

21. Ibid.

22. Steve Connor and Martin Whitfield, "Scientists at Odds in 'Gay Gene' Debate," *Independent*, July 17, 1993, p. 3.

23. Ibid.

24. Andrew Brown, "Christians Focus on Questions of Abortion," *Independent* (London), July 17, 1993, p. 3.

25. Brian Simpson, "Letters to the Editor," *Independent* (London), July 17, 1993, p. 15.

26. Guy Burch, "Letters to the Editor," *Independent* (London), July 17, 1993, p. 15.

27. Tim Radford, "Your Mother Should Know," *Guardian* (London), July 17, 1993, p. 38.

28. Richard Dawkins, "Could a Gay Gene Really Survive?" *Daily Telegraph* (London), Aug. 16, 1993, p. 12.

29. "Comment: Homosexuality and the Age of Consent," *Daily Mail* (London), Feb. 21, 1994, p. 8.

30. Geoffrey Levy, "TV Mail Opinion: Boy Meets Boy Love Triangle," *Daily Mail* (London), Jan. 13, 1990.

31. For debates within feminist genetics, see R.C. Lewontin, "Women Versus the Biologists," *New York Review of Books* 41 (Apr. 7, 1994): 31–35.

32. For example, Steve Connor, "Regulation of Gene Tests for Inherited Diseases Urged," *Independent* (London), Sept. 19, 1994, p. 6.

ANDREW ROSS

THE GREAT WHITE DUDE

The best job descriptions are the ones that appear to be dreamed
up by successful applicants. Few examples compare with the latest search for
a flesh-and-blood ecological superman. Consider Steven Seagal's latest
action-adventure flick, *On Deadly Ground*, directed by Mr. Ponytail Toughguy
himself. In the last scene of the film, we see our hunk du jour preaching his
newfound religion of environmentalism to the assembled native peoples
of Alaska, whose fragile world he has in the course of the movie saved from
the evil designs of an exceedingly mean petroleum mogul motherfucker
(played with hammy insouciance by the shameless Michael Caine). Invited by
the tribal council to pronounce a world-historical lesson on their behalf to the
press, Seagal takes the opportunity to lay it on thick.

How many of you out there have heard of alternative engines? Engines that can run on alcohol or garbage or water, or carburetors that get hundreds of miles to the gallon, or electromagnetic engines that can practically run forever? You don't know about them because if they were to come into use they would put the oil companies out of business. The concept of the internal combustion engine has been obsolete for about fifty years but, because of the oil cartels and corrupt government regulation, we and rest of the world have been forced to use gasoline for over a hundred years. Big business is primarily responsible for destroying the water we drink, the air we breathe, and the food we eat. They've no care for the world they destroy, only for the money they make in the process. How many oil spills can we endure? . . . Go to some remote state or country, anywhere on earth, and do a little research and you'll realize that these people broker toxic waste all over the world, that they basically control the legislation, in fact, they control the law. The law says that no company can be fined over $25,000 a day. For companies making ten million dollars a day by dumping illegal toxic waste in the ocean, it's only good business to continue doing that. They influence the media so that they can control our minds. They've made it a crime to speak out for ourselves.

Maybe we're all being chemically and genetically damaged, and we don't even realize it. Unfortunately, this will affect our children. We go to work each day and, right under our noses, we see our car and the car in front of us spewing noxious and poisonous gases. How many of us would have believed, if we were told twenty years ago, that on a certain day we wouldn't be able to see fifty feet in front of us, that we wouldn't be able to take a deep breath because the air would be a mass of poisonous gas, that we wouldn't be able to drink out of our faucets and have to buy water out of bottles. The most common and God-given rights have been taken away from us; unfortunately, the reality of our lives is so grim no one wants to hear about it. What we need is a responsible body of people that can actually represent us rather than big business. This body of people must not allow the introduction of anything into our environment that is not absolutely biodegradable or able to be chemically neutralized upon production. And finally, as long as there's profit to be made from polluting the environment, companies and individuals will continue to do what they want. We have to force these companies to operate safely and responsibly, with all of our best interests in mind, so that when they don't, we will take back our resources and our hearts and minds to do what's right.

The speech is set against a shifting collage of environmental atrocity images. At its conclusion, a tribal elder blesses future generations of the Indian nations, and embraces Seagal in a final freeze-frame.

This is not a commercial for Dow Chemical, although it is only a matter of time before corporate "greenwashing" moves beyond its currently advanced

state of slick fantasy into some realm of mendacity heretofore unimaginable. Nor is it the Oscar acceptance speech of Seagal's dreams, or the first salvo in some campaign to usurp Robert Redford's celluloid eco-throne. Among other things, it is is the latest evidence that the "Political Correctness" monster has broken free from William F. Buckley's genteel leash, and is now lurching its way into the scary psychic domain of . . . the Great White Dude. PC Steve has a message as ham-fisted as the kidney punch you saw coming from the film's very first brawl. In that scene, he stops short of making mincemeat of a red-neck oilman who has publicly humiliated a native Alaskan in order to ask the bruised and walloped fellow a stunningly inappropriate question: "What does it take to change the essence of a man?" Seagal's character, a crack oil fire-fighter and all-terrain fight maven with a soft spot for the spirit world of indigenous religion and a taste for rough environmental justice, is expected to provide a model answer in the course of the narrative.

We have not seen the last of this sort of spectacle. It is a little chunk of the near-future in which a big, lean lump of weirdness like Steven Seagal gets to rewrite the book on political correctness. On reflection, this is not such a bizarre turn of events. Progressive values are habitually ventriloquized, cannibalized, transmogrified by those seeking to channel the appeal of these values onto more deadly ground. We should have learned by now to expect to receive strange emissaries, even enemies, bearing messages we thought belonged to

us. There is no doubt, for example, that in mainstream popular culture we will see a queer Seagal, or his like, within the decade. There is also no doubt that the recent PC onslaught from the right was designed to melt into air all that we thought were solid gains in the field of cultural justice. This strategy of appropriation is usually associated with postmodernism, but it really is as old as the hills, especially when the contested ground happens to be libertarian.

As Seagal's speechifying suggests, what is alluded to is a long libertarian tradition of reclaiming inalienable rights, freedoms, and controls over the American birthright that are constantly in danger of being pirated and possessed by government and big business. We must take back what is rightfully ours. These days, of course, the white man can only legitimately voice this claim if he speaks in the name of, or in common cause with, the native man. He may still speak with a forked tongue, but the moral power of environmentalism (peppered with white guilt) demands at least that he speak up for, or in cohort with, the native. Typically, then, the Future Man has to stand alongside the First Man.

Of course, this leaves out a lot of people. A huge portion of North Americans have never felt comfortable with this form of libertarian discourse that responds to the call to repossess landed rights. Chicano populations of the "occupied lands" of the Southwest have a different story to tell about dispossession, while African-Americans, along with first- and at least second-generation immigrant North Americans, have no such history of landed possession to appeal to. Consequently, these are the peoples whose voices carry diminished power in dissident scenarios like this. It is men like Seagal (or his character), men who are born free and with a historical sense of full constitutional entitlement, men with private arsenals, men who use advanced technology, and who have not therefore been mastered by technology, men whose self-sufficiency positions them beyond class and race; it is such men who are scheduled to speak in such settings, alongside native peoples who alone can grant them salvation for their settler ancestors' sins. Seagalian men have their origin in the same Sagebrush Rebellion that brought Reagan to power. Their fierce individualism alludes to a culture of free association identified with the Western states that preexists the culture of social security identified with East Coast liberalism. So, too, their libertarian form of environmentalism is geared toward direct, untrammeled encounters with "wilderness," as opposed to the more left utopian version which sees the congeries of scarcity politics, risk management, and sustainability regulation as a conceptual gridlock through which we must struggle before an ecological society develops. The Seagalian shares not a little with libertarian cybercowboys of the technosphere like John Barlow and Mitch Kapor

of the Electronic Frontier Foundation, who argue that freedom of information and free enterprise go together like a horse and carriage.

The biggest mistake is to see the Seagalian as an unreconstructed fantasy. Such men exist—they are not all discourses—but they must constantly update and modernize their profile if male dominance, of which they are a dominant form, is to be maintained. Their righteous anger, their showy heroism, and their monkey-wrenching defiance in the face of corporate, or any form of collective power must be constantly retrofitted at the same time as they appeal to traditions of long-held rights and freedoms. Such men, then, are not fixed Platonic forms. They can no more afford to be yesterday's man than they can entirely be seen to embody the ruthless futurism of the economic order to which their fortunes are ultimately tied. In this respect, it should be said that masculinity, whatever it is, is not individual, it is cultural—by which I mean that you do not find the full gamut of masculinity in any one individual, nor should you expect to. (An influential part of the women's movement has been devoted to arguing the same of femininity—although it is clear that the feminist rejection of the myth of Superwoman means something quite different from the rejection of Superman, even a PC Superman.)

In what some refer to as the "society of the spectacle," iconic figures like Seagal (or his more silky competitor, Jean-Claude Van Damme), or the late, culturally-tortured Kurt Cobain, or rapper Tupac Shakur's switch-hitting continuum

of black love and rage, or even the Bill Clinton of "I feel your pain" fame, are cited as shorthand for particular, individual versions of masculinity, some that are considered more progressive than others. It is a fatal mistake, however, to think that any of these are state-of-the-art expressions of patriarchy, or alternatively, role models for better kinds of men. In their hit song, "Whatta Man," Salt 'N Pepa are much closer to the mark when they do a wry but enthusiastic take on the masculine object of desire, building up an identikit fetish picture of ideal pick-and choose masculinity—"body like Arnold, face like Denzel."

It is because masculinity is fully cultural—a varied expression of the full spectrum of a culture—and not individual that it is a powerful medium of patriarchy. Of course, it is not the only medium, since patriarchy relies upon entrenched legal and economic structures that are relatively independent of what we ordinarily associate with the social and cultural profile of masculinity. It is also a mistake to think that the name of the game is simply about reforming masculinity—transforming old kinds of men into new kinds of men. Patriarchy is constantly reforming masculinity, minute by minute, day by day. Indeed, the reason why patriarchy remains so powerful is due less to its entrenched traditions than to its versatile capacity to shape-change and morph the contours of masculinity to fit with shifts in the social climate; in this it shares with capitalism a modernizing hunger to seize the present and dictate the future. Sometimes we feel that the new man, even when he is PC, is much less palatable than the incorrect guy he displaced.

Consider the difference between Arnold Schwarzenegger's original and reformed Terminators: bad to the bone in the first film, staunch protector of women and children in the second. Why do most of us prefer the first, lean, mean Terminator? Why is he more sexy? Better clothes? Better dialogue? I don't think so. Is it because he is such a clean parody of the simple male psyche—programmed and ruled by a single, linear urge? Probably. But, as Film Theory 101 reminds us, he is also part of a narrative, one that produces, in the first film, a thoroughly independent, self-sufficient Sara Connor, and, in the sequel, a nuclear family in which the same character, for all of her hard-body chutzpah, is delivered into dependence on his protective function for her son. Ever since *The Terminator*, Schwarzenegger's body has been at the service of the state, a willing recruit in the ever-shifting struggle for hegemony in the field of ideas and values. In his latest, *True Lies*, he revels in the sadistic swagger of Homo Pentagonus, basking in the rays of a post-Cold War triumphalism. His smirking persona draws upon the knowledge that, with no real enemies on the horizon anymore, it is safe to deploy the military apparatus of the state to play cat and mouse with unfaithful wives and "Arab terrorists."

Seagal, then, is not the only reformed he-man of the post-Reagan era, but his quirky desperation to survive on the big screen makes him especially worth watching. In the latest film version, we are presented with a man, in a long line of science and science-fiction heroes, who wants to save the planet. As for his weaponry, he not only has the sword of science on his side (science for the people), he also has a pantheistic spirit world to draw upon, having, in the course of the film, come to fulfill a native prophecy in the cheesiest tradition of "A white man will appear, and he will . . . " He is therefore able to muster the combined support of some rather awesome secular and spiritual power in his struggle against big business, which, he tells us, controls government, controls legislation, controls the law, control our minds, controls our speech, but curiously enough, at least in in his words, only "influences the media."

Science has always needed such robust salvationists, but never more than today in the technocratic age of the lab and government grant. Historically, science waged its battles against religion by offering secular channels of redemption, the apostles of which erected a culture of sanctification for science that was as pious and devotional in its own way as the institutions fashioned by organized religion. As the crisis of science deepens daily, reeking with the rank militarism it has married into, as the full story of science's contribution to the ecological emergency becomes more and more apparent, as popular skepticism about science reaches new heights (it is reported, for example, that North

Americans now spend more money each year on alternative medicine than on Western biomedicine), as science is seen to have despiritualized the natural world and hastened on its callous destruction as a result, as this crisis intensifies, it is clear that science needs Eco-Man badly, as a ruggedly conscientious representative of its best intentions. It needs Eco-Man to make contact with the prerationalist spirit world, to sit down, smoke the pipe of eco-peace, and make common cause with the shaman, whose knowledge of herbal medicine is ripped off daily by large pharmaceutical companies in their bid to patent plant genes. Eco-Man is just as badly needed to revive faith in science's own proprietary stake in saving the planet, refurbished now as a generational rallying cry for youth faced everywhere with a fiercely recessive future.

What do Seagalian men get out of this deal? For one thing, the ecology movement has been the only one of the new social movements where straight white males, even self-identified rednecks, have felt at home in their voice or their bodies. They have been able to play leading activist roles on the political frontier, notwithstanding the claims in certain ecofeminist circles that women, because they are biologically attuned to the rhythms of the earth, are the natural stewards of planetary life. Whether sabotaging developers' plans while on the front line with Earth First! or in the fold of the men's movement, beating the drums at the New Warrior adventure training weekends, angry white men have found an accommodating haven under the big tent of environmentalist science, where they are not automatically required to address questions about race, class, gender, and sexuality, and where there is enough room to put themselves at a distance from the wussy New Agers, the nerdy scientists, the celebrity fashion plates, and the card-carrying social-justice mavens, to name just a few of the other imaginary stereotypes populating this imaginary tent. Here, then, is one place on the map of progressive politics where the Great White Dude can hang his hat, while indulging in varying degrees in the wilderness cults traditionally associated with the making of heroic, white, male identities: the frontiersman, the cowboy, the Romantic poet, the explorer, the engineer, the colonizer, the anthropologist, the pioneer settler, and so on.

Seagal's character in *On Deadly Ground* is infused with much of the muscular self-righteousness of the hardcore Earth First! genre of Eco-Man, and little of the "sensitivity" associated with the countercultural environmentalist. In eschewing the nonviolence advocated by his female Native sidekick, he argues for the pragmatic satisfaction of kicking butt, an option that FBI counterinsurgents love to hear, even when it is being voiced by their own agents provocateurs. Indeed, it has been the historical fate of social movements to

falter when faced with such divisive options, especially when Seagalian types come forward to offer themselves as hardheaded solutions to liberal dilemmas. We need to learn how to respond to this new type in ways that resist the seductive perils of his live-free-or-die options, but to do so in a way that does not alienate. For if we cannot absorb this white male rage, then it is likely to be channeled into racial prejudice and gender chauvinism.

After the film's release, the oil companies had their predictably oily say, just as the biotechnology industry responded in kind to *Jurassic Park* in the summer of 1993. But my concluding questions are addressed to readers of this book. Is Seagal's rage against the machine one of the more acceptable forms through which white male rage can and might be channeled? Or is his kick-ass conscience simply another ruse of patriarchy, another wolf in sheep's clothing? Or deerskin, to be precise. Is Seagal's screen persona of the Social-Darwinist action-fighter in sympathy with his critique of petroleum capitalism or is it rather the supreme embodiment of the predatory worldview espoused by Exxon and Mobil? If, in our minds, the answer to these questions is a straightforward yes or no, then we are not yet prepared to consider seriously the evolutionary challenge, as it were, of the Great White Dude.

ANDREW ROSS

SANDER L. GILMAN

DAMAGED MEN

THOUGHTS ON KAFKA'S BODY

George Mosse has described "the idealization of masculinity as
the foundation of the nation and society."[1] A failure to be "masculine" is thus
seen in the national arena as pathological. In terms of the racial discourse of
the turn of the century, the pathologization of the male Jew's body is also his
feminization. Of course, "masculinity" is a complex and even contradictory
construction, and no Jewish writer of the early twentieth century is more impli-
cated in the confusions and difficulties associated with being a feminized male
Jew than Franz Kafka.

If anxiety about masculinity as a reflex of racial identity stands at the center
of Kafka's confusions about his body, then the ambiguity of that ill, diseased,

incomplete thing hidden within the father and within the self as well makes the very notion of the "masculine" in Kafka suspect. Indeed, much of the critical literature argues that central to Kafka's sense of self is his repressed homosexuality.[2] These views derive from polarities—"straight/gay" and "masculine/feminine"—articulated in the post-1950s era.[3] But these antitheses simply do not hold up when one looks back at the turn of the century. Our views must be modified in light of the construction of "homosexuality" during Kafka's own lifetime.

Once "gay" was constructed as a psychopathology in the mid-nineteenth century, it was given the medical label "homosexuality."[4] No longer a "sin," it became the concern of the physician and the specialist. In the 1860s, lawyer Karl Ulrichs developed the idea of a "third sex," arguing that there were three "natural" sexes—males, females, and "uranians." Homosexual Jewish scientists such as Magnus Hirschfeld transmuted Ulrichs's legal rhetoric into the language of medical science—and the idea of "sexual intermediary classes" was developed. By the 1890s, this view dominated debates within the homosexual emancipation movement. It also formed the basis of Otto Weininger's important formulation of homosexual identity in 1904. Kafka's strong interest in Weininger, like that of many Jewish males of his day, reflected to no little degree an interest in Weininger's account of masculinity and Jewishness.[5]

Jewish males formed a particular version of the "third sex." The circumcised body of the Jew was neither "straight" in a normative sense, nor "homosexual," except by extension and metaphor. It was a "third" version of the male—heterosexuals, "homosexuals," and Jews. The Jewish body, like the other two, was born, not made. Circumcision came to be seen as the exterior sign of the inherently different nature of the Jewish male. Jews were more often thought to be born circumcised.[6] This difference was understood as pathological, as it mirrored the psychopathology of the Jew. This meant that the male Jew, no matter what his sexual orientation, was closely associated with the pathological category of the "homosexual." Some sense of this special status can be judged from the fact that Jewish males were considered by Aryan science to be particularly predisposed to homosexuality.

As usual, it was the body of the Jew that betrayed him. Thus, the (male) Jew was noted as having an arm span less than equivalent to his height, as do women.[7] This was the case with Kafka. It was the biological (or "ontological") difference of the Jew that was believed to be the source of his feminized nature. Among Jews, according to a 1920 lecture by the Robert Stigler, professor of anthropology at the University of Vienna:

SANDER L. GILMAN

> [T]he physical signs of the sexual characteristics are noticeably vague. Among them, the women are often found to have relatively narrow pelvis and relatively broad shoulders and the men to have broad hips and narrow shoulders. . . . It is important to note the attempt on the part of the Jews to eliminate the role that secondary sexual characteristics instinctively play among normal people through their advocacy of the social and professional equality of man and woman.[8]

It is of little surprise, therefore, that the Jew was seen as overwhelmingly at risk for being (or becoming) a homosexual. In 1920, Moses Julius Gutmann observed, "All of the comments about the supposedly stronger sexual drive among Jews have no basis in fact; most frequently they are sexual neurasthenics. Above all, the number of Jewish homosexuals is extraordinarily high."[9] This view was echoed by Alexander Pilcz, a professor of psychiatry at the University of Vienna, who noted: "There is a relatively high incidence of homosexuality among the Jews."[10]

But gay society of the time also saw the Jew as different. Within gay culture in Germany, Jews were seen as essentially Jews even when they were also identified as gay. They were given Jewish nicknames (such as Sarah or Rebecca) even when their given names were in no way identifiably Jewish.[11]

For Kafka, then, the concept of masculinity was extremely complex, and, when he chose to confront it directly, as he did in the question of the ritual murder trials or the Dreyfus case, he often did so through the mediation of texts. The textual world was the one he wished to control. By looking at Kafka's reading and his response to these texts, it is possible to examine one specific moment in the intellectual relationship between notions of masculinity and anti-Semitism at the turn of the century.

In Kafka's reply to the works of Hans Blüher (1888–1955), we can find evidence of the development of his views and anxieties concerning the links between masculinity, illness, and race. In Blüher, the question of the homoerotic plays a major role, and Kafka's own representation of this experience becomes a testing ground for the bounds of the masculine. Blüher is one of the most fascinating intellectuals of the first half of the twentieth century. At the turn of the century, he was instrumental in the formation of the German Youth Movement (*Wandervogelbewegung*). Later, Blüher became an early follower of Freud, and some of his writings on sexuality were published by Freud in the journal *Imago*.[12] In 1917, Blüher's work culminated in the publication of *The Role of the Erotic in Male Society*, a two-volume study which traced the homoeroticism of the Youth Movement and proposed a concept of bisexuality that was heavily indebted to

Freud's early work.[13] Though, in many ways, Blüher's book created the Youth Movement, giving it a retrospective coherence that it lacked in actuality, it was apparently his attention to the erotic that captured Kafka's attention. In October 1917, Kafka noted in his journal, "Am eager to read Blüher."[14]

What Kafka finally read impressed him. Blüher dismissed traditional education as training for the state, and saw in the structures of formal education an attempt to subvert the natural tendencies of young men to bond. For Blüher, the spirit of the *Wandervogelbewegung* was antithetical to formal education; the Youth Movement created a space where bonding among male equals could take place. For this reason, he rejected the presence of women and Jews in his ideal society, while at the same time attacking the vague cult of "Germanness" that permeated the early movement. What struck Blüher was the persecution of homosexuals in the movement itself, which he saw as an unconscious suppression of the libidinal attachment to members of the same sex. He felt it was a neurotic process caused by repression. In Freudian terms, Blüher explained, this "self-hatred" was a defense mechanism. For Kafka, Blüher's text offered a model of an "ideal" male society where social repression might be suspended. Unfortunately, the very homoeroticism at the basis of this society was declared by the Youth Movement itself to be unhealthy.

Kafka was first exposed to Blüher during World War I, at a time when his own sense of masculinity was affected by his illness and by the urgency of definitions of the masculine in a society mobilized for war. On October 4, 1917, his friend Max Brod wrote to Kafka:

> Incidentally I received two books yesterday, which can help me. Both by Hans Blüher. "The Role of the Erotic in Male Society" and "Führer and Volk in the Youth Movement." [*sic*]— It is a hymn to pederasty, from which all cultural progress is expected.—I read the books without being able to stop. Today I am already more sober and see in them the description of the *German* man as the essential man.[15]

Brod's sense of Blüher's agenda was better than most. A great number of Jews followed Blüher's claim about the relationship of homosexuality to cultural progress, and advocated the male society, the *Männerbund*, which was the *Wandervogelbewegung*. But the "Aryan" mentality made it impossible for Jews to truly become part of this world, as Brod quite correctly saw. Nevertheless, Kafka began to read his own experiences in terms of Blüher:

> If I go on to say that in a recent dream of mine I gave Werfel a kiss, I stumble right into the midst of Blüher's book. . . . The book upset me; I had to lay it aside for two days. However,

it shares the quality of other psychoanalytic works that in the first moment its thesis seems remarkably satisfying, but very soon after one feels the same old hunger. This is "of course" easily explained psychoanalytically: Instant Repression. The royal train gets fastest service.[16]

Kafka's dismissal of psychoanalysis (he had indeed read his Freud) is, in part, a rebellion against a "Jewish" science, so understood at the time, that refused to acknowledge its Jewishness. It is the universal hermeneutics of psychoanalysis that Kafka condemns, not its validity. In his response, the conflict between the Aryan world of Blüher and the Jewish world of Freud is played out. For the moment, Blüher embodies both, even though it was obviously clear to Kafka that Blüher's idealized male society was in no way open to him as a Jew.

Kafka's anxiety about the homoerotic—the kiss he gives Franz Werfel, another Jewish writer, in his dreams—reflected his own ambiguity about his Jewish male body. For, within Blüher's cult of masculinity, only attractions between equals were possible (here, two Jewish writers from Prague). Yet the Jewish male body is also—if only in the rhetoric of the time—not a truly male body; it was the analogue to the body of the homosexual. If Arnold Zweig's account of the ritual murder trial made Kafka weep, reading Blüher upset him. Blüher's model of the homoerotic male society rejected the very Jewishness with which Kafka was forced to identify in the anti-Semitic society in which he lived. Were being a "real" man and being "Jewish" antithetical? According to Blüher, they were. This was a common problem for Jewish males of the turn of the century. Yet the rise of Jewish gymnastic societies throughout Central Europe and the rise of Jewish fraternities at universities testify to the desire to engage in various forms of male bonding. Kafka's own intense preoccupation with sports was probably an extension of this anxiety, coupled with the notion of the need to re-form the Jewish body, both without and within.

Kafka's own homoerotic feelings and fantasies must be read in light of the elision of the homosexual and the Jew. His passionate relationship with Oskar Pollack resulted in a short story, written in December 1902, that stressed the rhetoric of the body in a homoerotic setting; Kafka writes of himself as "Shamefaced Lanky" to Pollack's "Impure in Heart" (Kafka, *Letters to Friends*, pp. 6–7). His plan, in 1912, to "pose in the nude for the artist [Ernst] Ascher, as a model for St. Sebastian," again frames Kafka's body in the homoerotic context.[17] Finally, the overt references to homosexual activity in Kafka's writing, such as the deleted passage describing the painter Titorelli and K. in *The Trial*

or the "embrace" between the narrator and the Inspector in the "Memoirs of the Kalda Railroad," point toward a strong sense of the homoerotic as an aspect of Kafka's fantasy life (Kafka, *Diaries, 1914–1923*, p. 83).

In his relationship with the itinerant Yiddish actor Yitshak Lowy, Kafka felt a particularly powerful sense of attraction, as well as danger. When Kafka took Lowy to the National Theater one night in October 1911, Lowy chose the occasion to inform Kafka that he had gonorrhea. Kafka's response: "[T]hen my hair touched his as I moved his head toward me, I became afraid of the possibility of lice."[18] The tension between attraction and infection is evident in the contact, no matter how trivial, between "equals." But in Kafka's reading of Blüher, the desired acknowledgment of the homoerotic as an acceptable sign of belonging to the world of the "modern" is denied. For the male Jew may look or even act as if he is a member of this world, but it is always a sham and an illusion.

In the first court-martial trial of Captain Alfred Dreyfus, the primary witnesses, those who originally leveled that charge of treason that robbed him of his role as a soldier and as a man, were later revealed to have been homosexuals. Their homosexuality played an important role in the conventional understanding of the case, especially within the homoerotic culture of the French and German armies. In the medical discourse of the time, the homosexual was regarded as sick, or at least repressed; in that same context, the homosexual was seen as equivalent to the Jew; and, now, in conventional political debates, the homosexual was branded the false witness who betrays the Jew. These overlapping and contradictory stereotypes provide a slippery space in which all such categories are interdependent.

A common accusation against Jews in Germany and Austria after World War I was the "*Dolchstosslegende*," or the "legend of the stab in the back." According to this legend, it was the Jews who failed in their roles as soldiers, and betrayed Germany and the Hapsburg Empire. Only this could only account for the defeat. This was roughly analogous to the claim in French intellectual and popular circles that it was women and syphilis that had caused the loss of the Franco-Prussian War. Blüher, having broken with Freud, accepted the legend of the stab in the back, and argued openly for the exclusion of Jews from German society. His 1922 pamphlet on this topic, *Secessio Judaica*, attracted Kafka's attention.

On March 15, 1922, Kafka noted: "Objections to be made against the book: he has popularized it, and with a will, moreover—and with magic. How he escapes the dangers (Blüher)" (Kafka, *Diaries, 1914–1923*, p. 225). Then, Kafka tried to write a response to Blüher:

June 16, 1922. Quite apart from the insuperable difficulties always presented by Blüher's philosophical and visionary power, one is in the difficult position of easily incurring the suspicion, almost with one's every remark, of wanting ironically to dismiss the ideas of this book. One is suspect even if, as in my case, there is nothing further from one's mind, in the face of this book, than irony. This difficulty in reviewing his book has its counterpart in a difficulty that Blüher, from his side, cannot surmount. He calls himself an anti-Semite without hatred, *sine ira et studio*, and he really is that; yet he easily awakens the suspicion, almost with his every remark, that he is an enemy of the Jews, whether out of happy hatred or out of unhappy love. These difficulties confront each other like stubborn facts of nature, and attention must be called to them lest in reflecting on this book one stumble over these errors and at the very outset be rendered incapable of going on.

According to Blüher, one cannot refute Judaism inductively, by statistics, by appealing to experience; these methods of the older anti-Semitism cannot prevail against Judaism; all other peoples can be refuted in this way, but not the Jews, the chosen people; to each particular charge the anti-Semites make, the Jew will be able to give a particular answer in justification. Blüher makes a very superficial survey, to be sure, of the particular charges and the answers given them.

This perception, insofar as it concerns the Jews and not the other peoples, is profound and true. Blüher draws two conclusions from it, a full and a partial one. (Kafka, *Diaries, 1914–1923*, pp. 230–31)

At this point, his comments break off. Unable to proceed himself, Kafka wrote to his friend Dr. Robert Klopstock on June 30, 1922:

Secessio Judaica. Won't you write something about it? I cannot do it; when I try, my hand immediately goes dead, even though I, like everyone else, would have a great deal to say about it. Somewhere in my ancestry I too must have a Talmudist, I should hope, but he does not embolden me enough to go ahead, so I set you to it. It does not have to be a refutation, only an answer to the appeal. That ought to be very tempting. And there is indeed a temptation to let one's flock graze on this German and yet not entirely alien pasture, after the fashion of the Jews. (Kafka, *Letters to Friends*, p. 330)

Here, Kafka mimics the rhetoric of the early, Freudian Blüher, an Aryan arguing like a Jew, and he stresses his own Jewishness against Blüher's hypocritical "Germanness." Yet this "Germanness" is one, shared by Kafka and Klopstock; it is "not entirely alien pasture." Blüher's case, according to Kafka, is one of a "happy hatred or . . . unhappy love" that Blüher feels for the Jews, embodied in his "very superficial survey, to be sure, of the particular charges and the answers given

them." Kafka knew his psychoanalytic discourse well enough to point out to Klopstock, who certainly did also, the Freudian homoerotic in Blüher's text. This model, found in Freud's reading of the Schreber case, can be reduced to Kafka's formula: Is Blüher in love with the Jews, or does he hate the Jews because they make him love them? This is a far from unique reading of the anti-Semite as homosexual. Zweig, for instance, also evokes Schreber when, in 1933, he explains the anti-Semitic German as the psychotic homosexual.[19] If the homosexual is psychotic, shaped by the fixation of his own sexual identity at an earlier (anal) stage of development, then the real "primitive" is Blüher. Kafka sees his own psyche as deformed by his Jewish ancestry ("Somewhere in my ancestry I too must have a Talmudist"). He claims to retain this intellectual proclivity, but is too self-aware of it. This mind-set is not that of the homosexual, for here Kafka sets himself apart from Blüher's paranoia. Blüher becomes "this German" (Schreber) who will be the object of study "after the fashion of the Jews" (Freud/Kafka).

What is unstated in Kafka's dismissal of the "very superficial survey, to be sure, of the particular charges and the answers given them," is that Blüher stresses the superficiality of the Jew's Westernization.[20] For Blüher, the Jews remain the "Orientals," no matter how they seem to have physically changed. They regress to what they always have been, once they are removed from Western society. Blüher's *Secessio Judaica* evokes in a powerful manner the idea of a Jewish racial type: "The Jews are the only people that practice mimicry. Mimicry of the blood, of the name, and of the body" (19). Here, Blüher simply picks up the rhetoric of thinkers such as Werner Sombart, who argued in *The Jews and Modern Capitalism* that the Jewish body is inherently immutable:

> The driving power in Jewish adaptability is of course the idea of a purpose, or a goal, as the end of all things. Once the Jew has made up his mind what line he will follow, the rest is comparatively easy, and his mobility only makes his success more sure. How mobile the Jew can be is positively astounding. He is able to give himself the personal appearance he most desires. . . . The best illustrations may be drawn from the United States, where the Jew of the second or third generation is with more difficulty distinguished from the non-Jew. You can tell the German after no matter how many generations; so with the Irish, the Swede, the Slav. But the Jew, in so far as his racial features allow it, has been successful in imitating the Yankee type, especially in regard to outward marks such as clothing, bearing, and the peculiar method of hairdressing.[21]

For Blüher, as for Sombart, the Jews' mind-set persists, though their bodies (and hairstyles) seem to be changing. Their corrupt, materialistic thought disrupts

those among whom they dwell by generating ideas that seem universal, yet are inherently Jewish. And, as Blüher argues in *Secessio Judaica*, "the Jew Freud" and his notion of psychosomatic correlates represent only the most modern version of such corrosive Jewish thought (23). This Jewish influence can already be found in Spinoza's *Ethics,* in the identity of body and spirit. For Spinoza, as for Freud, when something occurs in the body it is because it occurs in the spirit (25). "Where ever spirit is there is also body. Every idea has a corporeal correlate" (25). The identity of mind and body, a central theme in Kafka's understanding of himself and his illness, is merely a Jewish "trick" to get Aryans to believe that their *Geist* (spirit) and their bodies are crassly, materialistically linked.

Thus, what seemed to be a "neutral" model of argumentation, the model of psychosomatic illness, was revealed to Kafka as "Jewish." And all the jokes about the "Jewish patient" turn out to have been rooted in the supposedly Jewish understanding of the body. In Blüher, the central idea is transformed from a joke into "philosophy," and is therefore clothed in a more somber rhetoric. He claims to reveal the "truth" about the psychologizing of the body that Pierre Janet declared at the turn of the century: that psychoanalysis is a Jewish science, not a universal one, because it is the product of a Jewish mind. Blüher argues that, with the social integration of the Jews into German culture, their physical being was modified by their internalization of their host's culture. But this is only superficial and temporary. Once the Jews are "reghettoized," once they are separated from the "body politic," Blüher claims, their "mimicry" of the German body too will end:

> One will see the Jews in Germany as clearly as one sees them in Russia and Poland. No one there confused him with the autochthonic man. The senses will be sharpened, and one will be able to ascertain the Jewish essence with the same security as one today distinguishes an African sculpture from Praxiteles. One will have the sense of the movement of the Jew, his walk, his gestures, the way his fingers grow from his hand, the form of his hair on the nape of his neck, the eyes and the tongue, so that no further errors are possible, and then the latent ghetto in which the Jew lives today, become manifest. . . . [The ghetto] is foremost a psychic manifestation. (55)

Thus, there would be no more risk of intermarriage and the production of *Mischlinge.*

Blüher also regarded this separation of Germans and Jews as necessary to save the Jews. He argued in *Secessio Judaica* that if the Jews were not reghettoized, there would be a "world pogrom" (57). But it would not be done

by the Germans: "Germany will be the only land that will be frightened from the act of murder. . . . It is ignoble to torture an unarmed enemy. The German is no Frenchman" (57). The Jews were doomed, Blüher felt, even if they attempted to create for themselves a separate state, for they have no "warrior caste" (58). The absence of Jews as soldiers confirmed for him their effeminacy. All that could be done, he felt, was to reghettoize the Jews, and thus keep the them protected and controlled.

Kafka sensed the significance of Blüher's call for the exclusion of the Jews. And he was not alone. Benjamin Segal, the editor of *Ost und West*, the most important Jewish periodical dealing with the interaction of Eastern and Western Jews, closed the final issue of that journal with an editorial on Blüher's text. Although he was well aware of the implications of Blüher's warning about "world pogrom," he dismissed him and all other such anti-Semites as self-haters. Segal charged that these anti-Semites were merely "mimicking" the enemies of the Fatherland. In other words, they were merely Mischlinge or baptized Jews in disguise.[22]

Kafka drew a connection between Blüher's condemnation of Jewish mimicry and his own anxiety about his self-definition as a writer. In writing about Friedrich von der Leyen's *Deutsche Dichtung in neuer Zeit*, a survey of contemporary "German" writing, Kafka noted that it seemed to be:

> accompanying music to the *Secessio Judaica* and it is astonishing how within a minute a reader, to be sure a well-disposed one, can organize things with the help of the book, how the crown of half-familiar, surely honest creative writers who turn up in a chapter entitled "Our Land" are classified by landscapes: German property must not be annexed by any Jews. (Kafka, *Letters to Friends*, pp. 346–47)[23]

Von der Leyen placed Jewish writing back into the ghetto. He stressed that Jews posed a danger to German culture in that they controlled the press, the theater, and most publishing. And he described them as "negative, judgmental, libelous, and destructive" (371). He concluded that Jews were "the power which is destroying the new *Reich*" (346). Von der Leyden felt that the "new German writing" he was promoting was being obscured by Jews, whom he regarded as "rootless" and therefore "especially receptive for the new/innovative/modern" (347). It was necessary, he claimed, to make "the German blood that runs through their veins visible again" (372). In his text, he contrasts, for example, Max Brod's unhealthy, Jewish image of the Thirty Years War with the healthy, German one of Hermann Löns; Brod's writing is clearly "colder and

more artificial" than that of the real "German" author (304). And yet, von der Leyen argues that the new nationalism that followed the Great War has disproved at least one important tenet of fin-de-siècle literature:

> Are then the insights of the present really so true, and are the dangers, which have been feared, really so fearful? The idea of inheritance, which underlies the tragedy of [Ibsen's] Dr. Rank [in *A Doll's House*] and [Ibsen's] *Ghosts*, is in our eyes a chimera. The passionate hopes, which the generations before us placed on an age of the woman—oh! how it is vanished in the light of reality! (22)

Inheritance, the bugaboo of the late nineteenth-century theories of degeneration, is for von der Leyden a "chimera." The centerpiece of the new culture will not be the reform of breeding through eugenics, but the political striving of the pure and select for the new *Reich*, that is, a culture minus the Jews.

The sense of being the isolated observer within an alien culture is ironized in Kafka's tale "A Little Woman," written in the last year of his life and included in his very last book, *A Hunger Artist*. In this tale, the Jewish woman represents the difficult and complex group with whom the German *Gemeinschaft* must constantly deal.[24] The male narrator couches the qualities of the "little (*kleine*) woman"—the very embodiment of "minor" (*kleine*) literature—wholly within the Blüherian discourse about Jewish difference. Here, the fantasy of the homoerotic and the Jewish merge completely, and the Jewish author becomes thoroughly feminized. In the course of *A Hunger Artist*, Kafka moves from the fantasy of the emaciated body of the Jewish artist in the title story to a fantasy of the feminized body of the Jew at the end.

Not only is the protagonist in "A Little Woman" described as "naturally quite slim," an attribute of the feminized body, but what is most striking about her body is "the impression her hand makes." The narrator says, "I have never seen a hand with the separate fingers so sharply differentiated from each other as hers; and yet her hand has not anatomical peculiarities, it is an entirely normal hand."[25] This is, of course, one of Hans Blüher's markers of the male Jew, "the way *his* fingers grow from *his* hand." Kafka's former professor, Hans Gross, the Prague criminologist (and father of Kafka's friend, the psychoanalyst Otto Gross), understands this as the "little, feminine hand of the Jew."[26] This feminized hand of the Jew transmutes itself in *The Trial* into Leni's "right hand" with the "two middle fingers, between which the connecting web of skin reached almost to the top joint."[27] This physical sign of the degenerate is echoed in *The Castle*, where K. observes Frieda's hands, which "were certainly small and

delicate, but they could quite as well have been called weak and character-less."[28] The hands of the woman and the Jew reveal their true character.

Echoes of such views, condensed for Kafka in his reading of Blüher, are found throughout this tale of the "little woman." They provide the core for the feminization of the male. She is a "frail sick woman" (Kafka, *Complete Stories*, p. 319) and she is "sharp-witted" (320). Her dealings with the narrator cause her to be "almost unable to work" and are characterized as an "unclean afflic-tion" (318). But this illness, according to the narrator, could also be a sham: "I say quite openly that even if I did believe that she were really ill, I should not feel the slightest sympathy for her" (319). Kafka employs Blüher's notion that psy-chosomatic illness is a Jewish invention, for only Jews believe that their bodies are "merely" extensions of the psyche. Here the feminization of the Jew is complete: she is ill, the inherently ill woman within. Kafka constructs a narra-tive voice separate from this feminized, ill, Jewish Other, stressing the inexorable link between the "little woman" and the narrative voice, represent-ing the ability of the male Jew to undertake the role denied him in Blüher's work, that of the creative artist.

Here, the role that Kafka selected for himself, the role of the writer, is denied the male Jew. The Jew's culture, like that of his body, is superficial and "cold." It is intellectualized, and therefore not "German." The Jew, hidden within the chrysalis of his Westernized male body, remains a Jew in all of his limitations and beliefs. His body reveals him and betrays him. He is fated, no, he is con-demned, to become that which he must become.

NOTES

1. George L. Mosse, *Nationalism and Sexuality: Middle-Class Morality and Sexual Norms in Modern Europe* (New York: Howard Fertig, 1985), p. 17. My own work has been greatly influenced by Mosse's, particularly the chapter "Race and Sexuality: The Outsider" in his groundbreaking *Nationalism and Sexuality*. An excellent collection of essays has recently followed up many of Mosse's suggestions: see Andrew Parker, Mary Russo, Doris Sommer, and Patricia Yaeger, eds., *Nationalisms and Sexualities* (New York: Routledge, 1992).

2. On Kafka and homosexuality, see Evelyn Torton Beck, "Kafka's Triple Bind: Women, Jews and Sexuality," in Alan Udoff, ed., *Kafka's Contextuality* (Baltimore: Gordian Press/Baltimore Hebrew College, 1986), pp. 343–88; Elmer Drost, "War Kafka schwul? Ein Versuch, seine Texte neu zu lesen," *TAZ* (Aug. 22, 1983); Gunter Mecke, *Franz Kafkas offenbares Geheimnis: Eine Psychopathographie* (Munich: Wilhelm Fink, 1982); and Ruth Tiefenbrun, *Moment of Torment* (Carbondale: Southern Illinois University Press, 1973).

3. Compare Wolf Kittler, "Die Klauen der Sirenen," *MLN* 108 (1993): 500–16.

4. David F. Greenberg, *The Construction of Homosexuality* (Chicago: University of Chicago Press, 1988), pp. 408–9.

5. Hartmut Binder, *Kafka in neuer Sicht: Mimik, Gestik und Personengefüge als Darstellungsformen des Autobiographischen* (Stuttgart: J.B. Metzler, 1976), p. 380.

6. See my essay "The Indelibility of Circumcision," *Koroth* (Jerusalem) 9 (1991): 806–17.

7. M.J. Gutmann, *Über den heutigen Stand der Rasse- und Krankheitsfrage der Juden* (Berlin: Rudolph Muller & Steinecke, 1920), p. 18.

8. Robert Stigler, "Die rassenphysiologische Bedeutung der sekundären Geschlechtscharaktere," *Sitzungsberichte der anthopologischen Gesellschaft in Wien* (I919/20): 7. This article was also published as a special number of the *Mitteilungen der Anthropologischen Gesellschaft in Wien* 50 (1920).

9. Gutmann, *Über den heutigen Stand*, pp. 25–26.

10. Cited by Hans F.K. Günther, *Rassenkunde des jüdischen Volkes* (1922; Munich: J.F. Lehmann, 1931), p. 273.

11. Albert Moll, *Die konträre Sexualempfindung* (Berlin: Fischer, 1893), p. 116.

12. Hans Blüher, "'Niels Lyhne' von J. Jakobsen und das Problem der Bisexualität," *Imago* 1 (1912): 386–400; and "Über Gattenwahl und Ehe," *Imago* 3 (1914): 477–98. Of importance in his discussion of homosexuality and his debt to Freud is his "Die drei Grundformen der sexuellen Inversion," *Jahrbuch für sexuelle Zwischenstufen* 13 (1913): 1–79. By 1926, however, Blüher had broken with Freud and denounced psychoanalysis as anti-German (see his *Traktate über die Heilkunde insbesondere die Neurosenlehre* [Jena: E. Dietrichs, 1926]).

13. Hans Blüher, *Die Rolle der Erotik in der männlichen Gesellschaft*, 2 vols. (Jena: E. Diederichs, 1917). The second volume is *Führer und Volk in der Jugendbewegung*. On Blüher and Kafka, see especially Binder, *Kafka in neuer Sicht*, pp. 346–95.

14. Kafka, *Letters to Friends, Family, and Editors*, ed. Max Brod, trans. Richard Winston and Clara Winston (New York: Schocken, 1977), p. 153.

15. Malcolm Pasley, ed., *Max Brod—Franz Kafka: Eine Freundschaft*, 2 vols. (Frankfurt a.M.: S. Fischer, 1989), vol. 2, p. 176 (my translation).

16. Kafka, *Letters to Friends*, p. 166.

17. Kafka, *The Diaries, 1914–1923*, ed. Max Brod, trans. Martin Greenberg and Hannah Arendt (New York: Schocken, 1949), p. 222. On the St. Sebastian theme in art, see James Saslow, "The Tenderest Lover: St. Sebastian in Renaissance Painting: A Proposed Iconology for North Italian Art, 1450–1550," *Gai saber* 1 (Spring 1977): 58–66; François Le Targat, *St-Sébastien dans l'histoire de l'art depuis le 15e siècle* (Paris: Paul Vermont, 1977); *St-Sébastien: Adonis et Martyr* (Paris: Editons persona, 1983); and Georges Eekhoud, "St-Sébastien dans la peinture," *Akademos* 1 (Feb. 15, 1909): 171–75. On the role of this image in gay iconography, see my "Touch, Sexuality and Disease," in William Bynum and Roy Porter, eds., *Medicine and the Five Senses* (Cambridge: Cambridge University Press, 1993), pp. 198–224.

18. Kafka, *Tagebücher*, p. 93.

19. Arnold Zweig, *Bilanz der deutschen Judenheit 1933* (Amsterdam: Querido, 1934), pp. 63–66.

20. All references are to Hans Blüher, *Secessio Judaica: Philosophische Grundlegung der historischen Situation des Judenthums und der antisemitischen Bewegung* (Berlin: Der weisse Ritter, 1922). On

Blüher's extraordinary impact on Jewish thinkers of the time, see Alex Bein's autobiographical footnote on Blüher in Alex Bein, "The Jewish Parasite," *Leo Baeck Yearbook* 9 (1964): 14 (fn. 39).

21. Werner Sombart, *The Jews and Modern Capitalism*, trans. M. Epstein (Glencoe, Ill.: Free Press, 1951), p. 272. See also Jeffrey Herf, *Reactionary Modernism: Technology, Culture, and Politics in Weimar and the Third Reich* (New York: Cambridge University Press, 1984), pp. 130–55.

22. "Philosophie des Pogroms," *Ost und West* (March/April 1923): 59–82, here 80.

23. Friedrich von der Leyen, *Deutsche Dichtung in neuer Zeit* (Jena: Diedrichs, 1922).

24. See the discussion in Jost Schillemeit's summary of the literature on the late writing in Hartmut Binder, ed., *Kafka—Handbuch in zwei Bänden*, 2 vols. (Stuttgart: Kroner, 1979), vol. 2, pp. 378–401.

25. Kafka, *The Complete Stories,* ed. Nahum N. Glatzer (New York: Schocken, 1971), p. 317. On hands and their meaning in Kafka (excluding the racial implications), see Binder, *Kafka in neuer Sicht*, pp. 240–65.

26. Hans Gross, *Kriminal-Psychologie* (Leipzig: F.C.W. Vogel, 1905), p. 121.

27. Kafka, *The Trial*, trans. Willa Muir and Edwin Muir (New York: Schocken, 1984), p. 110.

28. Kafka, *The Castle*, trans. Willa Muir and Edwin Muir (New York: Alfred A. Knopf, 1992), p. 39.

MASCULINITY AND THE
RULE OF LAW

four

THE RACE-CHARGED RELATIONSHIP
OF BLACK MEN AND BLACK WOMEN

THE CHRONICLE OF THE TWENTY-SEVENTH YEAR SYNDROME

It was not long after the terrible phenomenon of the Amber Cloud, when the nation had been totally preoccupied with saving its upper-class, white, adolescent youth from the devastating effects of Ghetto Disease, that it was discovered that the Amber Cloud had, after all, affected at least one category of the black population: able black women, many of them with excellent positions in government, industry, or the professions. Gathering the data was difficult, but it appeared that each month twenty-seven black women in this socioeconomic group were falling ill without apparent reason, about three months after their twenty-eighth birthday.

The illness itself was bizarre in the extreme. Without any warning, women who had contracted the malady went to sleep and did not wake up. They did not wake up. They did not die nor go into a coma. Their bodies functioned, but at less than 2 percent of normal. Nothing known to medical science could awaken the women, save one natural remedy—time. After four to six weeks, the illness seemed to run its course, the women awakened, and, after a brief recovery period, all their physical functions returned to normal.

That was the good news. The tragedy was that, in a special form of amnesia, the women lost their professional skills and were forced to return to school or otherwise retrain themselves in order to continue their careers. In some cases, this meant several years of work and sacrifice that some of the victims were unable or unwilling to make. After some time, medical researchers were able to delineate more specifically the characteristics of the black women at risk. They had: (1) held at least one degree beyond the bachelor's and had earned an average of thirty-five thousand dollars per year over the three years prior to their twenty-seventh year; (2) completed their twenty-seventh year of life; and (3) had neither been married to nor entertained a *bona fide* offer of marriage from a black man.

Women who were or had been married to, or who had received a serious offer of marriage from, a black man, seemed immune to the strange malady. But not sexual activity, or a relationship outside of marriage, or even out-of-wedlock motherhood served to protect the victims. Marriages of convenience did not provide immunity, nor did a sexual preference for other women. Strangely, black women married to white men also contracted the disease. Public health officials called the sickness the "Twenty-Seventh-Year Syndrome," while the tabloids referred to it, with an editorial snicker, as "Snow White's Disease."

For a time, the media followed the story eagerly. But gradually—because there were no fatalities and the victims of the malady were spread across the country—the ailment slipped into the category of illnesses, such as sickle-cell anemia, that strike mainly blacks, and thus are only of passing interest to whites.

The nation's refusal to make the Ghetto Disease cure available to black young people barred all hope that a national mobilization would be undertaken to find a remedy for the Twenty-Seventh-Year Syndrome. And, as one high-placed government health official explained, there was little interest in searching for a medical remedy when a social remedy was at hand: these women should each find a black man who would offer to marry them. "It was," he said, "as simple as that."

But as virtually everyone in the black community knew, the simple remedy was, in fact, extremely difficult. The Twenty-Seventh-Year Syndrome had added a dire dimension to what had long been a cause of deep concern to black leaders and a source of great pain and frustration to able black women. For many years before the strange disease made its appearance, the most successful black women had had a very hard time locating eligible black men with whom to have social relationships that might blossom into love, marriage, and family.

Social scientists have isolated several components of the social problem confronting all professional women, but exacerbated for blacks by the fact that the black population includes over one million more women than men, and by the high proportion of black men in prisons and among drug addicts compared with the very few who attend college and graduate school. In addition, those black men who survive, and achieve success comparable to that attained by women professionals, have many more social choices. They may not marry at all, or can marry very young women without advanced degrees or professional skills. Some few of the otherwise eligible men are gay; and much to the chagrin of black women, a goodly number are married to white women.

For all these reasons and more, many of the most talented, successful, and impressive black women remain single or do not marry until well into their thirties. As a result, at the very time when the black community is racking its wits about how to address the problem of teenage black girls becoming pregnant and bearing children by young males unable to support them, many of those black women most qualified to raise the next generation of black children remain unmarried and childless.

The unhappy paradox produces disunity in the black middle-class community, where women tend to condemn the inadequacies of black men, and the men, resentful at being further burdened with society's faults, lash out at black women as being unsupportive and hard-hearted. With the onset of the Twenty-Seventh-Year Syndrome, this debate intensified, as speakers claiming to represent the interests of men or women demanded that the other "do something."

Federal health officials, still smarting from the attacks by blacks outraged at the government's failure to extend the Amber Cloud Cure to black youths, determined to act aggressively on the Twenty-Seventh-Year Syndrome. Lacking funds to search for a cure, they decided, with little or no consultation, to issue compulsory Syndrome Control regulations which would, as they said, "serve as a quasi-cure by making known to the 'cure carriers' (black men) the identities of those persons at risk." In summary, single black women between

Lorna Simpson, *She*, 1992.

twenty-four and twenty-seven years of age and deemed vulnerable because of their marital and socioeconomic status were required to register with the government. If they had not established stable marriages with black men by the middle of their twenty-seventh year, the law required broad public disclosure of this fact along with detailed biographical information.

The populace in general and black people in particular were appalled and angered by the new regulations. The charges of "cruel and heartless" were not much reduced by amendments to the law providing that the records of a woman married to, or in a stable relationship with, someone other than a black man would not be made public. It was pointed out that while the Syndrome was disabling, it struck only twenty-seven women each month, and 324 women each year—a serious matter, to be sure, but hardly justifying subjecting literally thousands of black women to a humiliating public display of their personal lives. Civil liberties lawyers seeking to challenge the constitutionality of the regulations as being in violation of First Amendment rights of privacy were stymied by procedural provisions that rendered it difficult for any woman to gain standing to challenge the rules until after she had been subjected to the compulsory publicity in the regulations.

As it turned out, the first woman whose name was selected in a special drawing to receive the publicity expressed little interest in challenging the regulations. Amy Whitfield, a well-known writer, said the law represented a

particularly pernicious form of male chauvinism, one more indignity heaped on black women. Given the legacy of rape and degradation that her sisters had endured down through history, she assumed she should be thankful that a male-dominated society had not designed some still more odious process to harass those women already enduring the frightful knowledge that they might soon become a Twenty-Seventh-Year-Syndrome victim.

Ms. Whitfield explained that marriage was not the sole goal of her life, that she and her educated sisters had made contributions and lived full lives without the need to seek rescue from men who were not interested in them. "I am not opposed to marriage," she said. "There are men I would have married and men who would have married me—but they have never been the same person."

"Conjugal convergence," she went on, "requires more men than are available, particularly for black women, all of whom, owing to the horrors of American racial history, find it difficult to contemplate marrying a white man, while some consider it out of the question. Basically," she concluded, "if the public disclosure required by the statute serves to spotlight some of the dual burdens of racism and sexism black women carry, the humiliation may be bearable. But at this stage of my life, I am not interested in becoming any man's damned damsel in distress."

Most black men agreed. The frustrated anger they felt upon learning that the Twenty-Seventh-Year Syndrome attacked only black women turned to rage when government health officials announced their Syndrome Control regulations. Urged by a group of black ministers to vent their fury in positive ways, black men across the country organized "Together at Last" clubs to raise money for the medical research the government refused to fund, set up "sleep-care" facilities to nurse Syndrome victims, and established scholarships to assist recovered women in regaining their skills.

What black men did not do was rush out and propose to black women simply to save them from contracting the Syndrome. As one young black professional put it, "Black women have suffered enough because we have emulated the society's sexism. Now, in their time of need, we should not add to their Syndrome-caused despair by patronizing marriage proposals that are little more than romantic vaccinations."

But the syndrome experience did cause many black men who had—"as one option"—taken black women for granted to begin recognizing them for the remarkable individuals they are: survivors in a tough, hostile world, who have overcome difficult barriers and seek men able to share their success and

not be threatened by the strengths without which that success would not have been possible.

The change in black male attitudes was slow, halting, and produced no miracles of sex-role reformation. The syndrome continued to claim its predictable number of victims, and there remained far more black women than eligible black men. But out of tragedy came a new awareness and understanding. And while the "black male versus black female" debate continued, the bitterness disappeared from discussions that looked toward reform and away from recrimination.

"Well, I was wrong," Geneva began, "and you were right in predicting that I would not like your Chronicle. Despite some camouflage, it just brims with patriarchy and sexism. Sure, the society's racism is a substantial cause of the shortage of eligible black men. I rather doubt, though, that black women or the race will be much advanced if the only cure for racism's impact on the black families is male domination of the sort implicit in the so-called cure for the Twenty-Seventh-Year Syndrome."

I raised both hands in defense against her harsh words. "It was only a dream, Geneva. I'm not personally invested in it. Still, it can serve as a vehicle for discussing the degree to which racism has exacerbated for blacks the always-difficult social relationships between men and women. The focus was

narrow: namely, on those black women who, having overcome society's hurdles, find that their professional achievements present barriers to their hopes for personal happiness through marriage and family.[1]

"The Chronicle of the Twenty-Seventh-Year Syndrome does not disparage the fact that many, many women, regardless of race, live meaningful and entirely happy lives without either marriage or children. The simple point is that, in today's world, many white women and black women must choose the single road. And black women in particular are denied free choice on that important matter precisely because of society's erosion of the role of black men."

"And your Chronicle," Geneva burst out, "provides these societally disabled black men with their long-awaited chance to come riding to our rescue just as their white chauvinist prototypes do. Perhaps we should retitle it the 'Chronicle of the Black Male Castration Cure.'"

"You shouldn't condemn what you obviously don't understand," I cautioned. "Black men do feel castrated by the society, and can be male chauvinists in some of the worst ways imaginable, as a whole cadre of black women writers have been reporting to the world for years.[2] I certainly don't want to condone wife-cheating, wife-beating, and all the other forms of abuse—even though one needn't be a psychologist to recognize that much of this conduct is the manifestation of frustration with racism."

"There are some acts which we cannot blame on white people," Geneva said firmly, plucking a book out of a huge pile beside her chair and opening it to a page marked with a slip of yellow paper. "I agree with Grange Copeland, the character in Alice Walker's first novel who warns his son of the trap of blaming others for making a mess out of your life. Listen to this: 'I'm bound to believe that that's the way white folks can corrupt you even when you done held up before. 'Cause when they got you thinking that they're to blame for *every*thing they have you thinking they's some kind of gods! You can't do nothing wrong without them being behind it. You gits just as weak as water, no feeling of doing *nothing* yourself. Then you begins to think up evil and begins to destroy everybody around you, and you blames it on the crackers. *Shit*! Nobody's as powerful as we make them out to be. We got our own *souls* don't we?'"[3]

"That's a powerful statement," I said, "and it reflects a wisdom Grange Copeland has to travel a bitter road to gain. But that's my point. There's a history here that cannot be ignored. A major component of slavery was the sexual exploitation of black women and the sexual domination of black men. The earliest slavery statutes devoted substantial attention to prohibitions on interracial sex and marriage.[4] The clear intent of these laws was to delineate

Michael Ray Charles, *Beware*, 1994.

the inferior status of blacks as much as to discourage interracial sexual activity, a goal furthered by the double standards generally followed in their enforcement.[5] And while slavery is over, a racist society continues to exert dominion over black men and their maleness in ways more subtle but hardly less castrating than during slavery, when male-female relationships generally weren't formalized and when, even when a marriage was recognized, the black man's sexual access to his wife was determined by when the master or his sons or his overseer did not want her.[6]

"As Professor Oliver Cox observed," I continued, "'If a Negro could become governor of Georgia, it would be of no particular social significance whether his wife is white or colored; or, at any rate, there would be no political power presuming to limit the color of his wife.' On the other hand, as Professor Cox has also said, if in what is supposedly a democracy, the state can insist that a black man have a black wife, it is then possible to have a structure in which not only can the black not become governor, but he can be required to do the dirtiest work at the most menial wages."[7]

Geneva was not impressed. "That is digging rather deep into history for racial injustices to explain current failures by black males. You seem to forget that black women as well as black men suffered the pains of slavery. The black activist Lucy Parsons said it all when she wrote that 'we are the slaves of slaves; we are exploited more ruthlessly than men.'"[8]

"I've not forgotten, Geneva. But I am suggesting that, while the racial injustice was shared, the sexual harm differed. Black women were exploited, abused, and demeaned, and that harm was serious. Forced to submit to the sexual desires of their masters or of slaves selected by their masters, these women then suffered the agony of watching helplessly as their children were sold off. But black men were also dealt a double blow. They were forced to stand by powerless and unable to protect black women from being sexually available to white men, and were denied access to white women as a further symbol of their subordinate status. The harm done black men by this dual assault has never been fully assessed. Moreover, the assault continues in less blatant but still potent forms."

"True, it was a serious problem," said Geneva, "but the wounds in present relationships caused by the nonfunctioning of black men seem self-inflicted, as Alice Walker and scores of less articulate but no-less-wronged black women have testified."

My patience was exhausted. "Ms. Crenshaw, I am not a sociologist. I agree that historically 'black women have carried the greatest burden in the battle for democracy in this country.'[9] If you and your black sisters achieve a perverse pleasure out of castigating black men, I can't stop you. I think, though, that there is value in trying to find an explanation other than the condemnation 'no good' to explain our admitted shortcomings."

"I am listening," Geneva replied, "but I hope you do not expect me to maintain a respectful silence during your effort to justify with words what is often unjustifiable behavior."

"Having your sympathetic and impartial ear will make my task easier," I said, teasingly. "Let me say again that unconscionable behavior by black men makes my point. For the physical restraints of slavery that rendered the black male powerless have been perpetuated in the present, with economic restraints, joblessness, and discrimination in all its forms today rendering many black men powerless to protect wives and family. Shame and frustration drive them from their homes and lead them to behavior that can be as damaging to black women as any actions by whites in this racist society.

"While you and many proponents of women's rights feel that it is sexist for a man to feel some special responsibility to protect his woman, in this society such feelings go with the territory. And by making it so damned difficult to fulfill that protective urge, the society has turned many black men into modern instruments of their own oppression, mistreating black women and disrupting the struggle for a semblance of family life. This is not our intent, but it is, in fact,

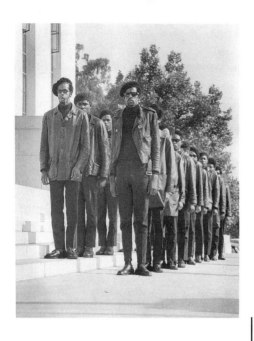

the result of conduct growing out of our unconscious realization that we, as much as our slave forebears, are powerless to protect whatever or whomever whites decide they want."

"It all sounds rather melodramatic," Geneva observed, "particularly now that laws barring racial discrimination, including interracial marriage, have been struck down by the courts."

"Again," I explained, "we have to look at history. It's important to remember that economic exploitation, rather than an abhorrence of interracial sex, was the real basis for all the so-called antimiscegenation laws that were contained in the first slavery statutes and remained on the books of twenty-nine states as late as 1951.[10] Professor Cox argued that these laws were motivated by the cultural advantage they secured for whites. By asserting that they were protecting the 'honor and sanctity of white womanhood,' white elites provided themselves with both a moving war cry and an excellent smoke screen for furthering and shielding their basic purpose: refusing blacks the opportunity to become the economic peers of whites."[11]

"In effect, then, white women became tools of white male oppression?"

"That at least is how one student of the problem, Calvin Hernton, characterizes it," I responded. "Hernton, who rejects Cox's 'economic' explanation as 'too mechanical', believes that both white women and black men are in a 'semi-oppressed' class in terms of jobs, political power, money, property, and

access to opportunities for higher status.[12] And as a predictable result, any number of black spokesmen—including Frantz Fanon, Malcolm X, and Eldridge Cleaver—have acknowledged the political implication in the black man's attraction for white women."[13]

"I wonder," Geneva interrupted, "whether you are not making too much of the economic and political functions of antimiscegenation laws. Is not the main view that these sanctions were motivated by whites' basic fear and abhorrence of interracial sex?"[14]

"One need not deny that view," I said, "to agree with Frantz Fanon that it is reasonable to assume that attitudes about sex are embedded in a given cultural and historical context; and that even if sexuality is basically biological, its form of expression is influenced by variables including economics, status, and access to power.[15] And Cox, on this point, notes that whenever whites are in a ruling-class situation, there is a very strong urge among black men to marry or have sex with white women."[16]

"It is this seemingly ungovernable urge that many white men fear and a great many black women detest," Geneva observed.

"Don't I know it! But Professor Cox is, I think, on target with his comment that 'it must not be supposed that it is the white woman as a mere sexual object which is the preoccupation of colored men, it is rather her importance to him as a vehicle in his struggle for economic and cultural position.'"[17]

"Does all that sociological theory explain the vastly greater numbers of black men who marry white women than black women who marry white men?" asked Geneva.

"Well, I gathered the census data a few years ago, and the disparity you speak of does exist. As I recall, of 125,000 black-white couples in 1977, three-fourths involved a black husband and white wife. And by 1981, the percentage of black husband-white wife couples had increased to almost 80 percent. I should add that interracial marriages of all types are on the rise, having jumped, between 1960 and 1970, by 108 percent (from 148,000 to 310,000). They increased 36 percent from 1970 to 1977, and even more from 1977 to 1981."[18]

"Those figures must put you in something of a quandary," Geneva remarked. "Wearing the sociologist hat you've been sporting for the last few minutes, you must view those interracial marriages as psychologically explainable but no less regrettable in the ammunition they provide for accusations and recriminations among black people. On the other hand, as an integrationist, I assume you applaud these figures as a happy fruit of civil rights victories in cases such as *Loving v. Virginia* (1967) that struck down antimiscegenation laws?"[19]

"I do feel some ambivalence," I admitted, "but I'm also aware that, as with other racial reforms, the removal of barriers against interracial marriage serves the needs of the whole society but not necessarily those of the blacks as people within that society. Chief Justice Warren, speaking for a unanimous Court in the Loving case, dismissed the state's arguments for retaining the laws as 'obviously an endorsement of the doctrine of white supremacy.'[20] Of course, he was correct, but the remedy—opening the way for marriage across racial lines—cured only one evil, while doing little to reconstruct the deeply damaged sense of what we might call 'black male wholeness.'"

"Evidently," Geneva said sarcastically, "it is sufficient cure for those black men who choose white women as wives or sexual partners."

"I'm not sure you're being fair," I responded. "White women must also choose black men. It is possible for a black man and a white woman to mate and marry for the old-fashioned reason: love. But my point is that, for whatever reason black men are drawn to choose white women, that attraction, and the Court's decision that made it legal, simply decreases the already inadequate number of potential mates for black women. And, as our discussion on this subject illustrates, the decision exacerbated tensions between black men and black women, particularly on the issue of black male responsibility to black women."

"A responsibility," Geneva observed, "that, according to your theory, they're too damaged by what happened in slavery even to recognize, much less assume."

I nodded. "But it's more complicated than that. The continuing powerlessness of black men affects black women as well, particularly strong black women. A strong woman doesn't achieve that status by accident. She knows her strength, has developed it over the years, appreciates it, perhaps even revels in it. It's her basis of survival. Her strength makes her intolerant of weakness, particularly in those whose weakness threatens her survival. Thus, even though she may love a man, her contempt for weakness will come out. And if her man is black, you can believe that in this society there will be many opportunities for that weakness to be all too obvious—no matter how successful he is and how strong he tries to be. No matter how hard she tries to accept him as he is, her true estimate of his strength comes out in ways that her man reads as a lack of respect—and resents precisely because he knows damn well that because of this society's racism he can never earn the respect his woman wants to give, and cannot."

I took a deep breath. "I haven't wanted to confess it, but I had one such reminder of my powerlessness last night when I stopped to help Delia Jones

as she was being harassed by that policeman. He pulled his gun and threatened me in a way he would not have threatened a white man similarly dressed and behaving as I did—a lesson I reinforced in effect by shielding my race-based inadequacy and warning him that well-connected white men I knew would cause him grief if he didn't leave me alone. It worked, but it was a further proof, in my mind, of who is strong in this country and who is weak."

"That wasn't weakness," Geneva said. "That was using your head to keep from losing it. We have always been able to outsmart white folks. It was a key part of our survival technique. You're foolish to confuse it with a stupid macho image of how a 'real man' would have handled the situation. For the most part, real men of that type are either myth or dead."

"It's easy for you, Geneva, to dismiss the protective male urge as patriarchal in origin and suicidal when emulated by black men. But didn't you just admit that you accepted—'acquiesced' was your word—in male-dominant modes of courtship because, given the current patriarchal structure of our society, it was likely the only romantic approach I could handle?"

Geneva blushed. "Please don't confuse the subject of the male urge to protect his woman with your inability to deal with me as lawyer and lover. My problem with your Chronicle of the Twenty-Seventh-Year Syndrome is that it ignores all the black males with problems like yours, and elevates to the level of indisputable truth the sexist ideal of men as the natural protectors of women. So, while recognizing that society is patriarchal, your Chronicle does not analyze the harm that priority does to the black community's struggle against racist oppression. Rather, it encourages black men to assume a role equal to the white man within the patriarchal order. It does not even hint at—much less espouse—a more desirable option: that is, for black men to reject the whole 'protective role' concept and become one with black women in order effectively to confront the common enemy—racism."

"My Chronicle is based on the world as it is," I tried to explain, "not as some of us would like it to be. Within that context, it provides a dramatic situation intended to show black men that black women, even those who have demonstrated outstanding ability and survival strengths, cannot themselves create black mates with abilities and strengths equal to their own. To the extent this is a problem—and at the risk of being labeled sexist—I consider it damn serious, and a problem that only black men can cure."

"And are you saying that, before the crisis caused by the Twenty-Seventh-Year Syndrome, black men were unable to function in what you call a 'manly' way regarding these single black women?"

"Why do you find that so hard to believe?" I asked. "There have been many such transcendent events in black history—in fact, in all history. Consider the reaction of black people to the Emancipation Proclamation and the Brown decision. Both sparked waves of activity far beyond anything justified by the words of the documents. Perhaps a closer example, because more tragic, was the assassination of Martin Luther King, Jr., in 1968. His death led to tremendous change. Losing him was a tragedy and certainly not a 'fair trade,' but it's clear that the civil rights reforms and progress of the following few years resulted from the transcendent event of his death."

"What do you think about Amy Whitfield, and likely many other women in her situation, who do not want to become any man's 'damn damsel in distress'?"

"I think such women miss the point, Geneva. No one should devise any sort of Twenty-Seventh-Year Syndrome as a means of getting black men to function. That would be evil, just as killing Dr. King was evil. The Chronicle simply replicates this type of evil. Even without the federal health regulations, the disease puts the spotlight on black men: they have opportunity and the obligation. If the television pictures of afflicted black women lying asleep in the hospitals don't provide the necessary incentive, nothing will. Black women are in danger. Only black men can save more of them from a pretty awful fate.

"And keep in mind that the women are not forced to marry in order to gain protection from the Twenty-Seventh-Year Syndrome. Men have only to provide black women with the *choice* whether to have a black home. That's all. Black women are entitled to that, as I think even you will agree. I can understand why women who have spent their lives developing and defending their individual identities do not want to change them, especially not to demean them for anyone. As Amy Whitfield makes clear in the Chronicle, she does not want her life to read like a dime-store medieval romance. But I don't think Amy or—in light of our conversation of last evening—even you are opposed to men expressing their interest in such a way as to provide black women with choice."

"In other words," Geneva said, "it's a matter not of whether women want to be saved, but of giving them a choice and thereby saving yourselves. I don't see why, even in your dreams, you men can envision only chauvinistic solutions that perpetuate sexist stereotypes.

"Amy Whitfield was kind. What she is trying to say tactfully is that most black professional women have 'choices.' But because of the quality of those choices, many reluctantly opt to remain single. If the black men in your Chronicle have not engaged in any self-reflection, if they have not determined and con-

tinue to fail to appreciate that black women face real and significant racial problems that equal and, yes, surpass those that men face, they will not provide a 'meaningful choice' to black women.

"More blatantly, unless black men can pause for one minute, can stop feeling sorry for themselves—that is, free themselves of their castration complex—and *try* to understand and empathize with the condition of black women, that condition—as hellish as the Twenty-Seventh-Year Syndrome—will not change. Black professional women will continue to opt to be alone or to compromise themselves for their wounded black warriors, providing their men with support while the men bemoan their inability to offer their women a form of protection that the women neither need nor would want save for their understanding that the men have a misguided need to provide it."

"Someday," I replied, "the society will evolve beyond its present rigid views of sex roles, but that time has not come. And black men won't be ready for the era of complete sex equity until they have gained that confidence and sense of themselves essential to male-female relationships based on mutuality and sharing."

"True enough, friend. I am simply saying that black men cannot hope to attain their independence through the subordination of their women. The black man needs to direct his attention outward—as I gather your Chronicle suggests some black men are doing through the 'Together at Last' clubs—and recognize that, even historically, as his sexual access to his wife was determined by the white man, the wife was similarly restricted from him. When she was raped, something that was hers—not his—was being robbed.

"Once black men realize that racial oppression equally afflicts black women, perhaps our mutual problems will be easier to address. The powerlessness about which black men so bitterly complain is no less severe in the black woman. These feelings emanate from what we expect of ourselves vis-à-vis our loved ones, as opposed to what society expects from us. But until black men critically assess the sexist expectations of society and define their own expectations, they will not be compatible mates for black women who have expectations of their own for themselves. The problem with the Chronicle is that it perpetuates this black male focus, instead of viewing the plight of the black woman through her eyes and, in the process, honestly assessing the problems black men have independently caused owing to their intransigent adherence to sexism."

"The issues involved here, Geneva, are as complex as any we have discussed. Your perspectives are valid, although not necessarily the primary concern of the Chronicle as I dreamed it."

"I have one last concern about your Chronicle."

"Yes?"

"If it was intended, as you claim, to reveal to black men their opportunity to give black women a choice, why does the Twenty-Seventh-Year Syndrome afflict successful black women who are involved in nonmarital relationships or have children out of wedlock, and especially why are black women married to white men not exempted? Women in these categories obviously had choices and exercised them, and yet all are subject to the illness. Why?"

I thought about the question for a full minute, and finally admitted, "I'm not sure. It may be that the supernatural powers responsible for the illness were influenced by that Victorian mind-set on sex you mentioned earlier. Further- more, the vulnerability of black women married to white men may reflect the strong negative feelings in some portions of the black community—as well as among whites—about interracial marriage, particularly when black men marry white women."[21]

"Your response is not convincing," Geneva observed. "And it maintains attention on the quantitative aspects of black women's choices, ignoring in the process the key qualitative issue for black professional women. I honestly do not believe any of us are personally—as distinguished from politically—dis- traught over the black men who are married to white women. They are simply not an issue. They are not 'eligibles' in our personal lives. Our distress is caused by the quality of the limited choices we do have. So, en masse from prisons, rejected homosexuality, and so forth, the quality of our choices would not necessarily change."

"Well, Geneva, this is a subject we could discuss for the remainder of your time without coming any closer to agreement than we are right now. I think we'd better move on to what I'm afraid will be the last Chronicle I have time for."

NOTES

1. See, for example, Paula Giddings, *When and Where I Enter: The Impact of Black Women on Race and Sex in America* (New York: Morrow, 1984), p. 149, who reports that, when there is a scarcity of women, men tend to have a protective, monogamous attitude toward them; while during a scarcity of men, protectiveness dissolves and men become reluctant to make permanent commitments. See also "How Black Women Can Deal with the Black Male Shortage," *Ebony* 41 (May 1986): 29–34; "Too Late for Prince Charming," *Newsweek* 107 (June 2, 1986): 54, 55.

2. See, for example, Alice Walker, *The Color Purple* (New York: Harcourt Brace and Javonovich, 1982); Gayle Jones, *Eva's Man* (New York: Random House, 1976); Ntozake Shange, *for colored girls who have*

considered suicide when the rainbow is enuf (New York: Macmillan, 1977): and Toni Morrison, *The Bluest Eye* (New York: Holt, Rinehart and Winston, 1970).

3. Alice Walker, *The Third Life of Grange Copeland* (New York: Harcourt Brace Jovanovich, 1970).

4. See, for example, Jonathan L. Alpert, "The Origin of Slavery in the United States—The Maryland Precedent," *American Journal of Legal History* 14 (1970): 189–122.

5. Eugene Genovese, *Roll, Jordan, Roll: The World the Slaves Made* (New York: Vintage, 1974), pp. 413–31.

6. According to Beth Day, *Sexual Life between Blacks and Whites* (New York, 1972), "In the South . . . black women . . . were lynched, murdered, and beaten by whites as well as sexually exploited on a mass scale. And their men had no means of protecting them" (p. 122); while Angela Davis, *Women, Race, and Class* (New York: Random House, 1981), has said, "One of racism's salient historical features has always been the assumption that white men—especially those who wield economic power—possess an incontestable right of access to Black women's bodies. . . . Slavery relied as much on routine sexual abuse as it relied on the whip and the lash" (p. 175).

7. Oliver Cox, *Caste, Class, and Race: A Study in Social Dynamics* (New York: Doubleday, 1948), pp. 526–27.

8. Lucy Parsons, quoted in Manning Marable, *How Capitalism Underdeveloped Black America: Problems in Race, Political Economy, and Society* (Boston: South End Press, 1983), p. 69.

9. Ibid., p. 103. See also Jacqueline Jones, *Labor of Love, Labor of Sorrow: Black Women, Work, and the Family from Slavery to the Present* (New York: Basic Books, 1985).

10. H. Applebaum, "Miscegenation Statutes: A Constitutional and Social Problem," *Georgia Law Journal* 53 (1964): 49, 50–51.

11. Cox, *Caste, Class, and Race*, p. 387.

12. Calvin Hernton, *Sex and Racism in America* (New York: Grove Press, 1966), pp. 32–33.

13. Charles Stember, *Sexual Racism: The Emotional Barrier to an Integrated Society* (New York: Elsevier, 1965). Stember points out that the phenomenon is not limited to black men, and quotes Philip Roth in his 1969 novel *Portnoy's Complaint*, in which the main character discusses his fascination with gentile girls (pp. 114–18).

14. Gunnar Myrdal, *An American Dilemma: The Negro Problem and Modern Democracy*, vol. 1 (New York: Harper & Brothers, 1964), p. 60.

15. Frantz Fanon, *The Wretched of the Earth*, trans. Constance Farrington (New York: Grove Press, 1965).

16. Cox, *Caste, Class, and Race*, p. 386.

17. Ibid.

18. Figures for 1970 and 1977 from U.S. Bureau of the Census, Current Population Reports, series P-23, no. 77, *Perspectives on American Husbands and Wives* (Washington, D.C.: Government Printing Office, 1978), pp. 7–10. Figures for 1981 from U.S. Bureau of the Census, Current Population Reports, series P–20, no. 371, *Household and Family Characteristics*, March 1981 (Washington, D.C.: Government Printing Office, 1982), pp. 163–64.

19. *Loving v. Virginia*, 388 U.S. 1 (1967).

20. Ibid., p. 7.

21. Stember, *Sexual Racism*, p. 8. See also polls indicating that resistance to interracial sex, though weakened, still exists, particularly among close relatives or family members of the people involved. One survey of these polls found that, between 1968 and 1972, the proportion of whites who disapproved of marriages between blacks and whites declined from 76 percent to 65 percent, but the proportion who would be "concerned" if one's own teenage child dated a black dropped only from 90 percent to 83 percent. And in a 1975 survey, fully 85 percent expressed disapproval, in varying degrees of intensity, to the idea of marriage of one's daughter to someone of another race.

R. CHARD D. ELGADO AND J. EAN S. TEFANCIC

MINORITY MEN, MISERY,
AND THE MARKETPLACE OF IDEAS

INTRODUCTION

As everyone knows, the social construction of masculinity is problematic. The stereotype of the ideal man is forceful, militaristic, hyper-competitive, risk-taking, not particularly interested in culture and the arts, protective of his woman, heedless of nature, and so on. And in many families, boys are conditioned actually to behave that way.

But the social construction of men of color is even more troublesome and confining than that of men in general. Men of color are constructed as criminal, violent, lascivious, irresponsible, and not particularly smart. In this chapter

Thomas Eakins and J. Laurie Wallace, *At the Shore*, c. 1882.

we review the history of society's depiction of men of color in stories, films, editorials, and other social texts. We find that these images are almost always negative, although their specific content varies from era to era. Equally important, the harmful nature of these images is rarely seen as such at the time, yet have eerie parallels across the four main racial groups we study. Moreover, these negative images and stereotypes are not accidental, but functional: Racist depiction, far from being a social evil, is a social good that enables society to accomplish goals that vary from era to era but always includes the subordination or marginalization of minority men.

Finally, the harmful images are not easily dispelled by counterimages, or "more speech," as legal theorists call it. For reasons we discuss, the racism of our time is only dimly seen as such. Countervailing speech, exhortation, narratives of all kinds aimed at dispelling the negative images of minority people thus rarely arise, and when they do they are apt to be dismissed as humorless, political, or extreme. We employ narrative theory and history to show how and why this happens. Not only is the vaunted marketplace of ideas a poor tool for dispelling harmful racial depiction, the very playing field is slanted. The system of narratives and received understandings that the would-be reformer must contend with itself contains a set of agreed-upon truths and presuppositions, including "feelings are minor," "the cure for harmful speech is more speech— talk back!" and "who would believe you—you are partial." The old adage that

one cannot use the master's tools to dismantle the master's house unfortunately has more truth than First Amendment theorists would like us to believe.

In this essay, we first set out the empirical evidence for (i) the ubiquity; (ii) the functionality; and (iii) the parallels among negative stereotypes of the four principal groups of color in the United States—African Americans, Native Americans, Mexican Americans, and Asian Americans. Then we explain why these negative images proliferate and endure, and develop a framework—the "empathic fallacy"—to explain why the system of negative depiction resists alteration through a talking-back or more-speech solution of the type favored by the American Civil Liberties Union (ACLU) and other free-speech traditionalists.

IMAGES OF THE MINORITY MALE IN AMERICAN LAW AND CULTURE

The images of African-American *women* in U.S. culture—the Mammy, the welfare mother, the militant-but-lazy office worker—are bad enough (and the same is true of Mexican señoritas, Indian squaws, and Asian temptresses and Mata Haris), but those of males of color are, if anything, worse. Early in our history, minstrel shows depicted African-American men as slow-witted, lazy, happy-go-lucky creatures fawning on the goodwill of their masters. The Sambo, a stock character incorporating these characteristics, appeared in popular American dramas in the eighteenth century. Portrayed by white actors wearing blackface, Sambo spoke gibberish and generally acted the buffoon. A later black male caricature, Jim Crow, added singing and shuffle-dancing to blackface minstrelsy, furthering the image of the happy, childlike slave. Harriet Beecher Stowe's Uncle Tom exhibited a dignity denied to previous black characters. As she drew him, the happy slave image took on a more somber cast, giving Tom a long-suffering, pious demeanor in the face of the hardships of slavery. Even so, her character's kindness and nobility enabled readers to be comfortable with white-over-black social relations. By drawing on previous stereotypes, Tom constituted little break with a happy past. Other stories from this period depicted black men as either contented with their lot or imbued with a kind of fatherly wisdom. Uncle Remus stories, for example, show the latter kind of male—kindly, wise, compassionate, incapable of doing harm.

This changed, however, during Reconstruction. The freed black, no longer enmeshed in the economics of slavery as a property interest of whites, was consequently less subject to direct control. His new liberty threatened the balance of social relations. His sexuality, previously denied or unacknowledged,

RICHARD DELGADO AND JEAN STEFANCIC

Anne Rowland, *Untitled (Sigmund Freud)*, 1987/93.

suddenly became the subject of obsessive attention. Tacit acceptance of miscegenation during slavery, justified by the economic necessity to create more workers, reversed itself into fear of race pollution—black men sexually overpowering white women. In fiction, black males were portrayed as brutish, aggressive, and bestial.

These widely held social attitudes found artistic expression in D.W. Griffith's 1915 movie *The Birth of a Nation*. In that film, a beastlike black man pursues a young white woman until she jumps from a cliff to her death. Other scenes showed black males as irresponsible, vindictive and threatening. The movie was based on the novel *The Klansman*, authored by Thomas Dixon, a white Kentuckian and former classmate of President Woodrow Wilson. Wilson thought so highly of Griffith's film that he requested a private screening for himself and members of the Supreme Court. Although the National Association for the Advancement of Colored People (NAACP) protested the vicious racial stereotyping in *The Birth of a Nation*, film critics lauded its purely cinematic achievements, which, in their view, outweighed any harm caused to blacks. Black men returned from World War I to a hostile environment in the United States, finding that their acceptance was influenced more by such derogatory film images than by an appreciation for their service in the armed forces.

When the literary movement known as the Harlem Renaissance sprang up in the 1920s, white onlookers were bemused and baffled, considering it a kind

of aberration. They were fascinated by its "otherness" and deemed it exotic. Not threatening in any economic sense, its sexual aspects were in tune with the new permissive era of the 1920s.

The depiction of Native-American males in our national literature parallels that of blacks. From the seventeenth century, Indians were placed on either end of a spectrum of social relations, but seldom in the middle. Early explorers, starting with Columbus, described the Native American as innocent, generous, and friendly. Initial contacts between settlers and Indians were often favorable. James Fenimore Cooper reflected these relations when, in *The Last of the Mohicans* (1826), he created the faithful Indian friend Chingachgook, a forerunner of the nonthreatening and loyal sidekick, Tonto.

Later, of course, conflict broke out. As happened with blacks, writers began to depict the Native American as menacing, hostile, and threatening. The first captivity narrative in which a white woman is taken away by pillaging Indians appeared in 1682. Other tales of the period depicted Indians as looters, burners, and killers. Cotton Mather and Puritan writers called them sorcerers and demons possessed by Satan. The legal system tapped theological notions to develop the "Discovery Doctrine," by which Indian land could be seized by any European person or nation. Nineteenth-century narratives obligingly followed suit, portraying Indians as barbarous and half-civilized, unable to enjoy stable, civilized, Western-style lives. This genre continued into the twentieth century, when early filmmakers featured Indians, played by whites, dancing war dances, launching surprise attacks on innocent or heroic whites, and engaging in other ruthless behavior. By 1911, the depiction of Native Americans was so skewed that four Western tribes sent protests to then-President William Howard Taft. But little changed. Indeed, just two years later, D.W. Griffith produced *The Battle of Elderbush Gulch*. In this film, as in the slightly later *The Birth of a Nation*, a white woman is in danger of sexual violation, this time by Indians. Trapped in a cabin, surrounded by hostile renegades, her fate hangs in the balance. The white men trying to defend her even deliberate whether they should kill her in order to save her from the Indians. The cowboys-and-Indians genre continued in this vein until World War II, when the enemy role in movies was transferred to the Japanese.

If most European settlers of America knew something of blacks and Indians, they had far fewer contacts with Asians and Mexicans. Chinese immigration, mostly male, was encouraged in Western states during the mid-nineteenth century. Most Chinamen, as they were called, worked in the gold mines, built railroads, and did the backbreaking work that other settlers shunned (much as today's immigrant workers perform tasks whites consider too menial or

low-paying to do themselves). During this period, depiction of Asians was either neutral or mildly negative. A few editorials and cartoons made fun of the newcomers' inability to speak perfect English, rendering them hapless and nonthreatening figures somewhat reminiscent of Sambo.

But many Chinese gained a foothold by working for others, then set off independently to run their own shops, laundries, and restaurants. Their perseverance, independence from whites, and willingness to help each other were both admired and feared; they became economic competitors. The easiest way to rally animus against them was to ridicule and scorn their physical and cultural traits and to question their motives and loyalty to the United States. If not rendered as harmless innocents, they were presented as sinister agents of evil, much as Indians and blacks had been portrayed. In 1919, in a film series called *Patria*, newspaper publisher William Randolph Hearst presented such a virulent image of Chinese immigrants as a "yellow menace" that even President Wilson protested. Hearst responded by changing the series so that it became predominantly anti-Mexican. In the 1930s, as Japan became a political threat on the world scene, filmmakers transferred the Asian stereotype to them, showing Japanese men, played by whites, as cunning, foul, savage, tricky, and potential rapists of white women.

Mexicans entered, settled, and remained in the Western and Southwestern regions of North America in the sixteenth century. Largely unknown by Eastern

settlers, they became part of the romance and mythology of the West, generally taking one of two forms: the harmless innocent or the wily villain. As the first, the Mexican was represented either as a shiftless but happy-go-lucky lover of song, dance, and food, or as a mysterious tall, dark, handsome, "Spanish" type. The villain image took the form of the conniving and treacherous *bandido* or the greaser. During and just after the war with Mexico (1848 to 1850), Mexicans were uniformly characterized the second way—as shifty and brutal. But when whites finally secured an economic advantage by winning the Texas territory, Mexicans were no longer a threat. Depiction took on a more generous quality. Though they still were rendered as indolent, pious, and lacking in resourcefulness, stories and scripts showed them as traditional, sedate, and law-abiding. There was, however, the ever-present fear of the Mexican who did not know his place, and might become sexually aggressive toward white women.

When the labor supply was ample, Mexicans were less of a threat. During these periods, early film imagery presented Mexicans as harmless buffoons or tequila-drinking clowns. In times of war or competition, however, the image changed. Movies such as Griffith's *The Greaser's Gauntlet* (1908) showed Mexicans shooting Anglo heroes in the back, stealing their gold or horses, lusting after white women. Novels and newspapers also reinforced these stereotypes. World War II brought a need for labor for the war effort. Most racial groups (except the Japanese) were afforded a temporary respite. Though the negative Mexican type continued somewhat, heroic Mexicans, such as Marlon Brando's character in the 1952 movie *Viva Zapata!*, began to appear.

WHY THESE NEGATIVE IMAGES PROLIFERATE AND ENDURE

As we have seen, the predominant images of men of color in any era are apt to be intensely negative, although the quality or content of the images changes from period to period—now a hapless, dim-witted figure, now a threatening animalistic one—in response to social needs. In one period, society needs reassurance that blacks are happy with their lot (as during slavery, for example), in another, it needs to justify repression. The sullen, out-of-control black suited the latter purpose. And the same is true for the other three nonwhite groups whose history we have briefly reviewed—the hapless, ever-smiling Sambo is to Charlie Chan as the Indian sidekick is to . . . and so on. Negative depiction, far from being a mistake or a product of ignorance, is *functional* for the dominant society—not a bad, in other words, but a good.

Moreover, the vicious images we have discussed *were not seen as such at the time*. The reading and viewing public was exposed to hundreds of such

RICHARD DELGADO AND JEAN STEFANCIC

scripts, pictures, narratives, and films. And, because so few persons in the dominant group had close friends who were black, Mexican, Native American, or Asian, the images became the reality. Narrative theory teaches that our sense of the world is the product of hundreds and thousands of such stories or narratives, which we use to interpret, construct, and understand our experiences, including new stories and narratives that others offer us. This explains why the dominant narrative of race is so slow to change—individuals interpret new narratives in terms of their preexisting stock, which serve as a kind of screen. If the new story is too different from the ones we hold, we pronounce it extreme, political, or bizarre. During every historical period, most readers tended to accept the existing stock characters of minority persons as "the way things are" or, at worst, as slight exaggerations. Except from members of the racial groups concerned, there were few protests.

History shows that one cannot effectively "talk back" against the dominant narrative of one's day. And, with race, the reason is that we simply do not see the racism of our time as such. We see it only years later, after the paradigm has begun to shift and society has adopted a different, sometimes more enlightened, view of the group in question. But while the image prevails, it constitutes the truth. Criticisms of images of blacks in novels or movies, for example, are rejected as humorless or extreme. Everyone uses stock characters, we say. What is so wrong with a film that includes a black maid? Are not many maids, in reality, black? And, just last week, I heard two of them talking in the accent and jargon I used in my script.

True, in every era a few courageous writers and artists speak out against the racism of their day. Unfortunately, they are generally ignored; they have no audience. Harriet Beecher Stowe's famous novel sold well only after decades of abolitionist agitation had sensitized her public to the possibility that slavery might be wrong. Nadine Gordimer won the Nobel Prize only after decades of writing about the evils of apartheid, and only when her country was on the verge of abandoning that system of governance. Early films by blacks found small audiences. Consider also the recent "discovery" of a generation of African American poets and novelists such as Charles Chesnutt and Zora Neale Hurston, who were writing fifty or a hundred years ago.

We have coined the phrase "empathic fallacy" to describe the mistaken belief that we can quickly and endlessly reform each other and ourselves through verbal means—by presenting arguments, novels, texts, and films that show another side of the story, that show stigmatized people as normal. Both history and narrative theory show that things simply do not work that way. The

marketplace of ideas is useful for making incremental, not large, changes; for correcting small, not systemic, error. Notions that are deeply inscribed in consciousness, that form part of the narrative by which we understand the world—including the counternarrative the dissenting writer offers—are for all intents and purposes unchangeable. Deeply inscribed narratives do not seem like narratives or stories at all, but the truth. The narratives by which we reason are unassailable because they form the basis from which we judge new narratives, including ones that would challenge our received views about, for example, the intelligence or niceness of black people as a group.

Furthermore, it is difficult to have one's counterstory (about an intelligent, sensitive, high-achieving Mexican, for example) heard. Those most likely to attempt to circulate those stories—creative people of color—face additional obstacles in being taken seriously. They strike us as partial or biased because of their very membership in the group whose status they are attempting to lift. Moreover, the storyteller of color confronts a host of cultural narratives and rules that reduce his or her credibility and impact. Dominant stereotypes of persons of color present them as shrill, unintelligent, lazy, affirmative-action babies, or—at best—soulful, poetic, deep, and in touch with their feelings. Who would take seriously a lecturer or storyteller like that?

Not only does the system of images resist changes, our political system of free expression often makes matters worse. Writers and graphic designers feel freer to use racist images because another writer is equally free to make an antiracist movie. Moreover, the system of free expression has an important apologetic function. Because there is a free market in ideas, our group's superior position must be deserved; *their* poverty must be a result of a fair competition. Our culture's ideas competed with their more easygoing ones and won: It was a fair fight. If black or Mexican people are poor and despised in many cases, well, what can be done?

Finally, our very imagery of outsider groups shows that we do not really want them to speak out effectively in their own behalf. Try to recall how people of color speak in the dominant narratives. Generally, poorly: in grunts, broken language, and words of one syllable. The dominant narratives contain very few examples of eloquent, self-assured speakers of color. In real life, of course, they exist in profusion. But when we encounter one, it is invariably a surprise. What a welcome exception, we say!

The empathic fallacy helps us to understand why many minorities place less stock in the First Amendment than others, and also why that amendment is now beginning to be seen as a legitimating tool of conservative forces. The

empathic fallacy is related to the pathetic fallacy, familiar from literary theory. The latter holds that nature is like us, has moods, thoughts, and feelings that we can understand. The poet, noticing that it is raining, writes, "The world weeps with me." The empathic fallacy points out a similar mechanism by which incessant and systematic depiction resists rapid change, through verbal means—exhortation, argumentation, preaching, texts of all sorts. Both fallacies are based on *hubris*, the belief that we can be more than we are, that we may somehow surmount our limitations of experience, positionality, and framework through a magical text, easily and endlessly making ourselves more and more humane. Both history and theory reveal that this is not so, indeed that a principal function of our system of free expression is to reproduce social reality, not to change it. Nowhere is this more visible than in the case of ethnic depiction. Images change slowly, resisting the one simple rational counterargument that reductionist First Amendment marketplace analysis holds ought to work. Pernicious images circulate, are believed, become ingrained. Fifty years later, when the times, economic conditions, and finally consciousness have shifted, we look back and say: "How could we have believed that? Why did no one protest?"—blithely ignoring the Willie Hortons, the Indian sports mascots, and all the other vicious images that circulate daily, freely, almost without protest, in our midst.

KENDALL THOMAS

"MASCULINITY," "THE RULE OF LAW," AND OTHER LEGAL FICTIONS

By way of a beginning, I want to quote the description that accompanied
the editors' invitation to contribute to this chapter on "Masculinity and the Rule
of Law":

> American legal studies have recently undergone a radical shift. The application of criti-
> cal theory to juridical thought by certain scholars has raised a number of new questions.
> Can universal legal "truths," themselves rooted in the sexist, racist, and class presump-
> tions of the 200-year-old Constitution, be deconstructed in order to accommodate the
> altered social terrain of the 1990s? Can a masculinist legal theory be developed to

advance the causes of equality, power-sharing, and self-awareness in legal practice? And finally, given the preeminent role that constitutional law plays in shaping the social landscape of our nation, can such innovations filter down to affect social contracts in general?

Because I do not wish to be misunderstood, I should note at the outset my sympathy for the spirit, if not the letter of this text. Nonetheless, I find myself unable to address the issues it raises without some preliminary interrogation of the terms in which they have been cast. The language in which these questions are posed assumes what I believe must instead be examined: namely, that American legal theory is indeed "masculinist." In my view, to accept this text's assumptive orientation regarding the gender of law is to risk premature foreclosure of urgent and unfinished work on crucial questions such as how and why legal and gender ideologies came to be implicated, and what their implication means for those of us who are struggling to make the law aspire to justice.

Accordingly, for reasons which I trust will become clearer as I proceed, I am going to breach my contract (as we lawyers say). My goal here is to approach the complex condominia of gender and law with a different conceptual compass, one which questions the very possibility of "masculinist legal theory." In short, rather than address the links between "masculinity and the rule of law," I would like to canvass some of the concerns of a critical account which refuses to take their connection for granted. We must not forget, as the title of this volume implicitly reminds us, that the mythologies of masculinity are *constructed*—they owe their existence to the "active work of selecting and presenting, of structuring and shaping" which characterizes all representations.[1] The same may be said about the relationship between the regime of masculinity and the rule of law, whose intersections are less fixed, and more fragile, than is sometimes assumed. This essay will look at a number of texts in which the nature and workings of that relationship are thrown in sharp relief. While I refer along the way to "official" legal texts, the burden of my discussion focuses on two recent films that not only explore the ambiguities of masculinity, but illustrate as well its unreliability as law's founding force and figure.

Before I proceed to the body of my argument, however, I must first say a few words about an undecidability which inhabits the very house of the rule of law. My point of departure here is a late essay by Michel Foucault on "The Subject and Power."[2] In this text, Foucault issues a call for the development of "a new economy of power relations" which might be "more directly related to our present situation."[3] Foucault suggests that this project should take "the forms of

resistance against different forms of power as a starting point."[4] One of the examples Foucault gives in charting the trajectory of such a project comes, interestingly enough, from law. If we want to find out what a society means by "legality," he writes, we would do well to begin by investigating "the field of illegality."[5] I find this formulation suggestive, and shall take it as a key premise in what follows. We cannot hope to track the operations of law unless we look at the relationship between law and its ostensible opposite, at the very lawlessness the law would have us believe is its enemy and determinate negation.

Now, the value of Foucault's methodological injunction should be obvious to anyone familiar with the history of constitutional politics in America. From its inception, American constitutionalism has been haunted by the specter of the lawless act on which our fundamental law was founded. For example, during the ratification debates which led to its adoption, opponents of the proposed Constitution accused the members of the 1787 Convention of foul play. The decision not to amend the Articles of Confederation, but rather to abandon them altogether was not within the Convention's authority. The enemies of the proposed new Constitution attacked the members of the Philadelphia Convention for exceeding their charge and illegally usurping the powers of the thirteen states whose interests they had been delegated to represent. Indeed, for some, that lawlessness was compounded by the fact that the Convention delegates had voted to disregard a key provision in the Articles of Confederation which stipulated that no change could be made in the national charter without the unanimous approval of the thirteen state legislatures. The members of the 1787 Convention had rather deviously determined that the proposed Constitution would replace the Articles of Confederation upon ratification by only nine of the thirteen states, and that that would be done in special constitutional conventions rather than in ordinary state assemblies.

It was against this lawless backdrop that James Madison, John Jay, and Alexander Hamilton wrote *The Federalist Papers*, one of the most disingenous documents in the annals of American propaganda. In a remarkable passage in *Federalist 40*, Madison undertakes to answer those who doubted whether the Philadelphia Convention was "authorized" to write a new national constitution.[6] During the course of his argument, Madison rejects all the charges levelled by the Constitution's critics, except one: "Instead of reporting a plan requiring the confirmation of *all the States*, [the Convention has] reported a plan which is to be confirmed and may be carried into effect by *nine States only*."[7] Madison's initial tactic is to "dismiss . . . without further observation" this objection to the Convention's conceded "departure from the tenor of their

commission."[8] A few lines later, however, Madison tries to justify the "admitted"[9] illegality of the Convention on the grounds that its members had been motivated by a spirit of "manly confidence in their country" which overrode any "ill-timed scruples" about sacrificing political "substance" to legal "forms."[10] In Madison's text, the ideology of masculinity reveals itself to be an enemy and not an ally of the rule of law. My point here is not merely that the American constitutional order was founded on an illegal act. What must be stressed as well is the way the "Founding Fathers" justified their open contempt for the rule of law by appealing to a masculinist rhetoric of "manly confidence."

The originary lawlessness of our constitutional founding has not been lost on subsequent generations of American scholars. As the constitutional theorist Bruce Ackerman has noted, modern jurists "are perfectly prepared to admit that the Constitutional Convention was acting illegally in proposing its new document in the name of We the People."[11] "There is a conceptual sense," writes Ackerman, "in which our very identification of the Founding as a Founding presupposes that the Philadelphia Convention acted without legal warrant under the preexisting Articles."[12]

In this respect, the inaugural illegality of the American Constitution—a document which has come to stand for the very idea of the rule of law in our culture—obeys the logic of "jurisgenis"[13] of which Slavoj Žižek has offered the following philosophical anatomy:

"At the beginning" of the law, there is a certain "outlaw," a certain Real of violence which coincides with the act itself of the establishment of the reign of law: the ultimate truth about the reign of law is that of an usurpation, and all classical politico-philosophical thought rests on the disavowal of this violent act of foundation. The illegitimate violence by which law sustains itself must be concealed at any price, because this concealment is the positive condition of the functioning of law: it functions in so far as its subjects are deceived, in so far as they experience the authority of law as "authentic and eternal" and overlook "the truth about the usurpation."[14]

If Žižek's analysis is correct (and I think it is), it seems to me that we have to draw a distinction with respect to legal ideology similar to the one between the "masculinity" and "men" on which Eve Kosofsky Sedgwick insists in her contribution to this volume.[15] It is a mistake to assume that the notion of the rule of law has any necessary connection to either the idea or the fact of legality. This is so because "there is no 'original' law not based upon crime: the institution of law as such is an 'illegitimate' usurpation."[16] The rule of law, then, is the name for a certain radical impossibility. In the American context, this "impossibility" is the lawlessness that Madison tries to explain away in the *Federalist*. It is the enabling but effaced "crime" that not only coincides with, but conditions the "justice" that "We, the people of the United States" claim to "establish" in the Preamble to the Constitution.

This constitutive lawlessness continues to insinuate itself in our national political ideology and legal institutions. Drawing again on Žižek, we might say that the "official discourse" of American constitutionalism has been split throughout its history into two different and incommensurable parts, one public and transparent, the other more hidden and secret.[17] In the public discourse, the state or, as we prefer to say in the U.S., the government, is a government of law; the power of the state is power of, by, and for the people; and the commitment to popular sovereignty is a commitment to the principle that every member of the body politic is equal, and entitled as such to the equal protection of the law (to use the phrase from the Fourteenth Amendment).

In its private, hidden, and secret discourse, however, the law reveals its "shadowy double."[18] In this discursive register, which everyone knows but few will openly acknowledge, the rule of law becomes a reign of terror. Citizens become suspects, and suspects become wild animals. Entire neighborhoods become battlefields, particularly in the cities, which have been largely ceded to the "darker hordes." Policemen become pimps and patsies who can be bought and sold for the right price. Prosecutors wage successful mayoral

José Galvez, *Home Boys/White Fence*, 1983.

campaigns in major urban centers on a promise to rid the streets of their human garbage. The legal system operates above and beyond the law, arrogantly assuming the power to place whole sectors of society under a permanent state of emergency. This secret discourse of law is a discourse in which legality becomes "its own obscene, perverse" negation.[19]

Needless to say, in the United States, the constitutive lawlessness of law is for the most part concealed in the courts, and in American legal scholarship, the great bulk of which focuses fetishistically on arcane arguments about the fine points made in opinions issued by state and federal courts. To be sure, every so often, the public discourse of the rule of law reveals its repressed ideological faultlines. In this connection, it seems appropriate to recall one notorious example. In a famous 1977 television interview, an incredulous David Frost asked former President Richard Nixon if he believed "that there are certain situations . . . where the President can decide that it's in the best interests of the nation or something, and do something illegal."[20] Nixon's response warrants full quotation:

> Well, when the President does it, that means that it is not illegal. . . . If the President, for example, approves something, approves an action because of the national security, or, in this case, because of a threat to internal peace and order, of significant magnitude, then the President's decision in that instance is one that enables those who carry it out to carry it out without violating a law. Otherwise they're in an impossible position.[21]

These words not only provide an exemplary instance of the perverse logic by which one masterful manipulator of our legal norms tried (and failed) to bend the law to maneuver his way out of "an impossible position." Nixon's remarks also stand as a more generalized figure of the corruption of juridical imagination in the National Security State, when civil society is held hostage by the government over which it is supposed to be sovereign. From a jurisprudential perspective, Nixon is an heir less of James Madison than of Carl Schmitt, the German jurist whose doctrine of "the decision on exception" defended the state's unlimited authority to suspend the rule of law in the name of a higher political theology.[22] In a state of affairs in which the very officials who are sworn to uphold and defend the Constitution are all too ready to view *any* challenge to their authority as a subversive "threat" to "peace and order," a successful account of juridical politics must remain alert to the complex rhetorical reversals by which the rule of law is conscripted to serve regimes of lawlessness.

My discussion thus far has focused on the depiction of the rule of law in American legal institutions and ideology. I want now to turn from these "official" stories about the rule of law to the representation of legality in the field of popular cultural production. My specific interest here is in the image of law in the Hollywood film.

As an historical matter, American movies have performed a signal ideological service in inscribing the idea of rule of law in the national imaginary. In this respect, the Hollywood film is a crucial component in forging what Lauren Berlant has termed the "National Symbolic," that cultural constellation whose ideas, images, metaphors, rituals, and narratives "provide an alphabet for a collective consciousness or national subjectivity."[23] One need only mention here the affirmative cultural work represented by films such as John Ford's *Young Mr. Lincoln*, John Frankenheimer's *Seven Days in May* or Sidney Lumet's *The Verdict*, each of which places the triumph of the rule of law at the center of its narrative universe. However, recent years have brought us a number of movies about what happens to lawyers, cops, and judges when the rule of law begins to suffer from ideological exhaustion. In *The Firm*, *In the Line of Fire*, *A Few Good Men*, *A Perfect World*, *Carlito's Way*—to mention a few examples—the viewer is thrown into a topsy-turvy world in which the idea and the institutions of law are overrun by lawlessness.

For our purposes, two of the most interesting of these recent films are David Mamet's *Homicide* (1991) and Bill Duke's *Deep Cover* (1992). In *Homicide* and *Deep Cover*, crises in and of law are thematized as crises in

Jean-Michel Basquiat, *Untitled (Sugar Ray Robinson)*, 1982.

and of hegemonic myths of masculinity. *Homicide* tells the story of one day in the life of Detective Robert Gold, played by Joe Mantegna. Bob Gold is a hostage-negotiator in the homicide squad of an unnamed urban police department. Bob is the very Word of Law made flesh—his moniker in the squad is "The Orator." In his own eyes, Bob is only a cop who is "just trying to do his job." Indeed, for Gold, his job defines who and what he is. No mention is made during the film of the possibility that Gold might have a family, or even a home.

When the film opens, Bob and his partner, Tim Sullivan, are assigned to bring in Randolph, a black convict and fugitive from justice who has eluded the FBI. Unfortunately, Bob and Tim stumble on what, at first glance, appears to be a routine homicide. The elderly white owner of a "Mom and Pop" shop in a poor black neighborhood has been brutally murdered. Bob suddenly finds himself yanked off the case on which he and Tim have been working. You see, Gold, like the murder victim, is a Jew. The dead woman's son wants Gold to find her murderer. When Bob protests, his boss tells him simply, "You were there, you're his people, you got the case." Although Bob denies this identification—they're "not my people, baby" he says to his partner in a later scene—he has no choice but to accept his new assignment. Over time, however, Gold becomes obsessed with the case, ignoring his partner's warning: "Bob, I'm gonna tell you what the old whore said, and this is the truest thing I

know. When ya start comin' with the customers, it's time to quit." Gold's homicide investigation becomes a search for the Jewish identity to which he has, until now, been utterly indifferent. As the story unfolds, Gold finds himself trapped between two conflicting loyalties—his work as a policeman, and the "work" (as he puts it) of a secret paramilitary network whose existence Gold discovers in the course of his murder investigation.

I want to focus here on two moments in *Homicide* that are crucial to the film's exploration of the rule of law and its relationship to mythic narratives of masculinity. The first scene takes place after Detective Gold stumbles on the headquarters of the Jewish underground group. The leader of the organization is an old man who confirms Bob's suspicions that the murder victim had run guns to "Palestine" during the war to establish the state of Israel. Although he offers to do "anything" to help the group, when the leader of the group asks Gold to turn over a list of names he found in a box of rifles that were hidden in the murder victim's store, Gold refuses. He is, in his words, a "sworn police officer." The old man presses Gold: "Where are your loyalties? You want a home, you want glory, you're willing to do nothing." Bob can only reply, "I took an oath." Gold is bound not merely to obey, but to uphold, the rule of law.

As Gold is about to leave, he sees a woman whom he first met at the home of the murder victim's son. Shaken by his encounter, Bob finds himself confiding in this woman, an Israeli Jew whose name he never learns. In the course of this conversation, Gold confesses his disenchantment with the vocation on which he has staked his very identity. Bob realizes that he was never really accepted by the men and women with whom he worked—he says at one moment that the only reason he was assigned to be the squad's hostage negotiator was "'cause I knew how the bad guys felt," because he was the "outsider." In the symbolic economy of the film, Gold's loss of faith in his law enforcement work is figured as a loss of faith in his masculinity:

> What could I tell you about it? They said I was a pussy all my life. They said I was a pussy because I was a Jew. And the cops, they'd say, "Send a Jew, might as well send a broad on the job. Send a broad through the door." That's what they said. . . . All my goddamn life. And I listened to it. Huh? I was the donkey, I was the clown. . . . You have your own home. . . . Now what can that be like, to have your own country? . . . I sat with those guys tonight . . . with heroes, Jewish guys who had nothing to prove. And I . . . and I felt, all my life, I gotta be the first one in the door. Huh? Not for me, all for someone else. Why? Because I'm no good. Because I'm nobody. I want to be a part of it. That's all.

Mary Kelly, *Gloria Patri (details)*, 1992.

In an effort to recover his shattered manhood, Gold literally begs to become part of the paramilitary group. Bob is recruited to bomb the headquarters of a suspected anti-Semitic organization, not knowing his actions are being photographed by the same people in whom he has placed his trust. Gold discovers that he has been betrayed at the very hour when, across town, his partner Sullivan and the rest of the members of the homicide squad are about to apprehend Randolph, whose mother Bob himself had persuaded to turn her son in.

Bob rushes to the site of the police stakeout, only to discover that the setup has gone bad. Told that his partner has been wounded in an exchange of gunfire with the Randolph, Gold rushes into the building where the fugitive has taken cover. As if to underscore the homosocial bonds that bind them, Tim dies in Bob's arms after asking, "Bobby . . . you remember that girl that time, Bob?"

Gold rushes in alone to the criminal "underworld" to look for Randolph, screaming "you shot my partner, you fucking nigger, I'm gonna kill you!" When he makes his way to the basement where Randolph has holed up, Bob suddenly realizes that he has lost his gun. This loss of his weapon is a virtual castration that prefigures Gold's actual dismemberment in the ensuing violent scene. Grabbing a length of chain, which, like a signifier of his emasculation, hangs limply from his hand, Gold comes up on Randolph. The fugitive fires his

gun, hitting Gold, who falls to his knees. When Randolph asks, "You came for me, motherfucka? What you want me for?" Gold replies, "I came here to kill you," to which Randolph remarks sardonically, "Yeah, well you forgot your gun, Jim. Where's your gun?" Randolph taunts Gold, asking "You wanna beg for your life?" Gold responds "No. It's not worth anything." Gold then informs Randolph that he's been set up: "Randolph, your mother turned you in. You know she did it. How else would we find you here?" Randolph shoots Bob a second time, remarking, "Look at you man, you a piece of shit." The lawless fugitive has forced the wounded Gold to confront the "waste" to which his quest for masculinity has led him. Bleeding profusely, Gold has been literally rendered a *corps morcelé*, reduced to the corporeal state of a human infant, whose body consists of unwieldy "bits and pieces."[24] Gold lies prostrate while speaking the words that end his encounter with Randolph:

> That's right, I am a piece of shit. It's all a piece of shit. I killed my partner, and your mama
> turned you in. . . . You want your passport, I got it. It's a phony. All that shit, man, we made
> it up. Look at it. Your mama turned you over, man. That's right."

By the final scene of the film, we learn that the "wasted" Gold has not only failed to avenge his partner's death; Gold has failed as well to crack the murder case that led to his illusory search to save his imperiled masculinity in the film's diasporic underworld. In the closing minutes of *Homicide*, Gold limps on a cane into the precinct "house," only to find that this family has disowned him, too. In a moment which represents the ultimate mockery of his manhood, Gold learns that the proprietor of the grocery store was murdered by two young boys from the neighborhood. His supervising sergeant tells the utterly broken Gold, "You're off homicide. You're off." Gold, in short, has become an alien and an outlaw, welcome in neither of the two worlds to which he has sought to suture his identity as a "real" man. Like the law for which it functions as a figure, masculinity serves both as tool and trap. In the vision of male subjectivity depicted in *Homicide*, the undecidability of masculinity invests it with the power both to shape and to shatter those who fall within its jurisdiction.

Like *Homicide*, *Deep Cover* offers a searing examination of how narratives of legality and masculinity depend on one another for their mutual (de)construction. The film may be read, too, as a fascinating meditation on the lawlessness of law. The central character in *Deep Cover* is John Stevens, played by Lawrence Fishburne. Stevens is black, and the son of a coke-head father. The first scene of *Deep Cover*, told in flashback, takes place during the

Christmas season. The young John Stevens watches in horror as his father is shot and killed—in the narrative economy of the film, castrated—in a failed attempt to rob a ghetto liquor store. Years later, John Stevens becomes a uniformed cop; his choice of career is clearly driven by a desire to do penance for, and avoid, the fate of his "lawless" father.

When he is recruited to work in Los Angeles as part an extended undercover drug sting, Stevens gives up his uniform. The decision to "go under and stay under," Stevens tells us, was one "I knew I'd regret for the rest of my life." The target of the sting is the nephew of a Hector Guzman, "an influential Latin-American politician" whom Washington wants to discredit. Among the figures Stevens encounters during his undercover work is David Jason, played by Jeff Goldblum. The decidedly homosocial relationship between Stevens and Jason becomes the fulcrum of the film. Jason is a major player in the Guzman cocaine ring, but he is also a lawyer. When Stevens and Jason become business partners, Stevens slowly becomes unmoored from his original mission, becoming no less a criminal than the drug dealers he had been assigned to apprehend. In one scene, Stevens liquidates a rival dealer:

> I had killed a man . . . a man who looked like me, whose mother and father looked like my mother and father, and nothing happened. The police didn't come after me. No one did. I could have killed others if I'd wanted to and gotten away with it.

This utterly lawless act marks a turning point: Stevens' murder of "a man who looked like me" represents the symbolic death of the lawman, and of the man, he used to be. Stevens returns home and stares blankly in a mirror, fingering an old photograph of his father and clutching the bloody dollars his father stole in the scene that opened the film.

After a brutal and brutalizing series of adventures in the drug world, culminating in a bad bust, Stevens is called in from the cold. His boss, Jerry Carver, tells Stevens that the State Department has directed the FBI to call off the undercover mission. Stevens is devastated: "Jerry, I sold drugs. I watched people die, and I didn't do nothin'. . . . I killed people. You lied to me! . . . What am I gonna do now?" Carver invites Stevens to come with him to Washington to share in "the spoils of war." Steven replies:

> I can get more clout and money on the street than I can get followin' your ass to Washington. Know what, this whole fuckin' time, I'm a cop pretending to be a drug dealer. I ain't nothing but a drug dealer pretending to be a cop. I ain't gon' pretend no more, Jerry. I quit.

By the end of his mission, Stevens has lost all hope of cover. Like Bob Gold in *Homicide*, John Stevens has been stripped not only of his career, but of his manhood as well. Naked, Stevens decides to become one of the "beasts" that inhabit the chocolate city jungle—"no longer the hunter, but the game," no longer a man but an animal.

I want to call attention to three key gestures in the scene from *Deep Cover* in which Stevens takes his fateful decision to leave the force. The first is the moment Stevens turns over his gun to Jerry Carver, the FBI agent who recruited him. This highly stylized transaction functions within the symbolic economy of the film as a ritual surrender of the chief signifier of the lawman's masculinity. The second decisive gesture follows the first: Stevens cuts open a bag of contraband cocaine in his car with a long pointed knife, which he then uses to shove the white powder up his nose. A voice-over reminds the spectator that Stevens has just broken the promise on which he has staked his manhood: "Never have, never will." Stevens has been brought to the recognition that "the whole game had been a joke . . . a joke on me. I was a fool." As if to underscore what his naïveté means for his manhood, Stevens adds, "I'd been turned out like a two dollar whore." We then watch a single tear run down Stevens's cheek. This tear, like the moment when Stevens tears open the cocaine-filled bag, recalls the death of his "lawless" father. Taken together, these "tears" represent not merely a rending, but an utter ruination of Stevens' masculinity. Like the film as a whole, this scene shows that the myths of masculinity are too fragile a foundation for the erection of male subjectivity. Indeed, the narrative structure of *Deep Cover* exposes the unreliability of masculinity in all its forms, an unreliability which finds its most powerful expression in the film in the figure of the father, who is, of course, the very progenitor of the law.

I have already noted the central place occupied in *Deep Cover* by the spectral image of Stevens's father. This father, as we know from the first scenes of the film, is a "bad," lawless father. Throughout the film, but even more insistently once he decides to quit his job, Stevens is tracked by Taft, an older black cop played by Clarence Williams III, of *Mod Squad* fame. In the symbolic world of the film, this cop is the good, "lawful" father whom Stevens never had. In the film's earlier scenes, Taft has tried without success to persuade Stevens (whom he calls "son") to forswear his life of drug-dealing, not realizing that Stevens is in fact not a criminal, but a cop. In the final scenes of *Deep Cover*, this "lawful" father (like Stevens's "lawless" father) dies a bloody death, not realizing until it is too late that he has made a fatal mistake. Like the prodigal

"son" he has tried to redeem, Taft is a victim of an elaborate masquerade of lawlessness posing as law.

I read *Deep Cover* and *Homicide* as fables about the emptiness of masculinist law. These two films hold up a mirror which reflects the disfigured face of the rule of law, of the lawless acts that established it, and of the perpetual crimes that sustain it. In short, *Deep Cover* and *Homicide* are contemporary cultural texts whose theme is at least as old as the founding of our national Constitution. At the conference which occasioned this essay, film theorist Paul Smith reminded us that there are many masculinities, not just one. The lesson I take from *Homicide* and *Deep Cover* is that there are not only not *many* masculinities—there are *none*, or none, at least, on which a man can rely. Masculinity, it would seem, is not a fullness or a plenitude, but a cipher.

As film texts on the relationship between legality and masculinity, *Deep Cover* and *Homicide* suggest that the myth of masculinity is unable fully or finally to serve as law's enabling ideological fiction. This is not simply because the regime of masculinity cannot tame the force of the constituent violence that the law must repress in order to establish its legitimacy. This failure may be traced as well to a congenital defect which is lodged in the heart of the language of masculinity *as such*. *Deep Cover* and *Homicide* bear witness to the hole of meaning in a symbolic order which is supposed not only to serve as a figure and ground for the rule of law, but to authorize the masculinist myths on which the law is founded.

We might invoke in this connection a passage from *The Federalist Papers*, which I mentioned at the beginning of this essay, and with which I want to end. In *Federalist 37*, James Madison concedes and laments the fact that the text of the proposed Constitution is shot through with unavoidable ambiguity. This ambiguity, he admits, is not likely to find a ready solution. The problem of textual indeterminacy thus poses a stumbling block for the "science of politics," which the Founders believed they had so well mastered that the Constitution would be a "machine that would go of itself."[25] Madison goes on to argue that this semantic deficit is not peculiar to the language of law, but stems from the law of language itself. "No language," he writes, "is so copious as to supply words and phrases for every complex idea, or so correct not to include many equivocally denoting different ideas."[26] Every act of signification necessarily falls short of its expressive ideal:

> Hence it must happen that however accurately objects may be discriminated in themselves, and however accurately the discrimination may be considered, the definition of

them may be rendered inaccurate by the inaccuracy of the terms in which it is delivered. And this unavoidable inaccuracy must be greater or less, according to the complexity and novelty of the objects defined. *When the Almighty himself condescends to address mankind in their own language, his meaning, luminous as it must be, is rendered dim and doubtful by the cloudy medium through which it is communicated.*[27]

If God cannot escape the snares of language, how could Madison and his contemporaries hope to do so? *Federalist 37* recognizes that the authors of the Constitution could neither anticipate nor avoid the dangers of errant utterance and interpretation. The Framers could not purify their creation of the contaminant transgression that gave birth to it, because the stains of that founding transgression are secreted in the very words of the constitutional text. Madison and his generation were finally powerless to protect the Constitution against the lawlessness that language poses for law. As I read it, *Federalist 37* presents a theory of language as a force which cleaves the subject from its desired meaning, and thus cuts the subject off from itself. Madison recognizes that the "manly spirit" with which the Founding Fathers had so "confidently" defied the legal order established under the Articles of Confederation could not defeat the subversive law of the signifier. The subject of constitutional law is subjected to a sovereign symbolic order which obeys no laws but its own. In this respect, Madison's vision of the unruly and unsettling effects of human discourse sounds a remarkably modern note. Indeed, one could say (somewhat perversely) that the Madison of *Federalist 37* is the philosophical father of Jacques Lacan: "The Father must be the author of the law, yet he cannot vouch for it anymore than anyone else can, because he, too, must submit to the bar, which makes him, insofar as he is the real father, a castrated father."[28]

My project in these pages has been to show that while the regime of masculinity does indeed serve as an indispensable enabling fiction for the idea of the rule of law, it does so in complex and unpredictable ways. I have tried, more precisely, to indicate how and why this founding legal fiction always already fails to sustain itself. When placed under critical interrogation, the construct of masculinity is forced to confess its secret complicity in the creation of legal meaning, and thus to collude in its own as well as law's apprehension and arrest. The subject of masculinity must "submit" (in Lacan's words) to the laws of language, to a symbolic order which mocks its imagined claims to unity, coherence and mastery. The rule of masculinity is not merely law's "true lie," but its imperfect, impeachable alibi. Given the instability of the masculine metaphor from which law carves its chief ideological cornerstone, it should come as no surprise to

learn that the rule of law can never secure itself against the undecidable illegality that both establishes and undermines its very concept.

NOTES

1. Stuart Hall, "The Rediscovery of 'Ideology': Return of the Repressed in Media Studies," in Michael Gurevitch, Tony Bennett, James Curran, and Janet Woollacott, eds. *Culture, Society and the Media* (London and New York: Methuen, 1982), p. 64.

2. Michel Foucault, "The Subject and Power," in Hubert L. Dreyfus and Paul Rabinow, *Michel Foucault: Beyond Structuralism and Hermeneutics* (Chicago: University of Chicago Press, 1983), p. 208.

3. Ibid., p. 210.

4. Ibid.

5. Ibid., p. 211.

6. Clinton Rossiter, ed., *The Federalist Papers* (New York: New American Library, 1961), p. 247.

7. Ibid., p. 251.

8. Ibid.

9. Ibid.

10. Ibid., p. 253.

11. Bruce Ackerman, *We the People: Foundations* (Cambridge, Mass.: Belknap Press, 1991), p. 41.

12. Ibid., pp. 41–42.

13. I take this term from constitutional scholar Robert Cover. See Robert Cover, "The Supreme Court, 1982 Term—Foreword: Nomos and Narrative," *Harvard Law Review* 97 (1983): 11.

14. Slavoj Žižek, *For They Know Not What They Do* (London: Verso, 1991), p. 205.

15. Eve Kosofsky Sedgwick, "Gosh, Boy George, You Must Be Awfully Secure in Your Masculinity!" pp. pp. 11–20 in this volume.

16. Žižek, *For They Know Not What They Do*, p. 209.

17. Ibid., p. 59.

18. Ibid.

19. Ibid.

20. Transcript of Frost-Nixon interview, *New York Times*, May 20, 1977, p. A16.

21. Three years before this interview, Nixon's defense of what amounts to a species of *raison d'état* was given explicit constitutional recognition in the language of a decision by the U.S. Supreme Court. I am thinking here of the Court's scandalous opinion in *U.S. v. Nixon*, 418 U.S. 683 (1974).

22. Carl Schmitt, *Political Theology*, trans. George Schwab (Cambridge: MIT Press, 1985).

23. Lauren Berlant, *The Anatomy of National Fantasy* (Chicago: University of Chicago Press, 1991), p. 20.

24. Richard Boothby, *Death and Desire* (New York: Routledge, 1991), p. 24.

25. For a discussion of the Framers' scientistic conception of constitutional politics see Gordon S. Wood, *The Creation of the American Republic, 1776–1787* (New York: W.W. Norton, 1972). For a discussion

of the mechanistic metaphor in American constitutionalism, see Michael Kammen, *A Machine that Would Go of Itself* (New York: Alfred A. Knopf, 1986).

26. Rossiter, *Federalist Papers*, p. 229.

27. Ibid.

28. Jacques Lacan, "Desire and the Interpretation of Desire in *Hamlet*," in Shoshana Felman, ed., *Literature and Psychoanalysis* (Baltimore: Johns Hopkins University Press, 1982), p. 44.

PATRICIA J. WILLIAMS

MEDITATIONS ON MASCULINITY

1. SUFFER THE LITTLE CHILDREN

I take my son to the playground several times a week. At two
years of age, he requires lots of exercise before either he or I get any rest. If I go
to the playground closest to my house, he is almost always the only black child
there. This alone makes the playground political. Two incidents, for quick exam-
ples, happened on two consecutive days: On Monday, my son went over to the
benches to play with a little girl who lives on our street. He sat on one end of the
park bench, she on the other. They laughed and swung their feet back and forth
as though they were trying to see who could swing their legs harder. Another
little girl of about three ran up to the little girl with whom my son was playing

and tried to drag her away. She told her to stop playing with him and she told my son to go away. She whispered in the neighbor girl's ear and they both looked at him with sober faces. But the leg-swinging game was too much fun for the first little girl, who, after all, knew my son, and she went on kicking her legs—though considerably subdued. The second little girl gave up and ran to her mother who was standing within earshot, and said, "I don't like that little boy. He's scary." Her mother advised her, "Well, stay close to me then."

On Tuesday, we arrived at the playground and my son ran immediately to the sandbox. There were two little girls of about four already there. The moment my son got into the sandbox, one of the little girls started screaming: "Get out of here! Don't you get near me! Go back to where you came from! Get out! I said get out!" My son was startled—his face literally crumpled and he burst into tears immediately. He came running over to me, threw himself into my arms and sobbed on my shoulder as though his heart would break. I held onto him tightly, trying desperately to figure out some adult response or neutral intervention, but still the little girl kept screaming, waving her plastic shovel like a can of mace: "I said get out of here and don't you ever come back!"

2. UNHOLY GHOSTS

New York Times essayist Brent Staples writes about the fearsome social profile of the black male self. He writes about his dawning realization, while a student at the University of Chicago, that white people were afraid of him:

> I'd been a fool. I'd been grinning good evening at people who were frightened to death of me. I did violence to them just by being. How had I missed this? I kept walking at night, but from then on I paid attention. . . . I tried to be innocuous but I didn't know how. The more I thought about how I moved, the less my body belonged to me; I became a false character riding along inside it.[1]

Staples describes how he went through a period of whistling Vivaldi so that people would hear him coming and "they wouldn't feel trapped"—in effect he hung a bell around his neck, playing domesticated cat to a frightened cast of mice.

> Then I changed. . . . The man and the woman walking toward me were laughing and talking but clammed up when they saw me. . . . I veered toward them and aimed myself so that they'd have to part to avoid walking into me. The man stiffened, threw back his head and assumed the stare: eyes ahead, mouth open. I suppressed the urge to scream into his face. Instead, I glided between them, my shoulder nearly brushing his. A few steps beyond them I stopped and howled with laughter. I came to call this game "Scatter the Pigeons."[2]

PATRICIA J. WILLIAMS

The gentle journalist who stands on the street corner and howls. What upside-down craziness, this paradoxical logic of having to debase oneself in order to retrieve one's sanity from the remaindered edges of market space.

3. UNREASONABLE MEN

Fathers here, fathers there, fathers, fathers everywhere. Kind, distant, brutal, overbearing, biased, and wise. If Richard Wright "orphaned" himself, as author John Edgar Wideman contends in his book *Fatheralong*,[3] it seems as though the present generation of African-American authors has en-fathered itself to a fare-thee-well. If Wright "leaves his father behind, a memory frozen in time, mired in the red clay of a Mississippi plantation, a pillar of salt turned toward the past,"[4] this generation has made paternalism and avuncular glow central characters in the constitution of nostalgia. If Wright, "[a]s author, . . . steals the Promethean fire, assumes the role of father, creates a world and its inhabitants,"[5] today's authors are busy fanning the flames of a wistful ambivalence about how to make the world better for black men, an angst that has grown to a directed anxiety verging on obsession with compensatory fatherhood.

This rush, this compulsive drive to romanticize paternal authority, is a quite different enterprise than just appreciating fatherhood. On one hand, it is clearly a move to counter the wild, Willie-Horton, seed-spewing stereotypes that so flood the media. It is also a move that has eliminated from public view much of the real-life presence of men, particularly black men, in its nostalgic yearning for the Dick-and-Jane nuclear family of the fictionalized past. In his fascinating ethnography, *Slim's Table*, Mitchell Duneier documents a year's worth of conversations with a group of black working-class men—a group generally rendered completely invisible in accounts of black social life.

> Many of these men grew up in homes where the father was at least as absent as in today's white middle-class families. Yet these are still people whom the contemporary men's movement would envy. They are consistently inner-directed and firm, and they act with resolve; their images of self-worth are not derived from material possessions or the approval of others; they are disciplined ascetics with respect for wisdom and experience; usually humble, they can be quiet, sincere, and discreet, and they look for those qualities in their friends. They are sensitive, but not "soft" in any sense that the men's movement sees as the basis of its gender crisis. They know how to put their foot down, and how to "show their swords."[6]

On one level, it is astonishing to me that I have to cite a sociologist to convince anyone that a black working class exists at all, that it takes a social

scientist in a lab coat scribbling down "objective" observations, to document the sighting of "decent," "hardworking," black men, as though they were mythical beasts or an extinct species whose existence has been long in question. At the same time, such a study is a welcome contrast and antidote to the overwhelming media mythology of black men as lazy, criminal, undeserving, and drug-addicted. Furthermore, Duneier introduces the idea, almost stunning in these times, that such men could be role models for whites:

> As the men's movement searches for a masculinity it can admire, it might begin by studying black males of this sort and attempting to comprehend how the older ghettos formed men of such character. Indeed, sociologists and psychologists need to explore with greater care the hypothesis that the adaptations of some black men have produced at least some variants of a ghetto-specific masculinity with positive characteristics that might serve as a model to men in the wider society.[7]

Duneier's reference to "older ghettos" reflects the fact that his study focused on a group of men in their fifties and sixties—and he and his subjects tend to locate their moral development as a product of a romanticized and long-gone past. Yet I would love to see him do the same study among some younger, black, working-class men—the postal workers, the window washers, the policemen and ubiquitous black security guards, the janitors, and the messenger "boys." My instinct and my experience, growing up in a working-class, mostly black neighborhood, lead me to believe that the moral isolation the men in Duneier's study expressed is less the result of age than of existing in a world where every public image, prototype, archetype, and stereotype denies the existence of Others Like You—this society relentlessly exceptionalizing those few blacks it acknowledges to be "good."

We live in a world filled with the presence, not "absence," of men, most of whom are fathers at some time in their lives. Sometimes black, sometimes white, sometimes heroes, and sometimes villains, they are more complex than Mrs. Doubtfire, less bathetic than Mr. Rogers. Most of them are quite impossible to summarize in a Disney movie about lions and hyenas. Most are just responsive interconnected beings in very tough times, neither captains courageous, nor victims, nor ideological icons.

But, with the agency of Reasonable or Average Black Men being pretty completely blockaded from the script of the great American dream, black men's social lot is made far grimmer for having been used as the emblem for all that is dangerous in the world, from crime to disease. The conceptual cloak

that makes any white criminal anomalous in relation to the mass of decent white citizens is precisely reversed for black men: any black criminal becomes all black men, and the fear of all black men becomes the rallying point for controlling all black people. The dehumanizing erasure of black men's humanity has created a social cauldron of much rage, much despair, and even more denial. Anthropologist Carlos Vélez-Ibañez describes the related disproportionate criminalization and economic isolation of Mexican Americans in terms of a "distribution of sadness." I think the term is a powerful one, because it captures some of the psychic and emotional costs of prejudice in the United States—the free-floating, poisonous enervation that corrupts our ability ever to have that long-overdue national dialogue about race, gender, homophobia, and all the rest that blocks the full possibility of American community. The notion of displaced sadness also captures some of the hidden social trauma inflicted upon whites as well as blacks, contained in lost images like the one conveyed to me by Boston University psychology professor Jessica Daniels: in her archival research, she found a photograph of a public lynching from just after the turn of the century. It showed the white citizens of a small Southern town turned out to watch a black man hang. Among the assembled was a little white girl, clutching a doll with a noose around its neck.

The trauma and violence of racism in the lives of white people seems generally unacknowledged as having a close genealogical relation to those all-too-obvious harms of racism inflicted upon black children living in inner cities. Yet Studs Terkel relays the story of a white woman whose experience embodies the way in which, I think, much white-on-white violence is made invisible in very racialized ways:

> One time we were in a department store by the yard-goods section. My mother, her mother, and her grandmother. Four generations. My great grandmother whispered to my grandmother, "Look over there at that black man. He's looking at little June." . . . I can remember even at that time thinking "My God, this is crazy. I go all the time and tell you Uncle Bill or Dad or these other people are molesting me." No black people had ever given me any trouble. Yet, they were so worried about that.[8]

You can pick a newspaper any day of the week and read between the lines for this kind of erasure. As I write, there is a series of stories in the *New York Times* chronicling the shooting of a black undercover officer by a white undercover officer. Police Chief William Bratton calls the mistake "tragic but understandable," and promises to "consider instituting training that transit offi-

cers receive to teach them to be sensitive to the possibility that a person who appears to be a suspect may actually be an undercover officer."[9] Black men, even the upstanding, hardworking, model-police-officer kind, have been defined as those who are apparently and categorically "suspect"; it is "understandable" to shoot them (in the back, several times) when there is only the slimmest "possibility" that they may actually be anyone other than a suspect. The police department just might "consider" training its officers about that presumption of innocence everyone's always telling black people to have such faith in.

4. I AM SOMEBODY

Wednesday morning. I stood on Sixth Avenue trying to hail a cab. I usually do not have too much trouble these days—accompanied by a two-year-old, I am friendlier-looking, I am told. But this particular morning it was drizzling, and cabs were having a field day of market choice. I was competing with men and women in navy-blue suits and attaché cases. I held my son with one arm and waved his lunch box in the air with the other. Cabs stopped just short of me and just beyond me, cabs stopped on the southern corner for pickups that appeared out of nowhere, so I crossed over and stood on the south corner. Suddenly, it seemed as if all the cabs were having brake trouble, and they could not seem to stop, except for pickups on the north corner. My son was exhilarated by this game. He stuck his little arm out, with all the fingers spread (I guess I do it like that) and shouted "Taxi! Taxi!" with energetic delight. I think he is as cute as a button, but it was twenty minutes by the big old clock on the church tower before a cab stopped for us. An old driver, said he had been a cabbie for forty years. He stops "for anybody," he assured me, "doesn't matter who you are." He was a genuinely nice man, and in the effusion of my gratitude, I tipped him 30 percent which made him pretty effusive, too.

For the rest of the day, I pondered this odd status of being "anybody," this post-civil-rights equality in which it does not matter who we are.

5. DAILY BREAD

Walking up University Place behind two young, white men on a bright Thursday afternoon. A tattered, young, black man held out a paper coffee cup and asked for "spare change, something to eat." Both of the young white men dug deeply and immediately into their pockets, and gave. As they continued up the street, one said to the other, "I'll give as long as they ask for it in the right way."

Robert Colescott, *Susanna and the Elders (Novelty Hotel)*, 1980.

On the subway, later that day. There was an old black woman, a bag lady, stooped, asleep or unconscious, her smell overwhelming—so overwhelming that her end of the car was empty, as others who got on gave her a very wide berth. A white man in his mid- or late twenties stepped on board, and immediately began to fan the air with grand gestures. He said, "Oh, God!" loudly, and to no one in particular, but with great self-importance, his eyes scanning the passengers for someone with whom to complete the drama of his observations. He chose a young black boy of about twelve or thirteen years of age, sweet-faced, gentle-eyed, a knapsack of books on his back, a school kid in a baseball jacket, a random straphanger, an adolescent daydream written across his face. The white man looked over at him and intoned in a very loud voice: "You see that? That's why you better learn how to work!" Heads turned. The kid looked stricken, then giggled tensely, looked back at the subway car full of those robotic eyes, and smiled a smile full of pure, incipient rage.

6. DINING ALONE

Early Friday evening, I was sitting by myself, having a very late lunch in a restaurant in Flushing, Queens. There was a table of six men in gray business suits and wide-striped ties. One had a strong Boston accent. One was black. They were all middle-aged and comfortably, not greatly, overweight. Their conversation was loud and cheerful, impossible to read my newspaper over. They gloated over

"the fate of the yuppies," now that the stock market was in a moment of great uncertainty. "They're going to learn," said one, "that there's more to life than being a boy genius and driving a BMW." The black man contrasted "them" to "people like us." (Is this a victory of class over race? of Queens over Manhattan? or the co-opting of the yearning to belong? I listened on, trying to decipher the bounds of identity at work in this interestingly-structured line drawing.) They discussed getting reservations at the Golden Nugget Casino in Atlantic City. They discussed someone's sister-in-law who works at Radio City. They told a funny story about riding on a train. A voice said, "Beautiful, beautiful—even the conductor was hysterical." Another voice took up the storytelling: "We was in Vegas . . . " And another: "We went to Niagara Falls and the guy says to me . . . "

The conversation moved on to cars. Trans Am. Camaro. Something with a lot of letters and numbers in its name. Someone said about financing, "Yeah, but it's nice to have the clout." The tone of that voice gave "clout" physicality. I listened to the inflections of the voices. They rose and fell with authority and braggadocio and reassurance. They were false and strong. They interrelated in a series of subtle vocal tests. Their voices rose with structured incredulity; their voices fell with the conspiracy of "well-of-course"s. They laughed too loudly. They laughed too long. They repeated for emphasis and to fill emptiness. They closed ranks behind each others' cruelties. They received phone calls from the bar, they received them with the smiles of the chosen, the important. The others conspired in donating the respect that comes with being in demand.

They were indistinguishable from yuppies, except for their ties, their grammar, and the brands of their cars. They were elitist, privileged, insecure, driven. They chewed up and spewed out the fat and gristle of expansive lifestyles. They strove with each mouthful of words to distinguish themselves from each other and themselves from the common world. They resented the possibility of others who think themselves "better" than they. They exacted the social grace of lowest common denominator—the narrow pluralism of eating Franco-American and driving Oldsmobiles—even as they reinforced this paradoxical hierarchy of the common man with words like "intelligence quotient" and "the brightest and best." The permissible range of disagreement—and discussion—seemed to be things to eat, cars to drive.

They do the same thing in Manhattan, of course, except it's about Dean & Deluca, and real estate with a view.

I felt for the others through the black man. I felt for myself through the black man. He was the most quiet. When he spoke, his voice was the most pluralistic, the most eager to gloss over and unite. There was yearning in his tone.

When the others were insensitive to someone's feelings, his was the biggest silence. I listened to the depth of that silence, and imagined I heard him disconnecting; I imagined the internal noise of his silencing himself; I imagined the power of his disagreement and the struggle of his conformity, the power of his need to be seen as belonging, at a deep and eternal level. The others tested in their pushing away, their verbal gauntlets of double-edged jocularity. He took no such risks. His jokes were deep-voiced, anchored in forethought, encompassing, unimaginative, and safe. He ate the safest things on the menu; he drove the most conventional, big, male car made in America.

7. BROTHER, BROTHER

Some years ago, I had a black student who pelted me with his testy, angry, biting words. In weekly memos to me he evaluated my teaching in most unkind terms. He referred to himself as a "handsome young black revolutionary" seeking the instructive guidance of a "black brother" of a people's lawyer. He told me I was "cold" and "bourgeois." I was terrified by the potential truth of what he said; I was lost in the impossibility of being brotherly.

I used to wonder at the source of his words—the competition, the struggle to be seen, the assertion at the expense of another. On several occasions he spoke out in class in such an angry way that everyone else was verbally obliterated. "You don't know what it's like to suffer," he seemed to say. He

obliterated to the exact degree to which his warrior spirit had been insulted and not honored. He spoke with fire and violent words.

I did not try to control him. I could not put out the fire in those words. But he burned me. He inserted himself into the innocent school-bookishness of the other students and singed them, too. Then he absented himself for long periods. He attacked and hid. He was both cowardly and deeply committed.

I wanted nothing to do with him. He annoyed me terribly. I braced myself against his approach—face-to-face, assaultive, seeking touch, confrontation, assertion, resolution. Who are you anyway, who is it behind that mask? ("You sound like an FM radio announcer," he said, "always so composed and cool and unflappable; I want to turn your knobs to the AM dial.")

He pushed every last one of my buttons.

8. THE NAME OF THE FATHER

The first black professor I ever had was in college. He was a truly great teacher, but I secretly subjected him to a kind of cruel scrutiny that came from my own need for resolution. Where did Mr. X's voice come from, I wondered nearly obsessively. It was so calculated and formal. It was so pacifying and constructed and smoothly beyond allegiance to any region. It was a voice that swallowed up any trace of his history. I always thought of it as a self presented to hide another self. Sometimes Mr. X's voice was like my father's voice, rolling and bell-toned, from the diaphragm, plotted and planned with vowels arched like cathedral clerestories. My father was determined to eliminate the experience of the segregated South in which he had grown up. He wanted to be born again in the North, speaking in non-Southern tongues. I could never figure out what Mr. X might be trying to eliminate, if anything; I did not know in what world, or in whose mouth, he might have thought he had been reborn.

My own obsession with language comes from needing to escape the truth of my own childish voice, whose sound has never felt my own. Somewhere inside I have a self that has no voice, a me that has no means of expression beyond my body, beyond, perhaps the reenactment of my dreams.

Mr. X struck me as someone who used language to hide, too. He had a voice full of agendas. Sometimes his voice was that of a child, or of a grandmother speaking to a child, full of sinners redeemed, jealousies overcome, just desserts and blessed events and going with god. This was a voice full of innocence and mockery.

Then there was a voice full of seduction and charm, the voice that Mr. X used most of the time—his everyday voice, although it was not an everyday

PATRICIA J. WILLIAMS

voice. The voice with which I was most captivated. The smooth flow of confidence and caring and protective control promising peace and love and the absence of discord for ever and ever. We students used to float like boats on that voice, that trust. The voice that invited us to go walking with him through the texts he assigned, the books he loved, unraveling their meanings with such suggestive mystery.

Then there was the voice that he employed in occasional flashes as the school year wore on: a stern and totally different inflection, filled with impatience and pique and fatigue. What was interesting to me was not just that he expressed anger and disapproval and always-tired-under-pressure-ness—it was that the voice itself changed. The accent changed, too subtly for me to put my finger on, but perceptibly. And the tone changed. It was not from the lazy, just-behind-the-eyes place of the flirtatious voice, it was not the innocent protestation of the young-boy voice, it was icy, and inflexible, and on the tip of the tongue, and at the front of the nose, and at the heart of his heart. This was as close to a real voice as Mr. X had; and it was cruel, tired. I call it real only because it came quicker than the others; it was the least thoughtful of his voices, it was the least premeditated and the most pronounced, the most regional, the most rooted in the body. It was rooted in anger, a sharp, dead voice, like steel. It was impossible to talk to Mr. X at those times. I made the mistake of trying once, but that was the voice that ended all discussion. I imagined that I had met his father in that voice, at those moments. It was the voice, though occasional, that I was afraid would overtake us all, this father of hate that spilled from the flesh of Mr. X's nose and mouth; it was the voice that brought out my own worst, frightened-little-girl voice that will capitulate to everything, just-please-don't-hate-me-like-that voice—it was the voice that made me scared and made me feel as though I should run for my life. If only, I used to think, if only I could just once learn to confront that angry voice with something other than the scared, intractable, but capitulating child.

But always and quickly, Mr. X returned to the safe haven of that voice that he reserved for high theoretical discussions. He would furrow his brow to accompany the breathy, quick phrasing. He became innocently beautiful again, yet querulous; intensely and brilliantly convoluted, yet calculatedly puzzled at the inability of the average audience to keep up. This was the voice that reduced us all to peasants—but, god, such adoring peasants. Bonny Prince X had captivated us all again with the sun of his words, the golden coin of his thoughts.

What I never heard in Mr. X was a genuine, grown-man voice that was relaxed, and good-natured, and could express without theater the knowledge

that was stored so copiously in the prince's coffers. I heard only the strain of a created being, very much like myself, the words cracking with politeness and convention, the voice as polished and rounded as my father's in the throes of his self-conscious racial remake.

Writing is my best escape. My speaking is at odds with my writing, because my speaking voice is full of the tension of my ancestors' aspirations and pretentions; my voice is their shelter and escape and surface-to-the-world, but it is not my vehicle for letting out the heart of things. My speaking voice is not trained for the job of intimacy, or silliness, or small things like washing dishes. My voice, like Mr. X's, is full of grandeur and sweep and appalling civilization.

I write in silence, without the fierce distraction of my noisy voice. I write myself out as faithfully as if I were sweeping my house or caring for my son, because the act of writing is wild and simple and tolerant, in a way that my speaking voice is not. My silence is observant, an open eye, a secret shelter, vulnerable and dangerous and always deadly accurate. It is the distance that speech rushes in to fill, it is the honesty that the lie of my speaking voice rolls over like water, like cream, like the dangerous slithering of a deadly, impassive neutrality.

NOTES

1. Brent Staples, "Into the White Ivory Tower," *New York Times Magazine*, Feb. 6, 1994, pp. 24, 36.

2. Ibid., pp. 24, 44.

3. John Edgar Wideman, *Fatheralong: A Meditation on Fathers and Sons, Race and Society* (New York: Pantheon, 1994).

4. Ibid., p. 71.

5. Ibid.

6. Mitchell Duneier, *Slim's Table* (Chicago: University of Chicago Press, 1994), p. 163.

7. Ibid., p. 164.

8. Studs Terkel, *Race: How Blacks and Whites Think and Feel About the American Obsession* (New York: New Press, 1992), p. 346.

9. Clifford Krauss, "Subway Chaos: Officer Firing at Officer," *New York Times*, Aug. 24, 1994, p. A1.

Marjorie Heins

MASCULINITY, SEXISM, AND CENSORSHIP LAW

INTRODUCTION:
MATTHEW FRASER AND THE SEXIST ASSUMPTIONS
OF CENSORSHIP LAW

In 1986, the U.S. Supreme Court decided what may have seemed
like a rather trivial case. It involved a young fellow named Matthew Fraser, who
gave a ribald, sophomoric, student-government campaign speech full of silly,
phallic, double entendres during a public high school assembly. The school
administrators decided to punish Fraser for his "lewd and indecent" speech;
Fraser sued, claiming violation of his First Amendment rights.

The Supreme Court upheld the punishment, rejecting Fraser's First Amendment claim. Its reasons were interesting. Writing for the Court, Chief Justice Warren Burger opined:

> The pervasive sexual innuendo in Fraser's speech was plainly offensive to both teachers and students—indeed to any mature person. By glorifying male sexuality, and in its verbal content, the speech was acutely insulting to teenage girl students.[1]

Now, for anyone who is ingenuous enough to harbor the delusion that courts are value-free repositories of some abstract principles called "the law," and that judges do not inject their moral values and attitudes about sexuality and everything else into their decisions, the above excerpt from the thoughts of Warren Burger ought to be educational. As an indignant Justice John Paul Stevens wrote, dissenting in Matthew Fraser's case, there was no evidence that any student in the listening audience had actually found the speech offensive; moreover, said Stevens, young Fraser was:

> probably in a better position to determine whether an audience composed of 600 of his contemporaries would be offended by the use of a four-letter word—or a sexual metaphor—than is a group of judges who are at least two generations and 3,000 miles away from the scene of the crime.[2]

As Justice Stevens's dissent suggested, there are so many moral and sexual assumptions buried in Justice Burger's stated reasons for upholding the punishment of Matthew Fraser that a student of law and culture could easily spend an afternoon decoding them. But for present purposes, let me focus on the second sentence, with its notion that "glorifying male sexuality" is necessarily "insulting" to females—or, at least, to teenage females. Why did Chief Justice Burger think so? Many females, teenage and otherwise, welcome a certain amount of male sexual attention, and even, I daresay, enjoy a sexual innuendo every now and then. As one female wag wrote in a recent issue of *Newsweek* (commenting on the Lorena Bobbitt case):

> Some women find a penis distasteful, others can take penises or leave them, but many of us find penises rather vulnerable and endearing. It's the rest of men that scares us.[3]

Likewise, if Matthew Fraser's speech was truly offensive, uncivil, inappropriate to the educational setting, or simply not very funny, why should Justice Burger assume that the females in the audience would be more insulted by this assault on their sensibilities than the males? Do males automatically like

dumb phallic humor, and females not? Or was Burger revealing his true colors as an antipornography feminist who views all things phallic with distaste, if not rage, and who condemns the penis, at least in its turgid state, as a symbol of sexual dominance and rape?

This brief review of Matthew Fraser's case is as good an introduction as any to the subject of masculinity and the rule of law. Certainly the Supreme Court's decision in *Fraser* reflects attitudes about sex and power that operate in other fields of American law, including discrimination and civil rights, government regulation of so-called obscenity and indecency, and homophobia-driven attacks on art and literature with gay themes.

A BRIEF DIGRESSION: SEXISM AND SEX DISCRIMINATION LAW

In the early 1970s, feminist lawyers like Ruth Bader Ginsburg brought a series of sex discrimination suits to challenge paternalistic assumptions that were built into the social security law and others like it—assumptions, for instance, that women were not wage earners, but depended on husbands for economic support. In the process of striking down many of these laws, the Court gave the male plaintiffs in these cases dependents' or survivors' benefits that the law had denied them.

But other Supreme Court sex discrimination cases reflected a less egalitarian spirit, especially when the subject matter was sexuality. In perhaps the most notorious of these, the Court upheld a statutory rape law that made it a crime for males of any age to have nonmarital sex with a female under eighteen.[4] A male who was prosecuted under this law, known only as Michael M., protested his conviction as sex discrimination since the law did not punish females for having sex with underage males. But, as Harvard professor Laurence Tribe has observed, the young woman involved might equally have brought her own challenge to the law, on the ground that it denied her and other unmarried, adolescent females "the sexual freedom accorded to" their male peers.[5]

Although the dissenters in *Michael M.* protested that the law was illegitimate, based on archaic and oppressive attitudes about female chastity, the Supreme Court majority, per Justice Rehnquist, said the law's different treatment of males and females was justified by the state's interest in deterring unwed pregnancies.

Justice Rehnquist and his cohorts, however, were not so willing several years earlier to apply this same recognition, that pregnancy is distinctly a capa-

bility of females, when it came to laws or corporate policies that denied preg-
nancy coverage under otherwise comprehensive health care plans. Here, in
one of the Supreme Court's true flights into surrealism, the justices said that
the difference in treatment was okay because it was not based on sex.
Instead, the discrimination was simply between pregnant and nonpregnant
persons![6] In these pregnancy cases, as in *Michael M.*, the then-all-male
Supreme Court was reflecting two characteristics of patriarchy: the notions,
first, that pregnancy belongs to a special sphere, outside the world of work or
business—it is the special burden and lot of women, and is not to be viewed
as part of the human (that is, male) condition; and second, that premarital
teenage sex occurs because the male aggressor wants it—the female is the
semihelpless victim. And to the extent that she is not the victim, she need not
be punished by the law for her indiscretion, for pregnancy is deterrent and
punishment enough.

OBSCENITY LAW AND CONTROL OF FEMALE SEXUALITY

Let me return to the area of constitutional law that has been my specialty since
I began the ACLU Arts Censorship Project in 1991. How are sexist attitudes
and power relationships reflected in that strange beast, obscenity law, and
its near-relations: government regulation of so-called indecency, Catharine
MacKinnon-style antipornography ordinances, restrictions on homoerotic art,
and censorship of nudity (especially that pesky penis, again) in the arts and
entertainment.

Obscenity law, as I have previously said, is the First Amendment's "second
class citizen."[7] The obscenity exception to the First Amendment—the idea that
art or entertainment about sex is not entitled to full First Amendment protection
because it is "no essential part of any exposition of ideas"[8]—was invented by the
Supreme Court in the famous 1957 *Roth* case,[9] although, to be sure, it was wide-
ly *assumed* before then that pornographic literature or art could be suppressed.
The big problem in Roth was how to define that elusive concept, pornography.
That problem has persisted to this day, and is, of course, summed up in Justice
Potter Stewart's immortal remark: "I know it when I see it."[10]

The history of obscenity law, and of the Supreme Court's struggle to define
this category of speech that it says lacks First Amendment protection, has
been characterized by the same gender stereotyping, the assumption that
female sexuality is nonaggressive if not nonexistent, that we have seen in
Matthew Fraser's case and in the discrimination suits, like *Michael M.*, that
deal with sex relations. Originally, in English obscenity prosecutions, the legal

MARJORIE HEINS

question, as phrased in the 1868 case of *Regina v. Hicklin*, was "whether the tendency of the matter charged as obscenity is to deprave and corrupt those whose minds are open to such immoral influences and into whose hands of publication of this sort may fall."[11] As scholars have pointed out, that phrase—"those whose minds are open to such immoral influences"—meant primarily women and children, that is, those to whom sexual thoughts presumably would not naturally occur. Women were assumed to be frail, asexual creatures who had to be kept in ignorance and protected from the threatening effects of erotic awakening for their own sake and for the good of society.

Indeed, it was in the interests of "protecting" women that the scientists and historians who first discovered the erotic frescoes that enlivened life in ancient Herculaneum and Pompeii decided to lock them up in a "secret museum" so that women and children could not see them.[12] I am particularly fond, in this regard, of a remark by Lord Acton, once deemed a great authority on sex, who said that "the supposition that women possess sexual feelings could be put aside as a 'vile aspersion,'" because sexual emotion "'only happens in lascivious women.'"[13] Given this prevailing attitude, and the social imperatives it reflected, it was not surprising that American obscenity laws, when they came into vogue in the mid- to late nineteenth century, were explicitly designed, and zealously used, to suppress the circulation of birth-control devices or information about their use, and to prosecute both reproductive rights pioneers such as Margaret Sanger and authors of marriage manuals and other works describing female sexual response.

The Supreme Court's 1957 *Roth* decision rejected the *Hicklin* "depraved and corrupt" definition for obscenity, but hardly because the Court was interested in undoing the sexual double standard. The explicit reason for permitting obscenity laws, according to the majority in *Roth*, was society's interest in "order and morality,"[14] and particularly in controlling lascivious thoughts. The justices agreed that there was no empirical basis to believe that pornography-induced sex crimes or other antisocial behavior, but since obscenity was not protected by the First Amendment anyway, no proof of such a fact was required. Instead, as Justice Harlan wrote, in his separate opinion in *Roth*, the justices basically agreed that it is legitimate for legislators to decide that "over a long period of time the indiscriminate dissemination of materials, the essential character of which is to degrade sex, will have an eroding effect on moral standards."[15] (Justices Black and Douglas were the sole dissenters.)

Sixteen years later, in a series of major obscenity cases, Chief Justice Burger wrote in defense of obscenity laws that there was "ample basis for

legislatures to conclude that a sensitive, key relationship of human existence, central to family life, community welfare, and the development of human personality, can be debased and distorted by crass commercial exploitation of sex."[16] Justice Brennan, who wrote the decision in *Roth,* but who had since come to think that the whole enterprise of trying to regulate pornography was misguided and constitutionally bankrupt, now dissented, asserting that "'there appears to be little empirical basis for' the assertion that 'exposure to obscene materials may lead to deviant sexual behavior or crimes of sexual violence,'" that "explicit sexual materials are sought as a source of entertainment and information by substantial numbers of American adults," that "these materials also appear to serve to increase and facilitate constructive communication about sexual matters within a marriage," and, finally, that "[l]ike the proscription of abortions, the effort to suppress obscenity is predicated on unprovable, although strongly held, assumptions about human behavior, morality, sex, and religion."[17]

The connection between political control of female sexuality and obscenity laws was now plainly stated, but Justice Brennan came just one vote short of assembling a majority for his view, and obscenity law marched forward, into a future still more driven by conventional and majoritarian attitudes about gender. In a 1985 case, for example, the Court was faced with the problem of defining what appeal to the "prurient interest," a familiar part of the obscenity definition at least since *Roth,* meant in the context of a state obscenity law that purported to suppress materials that appealed to "healthy" as well as "unhealthy" sexual desires. It is no doubt a measure of how far American society had advanced by 1985 in talking frankly about sex that the Court evidently felt obliged to acknowledge the value at least of materials that yielded "only normal sexual reactions" or appealed to a "'good, old fashioned, healthy' interest in sex."[18] Thus, "prurient interest" was narrowed to mean only appeal to unhealthy, morbid, or shameful sexual desires.

I like to think of this case, called *Brockett v. Spokane Arcades,* as establishing the "healthy lust" standard in American constitutional law. Judges, juries, police, and prosecutors now must decide not only whether material has serious literary, artistic, or other value (thus entitling it to First Amendment protection),[19] but whether it appeals to "normal" or "abnormal" desires. In many parts of the country, of course, homosexuality is considered abnormal, and gay erotica can be targeted for prosecution and suppression precisely on the authority of the *Brockett* case. Likewise, government officials have threatened obscenity prosecutions against exhibits of explicit—and explicitly homoerotic—safer-sex ads. Before *Brockett* implicitly and after *Brockett* explicitly,

First Amendment protection has become a function of moral judgments about "correct" gender roles and "healthy" sexual desires.

THE MACKINNON TWIST ON OBSCENITY LAW

In the 1970s and early eighties, a very smart woman named Catharine MacKinnon developed a theory that obscenity laws were all wrong—not because sex information and entertainment should be protected by the First Amendment, but because these laws targeted the wrong type of material, and for the wrong reasons. It was not morality, or the preservation of traditional family life against (in Justice Burger's words) the "crass commercial exploitation of sex," that was the goal. Instead, MacKinnon theorized that pornographic materials that eroticized violence or domination conditioned men to be aroused by those acts, and were, therefore, responsible not only for rape and other sexual abuses visited through the ages by men upon women, but for all or most other forms of sex discrimination and oppression. Eliminate the materials, she reasoned, rewire the sexual conditioning of males (and perhaps many females, too), and the brave new egalitarian future will come into view. Suppression of erotic art and entertainment was justified in the interests not of morality and preservation of family life but of equality and female freedom. The crime of pornography became the sin of sex discrimination.

Accordingly, MacKinnon and her colleague Andrea Dworkin drafted an ordinance, adopted by the City of Indianapolis, that would have suppressed pornography, as they defined it, that is, "sexually explicit subordination of women, whether in pictures or in words," including presentation of women in scenarios of degradation, "shown as filthy or inferior," or as "sexual objects for domination, conquest, violation, exploitation, possession, or use, or through postures or positions of servility or submission or display."[20] The ordinance was promptly struck down by the federal courts, but not because the judges necessarily rejected MacKinnon's thesis that pornography caused real-world harm. (Indeed, the federal appeals court appeared to accept this dubious thesis, at least for purposes of argument.) No, the reasons MacKinnon's ordinance was invalid, deriving from well-established constitutional jurisprudence, were, first, that it singled out for suppression material that was protected by the First Amendment, indeed, that might have substantial literary, artistic, or other value; and second, that the ordinance did so on the basis of the viewpoint expressed, that is, advocacy of female subordination. Such "viewpoint discrimination" is the cardinal First Amendment sin; as Judge Frank Easterbrook wrote, "[a]ny other answer leaves the government in control of

all of the institutions of culture, the great censor and director of which thoughts are good for us."[21]

This is not the place to launch into a full-blown refutation of Catharine MacKinnon's theories or to illustrate why they are, in their way, as dangerous to free expression and female sexual liberation as anything thought up by male-supremacist judges down through the ages.[22] Suffice it to say here that, although MacKinnon's theories may in some ways be superficially appealing, her *remedies* for what she considers dangerous sexual conditioning reinforce the very patriarchy and sexism that she wishes to obliterate.

First, her definition of pornography, or the "sexually explicit subordination of women," is both vague and very broad, going well beyond actual rape or physical coercion. Indeed, buried in that definition are condemnations of images of women as sexual objects to be "possessed" or "used," "penetrated by objects," or in positions of "submission or display." Numerous critics have observed how broad and subjective these standards are, and how much art and literature they cover. Indeed, most sex acts, whether heterosexual or homosexual and whether or not including intercourse, involve possession, use, penetration, submission, and display. Yet MacKinnon does not distinguish between rape and intercourse; she sees them as expressing "the same power relation," sees sexuality itself as "violating," and pornography as bad because it shows that women (or some of us at least) "desire to be fucked."[23]

Second, MacKinnon and Dworkin perpetuate stereotypes about sexuality by presupposing female passivity and failing to take account of widespread feminist reaction against the oppressive virgin/whore dichotomy, not to mention the uproarious "bad girls" phenomenon, the Annie Sprinkles and Pat Califias of our rich and multifarious culture. Sexual expression, for both men and women, is simply too various, too idiosyncratic, to permit thought-control constraints of the MacKinnon type, even putting aside the sobering definitional problems and the inherent incongruity and danger of reposing in government agencies, including courts, the power to decide what ideas and fantasies shall be allowed.

Dominance/submission scenarios, for example, are a staple of sexual fantasy, including homoerotic literature, as the recent Canadian experience nicely illustrates. Ever since that nation's Supreme Court decided in 1992 to graft MacKinnon's theories onto Canadian obscenity law,[24] the great bulk of material censored has been homosexual in orientation, and the first prosecution was against a gay bookstore for carrying a lesbian magazine, *Bad Attitude*, that contained a sexual fantasy story involving coercion.[25]

Events recounted in the 1994 survey of arts censorship published by People for the American Way also illustrate the point. The report describes at least eight incidents in which someone objected to an artwork because he/she felt it was degrading to women or constituted sexual harassment. In one case the offending image was a penis. In another, an art professor was taken to task for showing slides of Robert Mapplethorpe's photographs to his class. In California, citizens objected to a sculpture showing a nude woman crucified on a cross because the work "truly insults feminism. . . . Placing a woman in a position of torture and death reinforces women as weaker, objects to be manipulated and used."[26] It would seriously understate the matter to suggest that these objectors may have failed to grasp the very point of the artwork in question.

CENSORSHIP AND HOMOPHOBIA

Homosexuality is, not surprisingly, a target of censorship efforts not only under traditional obscenity law (the "unhealthy lust" standard) and MacKinnon-style thought control (censorship of gay literature here and in Canada), but under all sorts of government programs.

It was not accidental, for example, that back in 1989 it was the explicitly gay works of a decidedly gay photographer, Robert Mapplethorpe, that pushed the hottest buttons, evoked the greatest outrage, and produced the greatest headlines in the emerging National Endowment for the Arts controversy. Complaints about NEA funding decisions since that time have ranged from mildly to rabidly homophobic, with a 1992 incident involving the rejection of funding for three gay film festivals being perhaps the least subtle example.[27]

The "not with my tax money" rhetoric that was so popular during the hottest years of the NEA controversy has since become the argument of choice in myriad state and local campaigns to purge any positive references to or information about homosexuality from government funding or benefit programs. In 1993, for example, a brouhaha developed in suburban Cobb County, Georgia, over a small amount of county arts funding that had been used to help stage Terrence McNally's play, "Lips Together, Teeth Apart" at the local repertory theater—not a notoriously gay play, but its setting on Fire Island, and a few references to gays, were enough to stir the pot of protest, resulting, ultimately, in a city council vote to eliminate the county arts funding program.

Homophobia has also been driving library censorship battles, where the main target is usually gay-positive literature such as *Heather Has Two Mommies* or *Daddy's Roommate*. Late in 1993, protesters on the religious

right forced the removal of *Annie on My Mind*, a book about two high school girls who discover they are gay, from school libraries in several Kansas towns. In one chilling episode, protesters burned the book in front of the Kansas City School District building. In a Texas town, *The Drowning of Stefan Jones*, a novel that condemns gay-bashing, was removed from both school library and curriculum, because it was deemed offensive to Christians. In Utah, the state board of education bans from any school programs "the acceptance or advocacy of homosexuality as a desirable or healthy sexual adjustment." Similar language was proposed by Senator Jesse Helms in 1994 as a restriction on public school districts receiving federal funds, and the measure passed the Senate by a comfortable margin.[28]

Now, homophobia is about, among many other things—traditional notions of virility, and fears of emasculation. As James Baldwin once explained, "[T]he condition that is now called gay was then called queer. The operative word was *faggot*, and later, pussy, but those epithets really had nothing to do with the question of sexual preference: You were simply being told that you had no balls."[29]

Fast-forward and we have our old nemesis, Warren Burger, writing in a particularly ill-spirited concurrence to the Supreme Court's 1986 *Bowers v. Hardwick* decision, that condemnation of homosexuality has "ancient roots," being "firmly rooted in Judeao-Christian moral and ethical standards," and being "a capital crime under Roman law."[30] (Burger conveniently omitted the Greeks from this list.) He went on to describe homosexuality (quoting Blackstone) as "'the infamous crime against nature,' . . . an offense of 'deeper malignity' than rape, . . . a heinous act 'the very mention of which is a disgrace to human nature.'"[31] Please note: this is a supposedly neutral, dispassionate Supreme Court opinion.

Fear of emasculation or vulnerability may also account for the oddly disparate responses to art containing male and female nudity. The penis, even in sweet repose, appears to be more threatening in this culture than any aspect of the female anatomy. Perhaps it is just a question of anxiety about size (big Mapplethorpes get more frenzied reactions than little Davids or Greek gods), but nudity does denote vulnerability, and the continuing taboo against "frontal male nudity" in movies, for example, where female fronts are standard fare, suggests another way in which censorship, whether government- or industry-imposed, is driven by attitudes about masculinity that have been with us at least since the Victorians. As one artist whose sculpture of a naked boy was removed from an exhibit space in Pennsylvania explained, "I suppose if it had

been a female figure, there wouldn't have been a problem. We're not used to seeing males exposed, if you will."[32]

It may be, ironically, that the homophobia manifest in so many of these censorship incidents can be used to advance equality. As the federal appeals court emphasized when it invalidated MacKinnon's antipornography ordinance, laws or other government actions that are demonstrably viewpoint-discriminatory, that is, aimed at the suppression of disfavored ideas, are highly vulnerable under the First Amendment. When school boards remove library books on grounds of "vulgarity," those who object to the censorship may have a difficult legal argument. When books are removed because they are thought to advance the subversive idea that homosexuality is healthy and acceptable, the decision is much more likely to be found unconstitutional. At least, that is the theory the ACLU is pursuing in a case brought against a Kansas school district for removing *Annie on My Mind*, and will continue to pursue when books and art are banned by homophobes.

A FOOTNOTE ON CENSORSHIP AND SEXISM

This brief survey illustrates, I hope, one good reason for opposing censorship. For it is well-nigh inevitable that censorship of sexual ideas and information will target the expression of women, sexual minorities, racial minorities, all those who have not been in power, have not set the rules. Free speech, especially about sex, is the most critical tool that underprivileged and outsider groups have for deconstructing masculinity and other bad habits.

NOTES

1. *Bethel School District No. 403 v. Fraser*, 478 U.S. 675, 683 (1986).

2. Ibid., p. 692.

3. Cynthia Heimel in *Newsweek*, quoted in Andrea Sachs, "Rise of the Penis: Fall of Inhibitions," *Columbia Journalism Review* 32 (March/April 1994): 8.

4. *Michael M. v. Superior Court*, 450 U.S. 464 (1981).

5. Laurence H. Tribe, *American Constitutional Law*, 2d ed. (Mineola, N.Y.: Foundation Press, 1988), p. 1576.

6. *Geduldig v. Aiello*, 417 U.S. 484 (1974); *General Electric Co. v. Gilbert*, 429 U.S. 125 (1976).

7. Marjorie Heins, *Sex, Sin & Blasphemy: A Guide to America's Censorship Wars* (New York: New Press, 1993).

8. *Chaplinsky v. New Hampshire*, 315 U.S. 568, 571-72 (1942).

9. *Roth v. United States*, 354 U.S. 476 (1957).

10. *Jacobellis v. Ohio*, 378 U.S. 184, 197 (1964) (concurring opinion). Stewart wrote:

I have reached the conclusion, which I think is confirmed at least by negative implication in the Court's decisions, . . . that under the First and Fourteenth Amendments criminal laws in this area are constitutionally limited to hard-core pornography. I shall not today attempt further to define the kinds of material I understand to be embraced within that shorthand description; and perhaps I could never succeed in intelligibly doing so. But I know it when I see it, and the motion picture in this case is not that.

The film prosecuted for obscenity in *Jacobellis* was Louis Malle's celebrated classic *The Lovers* (1959), with Jeanne Moreau.

11. *Regina v. Hicklin* (1868), quoted in *Heins, Sex, Sin & Blasphemy*, p. 20.

12. Walter Kendrick, *The Secret Museum: Pornography in Modern Culture* (New York: Viking, 1987), pp. 11–13 (cited in Heins, *Sex, Sin & Blasphemy*, p. 138).
 Ellen Willis writes:

 The basic purpose of obscenity laws is and always has been to reinforce cultural taboos on sexuality and suppress feminism, homosexuality, and other forms of sexual dissidence. No pornographer has ever been punished for being a woman hater, but not too long ago information about female sexuality, contraception, and abortion was assumed to be obscene. In a male-supremacist society the only obscenity law that will not be used against women is no law at all.

 Ellen Willis, Nan Hunter et al., eds., *Caught Looking* (New York: FACT Book Committee, 1992), p. 58.

13. Havelock Ellis, *On Life and Sex*, quoted in Heins, *Sex, Sin & Blasphemy*, p. 137.

14. *Roth*, 354 U.S. at 485, quoting *Chaplinsky v. New Hampshire*, 315 U.S. at 571–72.

15. Ibid., p. 502.

16. *Paris Adult Theatre I v. Slaton*, 413 U.S. 49, 63 (1973).

17. Ibid., pp. 107—8, 109, quoting in part *Stanley v. Georgia*, 394 U.S. 557, 566 & n.9, and the Report of the *President's Commission on Obscenity and Pornography* 27 (1970).

18. *Brockett v. Spokane Arcades*, Inc., 472 U.S. 491, 499 (1985).

19. This was part of the standard established by the Supreme Court in *Miller v. California*, 413 U.S. 15 (1973), for determining whether a work was protected by the First Amendment or was obscene and therefore without constitutional protection. To be obscene, the work had to depict specified sexual activities in a patently offensive manner, appeal to the "prurient interest" (clarified in *Brockett* to mean a "shameful or morbid interest" in sex), and lack serious literary, artistic, political, or scientific value.

20. *American Booksellers Association, Inc. v. Hudnut*, 771 F.2d 323, 323 (7th Cir. 1985), quoting Indianapolis Code §16–3(q).

21. Ibid., p. 329.

22. For some excellent sources, see Marcia Pally, *Sex & Sensibility: Reflections on Forbidden Mirrors and the Will to Censor* (Hopewell, N.J.: Ecco Press, 1994); Carole S. Vance, ed., *Pleasure and Danger: Exploring Female Sexuality*, 2d ed. (San Francisco: Pandora, 1993); Ann Snitow, Christine Stansell, and Sharon Thompson, eds., *Powers of Desire: The Politics of Sexuality* (New York: Monthly Review Press,

1983); Nadine Strossen, "A Feminist Critique of 'The' Feminist Critique of Pornography," *Virginia Law Review* 79 (1993): 1099–1190; and Nadine Strossen, *Free Speech, Sex, and the Fight for Women's Rights* (New York: Scribner, 1995).

23. See Catharine A. MacKinnon, *Feminism Unmodified: Discourses on Life and Law* (Cambridge, Mass.: Harvard University Press, 1987), pp. 130, 154, 171–72 (quoted in Heins, *Sex, Sin & Blasphemy*, p. 158).

24. *Regina v. Butler*, (1992), R.C.S. 452.

25. *Regina v. John Bruce Scythes* (1993), Ont.Ct. (Provincial District). See the Human Rights Watch Free Expression Project Report, *A Ruling Inspired by U.S. Anti-Pornography Activists is Used to Restrict Lesbian and Gay Publications in Canada*, vol. 6, no. 1 (Feb. 1994).

 The attack by Canada Customs on gay literature continued full-tilt, despite a lawsuit filed by the Little Sisters Bookstore in Vancouver challenging the constitutionality of Customs' practices. In August 1994 Customs seized *Testimonies: Lesbian Coming Out Stories, Revelations: Gay Men's Coming Out Stories*, and *Unbroken Ties: Lesbian Ex-Lovers*, all headed for Little Sisters.

26. People for the American Way, *Artistic Freedom Under Attack* (1994), pp. 29, 36, 197. Other instances in which protesters used MacKinnonite rhetoric to attack works of art are reported on pages 40, 56, 92, 200, and 221. A number of the works were created by female artists.

27. The festivals were the only three rejected out of fifty-three that had been recommended for funding. The NEA quietly reinstated the funds a year later after negotiations with the ACLU Lesbian & Gay Rights Project and Arts Censorship Project, which had agreed to represent the festivals in litigation if necessary.

 Another NEA controversy around the same time involved the New York dance organization Movement Research and its *Performance Journal* #3, which contained gender-bending articles about cross-dressing and transsexuality in the context of performance and dance. Needless to say, Jesse Helms went ballistic, and the NEA, citing such alleged improprieties as the use of a guest editor, demanded return of some of its recent grant to Movement Research. The issue here was plainly gender: the *Performance Journal* images were threatening because they departed dramatically from conventional notions of masculinity.

28. The Helms proposal was eventually eliminated by a conference committee.

29. James Baldwin, "Here Be Dragons," in *The Price of the Ticket: Collected Nonfiction 1948–1985* (New York: St. Martins Press, 1985). The essay was originally published as "Freaks and the American Ideal of Manhood," in *Playboy* (January 1985).

30. 478 U.S. 186, 196 (1986). In *Bowers*, the Supreme Court, voting 5 to 4, upheld a Georgia sodomy law that criminalized homosexual as well as heterosexual acts, but that was only used to prosecute gays.

31. Ibid., p. 197.

32. *Artistic Freedom Under Attack*, p. 188.

MALE SUBJECTIVITY AND RESPONSIBILITY

five

GEORGE YÚDICE

WHAT'S A STRAIGHT WHITE MAN TO DO?

For the past year, I have been monitoring the feelings and ethical positions raised in an electronic network conference on "maleness." This electronic dialogue, called <gen.maleness>, has been in existence since May 1, 1989, and involves between fifteen and twenty participants, almost all straight, white men from Australia, Canada, and the United States. Coming from a range of occupational backgrounds, including several counselors and therapists (some of the discussions have a pronounced therapeutic register), they all seem to subscribe to some kind of progressive political agenda. Their collective political orientation might be described as more-or-less leftist

profeminist antimasculinism. That is, while their profeminist call to end sexism is quite distinct from the promasculinist stance of the men's movement, the conferees do endorse the men's movement's interest in a version of antisexism that does not reject male empowerment. In almost all cases, the debate circles back to the question of whether or not men, too, may be oppressed.

Most of the conference participants have been deeply marked by feminism, to the point of identifying themselves as feminists, and many are critical of the "mythopoetic" men's movement (as exemplified in Robert Bly's *Iron John*) for seeking to explain the shrinkage of men's emotional resources in terms of the loss of masculine myths and rituals. Some express the view that the men's movement should not be swept under the carpet of political correctness,[1] while others, along with Bly, criticize the "soft male" who speaks more of his own "pain" than of the more visible reality of women's oppression.

These are progressive men; they are antiwar, antiviolence, antisexist, antiracist. For them, the conference is a safe haven, an opportunity to discuss issues around masculinity without facing the ridicule of misogynists and homophobes, or, on the other hand, the derision of "man-hating" feminists and those men they call "profeminist misandrists."[2] Indeed, the presence of a few women who have intervened has generated much debate about the advisability of a closed "men's only" conference, analogous to the women's caucuses that historically have been formed in institutions and social movements. The topics the men want to talk about include power and violence (not only that wielded by men, but also what they call the nonphysical abuse of men by women), the hurt of being stereotyped, the lack of support networks for men, unwitting sexism, and ways to change behavior. The most important topic, however, is responsibility and its relation to the "oppression of men."

I chose to work on this electronic conference precisely because it is a forum for those men who are not colluding in the "undeclared war against . . . women" described by Susan Faludi in *Backlash*.[3] Even those men in the group who are most suspicious of feminism nevertheless subscribe to a strong antisexist position. When they use the word "responsibility," it is in the context of a recognition of men's roles in reinforcing patriarchy and fucking up the world. But they also claim a responsibility to themselves as men. Clearly these men have not, if we are to believe them, staged a "male revolt," what Barbara Ehrenreich would call a "flight from responsibility."[4] On the contrary, they claim to feel the strain of "overresponsibility" as a result of the various roles they have been coerced into assuming.

These men, though progressive, do not want to be left out of the redistribu-
tion of value that may follow from any future democratization of society. Indeed,
they want to enter this terrain of struggle, to stake their own claims, as diverse
groups jockey for a larger share of the pie. Group politics, whether we prefer to
think of them in terms of the interest-group label of yesteryear or the identity pol-
itics of the past decade (ultimately, I think they amount to much the same) is
always about making legitimate claims on resources and social recognition. In my
understanding of identity politics, legitimacy is based on claims to a cultural ethos
requiring recognition against the backdrop of a liberal, individual-rights-oriented,
social contract derived from Enlightenment universalism.[5] This implies that there
is no overarching ethical order from which to make an assessment of the legiti-
macy of any particularistic cultural ethos. Most often, however, this cultural ethos
is derived in part from the oppression that the targeted groups have suffered.
Claims to having been oppressed, then, are at the heart of claims to legitimacy.

Where responsibility enters this picture is in how to deal with oppression.
The two notions—responsibility and oppression—go hand in hand, as the fol-
lowing complaint, made by one of the participants, bears out:

> I have been learning a bit about overresponsibility lately that is important to us as men.
> It's a large piece of our oppression as men that is seldom recognized and even less often
> dealt with. We look at the symptoms of overresponsibility a lot; exhaustion, workaholism,
> driven, tense, got to fix it, to blame, no one else can do it, not good enough, weighed
> down. . . . We're expected to be overresponsible for our overresponsibility. From the inside,
> it looks like we just have to keep going, on our own with out anybody to help us. That we
> are about to drop but that we will just keep going anyway. I get to see this run rampant
> through the lives of all the men in my life in some way or other. It is deeply destructive
> to ourselves first off and eventually to others. . . . There's a bind that we get stuck in
> because we have been told a "good man" by society's standard is one who claims respon-
> sibility alone and grinds on alone without asking for help or rest. (PW)[6]

It is particularly apt that this participant should find the essence of his man-
hood in the responsibility that society "foists" upon him, which he claims
oppresses him. He complains about this oppression, and yet he accepts it as
a means to his own liberation. The claim by a middle-class, straight, white man
that he feels oppressed by overresponsibility might strike many as disingenu-
ous. Indeed, this "poor, oppressed man" is the theme of a number of popular
tracts, such as Warren Farrell's *The Myth of Male Power*.[7] It also forms the joke
of a parodic artwork by Erika Rothenburg that was included in the 1994 exhi-
bition "Bad Girls" at the New Museum of Contemporary Art.[8]

WHO ARE
THEY?

THEY'RE MEN, America's largest oppressed minority.
And whoever said that they rule the world couldn't have been one.

Men have such a hard life that they die an average of 8 years earlier than women.
They are 3 times more likely to be murdered.
They have a much higher incidence of heart attacks, AIDS and cancer.

More men suffer from homelessness. In many cities, homeless men outnumber women 10
to 1, but it's women and children who get the public's sympathy and attention.

Only men can be drafted—forced to go to war, kill and be killed.

Women can choose to have a career or not, but men are expected to bring in money. That's
why in ghetto neighborhoods where there are no jobs,
men become criminals and drug dealers.

A man's most innocuous remark can be construed as sexual harassment;
his most tenuous advance can be called rape. Yet whenever women want sex,
men are expected to perform. Unlike women, they can't fake it.

Our society does not allow men to cry. Instead, they are forced to
repress their emotions, an unhealthful practice that can lead to mass murders,
ulcers, heart disease, and cancer.

Men are subjected to barbaric practices that would be condemned if perpetrated
on any other group. Feminists demonstrate against ritual violence to women, for example,
but no one protests the ritual violence that young male babies are subjected to every day—
circumcision. It's another sad reminder of how men's pain is trivialized in our society.

Men must follow a dress code that is at once puritanically rigid and
sexually exploitative. At work, they must obey the most restrictive rules: suits and ties,
no loud colors, no skirts or dresses. But in public places like beaches and swimming pools,
they must expose their breasts in front of total strangers.

Men kill themselves at a much higher rate than women. With all their responsibilities and
the criticism they get for merely behaving the way they were taught,
is it any wonder that for them life is often not worth living?

Please give your time and money to the fight for men's rights.
After all, we'll never change society until we change things for men.

MEN.
THEY'RE 48% OF THE POPULATION AND THEY NEED YOUR HELP!

The point of this spoof (and of Faludi's *Backlash*) is that the claim that men are oppressed is simply one way in which men seek to dilute the politics of feminism and other antipatriarchal movements. Several of the contributors to this volume provide examples of analogous displacements of the agendas of subordinated groups struggling to gain or maintain a foothold in public spheres. In her essay "Male Trouble," for example, art historian Abigail Solomon-Godeau describes the projection of a soft masculinity in late eighteenth- and early nineteenth-century paintings depicting male nudes.[9] For her, this "newly feminized" representation of the male body was partly a way of repositioning masculinity in the place of the female, particularly in the role the female had occupied in the aristocratic public sphere.

Similarly, cultural critic Andrew Ross, in his essay "The Great White Dude," criticizes the ecologically-minded savior of the oppressed (Native Americans, in this case) as portrayed by Steven Seagal in *On Deadly Ground*.[10] According to Ross, the Seagal character's "reconversion" enables the white (and presumably straight) man to susbcribe to a feminized (ecologized) political correctness *and* maintain dominance. Another way to think through this situation would be to apply Gramsci's insight that hegemony is achieved by those groups who can manage to rearticulate the social and political discourses that have made common sense to diverse sectors. In our present situation, those groups might include feminists (particularly second- and third-generation), ecologists, animal rights advocates, racial and ethnic identity groups, the men's movement, and postmodernists of diverse ideological stripes (all, perhaps, except hard-nosed conservatives and post-Marxist deconstructionists).

Occupying the role of the victim by adopting the rhetoric of oppression is one such way to rearticulate the social and political discourse, and several men in the <gen.maleness> conference have done exactly that. For instance, RH cited a string of statistics regarding male suffering that rivals anything in Rothenburg's artwork or Farrell's book (for instance, white male teenagers are five times more likely to commit suicide than their female counterparts, black males have a lower life expectancy than black females, alcohol dependency is three times greater among eighteen-to-twenty-nine-year-old males than among women of the same age, and so on).[11] Progressive men who are unemployed, such as the one who made the following plea, are particularly prone to using the rhetoric of oppression to characterize their circumstances:

> I do not consider myself among the privileged, especially since like a growing number of men and women, I will be out on the streets looking for work in a few weeks. . . .

I do not deny that I have had some access to better jobs than others, but the fact that I cannot say what I believe without the very real threat of retribution from my employers and future employers should say something about whether I am privileged or oppressed.

I am not that special a circumstance. I am one of a class that gets taken to the cleaner by those who would imply that its interests lie in preserving the status quo. These are hard times, nameless one [a participant who criticized JS's claims to being oppressed], and I, a white male, am suffering in them along with my brothers and sisters of all colors and creeds. If you persist in trying to include me in part of the great conspiracy that keeps so many down, then you are only doing your part to keep the oppressed of this nation and this world divided. (JS)[12]

The argument that men are donning the mantle of victimhood for the sake of maintaining hegemony, however, is not fully explanatory, especially in the case of progressive, profeminist men. In her essay, "The Decline of Patriarchy," Ehrenreich argues convincingly that the rise of sexism today is not attributable solely to a decline of patriarchy. Rather, it is that the new roles have opened up for women in the global economy (due in part to post-Fordism and consumer culture in the "North").[13] As in her previous work, *The Hearts of Men,* Ehrenreich makes the case that, while the global economy's new social roles for women may mean greater employment (although not necessarily equitable remuneration) and greater salience culturally, the expense is the loss of the protection that men once offered under patriarchy in accordance with their own social roles. In other words, as women become more "masculine" (that is, they enter the workforce and the public sphere), men become more "feminine" (that is, they cultivate domesticity, feelings, and so on); men, consequently, no longer feel compelled (even rhetorically) to provide protection.

Perhaps oppression and victimization are not applicable to all traditionally subordinated subjects in today's global economy (which has displaced work as a source of value for an increasing number of men). Indeed, the point being made by many in the men's movement, as well some of the progressive men in the <gen.maleness> conference, is that self-esteem and cultural empowerment are among the most important ethical principles in any struggle for recognition. Feeling empowered "by finding out what your maleness actually means" is, then, crucial for legitimizing demands. This becomes quite obvious in discussions of oppression, which increasingly functions as a cause to be recognized today, particularly in relation to the "truth" ("we're oppressed") that men are "not permitted" to speak. As one conference participant put it:

Oppression is *felt;* response to it comes especially from the heart rather than the head. Yet you're making it clear that you don't consider men should allow themselves to *feel*

oppressed: you have valid reasons for doing so (e.g., in case it dilutes perception of women's oppression) but notice that you are arguing against men "speaking their truth." In effect, you're asking men to be dishonest about their feelings, in order to validate women's feelings—and then complain about this dishonesty! (TG)[14]

It is highly significant, of course, that this man should have chosen a traditionally "feminine" register (the emphasis of "feeling" over "reason") to "legitimize" the notion that men are oppressed. In part, this has to do with the therapeutic society in which we live: counselors, psychotherapists, and self-help authors all recommend that you should come to terms with "how you feel" rather than what you think or whom you blame. When the meaning of responsibility as "culpability" (who is to blame) gives way to a centrifugal sense of power, whereby pointing to perpetrators is thought to become pointless (or ideological), then no one is to blame. Of course, blame is a particularly tricky notion, and should be deconstructed. Rather than blame, I would say that it is responsibility, in the sense of assuming a relative privilege, that is at stake in the discussions in <gen.maleness>. They are largely debates around the move on the part of some to step away from assuming responsibility for the privileges that have accrued to them as men. This move requires establishing a new, discursive linkage among the notions of feeling, blame, shame, "power-within," self-esteem, and responsibility. Let me explain.

My first observation is that all of the men in the conference—whether pro-feminist or antimisandrist, whether members of the men's movement or not—place great importance on feeling empowered, even in those cases (or perhaps especially in those cases) in which men recognize that they have been abusive to women. The conferee least sympathetic to feminism's critique of men carefully crafted his treatment of oppression in such a way as to preempt a fall from power (powerlessness), redefining in the process the very notion of power as "power-within." Interestingly, he also based his analysis on the feminist movement's experiences with power:

I'd agree that "oppression" may not be a good term to describe the effect of men's gender stereotyping: but something very close to it does occur, and (I believe) it's this which then echoes round and round the culture as "oppression" in the sense that you mean. Much of early feminist study was concerned with understanding the stereotypic conditioning of women, and reclaiming a sense of choice; it's perhaps arrogant, but I believe that here we're doing much the same for men—reclaiming a sense of *choice* that allows us to break out of the cycles. My strong belief is that we'll begin to resolve many of the inter-gender issues not by disempowering men, but by empowering them to find a real,

functional and social sense of power—you'll have read in this conference the several dis-
cussions on power, derived in part from Starhawk's well-known model—and hence
choose their actions rather than fall into culturally condoned habits of abuse. (TG)[15]

However, this man's understanding of the workings of power absolves all from
its exercise, since it is the *culture,* rather than individuals and groups, which dri-
ves its distribution:

What I do *not* believe is that men—or anyone—oppress out of choice. My opinion (which
is far from universal!) is that men's oppression arises out of very deep fears and a deep
sense of power*less*ness which the culture encourages men to "export" to others. (TG)[16]

This line of argumentation is necessary to develop the crowning conclusion
that men actually have less power than women. By this, TG means that men
have less of the "power from within" which requires an affirmative sense of
"meaning and purpose, [which is denied by] our culture. . . . to men."[17] If some
men are abusive to women, then, it is because they are powerless, a condi-
tion that, when coupled with the anchorlessness of masculine subjectivity,
becomes "dangerous."[18]

The more "progressive" men in the group, those who have continually criti-
cized this man for his critique of feminism, nevertheless share his suspicion of
"models of oppression [because] they scatter-shoot across groups. Everyone
in that group gets convicted."[19] Another progressive man, EL, sees taking
responsibility for one's own acts as a means of reempowerment. This means not
blaming others for one's problems, since blaming others "takes power away
from us." Taking responsibility for EL means developing the "power-within,"[20] the
same term that DP used for "reclaiming the soul" against the "spiritual emptiness
and emotional sterility of [men's] lives of privilege." This is the form of "self-
interest" that can lead to "genuine change."[21] Without endorsing the "mythopo-
etic" inducements of Robert Bly and the "mythopoetic" men's movement, yet
accepting the "revolutionary" potential of the self-esteem that comes with devel-
oping the "inner world," several men argue that it is possible for men to thus "rid
[themselves] of [their] conditioning" and in so doing reap the "immediate
rewards" of "end[ing] isolation and emotional dependency. Ending social condi-
tioning means the end to contradictory inputs, an end to structural oppression."[22]

For MH, empowerment entails a rejection of "male power," traditionally
understood. This is made possible by the experience of shame, which is
derived from confrontation with others, both those "others" who claim oppres-
sion, and those closer "others" who constitute one's ancestors. Thus, MH is

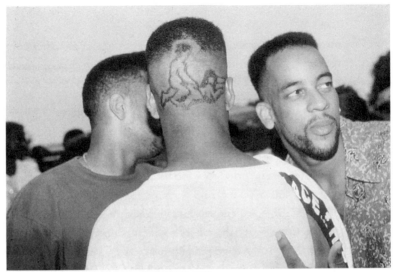

Bill Gaskins, *Untitled*, from the series Good and Bad Hair, 1992.

able to gain a certain self-esteem by confronting the privilege bequeathed by his ancestors, a confrontation that is enjoined by those who have experienced subordination in relation to that privilege.

> My shame for my ancestors and my offspring means that I can do something about who they are and who they were. In fact, my shame is revelatory in the sense that it teaches me just exactly who they were (and are) by revealing those parts in me that were unquestioned until my shame confronted them. (MH)[23]

Shame is experienced, then, as a way to take responsibility for and to redress the unjustified privilege that has been historically accorded because of gender, race, and class. It is also a way of gaining "power-within," on the basis of maleness, thus providing an ethical basis for male solidarity that is not beholden to the otherization of any different group. Shame leads the way to recognition and the inner life, so long as it does not slide into "toxic shame," which, rather than being a manifestation of "pride ('power-from-within') for having *stopped* previous oppressive behavior," is an unhealthy and "self-disempowering" indulgence in self-blame.[24]

It is possible, of course, to understand this "maintenance" of esteem and empowerment as the preservation of recognition, precisely when other groups (that have claimed oppression) have won over that terrain, at least in those places where identity politics has leverage. But it is a rhetoric that has, both for

these men's groups as well as for the "others," become a means to group self-formation. It is in terms of such a self-formation, then, that I speak of the problem of responsibility for progressive, straight, white men in today's United States.

Responsibility, thus understood, is an ethical substance, in the Bakhtinian sense of self-formation and relation to self [*rapport à soi*]. Bakhtin reworks Kant's abstract, universal, ethical imperative by bridging the incommensurable gap between sensibility and representation in action, whereby the self responds to its own need for (and through) an other.[25] In this sense, responsibility is an authoring of self through a responsive act, which is also a "ventriloquation" of the other's discourse of oppression. In Foucault, also, ethics has to do with action, in his case, the action by which the subject constitutes itself (which is a kind of authoring, also). This notion of ethics is different from a moral code, and it is characterized by practices that, for Foucault, differ from moral injunctions:

> [A]t certain times, in certain societies and groups, [an ethical concern] appears more important than the moral attention that is focused on other, likewise essential, areas of individual or collective life, such as alimentary behaviors or the fulfillment of civic duties.[26]

I want to use this notion of responsibility to speak of the constitution of progressive, straight, white, male masculine subjectivities today. In particular, I would like to consider the issue of subject-formation for straight white men as it relates to the subject-formation of other groups, most often women but also racial minorities. That is, these men clearly want to challenge the claims made by other groups regarding possession of the cultural capital that comes with the charge of having been oppressed. This may sound strange, but I would argue that both the politics of identity and the politics of disidentification are premised on a dialectic between claims of oppression and attributions of responsibility.

This dialectic of oppression and responsibility is worked out through the courts, through the administrative bodies of social institutions like schools and universities, and, insofar as representation is implicated, through museums and other media venues. More specifically, responsibility and oppression are always bound up in the many processes of social recognition, including: (1) the challenge to traditional rights discourse, first by the Civil Rights Movement, and then by arguments for collective rights, particularly as elaborated for new immigrant populations and other groups that have used "identity" as a platform from which to make claims; (2) the identity requirements of the client role as defined by the U.S. welfare state; (3) the practice of targeting consumers by the consumer and media markets; and (4) the discursive strategies that subordinated

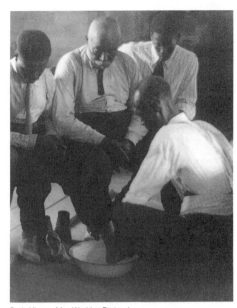
Doris Ulman, *Men Washing Feet*, n.d.

groups have developed to gain greater access to rights, services, and recognition. This conjunctural account does not hold to a model of ideological determination of behavior (although it does acknowledge the normative force of institutions), but it also does not exaggerate the agency of subordinated groups in democratizing U.S. society.

This conjuncture of factors constitutes the space for a specifically performative type of hegemonic politics that is characteristic of the United States. It could be said that the U.S. has developed a distinctive cultural politics in which interaction, from the organized institutional level to the more informal aspects of everyday life, has become an open-ended process of management of multiple images. This is a process akin to Ernesto Laclau's and Chantal Mouffe's account of the workings of hegemony in postindustrial capitalist democracies, that is, a management of "unstable differences."[27] In the case of the United States, this management often revolves around processes of identification that are open to rearticulation. The strategies whereby the "progressive" men of the electronic conference have sought to gain self-esteem and empowerment, while recognizing a measure of responsibility for unjustified privilege and the oppression of others, is an example of this process of rearticulation or reconversion of the ethics of identity.[28]

It will be useful, for the purposes of examining this ethics, to remember the four terms of Foucault's ethics. First, there is the "ethical substance," that which

GEORGE YÚDICE

delimits what moral action will apply (for instance, sensual pleasure among the Greeks, flesh among the early Christians, sexuality in Western modernity). My claim is that the men in the <gen.maleness> conference construe masculinity as an ethical substance. Secondly, there is the "mode of subjection," or the "way in which the individual establishes his relation to [moral obligations] and puts [them] into practice" (for instance, by divine law, by reason, by convention, by the pursuit of beauty as among the Greeks). For the conferees, it seems to me, oppression functions as a mode of subjection. Thirdly, there is the "ethical work" of self-formation or asceticism (for instance, moderation of the pleasures through dietetics, economics, and erotics among the Greeks, self-decipherment among the Christians). Self-help, therapy, and confessional modes (including those of the electronic conference) operate as the "ethical work." Finally, the fourth category is the *telos* or "place [an action] occupies in a pattern of conduct" such as that of salvation, immortality, freedom, or self-mastery.[29] These men also seek a kind of salvation, through the recognition (shame) of their action and powerlessness, in a leftist institutional context that they think gives recognition only to those who have a "difference" (that is, women, blacks, Latinos, gays, and lesbians).

Let me start with the "ethical substance": masculinity, the white, straight masculinity of progressive men. Among the participants in the electronic conference, responsibility seems to identify the substance of masculinity, even when this means taking responsibility for men's violence, as in the following statement:

> I don't think it's appropriate to evade responsibility for male oppression and violence, and particularly . . . I don't feel it's appropriate to place responsibility back on women. I've also talked a bit about our own responsibility as men for creating the stereotypes we now dislike. (EL)[30]

However, many of these men feel that they are coerced into playing the violent role by ideological and structural factors. But they also take individual responsibility for accepting this role:

> Every time I argue that men's experience of abuse is the key to ending their violence I seem to be misunderstood. I guess it's inevitable that people's gut reaction will be to think that I absolve individual men of any responsibility for their actions. I *do* believe that individual men are responsible for making a clear decision to end their violence. I don't (and can't) work with anyone, man or woman, who is not motivated to change. (GO)[31]

Responsibility, thus, is linked to the experience of oppression, which might be considered, along with shame, a "mode of subjection," or the means by which the individual establishes his or her relation to moral obligations.

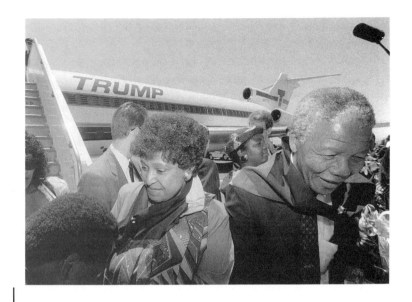

Assumption of oppression is the means by which many of these men recognize their responsibility, as in this statement by one participant:

> I, a white male, am suffering . . . along with my brothers and sisters of all colors and creeds. If you persist in trying to include me in part of the great conspiracy that keeps so many down [the reference is to the "great white male monolith" of power], then you are only doing your part to keep the oppressed of this nation and this world divided. (JS)[32]

As a kind of complement to their assumption of oppression, some of these men attribute a relative privilege to other oppressed groups in ways that make it, for them, difficult to distinguish between oppressors and oppressed. The strategy is to recognize their own privilege and then generalize the idea that all groups have some relative privilege. This enables the dedifferentiation and dehierarchization of all oppressions:

> To deny our male privilege because we are working class. Or to deny our racial privilege because we are women, or queer, or oppressed in any of the multitudes of other ways, is simply sloppy thinking. The world is not dividable into oppressors and oppressed with one hard and fast line. The networks of oppression are vast and complex. . . . This does not negate the oppression of others. There is no hierarchy of oppressions. But it does challenge us to recognize the complexity and variability of the networks of the oppressed. (BR)[33]

GEORGE YÚDICE

It could be said that, generally, men who attempt to come to terms with their masculinity will put into operation an "ethical work" through confessional, therapeutic discourse. To be able to speak of one's oppression is to "speak one's truth," as another man put it; this is the access to one's "inner life" or "power-within." This ethical work bears a curious analogy, perhaps an inverse one, to that of the Greek freemen described by Foucault; they gained their "self-mastery" through the same techniques that they used for the "mastery of others."[34] For the men in <gen.maleness>, however, self-mastery contradictorily implies dependence on the other. The process begins with shame, and proceeds to an inversion or dissolution of "blame," such that mastery is achieved as a sublation of "power-over" (that of the the oppressor) and "power-under" (that which the oppressed wield effectively against the former). It is precisely through this ethical work that some of these men convince themselves that the "power-under" of women (which functions as "psychic" or emotional abuse) is the equivalent of the "power-over" of men (most readily manifested in rape and other physically violent acts against women).[35]

The *telos* of masculinity projected in this electronic conference is analogous to the salvation that Foucault discerns in Christian ethics. It is a means to being recognized in a society that increasingly distributes recognition on the basis of difference. Ultimately, of course, this recognition (that "we are oppressed, too") is a form of disavowal: "I certainly don't subscribe to the belief that all of society's woes are the fault of every male being on the planet" (EC).[36]

Precisely because straight white men are perceived by progressives within identity politics and multiculturalism as the center of the dominant culture, they are not permitted to claim their own difference. There is an irony here, for the very objective of progressive politics today—to dismantle privilege—ends up keeping in place in our imaginary an ever greater monolith of power. Difference, which functions as the grounds for a politics of recognition, is only for the oppressed. What, then, are progressive, straight, white, men permitted to do in this context?

There is Gloria Anzaldúa's recommendation that the relatively nonoppressed just shut up and listen. Or there is the tendency to play it safe and, like those who claim difference, engage in a critique of other straight white men (for example, this essay, or Andrew Ross's critique of Steven Seagal's critique of white male destruction of the planet). Or simply to disavow: "No, I am not dominant, I am oppressed, too." This last tack, the incentive to disavow, may even explain why many straight white men are seeking to identify with (or *as*)

other groups. Perhaps the most salient example of this is the "queer on the streets but straight within the sheets" syndrome. A straight white man can thus have have his public difference without having to bare his privates to another man. Among the many college students I interviewed for an essay on whiteness, I was surprised by the many straight white men who took this route to opt out of privilege, to opt out of whiteness. One straight queer even affirmed: "I'm not white, I'm queer." Of course, we might argue that this is all for the better, that if all men turned queer then we might have a better chance of changing the larger social structures and displacing all normativities, as Judith Butler recommends in *Gender Trouble* and *Bodies that Matter*.[37]

But not even Pollyanna would really believe this. The problem as I see it is that, within identity politics (and even within those groups that prefer to wield disidentification as a politic), the competing claims to being oppressed have opened up a new ethics of self-formation, one that construes responsibility either as an attack on the racial-sexual monolith or as an accounting for one's identity. How could it be otherwise, when the "mode of subjection" for the "ethical substance" of identity today *is* oppression? Despite the claims by diverse groups to a culture-specific knowledge, whether in standpoint or subjugated knowledges, the ultimate legitimizing move is the claim to oppression. The problem is that this ethics of oppression ultimately relies upon a moral discourse that has no foundation. Even a white male identity politics makes a claim upon it. For all the talk of ethics, the struggle for recognition can be seen as a naked form of politics. As one participant in <gen.maleness> put it, the rhetoric of oppression is "simply politics as politics and power as power"(DM).[38] But this is power only insofar as normativities in civil society are concerned.

The difficulty with this view is that it is not clear what other kind of politics mediates between civil society, the state, and the economy. The politics of identity and disidentity may have garnered some gains for oppressed and subordinated groups in the past two decades but, ultimately, it is a problematic foundation for getting at the power that determines our day-to-day decisions. This is true not only because everyone, including straight white men, is getting in on the act, but also because other problems (involving economic policy, foreign policy, the environment, and so on) seem to be intractable to these politics. Many social decisions are made at levels beyond the reach of the contestation or the flouting of normativities, and these also contribute to oppression. In the end, I am not fully convinced that they can be redressed solely at the level of civil society.

GEORGE YÚDICE

NOTES

Throughout this text, respondents to the electronic conference, titled <gen. maleness>, are referred to by their initials or their on-line identification.

1. TG, response to the topic "Husband Battering," <gen.maleness>, June 25, 1992.

2. Regarding the men's self-misandry, heated debate has taken place concerning "political cross-dressing" as a means to evade criticism. TG, response to the topic "The Progressive Misogynist," <gen.maleness>, Apr. 4, 1992.

3. Susan Faludi, *Backlash: The Undeclared War Against American Women* (New York: Anchor Books, 1992).

4. Barbara Ehrenreich, *The Hearts of Men: American Dreams and the Flight from Commitment* (New York: Anchor Books, 1983). This is not the occasion to go into Ehrenreich's recommendations for strengthening the welfare state in the wake of men's abdication of upkeep of the family. Suffice it to say that in the current conjuncture, in which there is no viable socialist agenda on the horizon, holding on to the welfare state makes a lot of sense. The challenge, however, is not only how to finance it, that is, what revolutionary means might be necessary to allocate more funds for services, but also how to further democratize it.

5. This position enjoys widespread endorsement among multiculturalists and advocates of identity politics. To give just one example, Anthony Cortese argues that "[e]thnic groups make their own series of moral judgments, which are sometimes exclusive to their own existential conditions." See his *Ethnic Ethics: The Restructuring of Moral Theory* (Albany: SUNY Press, 1990), p. 137.

6. PW, "Men and Over-Responsibility," <gen.maleness>, Mar. 31, 1991.

7. Warren Farrell, *The Myth of Male Power: Why Men Are the Disposable Sex* (New York: Simon and Schuster, 1993).

8. The flyer was part of a larger installation by Rothenburg called *Men (West Coast)*, 1993. Excerpts from the work are reproduced in Marcia Tucker, ed., *Bad Girls* (Cambridge, Mass., MIT Press, 1994), p. 80.

9. Abigail Solomon-Godeau, "Male Trouble," see pp. 69–76 in this volume.

10. Andrew Ross, "The Great White Dude," pp. 167–175 in this volume.

11. RH, quotes from Ed Schilling, "It's Time to Pull Together," <gen.maleness>, Feb. 8, 1992.

12. JS, <gen.maleness>, Feb. 3, 1992.

13. Ehrenreich, "The Decline of Patriarchy," pp. 284–290 in this volume.

14. TG, <gen.maleness>, Mar. 30, 1992.

15. TG, <gen.maleness>, Jan. 22, 1992.

16. Ibid.

17. TG, <gen,maleness>, Jan. 8, 1992.

18. Ibid. See also SY, <gen.maleness>, Oct. 16, 1991.

19. JS, <gen.maleness>, Feb. 12, 1992.

20. EL, <gen.maleness>, Feb. 14, 1992.

21. DP, "Response to Susan Faludi," <gen.maleness>, Jan. 8, 1994.

22. EL, <gen.maleness>, Mar. 1, 1992.

23. MH, <gen.maleness>, Nov. 8, 1991.

24. TG, <gen.maleness>, Oct. 19, 1991.

25. Katerina Clark and Michael Holquist, *Mikhail Bakhtin* (Cambridge, MA: Harvard University Press, 1984), p. 77.

26. Michel Foucault, *The Use of Pleasure* (New York: Vintage, 1985), p. 10.

27. See Ernesto Laclau and Chantal Mouffe, *Hegemony and Socialist Strategy: Towards a Radical Democratic Politics* (London: Verso, 1985).

28. See my *We Are (Not) the World: Representation and Identity Politics in a Global Context* (Durham: Duke University Press, forthcoming).

29. Foucault, *The Use of Pleasure*, pp. 26–28.

30. EL, <gen.maleness>, Feb. 14, 1992.

31. GO, <gen.maleness>, Oct. 24, 1991.

32. JS, <gen.maleness>, Feb. 3, 1992.

33. BR, <gen.maleness>, Feb. 4, 1992.

34. Foucault, *The Use of Pleasure*, p. 75.

35. EL stated that the terms "power-over," "power-under," and "power-within" come from Nietzsche, <gen.maleness>, Feb. 8, 1992.

36. EC, <gen.maleness>, Mar. 31, 1991.

37. See Butler, *Gender Trouble: Feminism and the Subversion of Identity* (New York: Routledge: 1990), and *Bodies that Matter* (New York: Routledge, 1993). Butler advocates a "politics" of gender trouble, which can be extrapolated to a politics of cultural trouble. Thus, according to her, identity incoherence is more effective than an identity politics that achieves a stable platform for action on the basis of "constitutive exclusions." Her critique is directed not only at dominant or hegemonic identity factors such as heterosexuality, whiteness, masculinity, middle-classness, etc., but also at those identity stabilizations achieved on the part of "subaltern" or "subordinated" groups by their own forms of "constitutive exclusion" (e.g., a black masculinity bought at the cost of demonizing gayness, or a white feminist politics devised in absence of the recognition of the difference of women of color). Consequently, if one could live on the margins, so to speak, resisting the compulsion to engage in "constitutive exclusion," then one would be most effective in eroding the regulatory norms that are set up in both hegemonic and subaltern/subordinate society.

But what would such a politics be like? Would the activists of such a politics of "cultural trouble" go through life constantly flouting identity roles by not accepting any one of them or by successively changing them, a kind of constantly mutating drag?

What I am getting at is that a way has to be devised to transfer to the politically effective stage the desideratum of liberating identities from regulatory norms. To collapse the political and the performative in this way may in fact be counterproductive. Consider carnival, which is exactly such a limited form of transformism. In carnival, power is inverted by each estate going out in a drag that symbolized the status of the other. Sometimes, this mechanism causes riots and insurrections, but never revolutions that bring in a more egalitarian order. Instead, carnival drag functions as a safety valve for social frustrations endured throughout most of the life of the subaltern.

38. DM, <gen.maleness>, Apr. 10, 1993.

BARBARA EHRENREICH

THE DECLINE OF PATRIARCHY

I want to talk about the decline of patriarchy, and, I should explain
right away, I do not mean the decline of sexism, or misogyny, or even male
domination. I mean patriarchy in the original sense of the word, as the intimate
power of men over women, a power which is historically exercised within the
family by the male as breadwinner, property owner, or armed defender of
women and children. This is the traditional meaning of patriarchy: the rule of
the father, including the rule of older men over younger men and of fathers
over daughters, as well as husbands over wives. For more and more people
in the world, this particular kind of relationship is over—a memory, a thing of the

past. My focus will be on American culture, in which the decline of patriarchy has been particularly pronounced.

I want to start with some illustrations of what I mean by "the decline of patri-archy." One, obviously, is the very rapid rise in the number of families "headed" by women (the language here is itself borrowed from patriarchy). This is most pronounced among African Americans, but also among European Americans and, in general, among poor people around the world. About one quarter of the households in this country are now "female headed," and more than 50 percent of African-American households. At the same time, there has been a very rapid drop in the number of "traditional" families composed of a male breadwinner plus a woman who is a full-time homemaker. That is the sort of marriage/relationship that institutionalized and nurtured patriarchy, and it is getting harder to find. The rise of female-headed households partly represents choices exercised by women, but it also reflects changing attitudes on the part of men.

There are polls, for example, that show a declining interest on the part of men in supporting women as wives and full-time homemakers. One thing I always do when I speak to college audiences—it is not very scientific, I admit—is to ask how many women would like some time to stay home and be supported by men when their children are really small. Usually, you get one or two sheepish hands going up. Then, I ask how many *men* would be willing to marry somebody in that situation and support them. If you get even one guy to raise his hand, it is very unusual—everybody runs to get his phone number. Another sign of declining male interest in their traditional role is the rising age of first marriages, which is especially striking on the part of men.

There is also evidence, I think, of a declining interest in children on the part of men. Historically, men in patriarchical culture were supposed to be insistent on claiming those children that were genetically "theirs," to "claim their seed," and so on. Now, of course, we have something like 50 percent of divorced fathers defaulting on their child-support payments. We have the phenomenon of paternity suits, through which women try to get unwilling males to take some responsibility for their offspring. Another possible indication of declining male interest in children is the relatively high support for abortion rights among men—in some polls from the 1980s, male support for abortion rights actually exceeded that of women.

Another indication of a decline in patriarchal attitudes is the diminishing sense in our culture that women need "protection". Polls show more male than female approval for drafting women into the military, should the draft be rein-stated. Some of you may remember that when Phyllis Schlafley was

campaigning against the Equal Rights Amendment in the 1970s, the worst image she could conjure up was not the unisex toilets—though that was pretty scary, at least to those who had never been in an airplane—but the specter of women in combat. And this argument significantly undermined pro-ERA sentiments. Now, the last time I saw a poll on this, in 1993, 64 percent of Americans approved of women in combat. The Gulf War was the most "feminist war" in American history; that is, women served and were proudly claimed as warriors along with men. It was always our brave "fighting men and women" and there was almost no fuss over the deaths of more than a dozen women in combat-related situations, nor over their captivity as prisoners of war. After all that opposition from the antifeminist right in the 1970s, the issue died. When a woman was killed in a recent friendly-fire incident in Iraq, no special comment was made about it.

Finally, even the character of some of the antifeminist backlash today bespeaks the decline of patriarchy. Now, let me make a distinction here. Some of the antifeminist backlash comes from religious fundamentalists who are offering to *restore* patriarchy. That, in fact, is the basis of their perverse appeal to women. They say, in effect, "You know, girls, it's going to be all right, men are going to take care of you again when we take over." On what economic grounds this will be arranged, they have not yet explained. But the promise is still appealing to many women who are financially-dependent homemakers. But a lot of the backlash today is very different: I am thinking of Rush Limbaugh, Howard Stern, and some of the men whom George Yúdice has studied on the Internet. They are not saying they want to be patriarchs again, they are saying, "Hey, we are oppressed by you women." In the case of Howard Stern, we are not getting a plea to return home and be taken care of; we are getting a whine, or perhaps an even more disgusting sort of sound.

All this leads me to ask, why these changes? Why is this happening? Why is this happening in recent United States culture? Perhaps one reason is that very old theme of white American culture—male flight from women. It was Leslie Fiedler, the literary critic, who first commented on this theme in the early 1960s, saying that the classics of American literature bespeak a flight from "mature heterosexuality" on the part of men. And, by this, he meant the flight from women. In American literature, men do anything—chase white whales, float down the Mississippi on rafts—anything to get away from women. In so much of our culture—in fact, even within my own, working-class, Western, extended family—masculinity has meant freedom, motion, and adventure, while women stood for entrapment, stasis, and "civilization."

Isaac Julien, still from *The Attendant*, 1993.

A second possible reason for the decline of patriarchy is that men no longer depend on women for physical survival. One hundred years ago it was very hard for a man to live without a woman, because laundry, for instance, took all day, and food preparation and shopping took a tremendous amount of work. I think, too, that among technological innovations that deserve greater scholarly investigation are the invention of the drip-dry shirt and the TV dinner in the 1950s, after the invention of which, any fool could make his own dinner and get to work in the morning, in some fashion anyway.

Another factor contributing to the decline of patriarchy is the embrace of males by the American consumer culture. Thirty or forty years ago, male interest in consumption and shopping, in textures, tastes, flavors, and so on, was considered effete and suspicious. That paradigmatic sixties cultural icon James Bond played a central role in legitimizing consumption as a "masculine" activity. James Bond knew about wines, he could order a fine meal, he was a sharp dresser, all of which helped make male consumerism more masculine and mainstream. *Playboy* magazine also played a role in this, and one reason it had to be so aggressively heterosexual was to make men feel it was alright to shop for themselves, to indulge themselves as individuals. The ads in the early *Playboy* were not selling station wagons, washers and dryers, or other boring family items, they were selling things like sports cars, what used to be called "hi-fi systems," liquor, and so on. Today, of course, we have a huge

BARBARA EHRENREICH

area of marketing targeted at men, hopefully upscale men, but actually they will take anybody. Single men have more discretionary income than women do, and in settings like *GQ* magazine, it is accepted that males are a market for anything from furniture to cosmetics to gourmet food items.

One result of this new male consumerism is that men no longer need women to express their status. If you want to express your status in the world, you do not need a woman to furnish a house for you, or to otherwise establish that you are affluent and discriminating in your tastes. In fact, having an economically dependent woman would be a great drag on one's status. (I was just talking to a woman recently who told me her problem in meeting men is that she has a fine-arts degree and, unfortunately, men are only interested in meeting brokers and lawyers.)

But the most central, most decisive factor in the decline of patriarchy has been the decline of male wages. In fact, one of the reasons for the fact that women have been catching up in earnings is not that women have done so much better, but that male wages have dropped. Patriarchal power based on breadwinning is now an option only for very wealthy men, and this is a striking change. Men of color have long been paid too little to support a family, but this is no longer a "minority" problem. Young white males saw their wages decline by 20 percent in real terms in the twenty years from 1971 to 1991.

It should be clear from what I have said that the end of patriarchy is not the same as women's liberation—far from it. The end of patriarchy is no more women's liberation than the end of feudalism spelled liberation for the long-suffering peasantry of Europe, it just means new forms of exploitation and degradation. Patriarchy, like feudalism, implies a relationship of mutual obligation. It may be hypocritical, this sense of mutual obligation, but in patriarchy it meant protectiveness on the part of men. And that element of protection and being cared for—which can be seen as either comforting or infantilizing—is now gone. At least, I would say, the word "patriarchy," with its implications of intimate domination and protection, no longer describes the situation of growing numbers of women in the world. I am thinking of an African-American woman on the assembly line plucking poultry for Tyson's in Arkansas at the minimum wage, or a Malaysian woman who has been uprooted from her village to work for a U.S.-owned multinational corporation in an export-processing zone, or any female member of the world's growing "surplus population" (and I mean "surplus" from the point of view of capitalism) such as welfare recipients in the U.S. or the shanty dwellers of Bombay or Rio. Such women face male domination, they fear men, but that domination in a different form, and "patriarchy" does not

Jim, if you choose to accept, the mission is to land on your own two feet.

Carrie Mae Weems, *Jim, If You Choose To Accept, The Mission Is to Land on Your Own Two Feet*, 1990.

describe it at all. Domination, for them, takes a form which is impersonal, corporate, and bureaucratic. In fact, within the multinational corporation, your boss may even be female. The other form male domination takes is that of random (at least ostensibly random), individual, male violence. "Patriarchy" simply does not describe the situation of today's single women, or married working women, working in corporate workplaces and living in dangerous cities. Even if we modify the word, and call it "capitalist patriarchy" or "racist patriarchy," the word itself is anachronistic, and of little help in understanding the situation of more and more women in the world.

Now, one consequence in the United States has been what we could call the "masculinization of women." Maybe in the future we are going to have to have two books on masculinity—one about women's, the other about men's— because we no longer have even the hypocritical pretense of male protection. It is not possible, in fact it is quite dangerous, to go about the world being femme. You cannot do that anymore. It might be fun, it might be playful, but it is also dangerous. It is an option that we feel we have less and less. Many women are arming themselves, perhaps especially in the suburbs. I do not have statistics on this, but at target-practice ranges on the weekends, as many as a third of participants are women. There is even a magazine just for women gun owners, called *Women and Guns*. It has good information on how to accessorize your weapon, you know, now to tuck it into a boot or a formal

BARBARA EHRENREICH

gown. We have growing support among women for female violence against abusive men. The groundswell of support for Lorena Bobbitt, coming not from feminist intellectuals, but mainly from working-class women, "ordinary women," would be an example. And, then, of course, there is what the editors of this book might call the "realm of representation," which I call the movies. We get to see—and, in fact, we must want to see—more and more representations of tough women, killer women, bitchy women, from *Thelma and Louise* to *Basic Instinct* to *Serial Mom* and *Bad Girls.* Interestingly, the post-Armageddon world of grade-B science-fiction movies is a world of unisex violence. It is the world of *Mad Max,* in which the women are just as tough and trigger-happy as the guys.

But who can feel nostalgic for patriarchy. Its decline creates an opportunity for men and women to begin to meet as equals without the pretenses involved in gender roles, and to get together against our common sources of oppression—perhaps especially the market forces, which, more directly than ever, impinge on the lives of men and women throughout the world, and which have done so much to destroy the so-called traditional family and patriarchy itself. We are no longer bound to each other by economic necessity. Men can live economically without women. Women can get by without men (though not so easily, considering women's lower wages). Nor are we bound by that same necessity to reproduce that motivated men and women in somewhat more pronatalist times. Potentially, we can be brothers and sisters, comrades and lovers.

But the other potential future created by the decline of patriarchy is not so promising; it involves a further descent into the barbarism of male violence. As men continue to turn away from being protectors of women and become increasingly *predators* of women, women will continue to "masculinize" themselves, if only for purposes of self-defense. So either we can come together against the forces that are grinding both sexes down, or else the "battle of the sexes" may stop being a metaphor and become an armed struggle.

RICHARD FUNG

BURDENS OF REPRESENTATION, BURDENS OF RESPONSIBILITY

In many ways "identity politics" is for the left what "political correctness" is to the right: a shorthand dismissal. As a critique, its usefulness is in its malleability, deployed as it is against a wide range of political and intellectual positions. And, like the charge of "political correctness," it releases the attacker from any sustained engagement with the specifics of what is being repudiated. Whenever I come across the accusation of identity politics, I imagine, perhaps with a little paranoia, that it refers to me. For while I struggle against a view of race and sexuality as given, stable, essential quantities, as the sole determining factors in experience, or as the only fundamental

contradictions in society, my political engagement and my work are not only organized around the deconstruction of socially-produced identities; they are simultaneously and explicitly grounded in my particular contradictory experience as gay, Chinese, Trinidadian, Canadian, a video maker, middle-class, and so on. I do not believe I can shed my social location for a transcendent, universal perspective.

Simply put, I believe that some instances of organizing around identity are valid, others not. Sometimes there are practical reasons for exclusions: discussions of the *experience* of racism shift dramatically, depending on who is in the room; it therefore makes sense to have Asian-only or black-only spaces, even if one's strategy is to build up a larger, non-race-specific organization. In other instances, race segregation is simply a rote response with little justification or reason. Deciding between the two is a matter of engagement with particular circumstances. When "identity politics" is alleged, however, one is left with little more than a righteous sense of disapproval.

In the prospectus prepared by the editors of this book, the authors were asked to imagine the goals of a critical men's movement, and to explore "the role of male political responsibility" at "a time when religious fundamentalism, right-wing extremism, and divisive identity politics are polarizing the nation." I have two basic questions here: first, is there an identity as men that cuts across race, class, and sexuality, and that could be hailed by such a project of a men's movement? Second, does men's identity, whatever that may be, constitute a valid basis of organizing?

At the heart of the editors' statement lies a desire for social and political reconciliation. Nevertheless, my identity gets in the way of my identification with its premise. For one thing, as a Canadian I live in a country where the nation is always viewed as fragmentary, and where Canadian nationalism has always been defensive and reactive. Can you imagine a House Committee on Un-Canadian Activities? More significantly, however, it is important to me that both gay men and Chinese men have been defined as outside dominant constructions of masculinity—let us call it "Masculinity"—precisely on the basis of responsibility.

Whereas gay men are penalized for the actual transgression of same-sex activity, homophobia is managed through a much broader regulation of difference. There are many ways in which gay men confound notions of Masculinity that bind maleness to particular roles and behaviors—responsibility is one of them. As Barbara Ehrenreich has written, homosexuality is seen as "the ultimate escapism from the male role of breadwinner."[1] Certainly, the image of the

(white) middle-class gay man, unfettered by dependents but earning an income that is geared to supporting a family, is a central axiom in the homophobic construction of queers as a privileged minority undeserving of human rights protection.

In the age of AIDS, this trope has been supplemented by a another frame of gay male irresponsibility, that of a self-destructive and uncontrollable appetite for sex. Now widely promoted among liberal audiences by books such as *And the Band Played On* (also a made-for-TV movie), the notion of gay promiscuity as the cause of the AIDS epidemic is both conservative politically and hazardous pedagogically.[2] In the vilification of the baths, washrooms, and parks, the focus shifts dangerously from the kind of sex one engages in—unsafe or safer sex—to a moral agenda around the site of sexual activity, the number of partners one has, and the HIV status of those partners. (In fact, the baths may constitute a safer environment for sex, since they are consciously chosen for sexual activity. Most gay bathhouses in Canada feature safer-sex brochures and posters, free or easily available condoms, and even AIDS education counseling and HIV testing.)

Freedom from heterosexual responsibilities was also a principal charge against Chinese men living on this continent until the late 1940s. Early Chinese immigrants to North America, seeking employment first as miners and then as railroad builders, were mainly single men. For instance, of the 1,767 Chinese

living in Victoria, British Columbia, at the time of the 1884 Royal Commission on Chinese Immigration, only 106 were women: forty-one were listed as "married women," thirty-one were "girls," and thirty-four were "prostitutes."[3] The commission, called to address, among other issues, "the social and moral objections taken to the influx of the Chinese people into Canada,"[4] resulted in the imposition of a head tax on Chinese immigrants. Incoming Chinese were at first charged ten dollars, but by 1904 the sum had risen to five hundred dollars, an exorbitant amount at the time.[5] Nevertheless, the tax was seen as still not enough of a deterrent, and in 1923 the government passed what is commonly known as the Chinese Exclusion Act, which effectively cut off any chance of family reunification for Chinese workers living in Canada.[6] Until the Exclusion Act was lifted after World War II, therefore, Chinese communities were commonly referred to as constituting "bachelor societies."

The term "bachelor" is, of course, a misnomer, since many of the men were in fact married, but were separated from their wives and families by the threat of racial violence and by the state apparatus—not altogether separate elements. Herein lies the special significance of the term when applied to Chinese Canadians, summoning as it does the poignant image of connubial denial, a profound deprivation in a Chinese cultural context, in which generational continuity is seen as essential to spiritual survival.

Nevertheless, in a society that privileges heterosexual marriage as the right of passage into manhood, the term "bachelor" is burdened with a multitude of connotations. Most significant to me is its anxious suppression of the possibility of sexual relations between men—while the word "bachelor" has often been used as a euphemism for homosexual men, the designation generally turns on a presumption of heterosexuality. Second, while the label can be seen to infantilize the Chinese into nonmen, it simultaneously endows them with the sexual threat (prostitution, predatory sexuality, and so on) of men devoid of socially-sanctioned sexual release. Both connotations were used against the Chinese.

Whereas cheap Chinese labor was promoted by capitalist interests in the nineteenth century, Chinese workers were seen as an obstacle to the advancement of the white working class, and of white people in general. In such a hostile environment, it is not surprising that most Chinese men chose not to send for their wives, even in the early days when it was still possible. But because of their failure to fulfill the responsibilities of heterosexuality, the Chinese were blamed yet again. In testimony to the Royal Commission in 1885, for example, a Senator Jones of Nevada paraphrased the thoughts of one of

his constituents, a white miner:

> While my work is arduous I go to it with a light heart and perform it cheerfully, because it enables me to support my wife and my children. I am in hopes to bring up my daughters to be good wives and faithful mothers, and to offer my sons better opportunities in life than I had myself. . . . How is it with the Chinaman? The Chinaman can do as much work underground as I can. He has no wife and family. He performs none of these duties. Forty or fifty of his kind can live in a house no larger than mine. He craves no variety of food. He has inherited no taste for comfort or for social enjoyment. Conditions that satisfy him and make him contented would make my life not worth living.[7]

The sexual aspect of this danger saw Chinese men as posing a special threat to white womankind. This fear, whether genuine or simply a ploy to attack Chinese businesses, became more immediate after the completion of the railroads as male Chinese workers, barred from other labor, took on traditional women's occupations—in laundries, domestic service, and as cooks—thereby putting themselves in direct competition and direct contact with white women. In the early twentieth century, several Canadian provinces enacted laws preventing white women from working in Chinese businesses.[8]

Even today, when Chinese communities are no longer "bachelor societies" and Chinese men are no longer assumed to be bachelors, the figure of the

Chinese man in contemporary North American mass culture still oscillates for the most part between an asexual wimpiness and a degenerate, sexual depravity, reflecting and reproducing this unstable Masculinity. It is notable that, in the current, highly-promoted wave of feature films by Asian and Asian-diaspora directors, there are as many movies with homosexual themes as those featuring heterosexual relationships.

It is only recently that Chinese men have begun to function as regular sexual beings on screen, mostly in films by white directors, like *The Lover* (1991), *Dragon* (1993), and *Ballad of Little Jo* (1993). In films by Asian-diaspora directors, Asian male characters are seldom inscribed within the codes of Hollywood masculinity. Refusing the pressure to deliver role models, these directors often opt instead for a critique of patriarchal values, creating in the process male characters that are damaged and/or damaging to those around them; this is true of *Living on Tokyo Time* (1987), *Bhaji on the Beach* (1993), and most of Wayne Wang's films. For, while stereotypes undoubtedly affect the ways that we Asian men live our lives, the feminization of Chinese men in public representations should not be taken to mean that, as a group, we are any less prone to sexist attitudes and behavior. In fact, as an organizer with gay Asian men, I have observed that, in many Chinese families centered around Confucian values, however loose the interpretation, men are often able to carry on gay lives precisely because of the relative mobility allowed them compared to their sisters, a freedom that coexists with the oppressive obligation to produce sons.[9]

Specific histories burden the term "responsibility" for gay men and Chinese men. As a rallying cry for a new and critical approach to masculinity, therefore, its appeal is limited. But men's movements, whether in support of, hostile, or indifferent to feminism, have generally been founded on precepts that come from the experiences of middle-class, straight, white men. For example, a men's movement based either on a response to violence against women or on the supposed victimization of men (because the binary gender division does not allow them to touch, feel, and express their emotions), do not speak to the lives of most gay men. Although gay men are not immune to misogyny, and some gay men are married or in heterosexual relationships, our sexuality generally puts us outside the direct mobilization of men as the perpetrators of male (hetero)sexual violence in rape and spousal abuse. Similarly, while straight men may want to learn to touch other men (and still remain straight), it is homophobia that makes same-sex contact taboo—gay men are already penalized for touching.

Southern man with daughters and their nanny, 1848. Photograph by Thomas M. Easterly.

When I think of movement and men I think of troops. In some ways this is merely a glib dismissal. But it nevertheless points to a basic contradiction in the concept of a men's movement. For when one thinks of troops, there is the image of a monolithic and coordinated exercise of brute force, in many ways the ultimate statement of male power. On deeper examination, however, there are also internal axes of power and violence. In many real ways, then, men in troops (and there are women, too) are moving to and from very different places in their lives. The rank-and-file is filled with the urban and rural poor, the nonwhite, the undereducated—men with little to sell but their lives. The career officers display very different demographics.

Not only are men's experiences of gender different one from another, but they are different from those of women—and in a patriarchal world they are never on an equal footing. So even when a men's movement is not about learning to touch, feel, or cry without being unmasculine, even when men organize only to support women's demands, they are confronted with—and confounded by—their own power. To organize as men is to organize from a position of power. The problem of a men's movement is therefore related to, though not the same as, organizing as white, as middle class, or as heterosexual. In seeking to confront privilege (and not all versions of men's movement would admit to male privilege), men are forced to replay it.

While the notion of a movement founded on men's demands is difficult to

RICHARD FUNG

justify, all attempts to bring men together should not automatically be dismissed. Specific projects such as the Canadian White Ribbon Campaign, whose goal is to organize men to halt male violence, offers an interesting experiment. Although suffering from all the problems of expanding a constituency to working-class men and men of color, as well as the dilemma of finding themselves in competition with women's organizations for resources, this project has managed to raise the awareness of violence against women through a large, successful, public campaign.

I have closed this paper by mentioning a specific project, however briefly, because it seems to me that discussion of men's movements and men's organizing is not simply a theoretical issue. While intellectual analysis and assessment are always crucial, I find that questions of movements are best addressed in particular sites and in relation to the actual process of organizing.

NOTES

1. Barbara Ehrenreich, *Hearts of Men: American Dreams and The Flight From Commitment* (New York: Anchor/Doubleday, 1983), p. 24.

2. Randy Shilts, *And the Band Played On* (New York: St. Martin's Press, 1987).

3. *Report of the Royal Commission on Chinese Immigration: Report and Evidence* (1885; reprint edition, New York: Arno Press, 1978), p. 363. Although many Chinese women were assumed to be prostitutes, the actual number of sex workers is debatable.

4. Ibid., p. v.

5. Anthony B. Chan, *Gold Mountain: The Chinese in The New World* (Vancouver: New Star Books, 1983), p. 11.

6. The act restricted entry of people of Chinese descent to merchants, diplomats, students, and children born in Canada. Peter S. Li, *The Chinese in Canada* (Toronto: Oxford University Press, 1988), p. 30.

7. *Report of the Royal Commission*, p. xv.

8. Li, *The Chinese in Canada*, p. 28.

9. The key word on Confucianism is "loose." As Peter Li points out, even in nineteenth-century China "there is a profound difference between the ideals of traditional familism, as incorporated in the ethical precepts of neo-Confucianism, and the form of the Chinese family as an empirical reality" (Li, *The Chinese in Canada*, p. 57).

MICHELE WALLACE

MASCULINITY IN BLACK POPULAR CULTURE:

COULD IT BE THAT POLITICAL CORRECTNESS
IS THE PROBLEM?

In the recent battles of the culture wars, the mantra of "political
correctness" has had a chilling effect on multiculturalism and the prospect of
progressive change of all sorts. As such, taking political correctness seriously
as a form of critique was never anything I expected to do. In an article which
analyzes the various mixed messages of the term, cultural critic Bob Stam asks:
"Do we mean it in the original loftiest sense of a self-mocking apology for a polit-
ically indefensible taste, or in the right-wing sense of a broad brush attack on
an incoherent array of ideological bogeymen?" (*Social Text* no. 36, p. 30)

About two years ago, my response was to say that neither perspective had much to do with me, and that it was a fight between powerful men. But, at the time, I also suggested that a limited form of political correctness, or, as I defined it then, "a set of spoken or unspoken rules" plagued discussions of black popular culture. Now I would like to expand that critique to add that "political correctness" may be precisely the issue when it comes to the general inability of the dominant culture to take black people seriously and to see them as human beings.

Moreover, demonstrations of "political correctness" as the only visible alternative to wholesale denigration in the portrayal of blacks have had a devastating effect on black intellectual morale, in direct proportion to the degree that the black audience has assimilated the consumerist standards and values unrelentingly promoted in the media.

Let's face it, the world is in a hell of a mess, and nobody really knows how to fix it. Now that's a fact. And I do not know a single leftist I respect who will not admit that in private, if not in public. I will not go into detail about precisely what the problem is but I am sure you are familiar with the various hot spots: the post-Cold War impossibility of socialism; the immorality of global, postindustrial capitalism; too much meaningless and infuriating labor, red tape and traffic; too much garbage, waste, and war; too much ethnic strife, starvation, and conspicuous consumption. Illiteracy and superstition, homelessness and disease are rampant throughout the world and seem increasingly incurable. Meanwhile, the rich just get richer, and so forth.

At the same time, I do not see much of a point in blaming our problems on masculinity, binaries of gender, the heterosexual imperative, or even racialism, which is not to say that the heterosexual imperative or racialism is good. It is just to ask: if it is the fault of the heterosexual imperative and/or racialism, exactly who am I supposed to target? I myself am said to be heterosexual, and I am definitely a racialist, but I never consented to a "heterosexual imperative." No one ever asked my permission about the race situation. I was born into it. We all were. The point is that it is not a simple matter to fix what is broken. The enemy is ourselves. We are all implicated, particularly those of us who have the wherewithal to debate the problems. Perhaps the multimillionaires are slightly more culpable than I, but then, knowing that does not fix anything either.

So we are going to hell in a handbasket, but the thing that scares me the most is that pleasure might leave the world. The current interest in popular culture among leftist academics, intellectuals, and artists is largely motivated, I suspect, by the perception that popular culture—regardless of whose culture

Gottfried Helnwein, *Lulu*, 1988.

it may actually be—still seems able to maintain, against the onslaught of prudish utilitarianism and negativity, an intentional and deliberate space for fun and games, and damn the cost.

But the trouble I continue to have with black popular culture, perhaps especially the most vocal and prominent practitioners of rap, is not just a matter of a politically incorrect snobbism towards "renegade" forms of low culture. Granted, I am not especially enamored of the aggressive and belligerent stance often assumed in rap. I am getting to be too old, in any case, to kowtow to each new variation and twist in black youth culture. As an admitted outsider to many of the most highly contested forms of black popular culture, it still seems to me that the crucial problem for black intellectual and cultural life is a problem we all share: the problem of celebrity. Within the dynamic of an increasingly technologized, computerized, and consumer-oriented dominant culture, the black body is frequently fetishized in disturbingly aggressive ways. This problem of how the procedures of celebrity are used to disenfranchise us all is not unknown in other communities and sectors of cultural production—among white rockers or high-priced actors in Hollywood films, for example. But it seems particularly unexamined and uncritiqued in African-American cultural and intellectual production.

The two categories of black intellectuals and cultural producers are increasingly confined to the limited binary of those who are rich, famous, and visible,

and those who are poor, obscure, and invisible. In fact, as the protagonist in Ralph Ellison's *Invisible Man* taught us, intellectual and/or cultural productivity among blacks requires that they seek out and explore complicated combinations of strategies of visibility and invisibility. As a consequence of my reading of Ellison and other black intellectuals, such as W.E.B. Du Bois, Richard Wright, Gwendolyn Brooks, Toni Cade Bambara, Ntozake Shange, and a host of others, I have come to see that the rich and famous treadmill is always a mixed blessing for any black person who is serious about his or her vocation, and whose vocation is other than self-promotion.

I deliberately will not call any names except those of the most famous who already circulate in the sphere of wholesale interpretation. The way both O.J. Simpson and Mike Tyson fell from grace as black men has everything to do with the binary appeal of fetishization. What appalls me is not that Simpson and Tyson are seen as monsters for their alleged crimes, but rather that they were idealized and worshipped to begin with. Only in the strangely parasitic black world spawned by the white dominant culture would a retired football star who was a sports commentator be a viable candidate for heroism.

As in any other community or culture, the best, brightest, and most productive people are rarely also the loudest, the crudest, the most duplicitous and hypocritical, the most calculating and aggressive, the most careerist, ambitious, shallow, and cutthroat. And yet, when it comes to the black world as projected through a white-dominated media, one quickly arrives at the impression that there are only two kinds of black people: the successful ones who do nothing but promote themselves, and the underclass ones who spend all their time robbing, stealing, doing drugs, and killing. We are all aware of this double image. What I am trying to point out is that they are flip sides of the same coin, and neither of them has anything to do with who black people— black men or black women—really are.

This is why, invariably, most black intellectuals and artists always pray for more powerful black influence in media, but even there the situation seems hopeless, because black media exist under the financial thumb of dominant media and dominant advertising. When I recently considered the array of black magazines available in Barnes & Noble—*Ebony, Jet, Essence, Emerge, Upscale, Vibe,* and about four or five hair magazines—I was discouraged. This is not to say *Essence, Emerge,* and *Vibe* do not cover their ground well. It is just that invariably what these magazines emphasize and foreground is the success of the subject in terms of fame, wealth, and conspicuous consumption—in the *Ebony* profile of Terry McMillan, it is the car she drives, the house she lives in.

Kerry James Marshall, *De Style*, 1993.

Just once I would like to see some focus on what thoughtful black people think about the issues: health, welfare, the economy, and so forth. Such commentary exists, but it is never highlighted. And thoughtful black people rarely become celebrities quoted in the *Times* on every topic from soup to nuts. But these thoughtful black people are so unexpected, their ability to earn a living is often seriously impeded. They are considered anachronistic in a black world in which coverage in the daily newspapers, the TV newsmagazines, and *Vanity Fair* broadcasts either our fame and celebrity or our abject monstrosity.

In the various arenas of cultural and intellectual work, it is a dangerous thing indeed at this juncture of racial politics to equate ability and talent with the desire to be as rich and famous as possible. Because black intellectuals and cultural producers have so little control over the designation of their heroes and "role models," invariably our representatives are chosen not on the basis of their intelligence or depth but rather on the basis of how much controversy they can stir up: the Clarence Thomases, the Farrakhans, the Jeffrieses, the Al Sharptons.

When you look at so-called black leadership as reflected by the mainstream media, what you see is a motley crew of the narcissistic, the vaguely ridiculous, and the inept. There is no actual lack of intellectuals, artists, and cultural workers in a wide array of fields. Rather, such people have always been there (although their number are shrinking), continuing their work and

MICHELE WALLACE

making themselves useful in relationship to the *real* issues. I am well aware of poststructuralist skepticism when I refer to the "real," but I just don't buy it. There is a whole lot going on in the world, and in order to engage with that world, it is necessary to bracket issues of representation.

Lately, I have been going quite often to use the research facilities at the Schomburg Center in Harlem on the corner of 135th Street and Lenox Avenue. The facility takes up an entire block. It is beautiful, calm, tranquil—an impeccably organized wealth of information, both in terms of staff and collections, which entirely contradicts the world of dominant black representations. Even the founder of the place, Arthur Schomburg, a black Puerto Rican—where does he fit among dominant racial stereotypes of black men? How many rappers mention him, or Carter G. Woodson, or W.E.B. Du Bois in their rhyme schemes?

Outside on 135th Street is the vision of hell unfolding. On one corner is Harlem Hospital, where a corpse was found in the laundry chute a few years ago. On another corner are the shabby stores and greasy spoons of the ghetto. On another corner, a schoolyard. And on the fourth corner, the Schomburg, elegant and pristine, an oasis in the desert.

Inside, I am surrounded by the helpful assistance of an almost entirely black staff—from security guards to librarians and administrators. Not one person shouts "Black Power!" In fact, no one raises their voice at all, and yet everybody looks almost proud.

The kind of people, male and female, whom I am trying to identify have a common attribute. Extremely thoughtful and sensitive people have a tendency to find celebrity somewhat problematic. They may even deliberately avoid it. If, however, you are black and avoid celebrity, you will certainly be invisible. You might end up homeless as well.

In what other field of American life and culture are people not generally suspicious of celebrity, bright lights, and fame? I do not know a single serious field in the arts, in sports, in academia, in the hard sciences, the social sciences, or the humanities, in which celebrity or wide audience appeal is considered more important than depth and substance. But in African-American life and culture, it sometimes seems, at least if you just read the newspapers and magazines and watch TV, as though fame is everything, and that anybody who is not constantly in the media could not possibly be doing anything important. Whereas I am inclined to assume precisely the opposite: I deliberately look for the person who does not spend his or her every waking hour trying to promote him- or herself and books. This is not to say that it is not nice to have famous black academics, writers, authors, artists, and

Deborah Willis, *T.W. Tie Quilt*, 1992.

athletes. It is both wonderful and necessary. I just think their value should be keyed to their substance.

For instance, Michael Jordan is famous for playing basketball perhaps better than anyone ever has on the planet, but the fact that he plays basketball so well does not make him a better human being than others in any way. In fact, it is likely that his personality is limited in some other way to compensate for his extraordinary abilities in this particular area. This is the way extraordinary abilities tend to work, which is precisely the reason that black artists and intellectuals should not be worshipped anymore than other kinds of people.

Worshipping them as heroes (O.J. Simpson) and saints (Martin Luther King, Jr.) seems to me the flip side of the way in which black men in conflict with the establishment are demonized. Black men on welfare, homeless, with AIDS, in jail, and so forth are seen as disproportionately villainous, just as famous blacks are seen as extraordinary freaks of nature. In both cases, blackness is fetishized. There is no middle ground. The idea that you could be good at something, in a quiet, self-confident way, becomes impossible to imagine, not only for the general American public but, more importantly, for young black people in general. They do not think it's possible because they rarely see it or hear about it.

Ultimately, the values that are held up to young black people by the dominant society are all wrong, and it is not simply a matter of masculine values.

MICHELE WALLACE

Masculinity is not an inherently meaningful designation. Such qualities as courage, heroism, militancy, aggression, competitiveness, coolness, grace, elegance in battle, rigidity, and sexual promiscuity are not qualities that only men have. They are qualities that are exalted in our society, and women who have them are just as likely to rise to the top as men, and perhaps just as likely to cause disaster in their personal relationships. The model of humanity such people employ is not real. It is a fantasy for men as well as women to think that you can be, in real life, a character in a movie.

Adults soon figure out that the price one must pay for recklessly flaunting such qualities may be death. The qualities that make it possible to grow old and to endure the frustration and pain that are inevitable in life, whether one is male or female, are patience, kindness, reflectiveness, gentleness, thoughtfulness, strength, determination, playfulness, warmth, friendliness, a sense of humor, and a dash of honesty. Reckless daring and adventure are the spice of life, not the meat.

Because of this, nothing maddens me more than the spectacle of Malcolm X's reification, fetishization, and commodification. Malcolm X died in the awful way he did because he discovered the lesson above too late to save his own life. He was not rich, but he was famous, and they killed him for it. In this sense, Malcolm X's life is a narrative much like the old, frightening, Grimm's fairy tales, in which characters were burned up or torn asunder. The lesson of Malcolm X's life is not that one should live as he lived, but rather to learn from the story of his death how to live.

S T A N L E Y A R O N O W I T Z

MY MASCULINITY

When, in the Spring of 1994, I was asked to contribute to this volume
on masculinity, my first reaction was to want to attack the idea of masculinity itself,
to show that it was one more essentialized identity defensively invented by men
to reassert their privileges, and adopted by some who felt left out of the sexual
and gender revolutions. I told my partner about my plan to take masculinity apart,
to expose its ideological core, and to conclude with a flourish by calling for the
elimination of the very word from the cultural discourse and the language of social
movements. Rather than offering the approbation I had expected, she asked
me not to rush to judgment. It was not that my premise was wrong, she calmly

suggested, but that my strategy of unblinking attack might itself be a self-deception, invented to put off coming to grips with my own masculinity.

I have long been taken with Freud's notion of polymorphous perversity, elaborated in his *Three Essays on Sexuality*. Thus, I believe that my heterosexuality is constructed by the complex of everyday life interactions and institutions, and that my own, as well as most, masculinist identity is *overdetermined* by the social and cultural codes into which one is interpellated. If there is blame to pass around, I can always finger my family (I was an only male child); the schools I attended (where I was treated by my elementary school teachers as a genius manqué, manqué because they considered me a disruptive child—no shame for a kid who was eternally bored with school and impatient with arbitrary discipline); and my peer relationships (in which we collectively and emblematically imbibed the rituals appropriate to preparation for manhood).

Despite a physical handicap—I had a mild case of spastic paraplegia that became an integral part of my identit(ies) from childhood to the present—I played the usual sports and, at the age of eight, as a rite of passage, formed a secret club with my friends in an abandoned neighborhood icehouse. There, we reveled in our exclusivity and, liberated from the gaze of parents and other adults, smoked cigarettes. Sometimes we stole candy and other small items from the neighborhood Woolworth's, and roamed the Bronx, hanging onto the rears of trolleycars and buses. In the winter, the united front of Jewish and Irish kids fought the Italians with rock-filled snowballs. All of these activities were boy things; girls were relegated to the role of spectators or, more often, they simply left us to our own, male devices.

Or, of course, I can also always blame my masculinity on the current culprit of choice, the media. For me, as for all my friends, popular entertainments occupied a special, even dominant place. I listened avidly to the usual boys' radio programs, particularly *The Lone Ranger* and *The Shadow,* each in its own way quintessentially masculinist in that peculiarly American style. The heroes were rootless loners, mystery men with no intrinsic connection to the community, yet functionally tied to it as a sort of deus ex machina. (The *Lone Ranger* episodes invariably ended with our hero and his faithful sidekick, Tonto, riding off into the sunset to the grateful utterance of a townsman: "Thanks, masked man.")

These characters enabled me to envision an "outside," a way to distance myself from the prison house of my tiny nuclear family, which was perpetually near ruin, though it never quite fell apart, primarily because of my father's undying commitment to keeping it intact (they stayed together for my sake, as my mother never ceased reminding me), and from the claustrophobic walls of

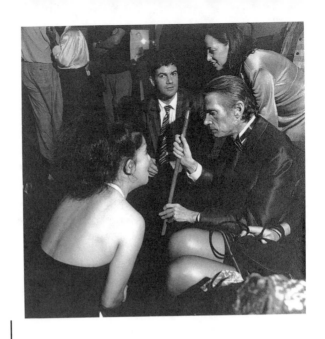

the schoolhouse, where my teachers issued alternating entreaties and admonitions that I behave myself, no matter how oppressive were the endless hours I and my friends were obliged to suffer in their classes. The movies were, in Hortense Powdermaker's famous phrase, a dream factory, but they also constituted a Pauline Kael-like refuge from everyday existence and a standpoint from which to evaluate the tawdriness of everyday life.

Behind my back, the movies helped consolidate my imagined outsider identity. When I found a real-life "outside" community—the postwar, radical, youth movement—it was not difficult to choose alienation. Notwithstanding its well-known elective affinity to political bankruptcy, the organized left offered, at least for a teenager, a rich intellectual environment and opportunities for social and cultural interaction not available on the streets—or in the schools. Moreover, like Clark Kent, I was able to live a double existence: son and student by day, outlaw revolutionary by night. In a period of political repression, the left provided a continuation of my secret club—only this time, with girls.

For my pretelevision generation, the Saturday afternoon movies were a powerful influence on our emergent self-images. The excitement was not so much the feature films—I hardly remember them. Rather, we waited impatiently throughout the school week for the serials. Topping the list was the big-screen version of *The Lone Ranger* but also important were *Buck Rogers*, an early science-fiction hero, and *The Three Stooges* (we, of course, identified

STANLEY ARONOWITZ

with the stooge who konked the others into conformity; we were never the victims, always the executioners).

Superman and *Batman,* the serials that glorified the most steroid-typical representations of manhood, occupied a special place in our pantheon. And, let us not forget the back pages of *Popular Science* magazine, which featured Charles Atlas, the ninety-eight-pound weakling who was transformed by exercise into the prototypical Greek god. We measured our physiques against these icons and, as pubescent males, could not avoid the feeling that we would never attain true masculine power. Even though the *specificity* of my formation violated many of the stereotypical features of an American boyhood of the postwar era—I was a bookworm, for example—I shared many of the conventional experiences of male children of my generation. From the age of seven until my early teens, I was the neighborhood sports statistician. Name the major leaguer, especially the members of the then-three New York baseball clubs, and I knew his batting average or E.R.A. for the current year, as well as other career statistics.

By the time I went to work full-time at the age of seventeen, I was acutely aware of the extent to which my male self had been culturally constructed, although this language was not available to me at that time. But I knew that my experiences were simply not shared by girls. Indeed, women remained a dark puzzle long after I married at the age of nineteen. Yet, in my twenties and thirties, I was already convinced that biology was not destiny, that, even if we cannot necessarily make the world as we please, we do make it. Thus, I did not consider myself naturally anything. My reproductive equipment was never decisive for determining my sexuality and, given a different formation, I believed I could have been a contender: a sensitive man—gay or straight—and with any luck, even androgynous. As it turned out, I remained throughout my life hopelessly hetero and, more to the point, relentlessly male.

My lifelong passions—reading history and philosophy, playing and listening to classical music, and doing other distinctly high-cultural things—did not shield me from a fairly conventional masculine formation. On the contrary, what I discovered is that the entire classical canon is not only dominated by men, it is an exclusive, all-male club. Until recently, women stood in reserve, waiting to be tapped, instrumentally, by a guilt-ridden or strategic establishment. Needless to say, the sexuality of gay composers such as Benjamin Britten, Michael Tippett, and Samuel Barber was discretely hidden from view, by themselves as well as by their mentors and managers, even as they were celebrated as representative national composers.

Similarly, until the late 1970s, many poets and writers concealed their homo-sexuality, while their colleagues paraded their heterosexuality. Frank O'Hara was recognized as a key figure in the "New York School" of poetry, but the fact that he was gay was not considered particularly significant for his art. I remember being surprised by an essay that Bruce Boone submitted to the premier issue of *Social Text* (Winter 1979), in which he showed the internal relevance of O'Hara's sexuality to his work. As recently as fifteen years ago, this was still a debatable point. And, although W.H. Auden never made a secret of his sexuality, his work was coded into the universalistic masculinity of the poetry pantheon.

Plainly, for a kid brought up in a working-class environment, any inclination toward such intellectual and artistic worlds is enough to earn him the designation "sissy-boy," or at least "weirdo." But I was able to forestall these "insults" with my physical clout and, therefore, I never really experienced a conflict between my artistic interests and masculine identification, though the "conflict" was obvious to many. Whenever the issue of my intellectual pursuits or my physical handicap was raised, I would answer my taunter with a bop to the face. Although I did not really enjoy fighting, I was big enough and aggressive enough to respond with my fists. In my neighborhood, if a boy was willing to fight, win or lose, he earned the respect of kids who could otherwise make his life miserable. I was regarded as a "real boy," and in my neighborhood my childhood was relatively tolerable.

For most of my life, I have been comfortable with my masculine skin, though not entirely happy about my own masculinism. Well before the advent of the so-called men's movement, I was, albeit inchoately, increasingly uncomfortable with my "macho" image, especially my reputation among members of the 1970s left as a "womanizer." I was disturbed by the strong reactions I sometimes received from women who were put off by my (unconsciously) masculinist self-presen-tation. Some years ago, after I had delivered a paper at the University of Pennsylvania, a female member of the faculty spoke of it as "masterful," a term she clearly meant as disdainful. Although I am sure my body language conveyed many features of the master's persona, she did not put it this way; rather, she directed her criticisms at my tendency toward universalizations, generalizations, and dogmatic certainties, and my consequent lack of spaces into which others, especially women, could insert themselves. So, aside from the dubious kines-thesis of my performance, my masculinism expressed itself in the complete performative principle, the consummate theatricality of the word.

I have always been down on the "men's movement," wondering when they would stop whining about the loss of male privilege concomitant with the rise of feminism. With secret pride, I felt superior. After all, throughout the years, with

several partners, I always shared the shopping, the cooking, and the chang-
ing of diapers. Now, I spend considerable time with our ten-year-old daughter
and, in our household, we have negotiated a fairly strict division of home labor.
Of course, as Arlie Hochchild and other students of the "egalitarian" family have
shown, even the most sincere efforts by men to share housework are never
quite successful. The historical legacy of sexism, combined with the enormous
pressures of the work world, still place most of the burden of child-rearing on
women and, with the exception of single-male-parent households (a rising phe-
nomenon), most men remain the parent of last resort. For the most part, it is still
too easy to use excuses to sluff off parental responsibility.

Still, I always felt that my credentials as an egalitarian parent were sound, if not
impeccable. In the mid-eighties, when I became a parent again, a bunch of my
friends became fathers for the first time in their forties. Some of them formed a
discussion group to address the new lives that had entered theirs. I hesitated to
join it. The person who invited me explained that the purpose of the group was
to prevent the potential burnout (let alone freak-out) attendant on the arrival of
a baby in a household inhabited by at least one feminist. I said I would try to
come, but I knew I would not. Later, a colleague at school began to get involved
in issues of masculinity, and wanted give a talk at the CUNY Graduate School,
where I was teaching. I said okay, but somehow neither he nor I followed up. In
retrospect, I think I resisted these overtures because I was uneasy about open-
ing up the whole question of masculinity, even if, at least in principle, I allowed
that it was important. Was I afraid of what I might find out about myself?

A few years ago, a prominent activist/intellectual wrote an essay for *Social
Text* in which, among other things, he complained that, with the emergence of
the "new" social movements, "white" men no longer had a place in the world
of social activism. I was disturbed by the argument; a part of me wanted to
deride the sentiment of displacement. Although I understood his feeling of
being stranded by movements which often arose precisely in opposition to
white straight men, my overriding feeling was that white men *should* suffer
some marginalization, lest the pattern of their virtual monopoly over politics be
reasserted. I was even more taken with another part of the author's complaint.
Although he did not say it directly, it seemed to me that he was asking whether
men should be held responsible for their masculinity.

The general question of political responsibility had been broached earlier in
the century by Hannah Arendt and Dwight Macdonald in eloquent essays con-
cerning the complicity of the German people in the Holocaust. Much of the
debate, prior to their interventions, had centered on the narrow question of

whether "ordinary" Germans knew of the crimes perpetrated by their leaders against Jews, gypsies, homosexuals, and the official enemy, the Communists. Macdonald's argument was that, in the absence of a genuinely democratic polity, the concentration of information in the hands of modern states precluded placing responsibility on ordinary people for the crimes of their leaders. While anti-Semitism was surely widespread in all layers of German society, and attitudes of racial superiority were rampant, Macdonald refused to condemn the German people. He specifically refuted the view of U.S. Secretary of the Treasury Henry Morgenthau, who called upon the allies to literally reduce Nazi swords to plowshares through relentless deindustrialization. Morgenthau summed up the attitude of many Americans: that Nazism was merely the latest expression of a German racial trait that condoned violence.

In her celebrated discussion of the trial of Nazi war criminal Adolf Eichmann, Arendt made a more intellectually persuasive argument by pointing out the utter banality of evil than by attempting to discern whether leaders and followers were to blame. In Arendt's account, Eichmann could not have exercised conscience without betraying his own sense of bureaucratic responsibility. Similarly, I would argue that only those imbued with a profoundly antihumanist sensibility can grasp the degree to which sexism as common sense is inscribed in male culture today. To pose the problem as a matter of ethics misses completely this dimension of the problem of responsibility.

STANLEY ARONOWITZ

This analogy is apposite to female essentialism (cultural feminism) which remains an important influence within the contemporary feminist movement. Its *tendency,* always more powerful than its organizational weight, pervades such disparate factions as the antipornographers, the female separatists, and even some feminist critics of science. Their discourses often accept the notion of an inherently aggressive, violent, and territorial male ego/unconscious which can been seen as the source of all sorts of evils in contemporary culture.

According to antiporn feminists Andrea Dworkin and Catharine MacKinnon, for example, masculinity and its cultural forms—pornography, sexual intercourse, let alone more subtle symbolic discourses such as science—are violence against women, a sin that can be restrained only by law and the police power that enforces it. For them, with few exceptions, reason lies outside the purview of gender relations. Men are inescapably aggressive, whether because of socialization or testosterone. Dworkin holds that all sexual intercourse is rape, and that sexuality, which men trumpet as a universal desire, is merely another symptom of male domination. As a result, all men are to be held responsible for the oppression of all women.

Given these charges, it is tempting to dismiss much current antimasculinist discourse as a consequence of the pernicious influence of cultural feminism. Yet many men and women, lacking alternative perspectives on pornography and sexuality, are attracted to this charismatic doctrine which ascribes all evil, from wars to rape, to unbridled, virulent masculinity. But the idea of holding men responsible for the mass destruction visited upon various peoples since written history is absurd. Nor should all men have to take responsibility for that horrific expression of male rage, rape. While men must accept the feminist argument that masculinism is intertwined with many of the social disasters of our epoch, this is quite different from affixing blame for these occasions to every exemplar of the gender. It is precisely this dubious identification that made possible the effort to enact legislation against pornography. Having conflated rape with representation, it is a short step to restricting freedom for men, even when no overt acts of violence are involved.

However, masculinism, or some moral equivalent, would exist without men. This apparently paradoxical statement requires some elucidation. Masculinism is an instance of the naturalization of hierarchy and domination. Its main feature is to merge putative biological difference with territorial privilege. The operative term here is *arche,* the Greek word for "origin" or "foundation." In this case, to be a "man" is taken as a synonym for a wide variety of social and cultural traits whose antinomies are the feminine characteristics which typify

"woman," particularly caring, nurturing, responsibility, and, for some, pacifism. These normative traits then become psychological as well as cultural boundaries, used to distinguish the normal from the pathological, in groups as well as in individuals. The question is: Is masculinism the same as masculinity?

Even if I can deconstruct masculinity as an ideology that constitutes the mirror image of cultural feminism, showing them as birds of a feather, and even if I realize the degree to which my own "self" has been interpellated by masculinist formation, is that enough? Can I absolve myself from further investigation into the question of masculinity? My tentative reply is "no"; approaching the discourse on a relatively safe intellectual plane, and acknowledging my own formation, biographically, can be only the first steps in such an inquiry.

There are two ubiquitous and prevailing versions of the social-constructionist thesis. The older one proceeds from Emile Durkheim's invocation to treat society as an irreducible social fact which means, as a matter of rule, that neither psychology nor biology may be taken as a "storey" beneath the social. In other words, biological and psychological *determinations* are strictly precluded from consideration of social phenomena. Durkheim and his numerous followers among anthropologists and sociologists may grant that humans are part of natural history, simply a more advanced species of life within nature. But, in order to avoid reductionism, we are constrained, in this view, to recognize the formation of the self as a purely social matter. Accordingly, the individual introjects the moral and cultural order through the complex network of interactions with family, school, peers, work, and, more recently, through representations—especially the cultural products purveyed by various media. In terms of the common sociological wisdom, whatever his biological and psychological makeup, "man" is socialized into the social order by a fairly stable cultural system of values and beliefs.

Even Marx, who acknowledged that the first premise of history is human "physical organization" which obliges us to produce and reproduce our means of life, and asserted that labor as the dialectical mediation between a mutually determined human and nature, quickly moved on to social relations to explain the course of human development. "We know of only one science," claimed Marx, "the science of history." The specificity of human physical organization may be understood as the *arche* of social development, that is, a complex "origin" which, once described, may be subsumed under the history of social relations, especially the development of technology, labor, and the forms of social rule that emerge from the dialectic of labor.

The second variant of the constructionist view is that the "social" is not a thing, but a series of entangled discourses which interpellate individuals and groups. In this grid, "society" is taken as nothing more than spatially differentiated discursive positions; there simply is no human essence, much less a masculine essence. Masculinity and femininity are taken as linguistically constructed identities that are relatively fragile, and subject to restructuration by the power context in which they are situated. The "self," then, is a signifier, the outcome of the power/knowledge nexus within a specific milieu. When asked what the role of biology is in the formation of the self and for explaining action, Michel Foucault assured his questioner that, even if there were a biological dimension, it could have no effectivity given the layers of discourse that covered it. To this point, Donna Haraway adds that biology, far from explaining human characteristics, is always deployed as a weapon of power.

The problem with these views is they elide what really needs to be explained. Is the "natural" nothing other than a discourse, a situated knowledge whose most fundamental determinations are constructed? Can we merely comprehend the biological and psychological as epiphenomena of language in use? It seems too easy to dismiss any reference to these dimensions as essentialist, or to displace altogether the biological to the linguistic as Lacan does. Nor is it necessary to approve the politically dubious uses of biology in, say, the work of Richard Herrnstein or Charles Murray or, for that matter, the tacit essentialism of Catharine MacKinnon; or to adopt "instinct" or sexually differentiated chemical composition as the irreducible basis for human behavior, as many have done.

The question of masculinity itself begs taxonomic definition. Ernst Mayr has justly warned against overemphasis on morphology as an explanatory tool for addressing what species do in specific ecosystems. Like other ecologically oriented biologists, such as Richard Levins, Richard Lewontin, and Stephen Jay Gould, Mayr stresses the significance of three closely related factors within the ecosystem: genetic structure; the diversity of species, including diversity *within* a given species within the ecosystem; and the larger milieu, especially climatic, geological, and botanical.

To begin our taxonomic investigation, then, we must differentiate masculinism from masculinity. As I have already indicated, masculinism may be defined in relation to the essentialist ideology of biological determination. Masculinism naturalizes difference. It imputes male superiority on the basis of physical strength and/or gender differentiation with respect to sexual reproduction, and posits gender-determined mental propensities (such as men's

allegedly superior skill in logic, as manifested in business, scientific, and technological acumen). On the basis of these psychological and physiological categories, male privilege is justified. Or, in a more subtle and efficacious variant of the same argument, male privilege is coded as a form of functional differentiation with no necessary hierarchical implication.

In her 1974 report on male sexuality, Shere Hite asked a cross section of male informants what it means to be a man. Most of the replies reflected the stereotypes of traditional male culture: men don't cry, they don't complain, they're strong, they take care of their families by working hard, and, being sexually potent, they reproduce children. A minority of the informants, undoubtedly influenced by feminism and social constructionism, held that these male traits were entirely learned, and that only the reproductive function was at all "natural." If one does not accept biology as a metaphysical concept, one must take the biological as one system among the complex of systems that constitute the ecosystem. Therefore, it is not enough to repeat the social constructionist formula. Instead, we may argue that gendered learning is not only situated in the physiological constitution of the male part of the species, but has effectivity within the ecosystem. Moreover, "male" behavior becomes historically sedimented and may be transmitted between generations. Thus, rather than regarding masculinity as a mere ideology, we can now understand it as constitutive of the sex/gender system, the economy, culture, and politics.

So, it is no longer possible to take masculinity solely as representation, even if it has been socially and historically constructed. It has been too thoroughly "naturalized" by a series of practices which produce real boundaries between men and women. An autonomous women's culture arises as a reaction against exclusionary characteristics of male culture and as an affirmative culture in which women find mutual aid. But, just as culture is not a mental phenomenon, but a series of material practices that plant deep roots in language, representations, and so forth, forming gendered communities is not a socially ephemeral act.

At the same time, what makes a purely biologically based or functional difference, such as sexual reproduction, the founding moment of hierarchy and oppression requires more careful investigation, some of which has been under way since the second wave of feminism. It is not news to expose the fact that what may have been a neutral functional difference, childbearing, became the signifier of male power. But unmasking, although necessary, is not sufficient to overcome the reality of masculinist privilege. Given the extent to which the "two cultures" have become embedded in language (gestural as well as linguistic),

STANLEY ARONOWITZ

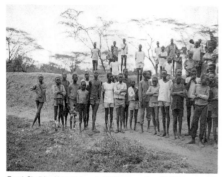
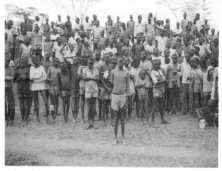

Fazal Sheikh, *Unaccompanied Minors*, section 2. At dawn on the morning of their move to a more permanent refugee community at

the body, and the habitus of our collective interactions, the distinction is not easily dislodged. Most people—of both sexes—still experience sexual difference as a thing of nature, as a biological fact. For them, it will take more than intellectual and political persuasion to overthrow masculinity.

The end of masculinity would begin with the utopian premise enunciated in Ursula Le Guin's *Left Hand of Darkness,* that sexual reproduction is both random and genderless. At least, we must imagine the neutralization of the reproductive function. Then, as has already begun to happen, women must cross over into a whole range of traditionally male domains, not merely powerful positions within the wage-labor system and other spheres of public life. And men must cross over into the anonymous worlds of housework and child-rearing, a space they have been reluctant to occupy. And for good reason: housework is real labor, is usually unpaid, and does not garner status or prestige.

Finally, we need a discourse on pleasure and pain. That is, the secret worlds of the two cultures must be revealed. This communication would foster shared experience and demystify male and female sexualities, though it would not necessarily abolish difference immediately. In other words, if male power were to be dismantled by various means (including in knowledge formations), we might get beneath the cultural posits of masculine/feminine to unmediated biological and psychological difference.

The problem with the plethora of attacks on masculinity is that they are not accompanied by an articulation of an imagined community in which difference is neutralized. Men are not offered the material equivalent, even in their imagination, of their current privileges. They are not shown the price of maintaining those privileges, even though most men are clearly aware, if only tacitly, of what they would have to give up if masculinity were to be eliminated.

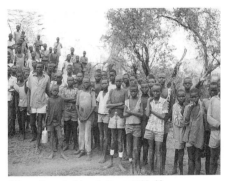

Kakuma, Kenya. Lokichoggio, Kenya, 1992–93.

What kind of discursive economy might be introduced? David Roediger, Alexander Saxton, and others have argued, for example, that the wages of whiteness depress the living standards of all workers, even if whites get more compensation than blacks. In the United States, the most racialized of "advanced" industrial societies, wage levels are lowest. Moreover, boundaries based on race constitute a deprivation for whites, who are diminished by their ignorance of some of the most impressive achievements in art, literature, religion, and music. Jazz and the blues are incorporated into mainstream popular culture, but only in a diluted form.

Politically, the walls between black and white have been among the most significant features of the conservative drift in contemporary politics, a trend that is beginning to hurt whites significantly, as many fall from middle-class to working-class status, from middle income to poor. In the process, they discover that the welfare state is not only for blacks. Increasingly, the whites who unwittingly allied with business to destroy the safety net are wounded by their own hand.

Like whiteness, maleness tends to depress wage and other measures of living standards. After the last quarter-century of feminist social activism, women still earn no more than 70 percent of male wages. In the 1970s and early 1980s, some public employees' unions with large constituencies among women developed an approach to wage equity called "comparable worth." Unions demanded that jobs typically assigned to women be evaluated by the same criteria as those within which men predominate. In the early years of the comparable-worth movement, these unions succeeded in winning substantial pay increases for large numbers of women, particularly in Washington, D.C., New York, and a few other areas. But the courts have tended to uphold challenges to comparable worth. State and local governments have sued,

STANLEY ARONOWITZ

claiming that the realignments were financially unfeasible, and even though some "male" jobs were also upgraded, the courts have agreed that the policy of comparable worth constitutes reverse discrimination.

Comparable worth was among the most radical proposals in the history of modern labor relations, and if it had been adopted as a feminist campaign, it might have struck a fatal blow to masculinism in the workplace. Unfortunately, neither the unions nor the feminists saw fit to make an extrajuridical battle to achieve genuine pay equity. I am not advocating this specific struggle over the larger project of addressing masculinism on a wide variety of fronts. I am merely citing this instance to demonstrate that appeals to "conscience" will never overcome masculinism, just as dogma will never transcend its profound cultural roots. Unless—and until—men are shown how they will benefit from ending their own cultural privileges, no real change will take place.

Similarly, an antimasculinist discourse must, in addition to deconstructing representations, show the material and spiritual costs of maleness. One point to be made is the extent to which men become victims of the emotional plague by the imperative of having to be always in control; how much we are deprived of genuine recognition and love not only by our mates but also by our children. Male power comes at the price of emotional isolation.

I am not opposing what Foucault in his last works attempted to revive: the ethic of caring. But, as he argued, this ethic is fulfilled not so much by acts of conscience, but by care of the self. Beyond moral oratory, the end of masculinism—whose close proximity to sexism must certainly be acknowledged—presupposes a serious effort to address alternatives to those privileges that sustain it. We will be judged by our willingness to engage in these investigations.

CONTRIBUTORS

Stanley Aronowitz is Director of the Center for Cultural Studies at the Graduate Center of the City University of New York. He is the author of *Dead Artists, Live Theories*; *The Politics of Identity*, *Science as Power*; *The Crisis of Historical Materialism*; *Working Class Hero*; and most recently, *The Jobless Future*, with William deFazio. He is a member of the editorial collective of *Social Text*, and convener of the Union of Democratic Intellectuals.

Leo Bersani is the Class of 1950 Professor of French at the University of California at Berkeley. He is also the author of *The Culture of Redemption*; and, with Ulysse Dutoit, *Arts of Impoverishment: Beckett, Rothko, Resnais*. Harvard has just published his new book, *Homos*.

Homi K. Bhabha has just published a new book, *Location of Culture*. In September 1994, he joined the faculty of the University of Chicago as Professor of Literary and Cultural Theory.

Derrick Bell is the author of *Confronting Authority: Reflections of an Ardent Protester*; *Faces at the Bottom of the Well: The Permanence of Racism*; and *And We Are Not Saved: The Elusive Quest for Racial Justice*.

Judith Butler is the author of *Bodies that Matter: On the Discursive Limits of "Sex"*; *Feminists Theorize the Political*; and *Gender Trouble: Feminism and the Subversion of Identity*.

Richard Delgado is the coauthor of *Words That Wound*; and the Charles Inglis Thomson Professor of Law at the University of Colorado.

Barbara Ehrenreich is a regular essayist for *Time* magazine and a regular columnist for *The Guardian*. She is also the author of many books, including *The Worst Years of Our Lives*:

Irreverent Notes from a Decade of Greed; *Kipper's Game*; *Fear of Falling: The Inner Life of the Middle Class*; and *Re-making Love: The Feminization of Sex*, with Elizabeth Hess and Gloria Jacobs.

Anne Fausto-Sterling is Professor of Medical Science in the Division of Biology and Medicine at Brown University. She is the author of *Myths and Gender: Biological Theories about Women and Men*, and has also written broadly about the role of race and gender in the construction of scientific theory and the role of such theories in the construction of race and gender.

Richard Fung is a Toronto-based independent video producer, writer, and activist. His videotapes, which include *Chinese Characters* (1986), *My Mother's Place* (1990), and *Dirty Laundry* (1995), have been widely screened. His articles and essays have appeared in many journals and several anthologies.

Sander L. Gilman is Professor of Germanic Studies, Professor of the History of Science and Professor of Psychiatry at the University of Chicago. He is also the author of *The Case of Sigmund Freud*; and *Freud, Race and Gender*.

Marjorie Heins is the Director of the ACLU Arts Censorship Project, and the author of *Sex, Sin and Blasphemy: A Guide to America's Censorship Wars*.

bell hooks is a writer and teacher who speaks widely on issues of race, class, and gender. Her most recent books are *Outlaw Culture: Resisting Representations; Teaching to Transgress: Education as the Practice of Freedom*; and *Sisters of Yam: Black Women and Self-Recovery*.

Wayne Koestenbaum is the author of *The Queen's Throat: Opera, Homosexuality, and the Mystery of Desire*; and *Rhapsodies of a Repeat Offender*. He is an Associate Professor of English at Yale University.

Philomena Mariani teaches in the Department of Urban Planning, Columbia University. She is the editor of *Critical Fictions: The Politics of Imaginative Writing*, and is currently completing her dissertation on family preservationism in theories of violence and criminality.

Andrew Ross is Professor and Director of the American Studies Program at New York University, and a columnist for *Artforum*. His books include *The Chicago Gangster Theory of Life: Nature's Debt to Society*; *Strange Weather: Culture, Science, and Technology in the Age of Limits*; and *No Respect: Intellectuals and Popular Culture*. Recently, he coedited *Microphone Fiends: Youth Music and Youth Culture*.

Eve Kosofsky Sedgwick is the Newman Ivey White Professor of English at Duke University. Her books include *Between Men: English Literature and Male Homosocial Desire*; *Epistemology of the Closet*; *Tendencies*; and a volume of poetry, *Fat Art, Thin Art*.

Paul Smith is the author of numerous articles on masculinity and feminism, a coeditor of the book, *Men in Feminism*, and editor of a forthcoming anthology, *Boys*.

Abigail Solomon-Godeau is an Associate Professor of Art History at the University of California, Santa Barbara. She is the author of *Photography at the Dock: Essays on Photographic History, Institutions, and Practices*; and the forthcoming *Male Trouble: A Crisis in Representation*.

Jean Stefancic is a Research Associate at the University of Colorado School of Law, Boulder.

Michael Taussig used to teach performance studies and now teaches anthropology in New York City. He has spent the last twenty-four years between Colombia and the United States and has written on the impact of colonialism on shamanism, and the abolition of slavery in *Talking Terror*; and *Mimesis and Alterity*.

Kendall Thomas is Professor of Law at Columbia University in New York, where he teaches courses in constitutional law, communications law, legal philosophy, critical race theory, and law and sexuality. His work has appeared in the Virginia, Columbia, and University of Southern California law reviews, as well as in *G.L.Q.: A Journal of Lesbian and Gay Studies*, and *Assemblage: A Critical Journal of Architecture and Design Culture*. He is coeditor of *Critical Race Theory: A Reader*, to be published this year by the New Press.

Carole S. Vance, an anthropologist at Columbia University, writes about sexuality and public policy. She is the editor of *Pleasure and Danger: Exploring Female Sexuality*. She has also written many articles about gender, the body, and representation.

Michele Wallace is Associate Professor of English and Women's Studies at City College of New York and City University of New York Graduate Center. She is also the organizer of *Black Popular Culture*; and the author of *Black Macho and the Myth of the Superwoman*; and *Invisibility Blues: From Pop to Theory*.

Simon Watney is an art historian, writer, and critic. He writes frequently for *Artforum* and *Parkett*.

Patricia J. Williams is a Professor of Law at Columbia University, and author of *The Alchemy of Race and Rights*.

George Yúdice teaches Latin American Literature at Hunter College, and Cultural Studies at the City University of New York Graduate Center. He is Director of the Inter-American Cultural Studies Network, and the coeditor of *On Edge: The Crisis of Contemporary Latin American Culture*.

BIBLIOGRAPHY

Aronowitz, Stanley. *The Politics of Identity: Class, Culture, Social Movements.* New York: Routledge, 1992.

Barthes, Roland. *Roland Barthes.* New York: Hill and Wang, 1977.

Bell, Derrick A. *And We Are Not Saved: the Elusive Quest for Racial Justice.* New York: Basic Books, 1987.

Berger, Maurice. *Ciphers of Identity.* Exhibition catalogue. New York: D.A.P. in association with Fine Arts Gallery, University of Maryland, Baltimore, 1993.

———, ed. "Man Trouble," *Artforum* 32, no. 8 (April 1994), pp. 74–83. Essays: Simon Watney, "Aphrodite of the Future"; Herbert Sussman, "His Infinite Variety"; Wayne Koestenbaum, "My Masculinity"; Todd Haynes, "Lines of Flight"; Kobena Mercer, "Fear of a Black Penis"; Berger, "A Clown's Coat."

Bergman, David, ed. *Camp Grounds: Style and Homosexuality.* Amherst: University of Massachusetts Press, 1993.

Bersani, Leo. *The Freudian Body: Psychoanalysis and Art.* New York: Columbia University Press, 1986.

———. "Is the Rectum a Grave?" *October,* no. 43 (Winter 1987): 197–222.

Bhabha, Homi K. "The Other Question: The Stereotype and Colonial Discourse." *Screen* 24 (November-December 1983): 18–36.

———. "Of Mimicry and Man: The Ambivalence of Colonial Discourse." *October,* no. 28 (Spring 1984): 125–31.

———. *The Location of Culture.* New York: Routledge, 1994.

Blount, Marcellus, and George P. Cunningham. *Representing Black Men.* New York: Routledge, 1995.

Bly, Robert. *Iron John: A Book About Men.* Reading, Mass.: Addison-Wesley, 1990.

Boone, Joseph A., and Michael Cadden, eds. *Engendering Men: The Question of Male Feminist Criticism.* New York: Routledge, 1990.

Brittan, Arthur. *Masculinity and Power.* Oxford: Basil Blackwell, 1989.

Brod, Harry, ed. *The Making of Masculinities: The New Men's Studies.* Boston: Allen and Unwin, 1987.

Brown, Wendy. *Manhood and Politics.* Totowa, N.J.: Rowman & Littlefield, 1988.

Butler, Judith P. *Gender Trouble: Feminism and the Subversion of Identity.* New York: Routledge, 1991.

———. "Imitation and Gender Insubordination." In Diana Fuss, ed., *Inside/Out: Lesbian Theories, Gay Theories.* New York: Routledge, 1991.

———. *Bodies that Matter: On the Discursive Limits of "Sex."* New York: Routledge, 1993.

Butters, Ronald R., John M. Clum, and Michael Moon. *Displacing Homophobia: Gay Male Perspectives in Literature and Culture.* Durham, N.C.: Duke University Press, 1989.

Camera Obscura, no. 17 (1988). Special issue, "Male Trouble."

Caplan, Pat, ed. *The Cultural Construction of Sexuality*. London: Tavistock, 1987.

Carby, Hazel. "'On the Threshold of Woman's Era': Lynching, Empire, and Sexuality in Black Feminist Theory." *Critical Inquiry* 12 (Autumn 1985): 262–77.

Chapman, Rowena, and Jonathan Rutherford, eds., *Male Order: Unwrapping Masculinity*. London: Lawrence & Wishart, 1988.

Claridge, Laura, and Elizabeth Langland, eds. *Out of Bounds: Male Writers and Gender(ed) Criticism*. Amherst: University of Massachusetts Press, 1990.

Cohan, Steven, and Ina Rae Hark, eds. *Screening the Male: Exploring Masculinities in Hollywood Cinema*. New York: Routledge, 1993.

Cohen, Ed. *Talk on the Wilde Side: Towards a Genealogy of Male Sexualities*. New York and London: Routledge, 1993.

Connell, R.W., *Gender and Power: Society, the Person and Sexual Politics*. Stanford, Calif.: Stanford University Press, 1987.

Cook, Pam. "Masculinity in Crisis?" *Screen* 23 (1982): 39–46.

Cornwall, Andrea and Nancy Lindisfarne, eds. *Dislocating Masculinity: Comparative Ethnographies*. New York and London: Routledge, 1994.

Crimp, Douglas, ed. *AIDS: Cultural Analysis, Cultural Activism*. Cambridge, Mass.: MIT Press, 1988.

De Lauretis, Teresa, ed. *Feminist Studies/ Critical Studies*. Bloomington: University of Indiana Press, 1985.

———. *Technologies of Gender*. Bloomington: Indiana University Press, 1987.

Delgado, Richard. *Failed Revolutions: Social Reform and the Limits of Legal Imagination*. Boulder, Colo.: Westview Press, 1994.

differences, vol. 1, no. 3 (Fall 1989). Special issue, "Male Subjectivity."

Dollimore, Jonathan. *Sexual Dissidence: Augustine to Wilde, Freud to Foucault*. Oxford: Clarendon Press, 1991.

Duneier, Mitchell. *Slim's Table*. Chicago: University Press, 1994.

Easlea, B. *Fathering the Unthinkable: Masculinity, Scientists, and the Nuclear Arms Race*. London: Pluto Press, 1983.

Edwards, Tim. *Erotics and Politics: Gay Male Sexuality, Masculinity, and Feminism*. New York: Routledge, 1994.

Ehrenreich, Barbara. *The Hearts of Men: American Dreams and the Flight from Commitment*. New York: Doubleday, 1983.

———. *Fear of Falling: The Inner Life of the Middle Class*. New York: Pantheon, 1989.

Epstein, Steven. "Gay Politics, Ethnic Identity: The Limits of Social Construction." *Socialist Review* 17 (May–August 1987): 9–54.

Faludi, Susan. *Backlash: The Undeclared War Against American Women*. New York: Anchor Books, 1992.

Fanon, Frantz. *Black Skin, White Masks*. New York: Grove Press, 1967.

Fausto-Sterling, Anne. *Myths of Gender: Biological Theories about Women and Men*. New York: Basic Books, 1992.

Foucault, Michel. "The History of Sexuality: Interview." Translated by Geoff Bennington. *Oxford Literary Review* 4 (1980): 3–14.

———. *The History of Sexuality. Volume I: An Introduction*. New York: Vintage Books, 1980.

———. "Friendship as a Lifestyle." In Sylvere Lotringer, ed., *Foucault Live*, trans. John Johnston. New York: Semiotext(e), 1989.

———. *The History of Sexuality. Volume II: The Use of Pleasure*, trans. Robert Hurley. New York: Vintage Books, 1985.

———. *The History of Sexuality. Volume III: The Care of the Self*. New York: Vintage Books, 1988.

Friday, Nancy. *Men in Love: Men's Sexual Fantasies*. New York: Arrow Books, 1980.

Fuss, Diane, ed. *Inside/Out: Lesbian Theories, Gay Theories*. New York: Routledge, 1991.

Garber, Marjorie. "Spare Parts: The Surgical Construction of Gender." *differences* 1 (Fall 1989): 137–59.

———. *Vested Interests: Cross-Dressing and Cultural Anxiety*. New York and London: Routledge, 1992.

Gates, Henry Louis, Jr. *The Signifying Monkey: A Theory of African American Literary Criticism*. New York: Oxford University Press, 1988.

Gaylin, Willard. *The Male Ego*. New York: Viking, 1992.

Gever, Martha, John Greyson, Pratibha Parmar, eds. *Queer Looks*. New York: Routledge, 1993.

Gilman, Sander L. *Freud, Race, and Gender*. Princeton: Princeton University Press, l993.

Golden, Thelma, et al. *Black Male: Representations of Masculinity in Contemporary American Art*. New York: Whitney Museum of American Art/Harry N. Abrams, Inc., 1994.

Gough, Jamie. "Theories of Sexual Identity and the Masculinization of the Gay Man." In Simon Shepherd and Mick Wallis, eds., *Coming on Strong: Gay Politics and Culture*. London: Unwin, 1989.

Green, Richard. *The "Sissy Boy Syndrome" and the Development of Homosexuality*. New Haven: Yale University Press, 1987.

Greenberg, David F. *The Construction of Homosexuality*. Chicago: University of Chicago Press, 1988.

Hagan, Kay Leigh, ed. *Women Respond to the Men's Movement: A Feminist Collection*. San Francisco: HarperSanFrancisco, 1992.

Halberstam, Judith. "F2M: The Making of Female Masculinity." In Laura Doan, ed., *The Lesbian Postmodern*. New York: Columbia University Press, 1994.

Hall, Lesley. *Hidden Anxieties: Male Sexuality, 1900–1950*. Cambridge: Polity Press, 1991.

Hall, Stuart. "Cultural Identity and Diaspora." In Jonathan Rutherford, ed., *Identity: Community, Culture, Difference*. London: Lawrence & Wishart, 1990.

Haraway, Donna J. *Primate Visions: Gender, Race, and Nature in the World of Modern Science*. New York: Routledge, 1989.

———. *Simians, Cyborgs, and Women: the Reinvention of Nature*. New York: Routledge, 1991.

Harding, Sandra. *The Science Question in Feminism*. New York: Cornell University Press, 1986.

———. *Whose Science?, Whose Knowledge?: Thinking from Women's Lives*. Ithaca: Cornell University Press, 1991.

Hearn, Jeff. *The Gender of Oppression: Men, Masculinity, and the Critique of Marxism*. New York: St. Martin's Press, 1987.

———. *Men in the Public Eye: The Construction and Deconstruction of Public Men and Public Masculinities*. London: Routledge, 1992.

Hearn, Jeff, and David H.J. Morgan, eds. *Men, Masculinities and Social Theory*. London: Unwin Hyman, 1990.

Heins, Marjorie. *Sex, Sin, and Blasphemy: A Guide to America's Censorship Wars*. New York: New Press, 1993.

Hemphill, Essex, ed. *Brother to Brother: New Writings by Black Gay Men*. Boston: Alyson Press, 1991.

Herek, Gregory. "On Heterosexual Masculinity: Some Psychological Consequences of the Social Construction of Gender and Sexuality." *American Behavioral Scientist* 29 (1987): 563–77.

Hocquenghem, Guy. *Homosexual Desire*. Durham, N.C.: Duke University Press, l993.

hooks, bell. *Yearning: Race, Gender, and Cultural Politics*. Boston: South End Press, 1990.

———. *Black Looks: Race and Representation.* Boston: South End Press, 1992.

———. *Outlaw Culture: Resisting Representations.* New York : Routledge, 1994.

Hull, Gloria, Patricia Bell Scott, and Barbara Smith, eds. *All the Women Are White, All the Blacks Are Men, but Some of Us Are Brave: Black Women's Studies.* Old Westbury, New York: Feminist Press, 1982.

Irigaray, Luce. "Any Theory of the 'Subject' Has Always Been Appropriated by the Masculine." In *Speculum of the Other Woman,* trans. Gillian C. Gill. Ithaca: Cornell University Press, 1985.

Jackson, David. *Unmasking Masculinity: A Critical Autobiography.* London: Unwin Hyman, 1990.

Jardine, Alice, and Paul Smith, eds. *Men in Feminism.* New York and London: Routledge, 1987.

———. *The Remasculinization of America.* Bloomington: Indiana University Press, 1989.

Jeffords, Susan. *Hard Bodies: Hollywood Masculinity in the Reagan Era.* New Brunswick, N.J.: Rutgers University Press, 1993.

Katz, Jonathan, ed. *Gay American History: Lesbians and Gay Men in the U.S.A.* New York: Thomas Crowell, 1976.

Kaufman, Michael, ed. *Beyond Patriarchy: Essays by Men on Pleasure, Power and Change.* Toronto and New York: Oxford University Press, 1987.

Keller, Evelyn Fox. *Reflections on Gender and Science.* New Haven: Yale University Press, 1985.

Kelly, Mary. *Gloria Patri.* Exhibition catalogue. Middletown, Conn.: Ezra and Cecile Zilkha Gallery, Wesleyan University, 1992.

Kimmel, Michael S., ed. *Changing Men: New Directions in Research on Men and Masculinity.* Newbury Park, Calif.: Sage Publications, 1987.

Kimmel, Michael S., and Michael A. Messner, eds. *Men's Lives.* New York: Macmillan, 1990.

Kimmel, Michael S., ed. *Men Confront Pornography.* New York: Crown, 1989.

Kinsman, Gary. "Gay Macho." In Michael Kaufran, ed., *Beyond Patriarchy: Essays by Men on Power, Pleasure and Change.* Toronto: Oxford University Press, 1987.

Koestenbaum, Wayne. *The Queen's Throat: Opera, Homosexuality, and the Mystery of Desire.* New York: Poseidon, 1993.

Kushner, Tony. *Angels in America: A Gay Fantasia on National Themes, Part One: Millennium Approaches.* New York: Theatre Communications Group, 1992.

Lacan, Jacques. "The Meaning of the Phallus." *Feminine Sexuality,* trans. Jacqueline Rose. New York: Norton, 1978.

Laqueur, Thomas. *The Making of Sexual Difference.* Cambridge: Harvard University Press, 1990.

———. *Making Sex: Body and Gender from the Greeks to Freud.* Cambridge, Mass.: Harvard University Press, 1990.

Leacock, Eleanor B. *Myths of Male Dominance.* New York: Monthly Review Press, 1982.

Lehman, Peter. "Penis-Size Jokes and Their Relation to the Unconscious." In A. Horton, ed., *Comedy/Cinema/Theory.* Berkeley: University of California Press, 1991.

Leverenz, David. *Manhood and the American Renaissance.* Ithaca: Cornell University Press, 1989.

Litewka, Jack. "The Socialized Penis." In Jon Snodgrass, ed., *A Book of Readings for Men Against Sexism.* Albion, Calif.: Times Change, 1977.

Lourde, Audre. "Age, Race, Class, and Sex: Women Redefining Difference." In Russell Ferguson et al., eds., *Out There: Marginalization and Contemporary Culture.* Cambridge, Mass.: MIT Press, 1990.

McCall, Nathan. *Makes Me Wanna Holler: A Young Black Man in America.* New York: Random House, 1994.

McGill, Michael E. *The McGill Report on Male Intimacy.* New York: Harper & Row, 1985.

McGrath, Roberta. "Looking Hard: The Male Body Under Patriarchy." In Aldair Foster, ed., *Behold the Man: The Male Nude in Photography,* exhibition catalog. Edinburgh: Stills Gallery, 1988.

Madhubuti, Haki R. *Black Men: Obsolete, Single, Dangerous?: African-American Families in Transition: Essays in Discovery, Solution, and Hope.* Chicago: Third World Press, 1990.

Majors, Richard, and Janet Mancini Billson. *Cool Pose: The Dilemmas of Black Manhood in America.* New York: Simon & Schuster, 1992.

Mangan, J.A., and James Walvin, eds. *Manliness and Morality: Middle-Class Masculinity in Britain and America 1800–1940.* New York: St. Martin's Press, 1987.

Mapplethorpe, Robert. *The Black Book.* Munich: Schirmer-Mosel, 1986.

Mellen, Joan. *Big Bad Wolves: Masculinity in the American Film.* New York: Pantheon, 1977.

Mercer, Kobena. *Welcome to the Jungle: New Positions in Black Cultural Studies.* New York: Routledge, 1994.

———, and Isaac Julien "True Confessions: A Discourse on Images of Black Male Sexuality." *Ten.8,* no. 22 (n.d.): 4–9.

Metcalf, Andy, and Martin Humphries, eds. *The Sexuality of Men.* London: Pluto, 1985.

Middleton, Peter. *The Inward Gaze: Masculinity and Subjectivity in Modern Culture.* New York and London: Routledge, 1992.

Min, Yong Soon. "Territorial Waters: Mapping Asian American Identity." *Cultural Studies* 4 (October 1990).

Modleski, Tania. *Feminism Without Women: Culture and Criticism in a "Postfeminist" Age.* New York: Routledge, 1991.

Moi, Toril. "Men Against Patriarchy." In Linda Kauffman, ed., *Gender and Theory: Dialogues on Feminist Criticism.* New York: Basil Blackwell, 1989.

Morrison, Toni, ed. *Race-ing Justice, Engendering Power: Essays on Anita Hill, Clarence Thomas and the Construction of Social Reality.* New York: Pantheon, 1992.

Mulvey, Laura. "Visual Pleasure and Narrative Cinema" and "Afterthoughts on 'Visual Pleasure and Narrative Cinema' Inspired by *Duel in the Sun.*" In Constance Penley, ed., *Feminism and Film Theory.* New York: Routledge, 1988.

Neale, Steven. "Masculinity as Spectacle: Reflections on Men and Mainstream Cinema." *Screen* 24 (November/December 1983): 2–16.

Nestle, Joan, ed. *The Persistent Desire: A Femme-Butch Reader.* Boston: Alyson, 1992.

Ortner, Sherry, and Harriet Whitehead, eds. *Sexual Meanings: The Cultural Construction of Gender and Sexuality.* New York: Cambridge University Press, 1981.

Penley, Constance, ed. *Male Trouble.* Minneapolis: University of Minnesota Press, 1993.

Pleck, Joseph. *The Myth of Masculinity.* Cambridge, Mass.: MIT Press, 1981.

Porter, David, ed. *Between Men and Feminism.* New York and London: Routledge, 1992.

Ross, Andrew, ed. *Universal Abandon?: The Politics Of Postmodernism.* Minneapolis: University of Minnesota Press, 1988.

———. *Strange Weather: Culture, Science, and Technology in the Age of Limits.* London and New York: Verso, 1991.

Rotundo, E. Anthony. *American Manhood: Transformations in Masculinity from the Revolution to the Modern Era*. New York: Basic Books, 1993.

Rutherford, Jonathan, ed. *Identity: Community, Culture, Difference*. London: Lawrence & Wishart, 1990.

———. *Men's Silences: Predicaments in Masculinity*. New York and London: Routledge, 1994.

Savran, David. *Communists, Cowboys, and Queers: The Politics of Masculinity in the Work of Arthur Miller and Tennessee Williams*. Minneapolis: University of Minnesota Press, 1992.

Scott, Gini Graham. *Dominant Women, Submissive Men*. New York: Praeger, 1983.

Scott, Joan. "Multiculturalism and the Politics of Identity." *October,* no. 61 (Summer 1992): 12–19.

Sedgwick, Eve Kosofsky. *Between Men: English Literature and Male Homosocial Desire*. New York: Columbia University Press, 1985.

———. *Epistemology of the Closet*. Berkeley: University of California Press, 1990.

———. *Tendencies*. Durham, N.C.: Duke University Press, 1993.

Segal, Lynne. *Slow Motion: Changing Masculinities, Changing Men*. London: Virago: 1990.

Seidler, Victor J. "Reason, Desire and Male Sexuality." In Pat Caplan, ed., *The Cultural Construction of Sexuality*. London: Tavistock, 1987.

———. *Rediscovering Masculinity: Reason, Language and Sexuality*. New York and London: Routledge, 1989.

———. *Recreating Sexual Politics: Men, Feminism and Politics*. New York and London: Routledge, 1991.

———. *Unreasonable Men: Masculinity and Social Theory*. New York and London: Routledge, 1994.

Showalter, Elaine, ed. *Speaking of Gender*. New York: Routledge, 1989.

Siegal, Carol. *Male Masochism: Modern Revisions of the Story of Love*. Bloomington: Indiana University Press, 1995.

Silverman, Kaja. *Male Subjectivity at the Margins*. New York: Routledge, 1992.

Simpson, Mark. *Male Impersonators: Men Performing Masculinity*. New York: Routledge, 1994.

Smith, Paul. *Clint Eastwood: A Cultural Production*. Minnesota: University of Minnesota Press, 1993.

Snitow, Ann, Christine Stansell, and Sharon Thompson, eds. *Powers of Desire: The Politics of Sexuality*. New York: Monthly Review Press, 1983.

Snodgrass, Jon, ed. *For Men Against Sexism*. San Rafael, Calif.: Times Change Press, 1977.

Solomon-Godeau, Abigail. *Mistaken Identities*. Exhibition catalogue. Santa Barbara: University Art Museum, 1993.

———. *Male Trouble*. New York: Thames & Hudson, 1995.

Spivak, Gayatri Chakravorty. "Displacement and the Discourse of Women." In Mark Krupnick, ed., *Displacements: Derrida and After*. Bloomington: Indiana University Press, 1983.

Staples, Brent. "Into the White Ivory Tower." *New York Times Magazine,* Feb. 6, 1994.

———. *Parallel Time: Growing Up in Black and White*. New York: Pantheon, 1994.

Staples, Robert. *Black Masculinity: The Black Male's Role in American Society*. San Francisco: Black Scholar Press, 1982.

Studlar, Gaylyn. *In the Realm of Pleasure: Von Sternberg, Dietrich, and the Masochistic Aesthetic.* Urbana: University of Illinois Press, 1988.

Taussig, Michael. *Mimesis and Alterity.* New York: Routledge, 1993.

Theweleit, Klaus. *Male Fantasies. Volume One. Women, Floods, Bodies, History.* Trans. Stephen Conway, with Erica Carter and Chris Turner. Minneapolis: University of Minnesota Press, 1987.

———. *Male Fantasies. Volume Two. Male Bodies: Psychoanalyzing the White Terror.* Trans. Erica Carter and Chris Turner, with Stephen Conway. Minneapolis: University of Minnesota Press, 1989.

Thompson, Keith, ed. *To Be a Man.* Los Angeles: Tarcher Books, 1991.

Tolson, Andrew. *The Limits of Masculinity.* London: Tavistock, 1977.

Vance, Carole, ed. *Pleasure and Danger: Exploring Female Sexuality.* San Francisco: Pandora, 1993.

Van Leer, David. "The Beast of the Closet: Homosociality and the Pathology of Manhood." *Critical Inquiry* 15 (Spring 1989): 587–605.

Walby, Sylvia. *Theorizing Patriarchy.* London: Basil Blackwell, 1990.

Wallace, Michele. *Black Macho and the Myth of the Superwoman.* London: Verso, 1990.

Wallis, Brian, ed. *Art After Modernism: Rethinking Representation.* Boston: David Godine, 1984.

———. *Democracy: A Project by Group Material.* Seattle: Bay Press, 1990.

Warner, Michael, ed. *Fear of a Queer Planet: Queer Politics and Social Theory.* Minneapolis: University of Minnesota Press, 1993.

Watney, Simon. *Practices of Freedom: Selected Writings on HIV/AIDS.* Durham, N.C.: Duke University Press, 1994.

Watson, Simon. *Dissent, Difference, and the Body Politic.* Exhibition catalogue. Portland, Ore.: Portland Art Museum, 1993.

Weeks, Jeffrey. *Sex, Politics and Society: The Regulation of Sexuality Since 1800.* London: Longman, 1981.

Weiermair, Peter. *The Hidden Image: Photographs of the Male Nude in the Nineteenth and Twentieth Centuries.* Cambridge, Mass.: MIT Press, 1988.

West, Cornel. *Race Matters.* New York: Vintage Books, 1994.

Wideman, John Edgar. *Fatheralong: A Meditation on Fathers and Sons, Race and Society.* New York: Pantheon, 1994.

Williams, Patricia J. *The Alchemy of Race and Rights.* Boston: Harvard University Press, 1991.

Yúdice, George, Jean Franco, and Juan Flores, eds. *On Edge: The Crisis of Contemporary Latin American Culture.* Minnesota: University of Minnesota Press, 1992.

PHOTO CREDITS

INDEX

Bersani, Leo, 35, 89

Bhabha, Homi, 3

Biological determinism: feminist critique of, 37–38; in violence research, 142–43. *See also* Genetics

Birth control, 254

Birth of a Nation, The (film, 1915), 214

Black, Justice Hugo L., 254

Blüher, Hans, 178–80, 181–85, 187

Bobbit, Lorena, 251

Body: eroticization of male in cinema, 81–96; Kafka and male Jewish, 176–87; and scientific construction of masculinity, 127–33

Boone, Bruce, 311

Bowers v. Hardwick (1986), 259, 262n.30

Boy George, 11, 12

Bratton, William (Police Chief), 242–43

Breast cancer, 14

Breiling, James, 138

Brennan, Justice William J., Jr., 255

Britten, Benjamin, 310

Brocket, v. Spokane Arcades (1985), 255–56, 261n.19

Brod, Max, 179–80, 185–86

Buckley, William F., 169

Burger, Chief Justice Warren, 251–52, 254–55, 259

Burr, Chandler, 159

Butler, Judith, 3, 4, 5, 281, 283n.37

C

Canada: Chinese immigrants to, 293–96; nationalism in, 292; obscenity law, 257, 262n.25

Canon, of classical music, 310

Carnival, as form of transformism, 283n.37

Castration, notions of in female and male contexts, 14–15, 20n.5

Censorship law, 250–60

Chapman, Anne, 113

Chesler, Phyllis, 98

Chesnutt, Charles, 218

Child abuse, biobehavioralism and, 154

Children: behavioral models of criminality, 135–54; male interest in and decline of patriarchy, 285; parenting responsibilities in egalitarian family, 312

Chinese Americans and Chinese Canadians: heterosexual responsibilities and male immigrants, 293–96; images of men in law and culture, 215–16

Chinese Exclusion Act (Canada), 294, 298n.6

Christian fundamentalism, family and authoritarianism, 153–54

Cinema. *See* Film theory

Circumcision, 177

Civil Rights Movement, 1, 64, 276

Civil society, 281

Class: and anti-Semitism, 62; and biobehavioral research on crime, 140, 153

Clastres, Pierre, 109

Cleaver, Eldridge, 203

Cleckley, Hervey, 147, 148

Clinton, Bill, 172

Clouston, T. S., 145–46

Cobain, Kurt, 171

Colonialism, and images of black males in popular culture, 102

Comparable worth, as approach to wage equity, 320

Computer network conference (<gen.maleness>), 267–81

Conformism, transgression and male homosexuality, 119

Confucianism, 296, 298n.9

Connor, Steve, 162–63

Conservatism, of Hollywood action movies, 91

Constitutional law, 223–25, 234–35

Constructionist theory, compared to social construction theory, 42–43

Consumerism, and decline of patriarchy, 287–88. *See also* Advertising

Fanon, Franz, 203

Farrell, Warren, 269

The Federalist Papers (Madison, Jay, and Hamilton), 223–25, 234–35

Feinberg, Leslie, 13

Femininity: heterosexuality and gender identity in Freudian theory, 26; as orthogonal to masculinity, 15–16; and representation of masculinity in pre- and postrevolutionary French art, 73, 74, 75; self-recognition and essentialism in, 18–19; as threshold effect, 16–18. *See also* Women

Feminism: critiques of biological determinism, 37–38; debate on sexual difference in, 165; essentialism in contemporary, 314; and hagiography of political father, 63–64; male theorists and, 119–20; white male identity politics and, 268

Feudalism, 288

Fichte, Johann, 59

Fiedler, Leslie, 286

Film theory: Eastwood and representation of masculinity in Hollywood films, 77–96; image of law in Hollywood films, 227–36; images of Asian men in, 296; images of black males in popular culture, 99–106; initiation rituals compared to cinema, 113; masculinity and political correctness in contemporary Hollywood films, 167–75; popular culture and social construction of masculinity, 308–10

Foreclosure, Lacanian notion of, 36n.2

Foucault, Michel: on biology and formation of self, 316; concept of ethics, 276, 277–78, 280, 321; definition of power, 5; model of gender, 6; on power and rule of law, 222–23

France, representations of masculinity in pre- and postrevolutionary art, 71–76

Frank, Judith, 13

Fraser, Matthew, 250–52

Freeman, Elizabeth, 121–22

Freud, Sigmund: case of the Rat Man, 59; on fear and anxiety, 60; influence on Blüher, 178–79, 180, 183, 188n.12; Levay on, 160; on masochism, 90; melancholy and formation of gender, 21–23, 23–24, 28–31; model of gender, 71; notion of polymorphous perversity, 308

Friedman, Richard, 12

Frost, David, 226

G
—

Gauntlet, The (film, 1977), 92

Gay and lesbian movement: and genetic determinism, 159; and hegemonic representations of masculinity, 117–18

Gender: Freudian theory of identity, 24–36; identity as performative, 4–5, 31–34; melancholy and formation of, 21–36; and sexuality in social construction theory, 45–46

Genet, Jean, 122

Genetics: biobehavioral research on criminality and violence, 140–42; gender and human development, 128–31; sociobiology and homosexuality, 158–65. *See also* Biological determinism

Gerard, François-Pascal-Simon (Baron), 72

Giddings, Paula, 208n.1

Gide, André-Paul-Guillaume, 122

Ginsburg, Ruth Bader, 252

Girodet-Trioson (Anne-Louis Girodet de Roucy), 72, 73

Giroux, Henry, 103

Goodwin, Frederick, 137–38, 139, 141, 142, 143, 153

Gordimer, Nadine, 218

Gramsci, Antonio, 271

Grand Canyon (film, 1991), 105

Greaser's Gauntlet, The (film, 1908), 217

Green, Richard, 132

Greer, Germaine, 15

Griffith, D. W., 214, 215, 217

Gross, Hans, 186

Race (*continued*)

 social construction and representation of men of color, 211–20; social relationships of black men and women, 193–208. *See also* African Americans; Asian Americans; Racism

Racism: of biobehavioralism, 153; trauma and violence in lives of white people, 242–43. *See also* Race

Rap music, 172, 301

Reconstruction, images of black male in law and culture, 213–14

Redford, Robert, 169

Regina v. Hicklin (1868), 254

Rehnquist, Justice William H., 252–53

Representation, of masculinity: black males in popular culture, 99–106; Eastwood as cultural icon in Hollywood films, 77–96; initiation rituals and, 109–13; in late-eighteenth- and nineteenth-century French art, 71–76; male identity politics and responsibility, 291–98; and political implications of homosexuality, 116–23; and social construction of men of color, 211–20; of tough women in Hollywood films, 290

Reproduction, cultural influence models of sexuality, 44–46. *See also* Abortion; Birth control

Responsibility: and antimasculinist discourse, 314; Holocaust and question of political, 312–13; representation and male identity politics, 291–98; white male identity politics and notion of oppression, 268–81

Richardson, Riché, 16

Riefenstahl, Leni, 56

Riggs, Marlon, 106

Rising Sun (film, 1993), 104–105

Roediger, David, 320

Ross, Andrew, 271, 280

Roth, Philip, 209n.13

Roth case (1957), 253, 254–55

Rothenburg, Erika, 269–70

Rubin, Gayle, 38

Rush, Benjamin, 144

S

Sadism, in cinematic erotics of male body, 81–96

Salt'N Pepa, 172

Sambo, as cultural image of black male, 213, 217

Sanger, Margaret, 254

Saxton, Alexander, 320

Schlafley, Phyllis, 285–86

Schmitt, Carl, 227

Schomburg, Arthur, 304

Schomburg Center, 304

Schopenhauer, Arthur, 108

Schwarzenegger, Arnold, 172

Science: child behavior and theories of criminality, 135–54; construction of masculinity in, 127–33; contemporary crisis of, 173–74; genetic determinism in sociobiological approach to homosexuality, 158–65; Kafka and male Jewish body, 176–87

Seagal, Steven, 167–70, 173, 174–75, 271

Sedgwick, Eve Kosofsky, 7, 74, 225

Segal, Benjamin, 185

Sex discrimination law, 252–53

Sexism: masculinity and censorship law, 250–60; and patriarchy, 284; and social relationships between black men and women, 193–208. *See also* Misogyny

Sexuality: obscenity law and control of female, 253–58; social construction theory and, 39–48; social psychological approach to, 157–58. *See also* Heterosexuality; Homosexuality

Sexuality of Men, The (Pluto Press), 78

Shakur, Tupac, 171–72

Shane (film, 1953), 79

Siegel, Don, 83, 85–86, 87, 88

Silverman, Kaja, 71, 73, 75, 88–90, 96n.9

Simmel, Georg, 109

Simpson, O.J., 302, 305

Slavery, sexual abuse and, 199–202, 207, 209n.6

Smith, Paul, 7